# The Quilted Home Handbook

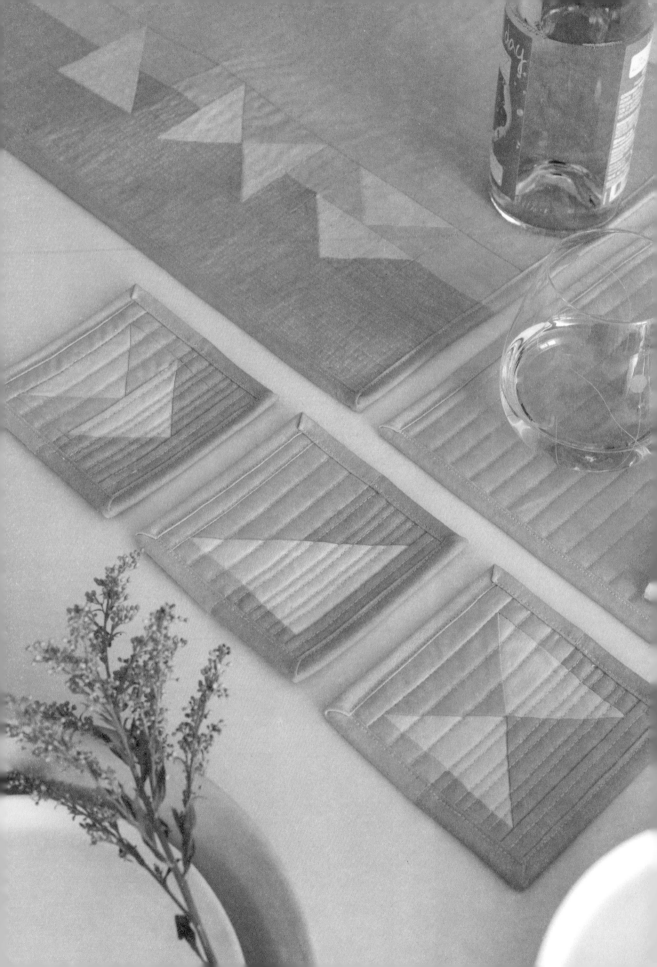

WENDY CHOW

# The Quilted Home Handbook

Transform Your Space with the Art of Quilting

Paige Tate & Co.

Eighteen months of renovating our home, twelve months of living out of our bedroom, and a construction zone during a global pandemic. Brian, there's nobody else I would have done it with. And welcome home Truffle, our little fur baby.

# TABLE OF CONTENTS

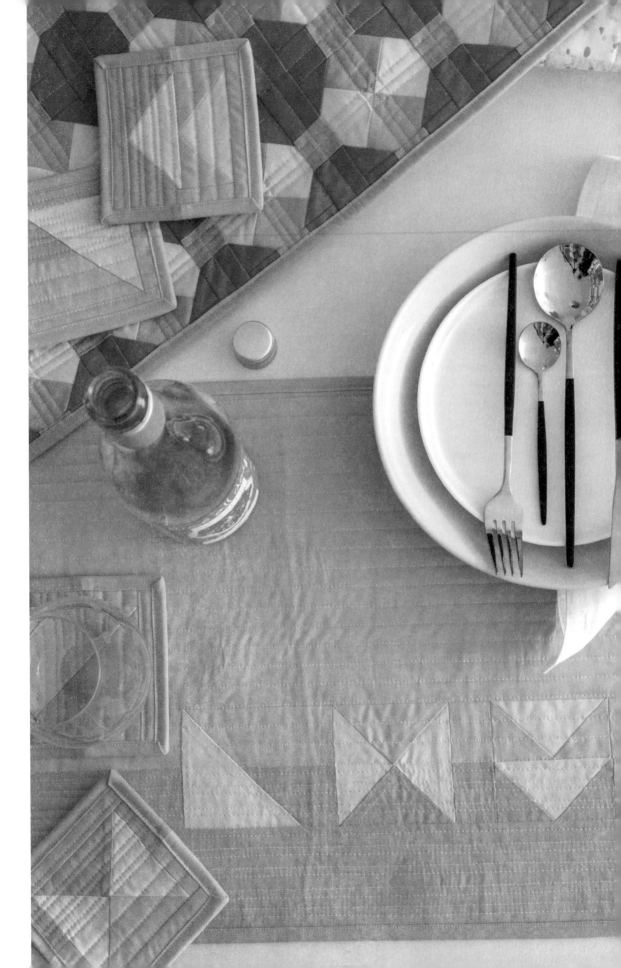

# INTRODUCTION

What you hold in your hands is a series of projects that have been brewing in my mind for quite some time. Many came from living in a construction zone and out of our bedroom with my husband for twelve months, most of which happened during a global pandemic that put our renovation to a standstill and forced us to work from home. I thought moving in together after nearly four years of living apart between Perth, Australia, and New York City was extreme. But working and living out of our bedroom 24/7 was next level. It's a miracle we didn't kill each other, run into any disagreements, or make a COVID-19 baby during this extensive time together!

Living out of our bedroom was a huge challenge, and frustrating at times. My desk became the heart and center of our home. Multiple times a day I cleared my workspace so we could cook, eat, work, and park our laptops to watch TV during our non-working hours. Our wardrobe doubled as our "doomsday dungeon," where we stored all our pandemic lockdown supplies. And my husband requested I go in there when I had to take calls, to drown the sound of talking and laughing.

As you can imagine, my mind often wandered to a hopeful place where we could put our feet up and enjoy our favorite shows and movies, not have to listen to music with headphones, entertain, try new recipes, and work from all corners of our home. I dreamt about how our home would look with all the furniture and décor in it, and of creating a space that brought us positive energy, inspiration, functionality, and comfort. Ultimately, I pictured our home as a place that we never wanted to leave. After all, the two of us are homebodies at heart. But more importantly, as a creative and quilter, I wanted to add personalized touches by introducing handmade goods—specifically, quilted home goods made with my hands. Table runners, coasters, cushion covers, and quilts for the bed and couch were on my to-make list.

It's been over a year since my husband and I completed our eighteen-month home renovation project, and we continue to switch out, rearrange, and add things to our space to discover what we like. Throughout this process I have learned it takes time to make a home one's own, and it continues to evolve as our set of responsibilities, composition of households, routines, trends, and tastes change. Our homes are so unique and special to each of us, acting as a reflection of who we are—our passions, interests, personalities, and styles—and the seasons of life we go through.

## WHAT TO EXPECT AND MAKING IT YOUR OWN

Whether you live in a shared space, a rental, or your own property, *The Quilted Home Handbook* was written to be part of your journey in personalizing and creating a space you'll love and enjoy. I hope to provide you with inspiration and the confidence to build an abode filled with handmade, quilted touches you can feel proud of. I hope that making your own décor brings you a sense of joy and belonging. The projects throughout the book are timeless and designed to be easily integrated and customized for your home or a loved one's space. I mean, who doesn't like to receive something specially handmade for them?

Quilts are not solely designed to sit on your couch or lie on your bed. *The Quilted Home Handbook* aims to show you the versatility of the art of quilting. The projects in the book are arranged by areas of a home: bedroom, living, and dining. However, you have full creative control and the flexibility to move these projects to other parts of your home as you desire—for example, throw cushions on the entryway or mudroom bench instead of on the living room couch. Some projects can even double as something else, with a wholly different function and purpose. For instance, the floor cushion pattern on *page 205* can also be a wall hanging or a bed for your furry family member. The functionality, purpose, and style of your projects will vary from everyone else's. This is the beauty of handmade and creating your own interpretation of a design. No two projects are ever going to look exactly the same.

Prior quilting knowledge isn't necessary to complete these projects. However, it is assumed that you have some basic skills and experience in operating a sewing machine. The Getting Started section (*page 32*) is dedicated to helping you gather all the tools you'll need to assemble your quilt from start to finish. Each pattern includes color ideas in Color Inspirations (*page 12*), detailed step-by-step instructions and diagrams, and tips for success. Some projects may require additional supplies, such as wooden dowels. These will be listed at the start of each pattern. You'll also find smaller projects, such as coasters, that make the craft of quilting approachable for beginners—and quick to tackle over the weekend. And of course, you'll find larger projects such as quilts for your couches and beds.

If you ever get lost or feel overwhelmed by the quilting jargon, there's a section of general instructions on how to assemble your quilt (page 39) and terms and abbreviations at the back of the book (page 259). You'll even find information on how to prepare your quilted project to be hung on the wall (*page 60*), create and attach bias binding tape (*page 84*), and quilt with a domestic sewing machine and add different quilting motifs to finish your project (*page 66*).

Consider this book your companion in creating personalized, quilted touches around your home. From inspirational photos and styling ideas to color inspirations, you'll find plenty here to get your creative juices flowing and quilting mojo going. Don't be afraid to experiment with the projects and ideas to make them uniquely your own!

## WHERE TO BEGIN

Creating a space that is meaningful, functional, and beautiful can be overwhelming. Before we jump into the technical quilty stuff, I want to leave you with a few points to consider as you flip through the book, begin to gather your fabrics, and start your next project. These suggestions and ideas might help guide you in creating a space with quilted home goods that speak to your needs, lifestyle, and story.

## GATHERING YOUR IDEAS AND DEFINING
## YOUR DESIGN AESTHETIC

First, gather your ideas and thoughts on how you envision your space. In other words, create a mood board. This allows you to dive deeper into your design goals and define your aesthetics, color preferences, and which projects to make. This process is particularly helpful if you plan on creating more than one project for your home, as you may want them to complement each other.

Flipping through magazines, browsing online, starting a Pinterest board, or simply going to your local home décor and furniture store are all great starting points to narrow down what you like. Your mood board could consist of color and texture swatches, patterns and prints, and room arrangements and styling.

Choosing an aesthetic can be tricky when there is more than one opinion to consider in your household. But it doesn't have to be—you can turn this brainstorming process into an opportunity to bond and get to know your household member(s) from a different perspective. You'd be surprised what you could learn about each other, and their opinions could provide some inspiration as well.

When we started our home renovation, my husband and I each created mood boards for each room on Pinterest. Then we exchanged links, picked our top three photos in each board, and merged them. Thankfully, our design aesthetics were similar: mid-century modern, clean lines, and timeless. However, our color palettes were polar opposites. Similar to my quilt-design aesthetic, I love pops of color, different textures, bold prints, and patterns—it was simple, solid, and neutral colors for my husband. We came to a mutual agreement to have neutral finishes everywhere—tiles, appliances, cabinets, walls, bathroom, lighting, and kitchen fixtures—and I was able to add colorful décor pieces around the home.

Keep your mood board easily accessible so you can reference it throughout the quilting process to ensure you stay on track and consistent with your aesthetic. And don't forget, inspiration strikes any time. Don't feel completely wedded to everything on your mood board. You can switch out and add new ideas at any time.

### MAKING IT HAPPEN

Once you have a good idea of the direction of your project(s) and space, it's about translating it into reality:

+ *Identifying the Functionality and Purpose:* Home goes beyond four walls. A home is a place that provides a sense of belonging, security, love, and comfort. These intangible features are created by those who live in the space and are achieved by identifying the functionality and purpose of each room. Think about how you and your household use each space, what is important to everyone using the room, and how it could be better. These considerations can drive your decision(s) in your next quilting project. For example, if entertainment is what you and your household enjoy, your next quilted projects could be influenced by what is in your living, kitchen, dining, and/or outdoor spaces. You might create conversation-starting

pieces, like a runner for your dining table, or coasters for the coffee table. Maybe you work from home and like to spread around in different rooms. Cushions might come in handy for back support and comfort for the long hours spent sitting.

+ *Finding Your Focal Point:* The focal point of a room is the first thing you see or are drawn to when you walk in. This might be an existing item, like a painting, rug, piece of furniture, or architectural feature. Alternatively, you might create a focal point by making and accessorizing the space with quilted wall hangings, throws, cushions, and more. With the focal point locked in, arrange the furniture and build around it with different textures, colors, and accessories. These changes can make a room more welcoming and elevate the feel, mood, and aesthetic of a space. For example, if you want your living room to be all about lounging and feeling cozy, center your room around the couch and create quilted throws and cushions to make it more inviting and plush.

+ *Creating Contrasts:* Contrasting elements, such as colors, patterns, prints, and textures, can make a focal point stand out, making a space look more cohesive. There are many ways this can be achieved in the quilting process; for example, fabric choices (colors, patterns, and fabric types), different thread weights, how you finish a quilt (machine or hand quilting).

+ *Playing With Colors:* Color can create a point of interest and add personality to a room, even if it only features neutrals. Color can also influence our moods, productivity, and minds. If choosing colors is not your forte or you need some inspiration to get your creative juices flowing, a great place to start is by typing "color palettes" into your web browser or social media search bar. But be warned . . . this can lead to hours of scrolling and bookmarking! Photos of real-life objects, sceneries, and illustrations are other great sources of color inspiration. You can also discover different color combinations by simply going out for a walk, admiring the work of local street artists, window shopping to see what colors are trending, watching the sun rise or set, driving to the beach, hiking a trail. The convenience of the smartphone these days makes it easy to capture and store these moments and inspirations as soon as they strike. As previously mentioned, if you plan on creating more than one project for a home or room, you may want the colors of the projects to complement each other. Throughout the quilting process, keep a swatch nearby of the existing colors in the space where you plan to add your quilted touches and/or the colors you plan on incorporating into your projects. This will help you stick to your overall design aesthetic and theme. Color Inspirations (*page 12*) features all the projects in three distinctive color themes to get you excited for your next project. You don't have to follow them to a T, but they are there if you get stuck.

Just like the quilted projects you will make; your home tells your story. Remember to have fun and enjoy every step, from choosing the fabrics and threads to cutting, assembling, styling, and enjoying the final product.

Let's turn the page to something more visually fun . . . color inspirations!

# Color Inspirations

One of the most rewarding things as a designer is seeing your interpretations of my designs and how you make them uniquely yours to fit in your space. This section features all the designs from the book in three color-ways: neutral; warm and vibrant; and cool and moody. These themes are based on directions someone may consider when designing or decorating their home. They are not here to limit you when making fabric and thread choices for your upcoming project, however, so don't feel that you have to make your projects in these suggested colors. They are purely here for inspiration and a point of reference.

All the fabrics used throughout the book were intentionally chosen so they can be easily replicated. All the solid-colored fabrics are Robert Kaufman Fabrics Kona Cotton, which comes in more than 300 colors and is widely available from local and online retailers globally. All the printed and patterned fabrics are from Hawthorne Supply Co., based in Upstate New York, whose in-house designers design their fabrics. These quilting cottons are available print-on-demand from Hawthorne Supply Co.'s online store and can be shipped worldwide. All the fabric details, including source, designer, collection name, and color is provided in this section. *Note:* The fabrics in this book were not sponsored by these companies.

# COLORWAY THEME 1: NEUTRALS

Neutrals encompass a wide spectrum of colors and shades, including white, beige, taupe, grey, and black. Some of these colors have warmer or cooler undertones, giving each its own flair and character. Lighter neutral shades can make a space look brighter and more open. Darker or muted shades of neutrals can create a cozy and comforting space.

Of the three colorway themes, the neutral path is the most versatile. You might be thinking neutrals are boring, but there are so many things you can do with this palette. Neutrals can help elevate a room, tie certain pieces of furniture or décor together, and give you room to experiment with other textures and colors that are bolder and more vibrant. In this neutral colorway, you may notice some of the projects also include pops of pink and green. These colors work to create contrast and accents among the different neutrals. These pops of color can be changed to better suit your space and preference.

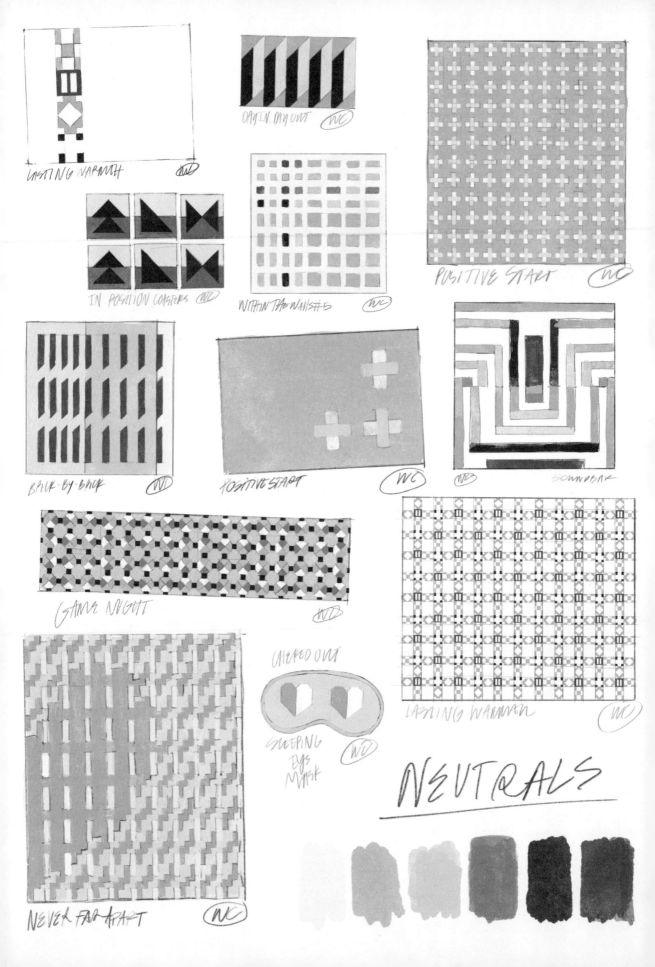

LASTING WARMTH

DAY IN, DAY OUT (WC)

IN POSITION COASTERS (WD)

WITHIN THE WALLS #5 (WC)

POSITIVE START (WC)

BACK-BY-BACK (WC)

POSITIVE START (WC)

(WD) SOUNDBAR

GAME NIGHT (WD)

CHECKED OUT

SLEEPING EYES MASK (WD)

LASTING WARMTH (WC)

NEUTRALS

NEVER FAR APART (WC)

## POSITIVE START BED QUILT

- ▨ FABRIC A (quilt top): Kona Cotton in Parchment
- ▨ FABRIC B (quilt top): Kona Cotton in Ice Peach
- ☐ FABRIC C (quilt top): Kona Cotton in Bone
- ▨ FABRIC D (quilt back): Happy Rainbows in Sandy Beige*
- ▨ FABRIC E (binding): Kona Cotton in Lingerie

## POSITIVE START SHAM CASES

- ▨ FABRIC A (sham front): Kona Cotton in Parchment
- ▨ FABRIC B (sham front): Kona Cotton in Ice Peach
- ☐ FABRIC C (sham front): Kona Cotton in Bone
- ▨ FABRIC D (sham back): Kona Cotton in Parchment
- ▨ FABRIC E (trim): Kona Cotton in Parchment
- ☐ FABRIC F (lining): Kona Cotton in Bone

## CHECKED OUT SLEEPING EYE MASK

- ▨ FABRIC A (mask front): Kona Cotton in Lingerie
- ▨ FABRIC B (mask front): Kona Cotton in Straw
- ☐ FABRIC C (mask front): Kona Cotton in Bone
- ▨ FABRIC D (mask back): Grid in Almond Cream*
- ▨ FABRIC E (elastic casing): Kona Cotton in Shadow
- ▨ FABRIC F (binding): Kona Cotton in Shadow

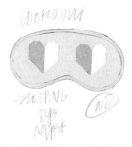

## LASTING WARMTH BED QUILT

- ☐ FABRIC A (quilt top): Kona Cotton in Bone
- ▨ FABRIC B (quilt top): Kona Cotton in Shitake
- ▨ FABRIC C (quilt top): Kona Cotton in Parchment
- ■ FABRIC D (quilt top): Kona Cotton in Moss
- ■ FABRIC E (quilt top): Kona Cotton in Pepper
- ▨ FABRIC F (quilt back): Grid in Almond Cream*
- ■ FABRIC G (binding): Kona Cotton in Moss

## LASTING WARMTH SHAM CASES

- ☐ FABRIC A (sham front): Kona Cotton in Bone
- ▨ FABRIC B (sham front): Kona Cotton in Shitake
- ▨ FABRIC C (sham front): Kona Cotton in Parchment
- ■ FABRIC D (sham front): Kona Cotton in Moss
- ■ FABRIC E (sham front): Kona Cotton in Pepper
- ▨ FABRIC F (sham back): Grid in Almond Cream*
- ▨ FABRIC G (trim): Grid in Almond Cream*
- ☐ FABRIC H (lining): Kona Cotton in Bone

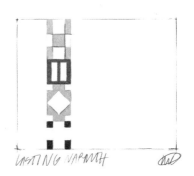

## DAY IN, DAY OUT LUMBAR CUSHION & COASTERS

- FABRIC A (cushion front): Kona Cotton in Light Parfait
- FABRIC B (cushion front): Kona Cotton in Pepper
- FABRIC C (cushion front): Kona Cotton in Straw
- FABRIC D (cushion back): Large Chevron in Graphite on Egret*
- FABRIC E (trim): Large Chevron in Graphite on Egret*
- FABRIC F (lining): Kona Cotton in Bone

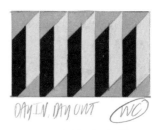

## WITHIN THE WALLS THROW CUSHION

- FABRIC A (cushion front): Kona Cotton in Haze
- FABRIC B (cushion front): Kona Cotton in Parchment
- FABRIC C (cushion front): Kona Cotton in Ice Peach
- FABRIC D (cushion front): Kona Cotton in O.D. Green
- FABRIC E (cushion front): Kona Cotton in Pepper
- FABRIC F (cushion front): Kona Cotton in Sable
- FABRIC G (cushion back): Grid in Almond Cream*
- FABRIC H (trim): Grid in Almond Cream*
- FABRIC I (lining): Kona Cotton in Bone

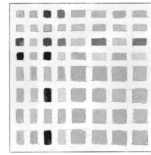

## SOUNDBARS THROW CUSHION

- FABRIC A (cushion front): Kona Cotton in Bone
- FABRIC B (cushion front): Kona Cotton in Lingerie
- FABRIC C (cushion front): Kona Cotton in Moss
- FABRIC D (cushion front): Kona Cotton in Pepper
- FABRIC E (cushion front): Kona Cotton in Ice Peach
- FABRIC F (cushion front): Kona Cotton in Shadow
- FABRIC G (cushion front): Kona Cotton in Smoke
- FABRIC H (cushion back): Kona Cotton in Parchment
- FABRIC I (trim): Kona Cotton in Parchment
- FABRIC J (lining): Kona Cotton in Bone

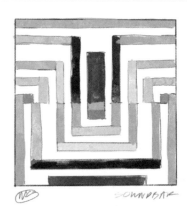

## BRICK-BY-BRICK FLOOR CUSHION

- FABRIC A (cushion front): Kona Cotton in Moss
- FABRIC B (cushion front): Kona Cotton in Light Parfait
- FABRIC C (cushion front): Kona Cotton in Shadow
- FABRIC D (cushion front): Kona Cotton in Bone
- FABRIC E (cushion back): Kona Cotton in Shell
- FABRIC F (trim): Kona Cotton in Shell
- FABRIC G (lining): Kona Cotton in Bone

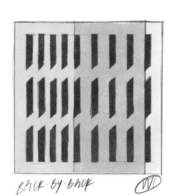

## NEVER FAR APART MATCHING THROW QUILTS

FABRIC A (quilt top): Kona Cotton in Straw
FABRIC B (quilt top): Kona Cotton in Bone
FABRIC C (quilt top): Kona Cotton in Lingerie
FABRIC D (back): Hearts in Golden Mustard Yellow on Egret*
FABRIC E (binding): Kona Cotton in Ice Peach

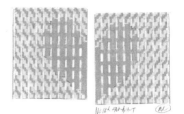

## GAME NIGHT TABLE RUNNER

FABRIC A (table runner top): Kona Cotton in Khaki
FABRIC B (table runner top): Kona Cotton in Pepper
FABRIC C (table runner top): Kona Cotton in Ash
FABRIC D (table runner top): Kona Cotton in Yarrow
FABRIC E (table runner top): Kona Cotton in Bone
FABRIC F (table runner top): Kona Cotton in Peach
FABRIC G (table runner back): Chevron in Graphite on Egret*
FABRIC H (binding): Kona Cotton in Moss

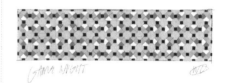

## IN POSITION PLACEMATS & COASTERS

FABRIC A (placemat and coaster top): Kona Cotton in Pepper
FABRIC B (placemat and coaster top): Kona Cotton in Leather
FABRIC C (placemat and coaster top): Kona Cotton in Sand
FABRIC D (back): Chevron in Graphite on Egret*
FABRIC E (binding): Kona Cotton in Pepper

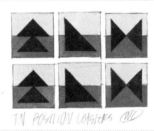

## *HAWTHRONE SUPPLY CO. FABRICS ENLARGED:

Erin Kendal, Happy Rainbows in Sandy Beige

Erin Kendal, Grid in Almond Cream

Erin Kendal, Chevron in Graphite on Egret

Erin Kendal, Hearts in Golden Mustard Yellow on Egret

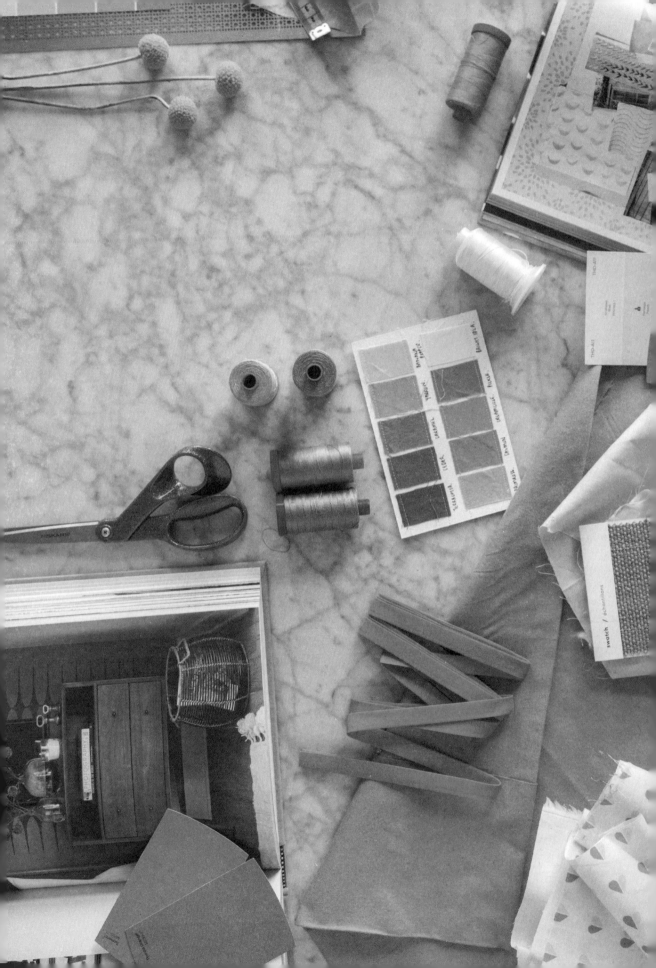

# COLORWAY THEME 2: WARM & VIBRANT

If I had full creative control over what colors our home was decorated in, it would be covered in rusts, pinks, blushes, yellows, and mustards. The introduction of some of these colors in my home and this colorway theme is centered around a yellow pot I picked up from a local plant store a few years back, which sits on our window sill today.

Bursts of warmer colors can create a welcoming and inviting space. And they most certainly have the potential to add personality and a focal point in a space that is bland. Warm colors work well paired with neutral colors as a playful and bold addition—one that people will not forget when they leave the room.

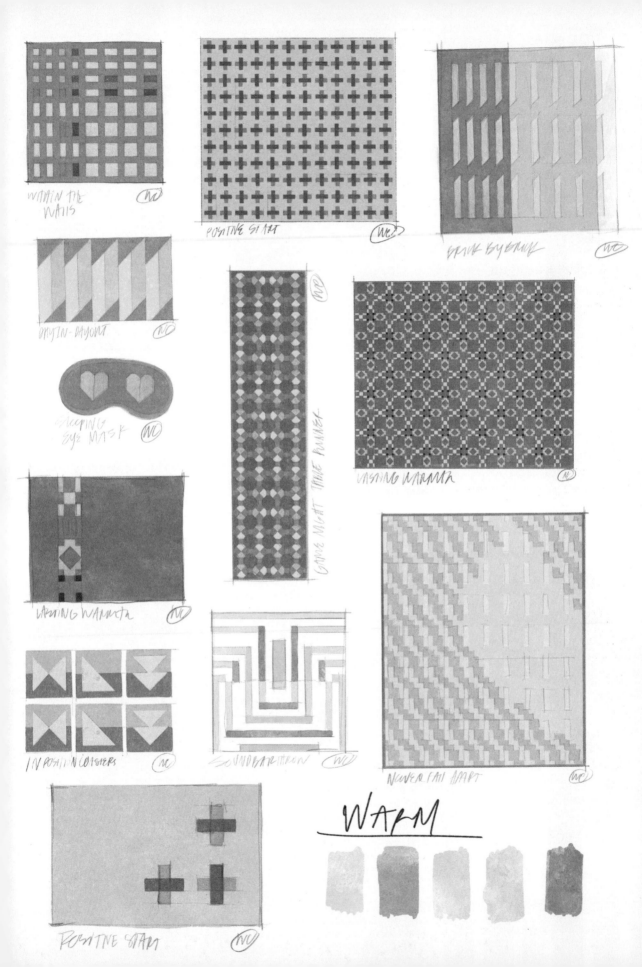

WITHIN THE WALLS

POSITIVE START

BRICK BY BRICK

DAY IN - DAY OUT

SLEEPING EYE MASK

GAME NIGHT TABLE RUNNER

LASTING WARMTH

LASTING WARMTH

NEVER FALL APART

IN POSITION COASTERS

SOUND BAR HERON

POSITIVE SPAN

WARM

## POSITIVE START BED QUILT
- **FABRIC A** (quilt top): Kona Cotton in Ice Peach
- **FABRIC B** (quilt top): Kona Cotton in Terracotta
- **FABRIC C** (quilt top): Kona Cotton in Mango
- **FABRIC D** (quilt back): Kona Cotton in Sand
- **FABRIC E** (binding): Kona Cotton in Ice Peach

## POSITIVE START SHAM CASES
- **FABRIC A** (sham front): Kona Cotton in Ice Peach
- **FABRIC B** (sham front): Kona Cotton in Terracotta
- **FABRIC C** (sham front): Kona Cotton in Mango
- **FABRIC D** (sham back): Kona Cotton in Ice Peach
- **FABRIC E** (trim): Kona Cotton in Ice Peach
- **FABRIC F** (lining): Kona Cotton in Bone

## CHECKED OUT SLEEPING EYE MASK
- **FABRIC A** (mask front): Kona Cotton in Curry
- **FABRIC B** (mask front): Kona Cotton in Ballet Slipper
- **FABRIC C** (mask front): Kona Cotton in Banana Pepper
- **FABRIC D** (mask back): Happy Rainbows in Yellow Sunshine*
- **FABRIC E** (elastic casing): Kona Cotton in Woodrose
- **FABRIC F** (binding): Kona Cotton in Woodrose

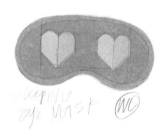

## LASTING WARMTH BED QUILT
- **FABRIC A** (quilt top): Kona Cotton in Cedar
- **FABRIC B** (quilt top): Kona Cotton in Ice Peach
- **FABRIC C** (quilt top): Kona Cotton in Champagne
- **FABRIC D** (quilt top): Kona Cotton in Blush Pink
- **FABRIC E** (quilt top): Kona Cotton in Bordeaux
- **FABRIC F** (quilt back): Sea Glass in Sunshine Yellow*
- **FABRIC G** (binding): Kona Cotton in Primrose

## LASTING WARMTH SHAM CASES
- **FABRIC A** (sham front): Kona Cotton in Cedar
- **FABRIC B** (sham front): Kona Cotton in Ice Peach
- **FABRIC C** (sham front): Kona Cotton in Champagne
- **FABRIC D** (sham front): Kona Cotton in Blush Pink
- **FABRIC E** (sham front): Kona Cotton in Bordeaux
- **FABRIC F** (sham back): Kona Cotton in Cedar
- **FABRIC G** (trim): Kona Cotton in Cedar
- **FABRIC H** (lining): Kona Cotton in Bone

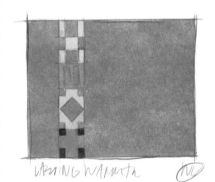

## DAY IN, DAY OUT LUMBAR CUSHION & COASTERS

- FABRIC A (cushion front): Kona Cotton in Ice Peach
- FABRIC B (cushion front): Kona Cotton in Acid Lime
- FABRIC C (cushion front): Kona Cotton in Pickle
- FABRIC D (cushion back): Kona Cotton in Pickle
- FABRIC E (trim): Kona Cotton in Pickle
- FABRIC F (lining): Kona Cotton in Bone

## WITHIN THE WALLS THROW CUSHION

- FABRIC A (cushion front): Kona Cotton in Creamsicle
- FABRIC B (cushion front): Kona Cotton in Champagne
- FABRIC C (cushion front): Kona Cotton in Terracotta
- FABRIC D (cushion front): Kona Cotton in Pickle
- FABRIC E (cushion front): Kona Cotton in Cedar
- FABRIC F (cushion front): Kona Cotton in Banana Pepper
- FABRIC G (cushion back): Grid in Clay*
- FABRIC H (trim): Grid in Clay*
- FABRIC I (lining): Kona Cotton in Bone

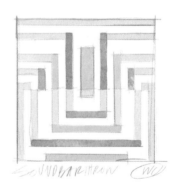

## SOUNDBARS THROW CUSHION

- FABRIC A (cushion front): Kona Cotton in Bone
- FABRIC B (cushion front): Kona Cotton in Champagne
- FABRIC C (cushion front): Kona Cotton in Lingerie
- FABRIC D (cushion front): Kona Cotton in Mango
- FABRIC E (cushion front): Kona Cotton in Canary
- FABRIC F (cushion front): Kona Cotton in Melon
- FABRIC G (cushion front): Kona Cotton in Ice Peach
- FABRIC H (cushion back): Grid in Mustard*
- FABRIC I (trim): Grid in Mustard*

## BRICK-BY-BRICK FLOOR CUSHION

- FABRIC A (cushion front): Kona Cotton in Acid Lime
- FABRIC B (cushion front): Kona Cotton in Mango
- FABRIC C (cushion front): Kona Cotton in Ice Peach
- FABRIC D (cushion front): Kona Cotton in Bone
- FABRIC E (cushion back): Kona Cotton in Pickle
- FABRIC F (trim): Kona Cotton in Pickle
- FABRIC G (lining): Kona Cotton in Bone

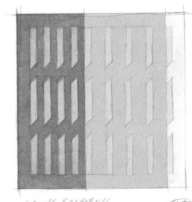

## NEVER FAR APART MATCHING THROW QUILTS
- **FABRIC A** (quilt top): Kona Cotton in Light Parfait
- **FABRIC B** (quilt top): Kona Cotton in Acid Lime
- **FABRIC C** (quilt top): Kona Cotton in Banana Pepper
- **FABRIC D** (quilt back): Cupid's Arrow in Ballet Pink on Egret*
- **FABRIC E** (binding): Kona Cotton in Acid Lime

## GAME NIGHT TABLE RUNNER
- **FABRIC A** (top): Kona Cotton in Cedar
- **FABRIC B** (top): Kona Cotton in Woodrose
- **FABRIC C** (top): Kona Cotton in Mango
- **FABRIC D** (top): Kona Cotton in Canary
- **FABRIC E** (top): Kona Cotton in Curry
- **FABRIC F** (top): Kona Cotton in Light Parfait
- **FABRIC G** (back): Sea Glass in Summer Coral*
- **FABRIC H** (binding): Kona Cotton in Primrose

## IN POSITION PLACEMATS & COASTERS
- **FABRIC A** (top): Kona Cotton in Champagne
- **FABRIC B** (top): Kona Cotton in Primrose
- **FABRIC C** (top): Kona Cotton in Mango
- **FABRIC D** (back): Sea Glass in Summer Coral*
- **FABRIC E** (binding): Kona Cotton in Mango
- **FABRIC E** (binding): Kona Cotton in Primrose

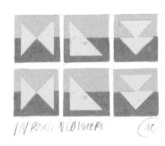

## *HAWTHRONE SUPPLY CO. FABRICS ENLARGED:

Erin Kendal, Happy Rainbows in Yellow Sunshine

Erin Kendal, Sea Glass in Summer Coral

Erin Kendal, Grid in Clay

Erin Kendal, Grid in Mustard

Erin Kendal, Cupid's Arrow in Ballet Pink on Egret

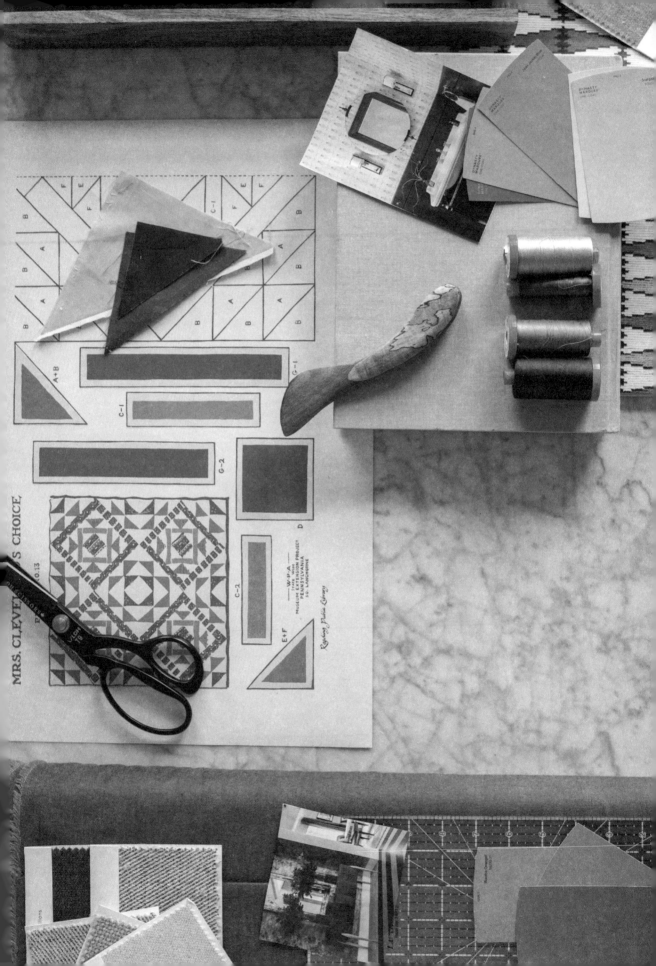

# COLORWAY THEME 3: COOL & MOODY

That's right. Things are about to get a little dark and moody around here. In this final colorway theme, we're introducing dark blues with warm undertones and blacks with touches of rich toffees, blushes, and greys to create more warmth, weight, and depth in a space. Projects incorporating these colors can be highlighted and balanced by surrounding neutral colors and contrasting textures like velvet and leather. These colors have the power to make a room look more sophisticated and cozy.

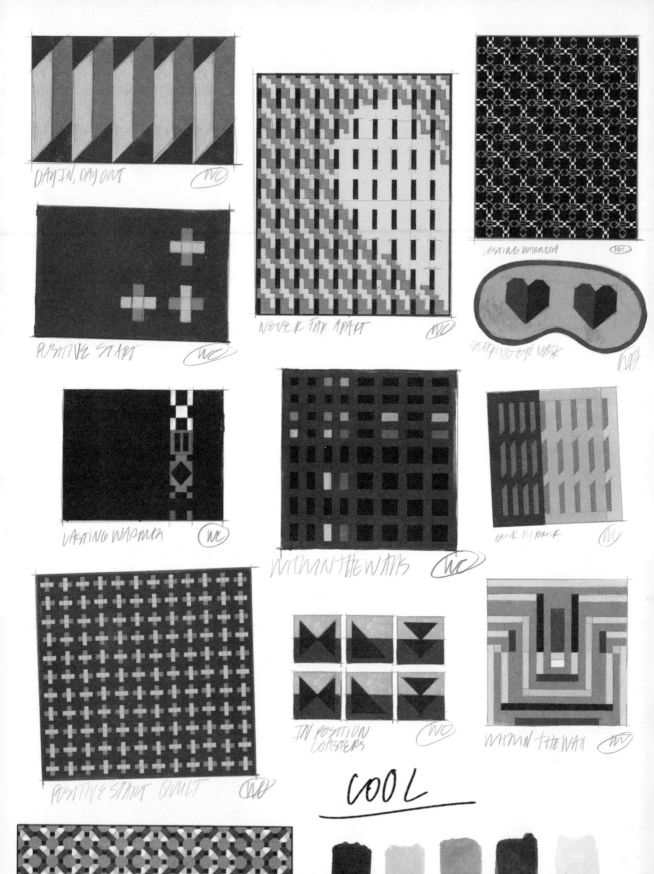

DAY IN, DAY OUT (WC)

POSITIVE START (WC)

NEVER FAR APART (WC)

LASTING WARMTH (W)

SLEEPING EYE MASK (W)

LASTING WARMTH (WE)

WITHIN THE WALLS (WC)

BRICK BY BRICK (W)

POSITIVE START QUILT (W)

TV POSITION COASTERS (W)

WITHIN THE WALL (W)

COOL

GAME NIGHT TABLE RUNNER (WE)

## POSITIVE START BED QUILT

- **FABRIC A** (quilt top): Kona Cotton in Celestial
- **FABRIC B** (quilt top): Kona Cotton in Ice Peach
- **FABRIC C** (quilt top): Kona Cotton in O.D. Green
- **FABRIC D** (quilt back): Suns in Fresh Mint*
- **FABRIC E** (binding): Kona Cotton in Teal Blue

## POSITIVE START SHAM CASES

- **FABRIC A** (sham front): Kona Cotton in Celestial
- **FABRIC B** (sham front): Kona Cotton in Ice Peach
- **FABRIC C** (sham front): Kona Cotton in O.D. Green
- **FABRIC D** (sham back): Kona Cotton in Celestial
- **FABRIC E** (trim): Kona Cotton in Celestial
- **FABRIC F** (lining): Kona Cotton in Bone

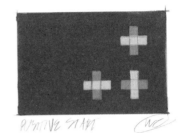

## CHECKED OUT SLEEPING EYE MASK

- **FABRIC A** (mask front): Kona Cotton in Shitake
- **FABRIC B** (mask front): Kona Cotton in Moss
- **FABRIC C** (mask front): Kona Cotton in Windsor
- **FABRIC D** (mask back): Raindrops in Chocolate*
- **FABRIC E** (elastic casing): Kona Cotton in Roasted Pecan
- **FABRIC F** (binding): Kona Cotton in Roasted Pecan

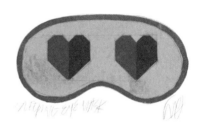

## LASTING WARMTH BED QUILT

- **FABRIC A** (quilt top): Kona Cotton in Pepper
- **FABRIC B** (quilt top): Kona Cotton in Shale
- **FABRIC C** (quilt top): Kona Cotton in Bone
- **FABRIC D** (quilt top): Kona Cotton in Dresden Blue
- **FABRIC E** (quilt top): Kona Cotton in Yarrow
- **FABRIC F** (quilt back): Golden Mustard Yellow on Egret*
- **FABRIC G** (binding): Kona Cotton in Grellow

## LASTING WARMTH SHAM CASES

- **FABRIC A** (sham front): Kona Cotton in Pepper
- **FABRIC B** (sham front): Kona Cotton in Shale
- **FABRIC C** (sham front): Kona Cotton in Bone
- **FABRIC D** (sham front): Kona Cotton in Dresden Blue
- **FABRIC E** (sham front): Kona Cotton in Yarrow
- **FABRIC F** (sham back): Kona Cotton in Pepper
- **FABRIC G** (trim): Kona Cotton in Pepper
- **FABRIC H** (lining): Kona Cotton in Bone

## DAY IN, DAY OUT LUMBAR CUSHION & COASTERS

**FABRIC A** (front): Kona Cotton in Ice Peach
**FABRIC B** (front): Kona Cotton in Yarrow
**FABRIC C** (front): Kona Cotton in Celestial
**FABRIC D** (back): Organic Speckle Marks in Shell Maple Brown*
**FABRIC E** (trim): Organic Speckle Marks in Shell Maple Brown*
**FABRIC F** (lining): Kona Cotton in Bone

## WITHIN THE WALLS THROW CUSHION

**FABRIC A** (front): Kona Cotton in Celestial
**FABRIC B** (front): Kona Cotton in Pepper
**FABRIC C** (front): Kona Cotton in Cedar
**FABRIC D** (front): Kona Cotton in Honey
**FABRIC E** (front): Kona Cotton in Ice Peach
**FABRIC F** (front): Kona Cotton in Shale
**FABRIC G** (back): Grid in Praline*
**FABRIC H** (trim): Grid in Praline*
**FABRIC I** (lining): Kona Cotton in Bone

## SOUNDBARS THROW CUSHION

**FABRIC A** (front): Kona Cotton in Shale
**FABRIC B** (front): Kona Cotton in Lingerie
**FABRIC C** (front): Kona Cotton in Roasted Pecan
**FABRIC D** (front): Kona Cotton in Prussian
**FABRIC E** (front): Kona Cotton in Shadow
**FABRIC F** (front): Kona Cotton in Moss
**FABRIC G** (front): Kona Cotton in Bone
**FABRIC H** (back): Grid in Praline*
**FABRIC I** (trim): Grid in Praline*
**FABRIC J** (lining): Kona Cotton in Bone

## BRICK-BY-BRICK FLOOR CUSHION

**FABRIC A** (front): Kona Cotton in Yarrow
**FABRIC B** (front): Kona Cotton in Celestial
**FABRIC C** (front): Kona Cotton in Fog
**FABRIC D** (front): Kona Cotton in Shadow
**FABRIC E** (back): Kona Cotton in Yarrow
**FABRIC F** (trim): Kona Cotton in Yarrow
**FABRIC G** (lining): Kona Cotton in Bone

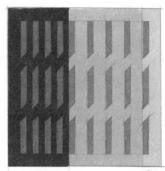

## NEVER FAR APART MATCHING THROW QUILTS

FABRIC A (top): Kona Cotton in Light Parfait
FABRIC B (top): Kona Cotton in Prussian
FABRIC C (top): Kona Cotton in Shale
FABRIC D (back): Kona Cotton in Prussian
FABRIC E (binding): Kona Cotton in Celestial

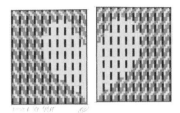

## GAME NIGHT TABLE RUNNER

FABRIC A (top): Kona Cotton in Shale
FABRIC B (top): Kona Cotton in Pepper
FABRIC C (top): Kona Cotton in Roasted Pecan
FABRIC D (top): Kona Cotton in Celestial
FABRIC E (top): Kona Cotton in Bone
FABRIC F (top): Kona Cotton in Ice Peach
FABRIC G (back): Swiss Crosses in Graphite on Egret*
FABRIC H (binding): Kona Cotton in Pepper

## IN POSITION PLACEMATS & COASTERS

FABRIC A (top): Kona Cotton in Windsor
FABRIC B (top): Kona Cotton in Fog
FABRIC C (top): Kona Cotton in Moss
FABRIC D (back): Grid in Ocean*
FABRIC E (binding): Kona Cotton in Windsor

## *HAWTHRONE SUPPLY CO. FABRICS ENLARGED:

Erin Kendal, Suns in
Fresh Mint

Erin Kendal, Raindrops
in Chocolate

Erin Kendal, Swiss Crosses in
Golden Mustard Yellow on Egret

Erin Kendal, Organic Speckle
Marks in Shell Maple Brown

Erin Kendal,
Grid in Praline

Erin Kendal, Swiss Crosses in
Graphite on Egret

Erin Kendal,
Grid in Ocean

# Getting Started

If you're new to quilting, we'll go over all the basics in the pages that follow. If you have some quilting experience already, you may still find it helpful to review this section before beginning any of the patterns in the book.

To help you decide on your next project, each pattern includes the skill level at the beginning. There are two levels of difficulty:

+ *Beginner*: Start here if you are new to quilting. These projects are the easiest and quickest to complete.

+ *Advanced Beginner*: Once you're feeling more comfortable and are up for a little challenge, move on to these projects. Some of them might require you to complete steps that aren't usually performed in a regular quilt pattern. For example, sewing an elastic casing or working with bias binding tape.

Before we get started on the exciting stuff, gather the right tools and materials and familiarize yourself with how to assemble your quilt from start to finish. For beginners, I suggest you read the information in *Tools* (*page 35*), and *Quilt Assembly from Start to Finish* (*page 39*) to get an understanding of the basics. Don't stress—you don't have to remember all the ins and outs right away. It takes time and practice. This information will always be here as a reference—even for seasoned and experienced quilters. If you're feeling confident and comfortable, feel free to jump ahead to *General Instructions* on *page 104* to get started.

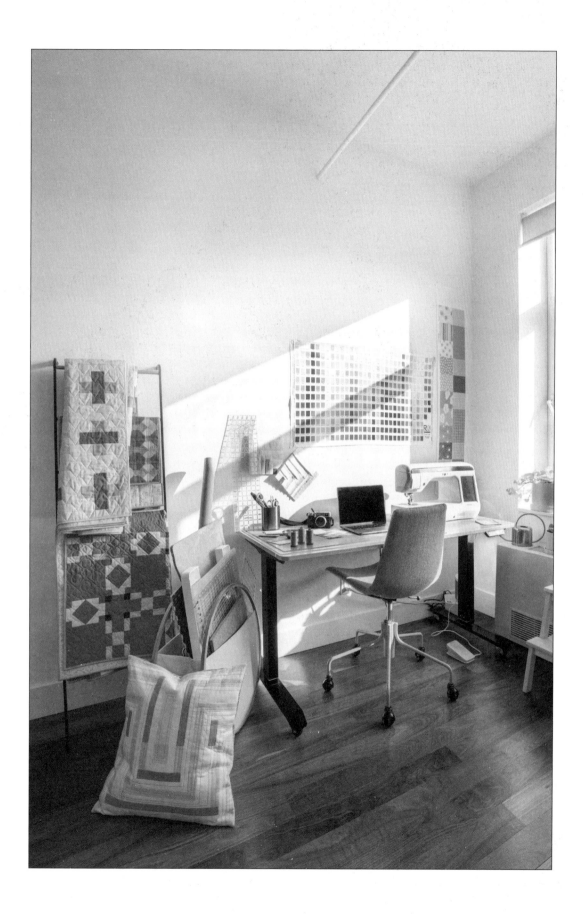

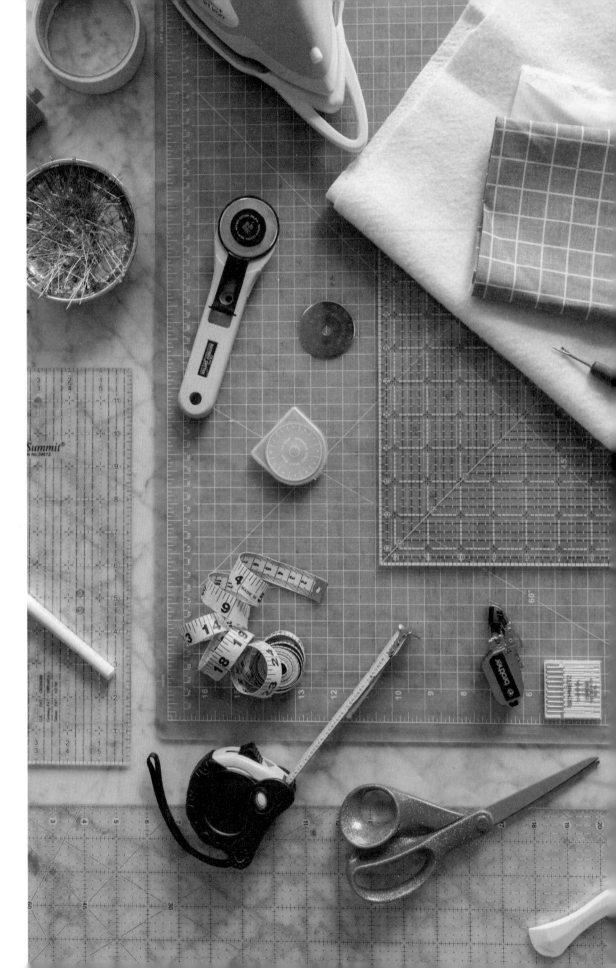

# TOOLS

The following is a list of essential tools. Over time, as you build your confidence, get more comfortable in your workspace, and gain a better feel for how you work, you can invest in other tools, such as smaller and larger rotary cutters and rulers, rotating cutting mats, wool pressing mats, and more.

**ROTARY CUTTER**: That pizza cutter-looking thing is a rotary cutter. Although fabric scissors are also on the list of essentials, you'll use this tool more often. Designed for more accurate and faster fabric cutting and trimming, rotary cutters come in various sizes. The gold standard size is 45mm. This is the perfect size to make all your basic quilting cuts.

**SPARE ROTARY CUTTING BLADES**: Dull rotary cutting blades slow things down. You know a blade is dull when you need to run the rotary cutter in the same place more than once to make a clean cut. Imagine having to run your rotary cutter more than once to cut each piece—that's comparable to cutting fabrics for at least two quilts! Keep spare blades available (in the packaging, of course) and replace the blade every two to three projects. With a sharp blade, you should be able to cut through six to eight layers of quilting cotton fabric at once.

**FABRIC SCISSORS**: Fabric scissors are convenient for making quick snips without compromising the crisp, fresh cuts you've made with your rotary cutter.

**QUILTING RULERS**: Quilting rulers can be used for cutting, measuring, and marking guidelines on fabrics. Quilting rulers come in various sizes and forms, each with its own purpose and ability to make cutting and measuring easier and faster. The three essential sizes I suggest investing in when starting your quilting ruler family are:

+ **6" x 24"**: With this ruler length, you can cut strips as long as the folded width of the fabric, prepare and trim large pieces, and square up your quilts. If you can only invest in one ruler, this is the one I highly recommend.

+ **6" x 12"**: This smaller ruler is perfect for cutting and trimming smaller pieces. Compared with the 6" x 24" ruler, the length will not weigh you down, and you'll have better control over your cuts.

+ **12½" x 12½"**: Cutting squares is a common occurrence in quilting, so it just makes sense to invest in a large ruler for all squares, big and small.

The best ruler size comes down to personal preference. As you develop your skills, you may want to invest in specialty rulers to help speed up the cutting and trimming process and to explore new techniques. For example, you might consider purchasing a 60° triangle ruler for triangle piecing or a Stripology ruler with slits used to cut multiple fabric strips, squares, or rectangles at a time.

**MEASURING TAPE:** This comes in handy to take measurements that are beyond the size of your quilting ruler (e.g., length of the quilt).

**CUTTING MAT:** A cutting mat protects your surfaces and helps prevent your fabric and ruler from slipping when cutting and trimming. I also use this tool when pinning pieces of fabric together so I don't scratch my desk.

Cutting mats come in various sizes, and the size you choose depends on the size of your workspace. If you're going to invest in just one cutting mat, ensure there is enough overhang to cover the width of the fabric. The standard width of quilting fabrics is 42", and it generally comes folded in half. You've probably done the math already . . . you'll need a cutting mat that is at least 21" in length.

Always store your cutting mat flat to prevent warping. Try to keep it clean and restrict its use strictly for fabrics. You don't want your other crafty projects to get stuck on your quilting project!

**PINS:** These will be your best mates and prevent your fabrics from shifting when you put them through the sewing machine. Use good-quality fine pins designed for quilting. Big, bulky pins can puncture and damage your project and make it more difficult to align your seams, compromising accurate piecing.

**SEAM RIPPER:** This is great for those moments when your hands have their own mind and do something that's not outlined in the pattern, or your seams are just slightly off and not aligned. Doh!

**SEWING MACHINE NEEDLES:** A dull sewing needle can damage your fabric and cause bad tension, puckering, and skipped stitches. It's also not good for your machine long-term because the machine needs to work twice as hard. Keep spare sewing machine needles available in your tool kit, just in case a boo-boo happens and your needle snaps. They will get dull from all the quilting you will be doing.

**THREAD:** You can't go wrong with 50-weight cotton thread for everything on your quilt project, from piecing to quilting to adding the binding. For piecing, you can use a finer thread weight, as low as 80-weight. This yields visibly flatter seams and makes it easier to match your seams.

**PAINTER'S OR MASKING TAPE:** What on earth is tape doing on the sewing table? It's useful for a number of reasons. For example, the paper-like surface is easy to write on when labeling your quilt blocks and pieces. You can also tape up your quilt blocks on the wall or a surface near your sewing machine as a quick reference when you are unsure how blocks should be assembled, especially with blocks that look really similar. The round edge of the tape roll can be used to trace round-edged corners on a quilt project.

**IRON:** Use an iron to smooth out any creases in the fabric before cutting, sewing, or quilting, and to press your seams to achieve accurate and precise piecing.

**FABRIC MARKERS:** These are available in various colors and forms, such as pens, chalks, and pencils. I keep a water-soluble blue fabric marker in my tool kit to mark guidelines for sewing. It's always a good idea to test your fabric markers on a scrap piece of fabric from the project you are working on to see how visible the marks appear and if they easily come off. You may want to invest in different colored markers depending on the color of the materials you are working with.

**HERA MARKER OR NON-SERRATED DULL KNIFE:** This is another useful tool for marking guidelines, particularly quilting guidelines, if you choose not to send your quilt to a longarm quilter.

**WALKING FOOT:** Newer sewing machines tend to come with this extension. The walking foot provides additional grip and works in unison with the built-in feed dogs under the presser foot on your sewing machine to prevent all three layers of quilting from shifting as your project moves through the sewing machine. This extension also helps reduce puckering and air bubbles in your project. If you plan on sending your quilts to be quilted by a longarm quilter, I would not worry about investing in a walking foot.

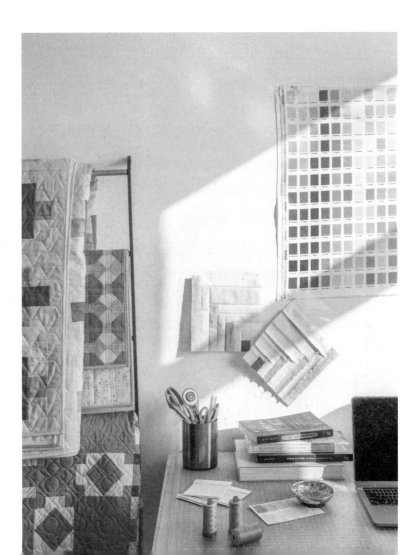

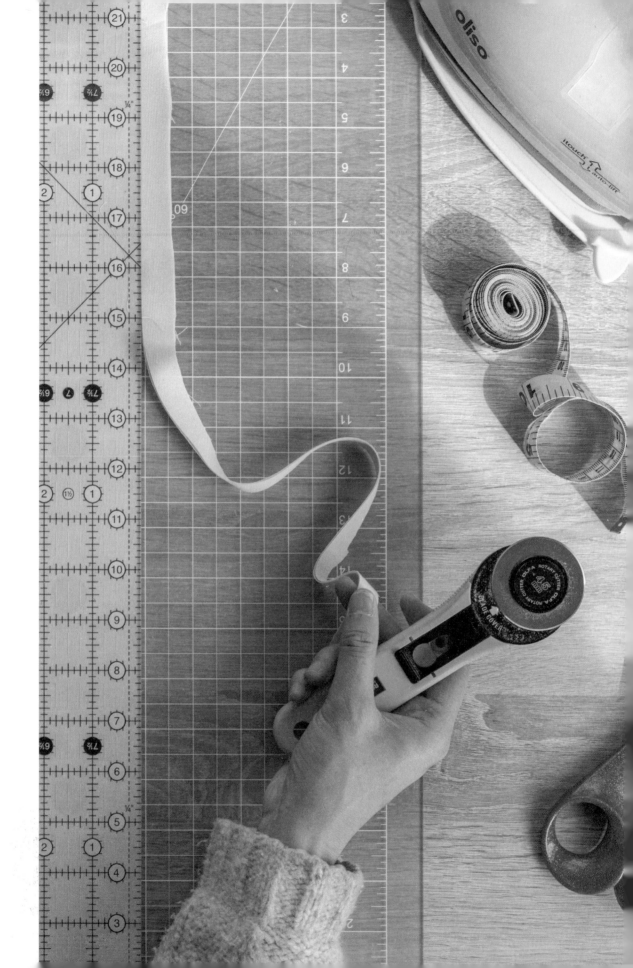

# QUILT ASSEMBLY FROM START TO FINISH

This section walks you through each step of the quilt assembly process, from choosing and preparing your fabrics to cutting, piecing, pressing, quilt-sandwich making, quilting, and binding.

### STEP 1: CHOOSING AND PREPARING YOUR FABRIC

One of the joys of the quilting process is picking out fabrics for your next project. You can mix and match different colors, prints, patterns, and textures to form something special and unique. Quilting fabrics are usually made of 42"-wide woven cotton. Fabric requirements in this book are based on 42" fabric width.

Quilting is a global craft, and fabrics are sold in different units in different countries. Therefore, I have converted the fabric requirements in each project into centimeters, as well as yards, based on experience. When I first started quilting, I walked into my local fabric store in Australia and none of the staff were able to assist with converting yards into centimeters. I ended up going home with more than enough fabric for three baby quilts, when all I needed was fabric for one throw quilt. I still have these fabrics in my stash to this day!

Sometimes manufacturers skip the prewashing (or preshrinking) process to speed up production time. This is why the topic of whether or not to prewash your fabrics before cutting comes up fairly frequently in the world of quilting. Some quilters prewash their fabrics to avoid the "antique" or crinkled look after washing their finished quilt. The golden rule is: if you choose to prewash your fabrics, prewash everything, especially if you are mixing higher-quality cotton fabrics with less-expensive or vintage cotton fabrics. The reason for this is because fabrics of varying quality shrink at different rates, causing the completed quilt to have wonky seams once it has been washed.

Personally, I prewash if I'm not sure or haven't used the brand before. However, I often find myself in the non-prewash category because I get too excited about starting a new project. I also don't like how the fabric can get a little limp after washing, making it a little finicky to work with when cutting and piecing.

## STEP 2: CUTTING YOUR FABRIC

Before cutting any squares, triangles, or rectangles for your projects, ensure you have done the following to achieve the most accurate piecing:

**01.** Always iron out all creases in the fabric [Photo A]. Sometimes this may mean ironing both sides of the fabric, depending on how it was stored.

**02.** Check that the cutting blade on your rotary cutter is sharp.

**03.** Use a ruler and rotary cutter to trim jagged or uneven edges. To do this, use the folded edge of the fabric as a guide to ensure it is straight and right-angled against the width of the fabric [Photo B]. Remember that no matter how straight fabric appears, the naked eye can play tricks on you.

Note that quilters work in inches. This is why all quilting rulers are in inches. If you grew up using the metric system, this can be a little weird. However, I highly recommended that you do not convert cutting directions into centimeters or millimeters. Designers spend hours calculating the size and number of pieces required to make a project, so you don't need to do the hard work to figure that out. Converting the directions into centimeters and millimeters may result in inaccurate piecing because the individual pieces of fabric and seams will not align with each other. Also, all cutting directions include a standard ¼" seam allowance.

Cut all larger pieces first. Why? You can maximize the remaining fabric, cutting those remnants into smaller pieces for the project. All cutting directions in this book start with the largest pieces and work down to the smallest, unless a particular order is otherwise specified.

Finally, just a few more cutting tips and housekeeping rules to keep in mind:

+ Cut away from the body, not toward yourself.

+ Do not cross your arms one over the other while cutting. If you're right-handed, use your left hand to secure the ruler and hold the rotary cutter in your right hand so you can cut your pieces from right to left. For lefties, right hand on the ruler, rotary cutter in the left hand, and cut from left to right.

+ Cutting can turn gruesome if you don't pay attention. Focus on what you're doing, and make sure your fingers are not in the way of the cutting blade.

+ Stand up when you cut. In doing so, you can use your body weight to apply pressure on the ruler to prevent the ruler and fabric from shifting, which allows you to achieve accurate cuts.

+ Measure twice, cut once. Double-check that your ruler is aligned correctly and ensure you have read the cutting directions carefully before cutting. Cutting the wrong size of pieces can stop a project in its tracks.

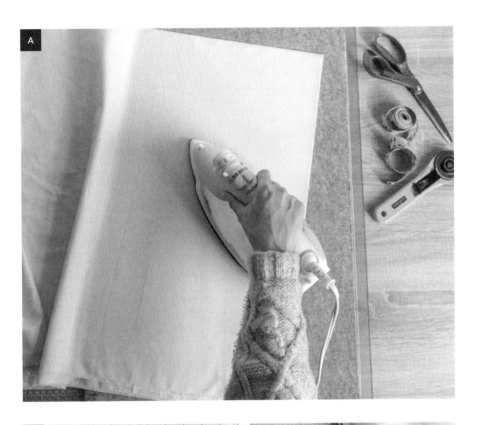

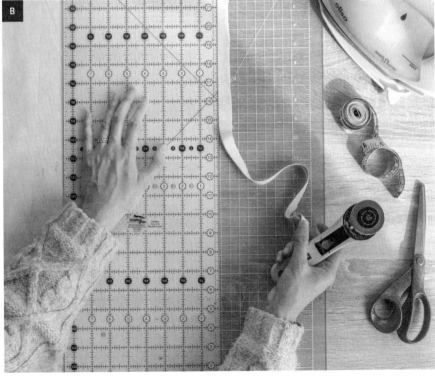

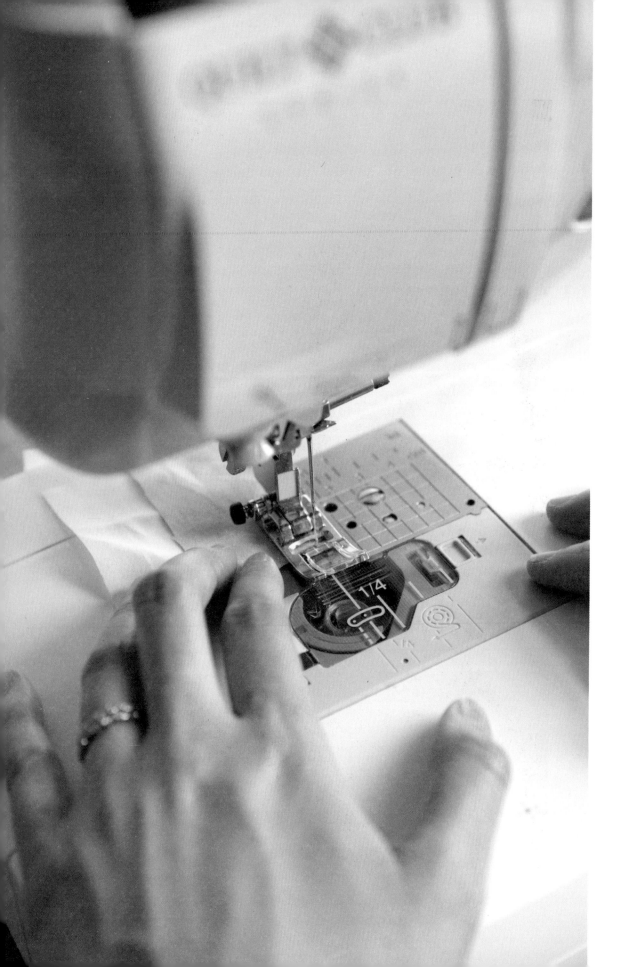

## STEP 3: PIECING

A majority of quilting patterns call for a ¼" seam allowance. If seam allowances are off, the individual pieces, corners, and points will not match up when sewn together. The more precise your seams are to the ¼" seam allowance, the more accurate your work will be.

Many sewing machines come with a ¼" seam allowance presser foot extension. If you don't have one, they are widely available at your local sewing/quilting shop or online retailer. However, even with this extension, I still recommend checking if the machine's needle position is at its true ¼" seam allowance. There are a couple of ways you can do this:

**01.** Place a quilting ruler between the machine and the presser foot of your machine, imagining the ruler is a piece of fabric. Ensure the quilting ruler is lined up with the right edge of the presser foot and gently lower the presser foot to secure the quilting ruler in place. Then turn the hand wheel to slowly lower the sewing machine needle to touch the ruler. On newer sewing machines, there's a function to lower and lift the needle. Don't press that button to lower the needle, unless you want it to snap and break the needle (this is clearly coming from experience).

If the needle touches the ¼" mark on the ruler, you're good to start sewing. If not, adjust the needle position left or right accordingly so it matches the ¼" mark on the ruler.

**02.** If your machine does not allow you to shift your needle position, place a quilting ruler between the machine and presser foot, and slowly lower the sewing needle with the hand wheel to meet the ¼" mark on the ruler. Again, you don't want to use the button that automatically lifts and lowers the sewing machine needle, if you are using a newer sewing machine. We know what happens there . . . snap!

Gently lower the presser foot to prevent the quilting ruler from shifting. Then stick a 3" piece of masking tape on the throat plate, with the left edge of the tape lined up with your new seam allowance tape guide. Remove the ruler. Once you've made these adjustments, test it out on a 4" square scrap fabric. Cut the fabric in half into two 2" x 4" rectangles. Sew the two pieces together and, using the tape as a guide, press the seams open. The new pieces should measure 3½" x 4".

You may notice throughout the book that some steps require a **SCANT ¼" SEAM ALLOWANCE**. A scant ¼" seam allowance is slightly narrower than the standard ¼" seam allowance used in quilt projects. Adjusting and scanting seam allowance takes into consideration the fabric loss after the seam is pressed open or to the dark side. There are a couple of ways to ensure your sewing machine is set up to successfully achieve a scant ¼" seam allowance:

**01.** If your sewing machine allows you to shift the needle position left or right, adjust its position one notch to the right. Adjust one notch back to the left if pattern calls for a ¼" seam allowance.

**02.** If your sewing machine doesn't allow you to move your needle position, and assuming you have taped down a ¼" seam allowance guide, eyeball approximately 1 millimeter (think about a strand of sewing thread or one-third of a ⅓") from the left edge of the ¼" seam allowance guide tape. Then lay a new piece of tape on top to create your scant ¼" seam allowance guide.

**03.** When you need to revert back to using ye olde ¼" seam allowance, carefully peel off the scant ¼" seam allowance tape without tampering with the ¼" seam allowance guide. If you accidentally ruin the tape that indicates where the ¼" seam allowance is, it's not the end of the world. Just spend a minute or so to set it up again.

There are a couple of methods to speed up the piecing process:

**01.** *Chain piecing:* Chain piecing is an efficient and quick technique to sew together pieces of fabric, one after the other. With this technique, you continuously sew your pieces together without cutting the thread between each set. Essentially, all the pieces are linked together with one continuous length of thread. Not only does this save time in stopping and starting the sewing machine at the end of each set, but it also saves thread.

**02.** *No pins:* Taking the time to pin and remove pins from your fabrics can take up valuable sewing time and potentially damage your fabrics. As you gain more confidence in sewing pieces together, you'll find yourself using fewer pins, or maybe none at all. To take the no-pinning route, carefully align two pieces of fabric together, holding them lightly, but not so lightly that they shift as you pass them through the sewing machine.

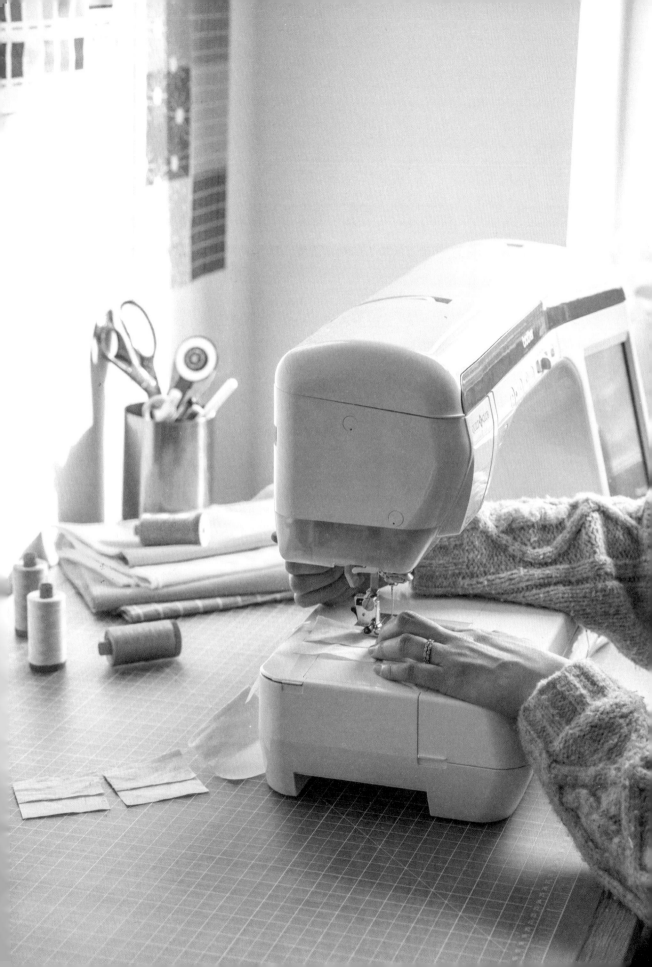

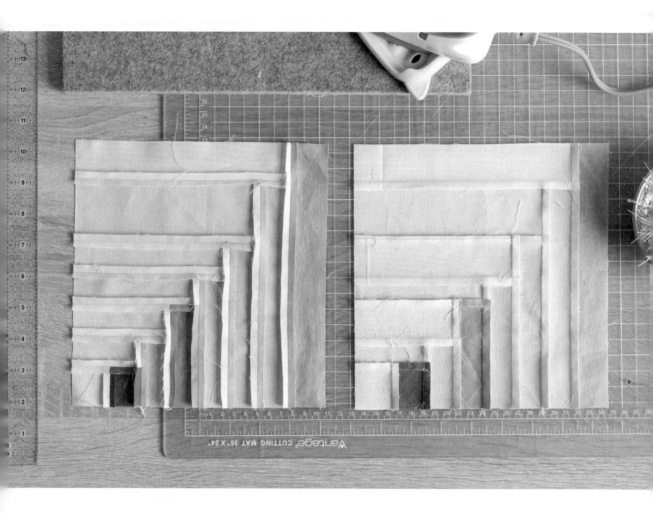

## STEP 4: PRESSING

*Press.* Do not "iron" back and forth like you would a shirt. "Ironing" can stretch and distort fabrics, especially smaller and thinner pieces. To press, use an up-and-down motion with an iron to flatten your seams. Pressing as you go is essential for creating flatter seams for accurate piecing and reducing seam bulk. There are a couple of ways to press your seams:

**01.** *Pressing open:* Separate the seam allowances and lay them flat in opposite sides of the seam on the wrong side of the quilt block. *Refer to the left block in the photo, on the previous page.*

**02.** *Pressing to the dark side:* Both seams are folded toward the darker fabric on the wrong side of the quilt block. *Refer to the right block in the photo, on the previous page.*

Each method has pros and cons.

| PRESSING OPEN | PRESSING TO THE DARK SIDE |
|---|---|
| **PROS** | |
| • Quilt tops lie flatter and crisper because seams are evenly distributed. <br> • Easier to align seams for more complex blocks when there are multiple points that need to be matched. | • Helps strengthen the quilt long-term. Pressing to one side protects threads from catching on things that may cause pulling, fraying, and stress on the fabric. <br> • Seams don't show through on lighter fabric. <br> • Pressing is easier and faster. <br> • Matching seam intersections is easier and faster, if seams are pressed in alternating directions. |
| **CONS** | |
| • Quilt is more vulnerable to damage because seams are exposed. <br> • Can be more time-intensive and difficult to align seams. | • Bulky seams. |

My pressing philosophy is this: you do you. Do what you're more comfortable and familiar with. As long as you're consistent throughout the project, you're good. If you're not sure, try both ways of pressing in separate projects or test blocks.

## STEP 5: QUILT-SANDWICH MAKING (BASTING)

Once your quilt top is complete, you have two options: assemble all three layers— quilt top, batting, and quilt back—yourself and make it into a "quilt sandwich," or send your quilt layers unbasted to a longarm quilter. You can find longarm quilting services by asking a fellow quilter in your area or searching on social media or Google. Using a longarm quilter is the easiest option, and you can pick visually effective and decorative finishes. However, this comes with an additional cost, and depending on your longarm quilter's workload, it may take weeks (or even months) to complete the quilting.

This step is about putting together your quilt sandwich (or basting). If you're sending your quilt to a longarm quilter, feel free to jump to *Step 7: Binding (page 55)*.

In the quilting world, "basting" is the term used for securing all three layers— quilt top, batting, and quilt back—to prevent shifting during quilting. There are a few methods to baste your quilt sandwich, including pinning, stitching, and spraying. If you're new to quilting or quilt sandwich making, start on smaller projects to build your skills and confidence. Wall hangings, baby quilts, pillows, and cushions are perfect projects for beginners.

### PREPARING THE QUILT BACK

Before making a quilt-sandwich, you need to determine if your quilt back (or backing fabric) is large enough to cover the entire quilt top with approximately 4" overhang on each of the four sides. Depending on the width of the backing fabric, you generally need to piece at least two lengths of fabric together for throw-size or larger quilts. To save time and effort (and potentially fabric), you can purchase backing fabrics in widths greater than the standard 42". For quilts smaller than queen size in this book that require the backing fabric to be pieced together, you need to cut the yardage in half lengthwise. For queen-size quilts or larger, you need to cut the required backing fabric yardage into thirds lengthwise.

TIP: Always remove selvedges before sewing backing fabric together. When joining backing fabrics, make a seam allowance exception; increase the seam allowance from ¼" to ½" and press the seams open. Incorporating these two steps in preparing your quilt back will reduce seam bulk, strengthen the quilt long-term, and reduce air bubbles in your quilt sandwich.

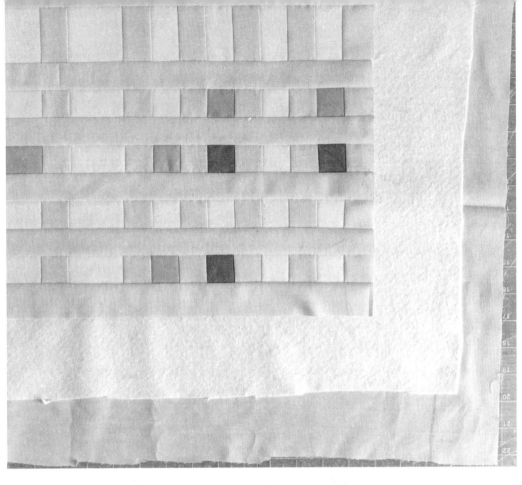

Speaking of bubbles, lumps, and bumps, these are a few important steps to follow to achieve a smooth and flat quilt:

**01.** Ensure your quilt sandwich making space is big enough to fit your whole quilt, and the surface you're working on is flat and hard, such as hardwood floors or a large worktable.

**02.** Iron out all creases and wrinkles in your quilt top and back, as well as your batting, since it's probably been folded up in packaging. For ironing batting, I recommend using a lower heat setting on your iron, especially if the batting is made with man-made fibers like polyester [Photo A].

Place quilt back with the wrong side facing up on your basting surface, *if pin basting*, or place batting on your basting surface, *if spray basting*. I also suggest lining your basting surface with a layer of newspaper, old bed sheet, or a painter's tarp that is bigger than the quilt sandwich, *if spray basting*. Doing so can prevent your workspace from being covered in sticky basting spray.

**03.** Lay the batting on top of the quilt back, *if pin basting* [Photo B].

*If spray basting*, lay the wrong side of the quilt back on top of the batting (so the quilt back is facing right side up). Peel back half the quilt back [Photo C] and spray the batting in small portions [Photo D]. Then stick the quilt back to the batting. Repeat until the entire surface has been covered. Next, starting at the center of the quilt and making your way to the edges, push out any air bubbles with a large quilting ruler [Photo E].

**04.** This step is all about adding the quilt top. Similar to step 3, lay the quilt top with the wrong side touching the batting [Photo F], and smooth out any lumps and bumps with a large quilting ruler.

*If pin basting*, place safety pins approximately 2" to 3" apart from each other and pin through all three layers. Use enough pins to secure the three quilt layers pinning around your marked quilting guidelines, so they won't get in the way when you're sewing [Photo G]. To speed things up, place all the safety pins in place and then close them all when you're done.

*If spray basting*, flip the quilt sandwich the other way so the batting is facing up [Photo H]. Peel back half of the quilt top and spray the batting in small portions. Then stick the quilt top to the batting. Repeat until the entire surface has been covered.

With an iron, iron the three layers of the quilt together to activate the glue. This prevents the layers of the quilt sandwich from separating as your work with it. This is also another opportunity to smooth out any lumps in the basted quilt.

Now your quilt sandwich is ready for quilting!

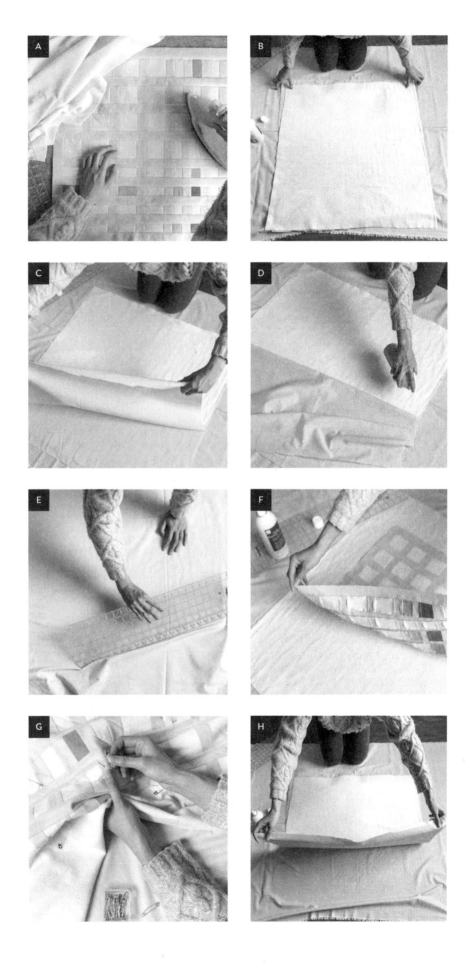

## STEP 6: QUILTING

The word "quilting" is versatile and can be used to describe different actions throughout the quilting process. For this point of the process, "quilting" is sewing together and securing the three layers of the quilt sandwich with straight lines or decorative stitching. This can be done by hand (also known as hand quilting) or by machine.

Quilting stitches and thread colors can accentuate the shapes and colors on your quilt top, as well as add other visual dimension and excitement to the overall look of the quilt. Sometimes stitching can compete with other design elements on the quilt. Therefore, before you begin any quilting, whether by hand or machine, use careful planning and consideration when deciding how to quilt your quilt. Coming up with a quilting plan could mean drawing the quilt design on a piece of paper, or you may simply have a general idea in mind.

Once you have a quilt plan ready, mark your quilting lines with a hera marker or a non-serrated dull knife. Use a non-serrated dull knife and a quilting ruler to achieve straight and evenly spaced lines. Apply a bit of pressure with the hera marker or knife to leave a mark in the fabric. This may mean having to go back and forth on the same area multiple times with pressure.

You may need to make a couple of adjustments to the sewing machine before quilting. First, change your presser foot to a walking foot for straight-line quilting, or for free-motion quilting use a free-motion or darning foot. Adjust the stitch length to anywhere between 2.5 and 3.0 and use 50-weight thread. The longer stitch length and different thread weight help showcase the quilting stitches. Your decision regarding these two variables comes down to preference: how visible would you like the quilting thread to be? If you're not sure, make a scrappy quilt sandwich and test different thread weights and stitch lengths to find what you prefer.

When you're done sewing your quilting design, sew approximately ⅛" away from the edge of the quilt top to provide additional reinforcement to the quilt sandwich before trimming off excess quilt batting and backing fabric and squaring up the quilt to attach the binding.

There's an entire section (*Quilting Finishes with a Domestic Sewing Machine, page 66*) that delves deeper into quilting with your domestic sewing machine; it includes tips and tools for successful outcomes and step-by-step instructions on how to achieve ten different quilting motifs to complete your project.

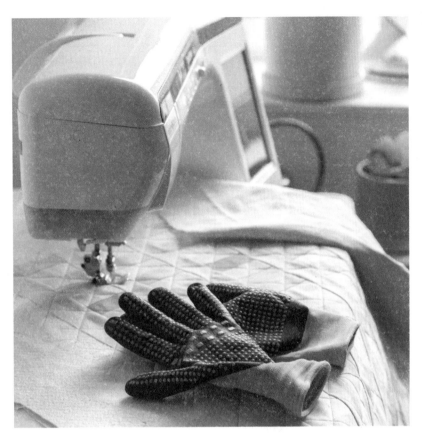

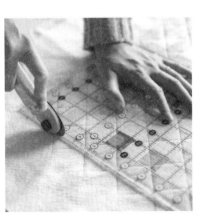

## STEP 7: BINDING

You're so close to the finish line, but before you can cross it you need to attach the binding to the quilt.

Binding is the long strip of fabric that wraps around the outer edges of the quilt sandwich to prevent the raw edges from fraying. It is another design element of a quilt and is attached at the very end of the quiltmaking process.

If you're considering turning your projects into wall hangings instead, flip to *How to Prepare a Quilted Wall Hanging* on *page 60* to follow a few short steps first. Then come back here for all the instructions on binding. Turn your projects into works of art displayed on the wall with the following compatible patterns from *The Quilted Home Handbook*:

+ Positive Start Bed Quilt (*page 107*)*

+ Positive Start Sham Cases (*page 113*)

+ Lasting Warmth Bed Quilt (*page 135*)*

+ Lasting Warmth Sham Cases (*page 151*)

+ Day In, Day Out Lumbar Cushion (*page 171*)

+ Within the Walls Throw Cushion (*page 179*)

+ Soundbars Throw Cushion (*page 193*)

+ Brick-by-Brick Floor Cushion (*page 205*)

+ Never Far Apart Matching Throw Quilts (*page 215*)

+ Game Night Table Runner (*page 231*)

*Note: I do not recommend turning bed quilts larger than twin size into wall hangings, due to the size and weight of the quilt. However, it is possible.*

One of the projects in this book (Checked Out Sleeping Eye Mask on *page 125*) requires bias binding tape. It's not often a quilting project calls for bias binding tape. In quilting, bias binding tape is generally introduced when the project has rounded or curved edges. The additional stretch in the bias binding tape makes it easier to attach to the project and allows the completed project to sit nice and flat. More details on the characteristics of bias binding tape, its benefits, different types, and how to prepare and attach it are shared in *Bias Binding Tape: What and How* on *page 84*. For now, here's how to prepare and attach standard, straight-grain binding strips to complete your project.

## PREPARING BINDING STRIPS

For the projects in this book, refer to "Binding Fabric" under the "Cutting Directions" in the quilt pattern to identify the number of 2½" strips required for the quilt size you are creating.

All the binding fabric requirements assume binding strips are 2½" wide. Feel free to experiment and/or make your binding strips skinnier. However, going narrower than 2" is not recommended. Anything skinnier than 2" does not leave much room to wrap the binding around the three layers of the quilt and makes attaching the binding more difficult and finicky. Try going up or down in increments of ¼" at first when experimenting with different widths of binding. From there, you'll discover your preferred binding width.

**01.** With the wrong side facing up, lay the binding strip horizontally and mark a small dot or line on the top edge 2½" from the left edge. Draw a 45-degree diagonal guideline from the bottom left corner of the strip to the marked dot or line [Photo A].

If working with a different binding width, the binding's width is going to determine where the small dot or line is drawn. For example, if the binding strips are 2" wide, mark a small dot or line on the top edge 2" from the left edge of the strip. Draw a 45-degree diagonal guideline from the bottom left corner of the strip to the marked dot or line.

**02.** Join all the binding strips to form one long binding strip by pinning two 2½" strips (or the chosen binding strip width) at a 90-degree angle, with the right sides together and the marked guideline facing up. Sew along the guideline [Photo B].

**03.** Trim a ¼" seam allowance to the outside of the sewn line [Photo C]. Press the seams open at the joints. Do not press seams to the dark side. Pressing the seams open will reduce seam bulk and create an even surface around the quilt.

**04.** Fold the binding in half lengthwise with the wrong sides of the fabric facing each other, and press flat [Photo D]. The width of the folded binding strip should measure half of the starting width. For example, a 2½"-wide strip folded in half would measure 1¼" wide, a 2¼"-wide strip folded in half would measure 1⅛" wide, and so on.

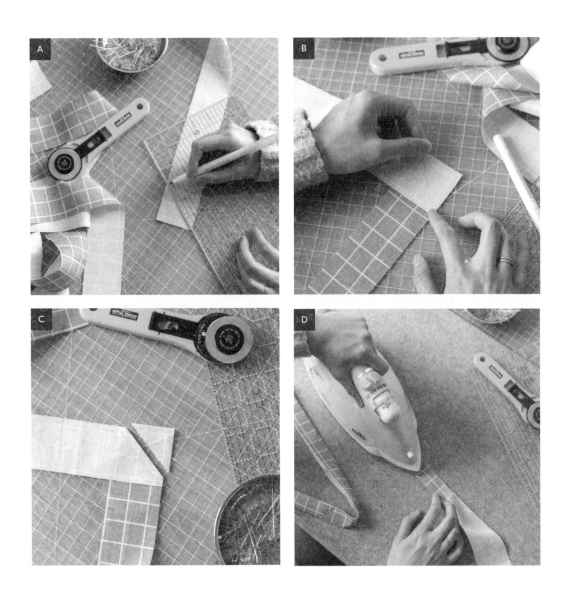

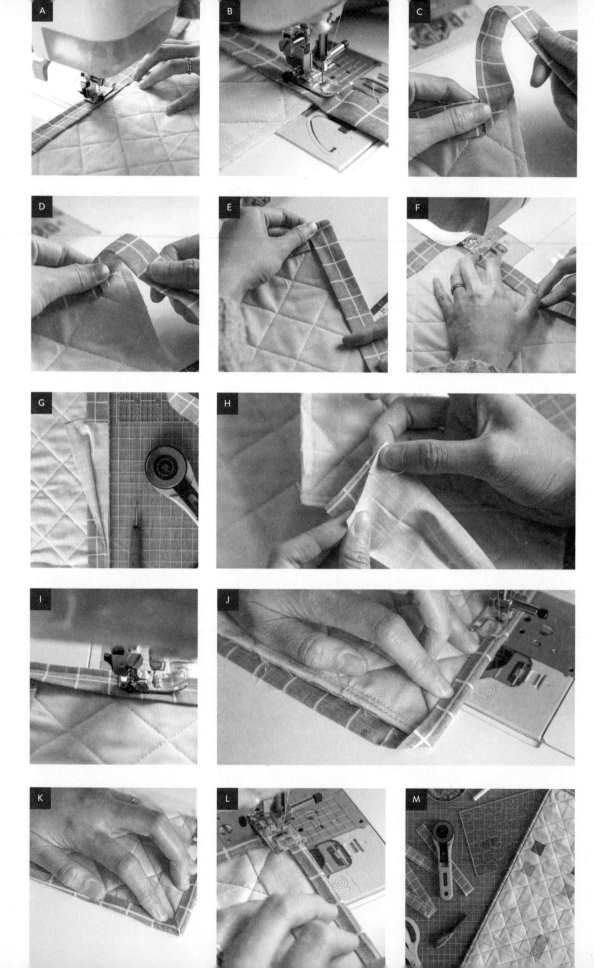

## ATTACH BINDING TO QUILT

There are two ways to attach binding to a quilt: hand binding and machine binding. For this example, I'll show you how to attach binding with your sewing machine. This method is faster and the quilts will hold up better over time.

**01.** Start with the quilt back facing up. Align the raw edge of the binding strip with the raw edge of the quilt sandwich. Start sewing at about 4" from the end of the binding strip and ¼" from the raw edges [Photo A].

**02.** Keep sewing until your needle is ¼" from the corner [Photo B]. Stop here and backstitch. Then remove the quilt from the sewing machine.

**03.** Turn the quilt 90 degrees, with the raw edge of the quilt sandwich on the right. Fold the binding at a 45-degree angle [Photos C and D] and then fold the binding strip back down so the raw edge is aligned with the raw edge of the quilt sandwich [Photo E].

**04.** Continue attaching the binding as in Steps 1-3 [Photo F] until you reach approximately 6" to 8" from the start of the binding. Then remove the quilt from the sewing machine.

**05.** Lay the quilt flat with the quilt back and the two ends of the binding strip facing up. Place the end of the binding strip on top of the start of the binding strip. Use a quilt ruler to mark ¼" past the start of the binding, so the two ends overlap each other [Photo G]. Cut on the marked guideline.

**06.** With the right sides together, sew the two ends of the binding strips together using a ¼" seam allowance and press the seams open [Photo H].

**07.** Attach the rest of the binding to the back of the quilt. Remove the quilt from the sewing machine [Photo I].

**08.** You're now in the home stretch! Fold the finished edge of the binding over to the quilt top and sew to secure it. When you reach approximately 2" from the corner of the quilt, stop and leave the needle and presser foot down [Photo J].

**09.** Gently fold and hold down the finished edge of the binding on the quilt top so there is a 45-degree angle overhang of binding at the corner of the quilt [Photo J]. Fold the binding perpendicular to the edge you have just attached, toward the center of the quilt, to form the corner of the quilt [Photo K]. You can secure the corner with your hands, pins, or a clip.

**10.** Continue sewing, and when you get to the tip of the corner fold, leave the needle in. Carefully lift the presser foot to pivot the quilt 90 degrees counterclockwise, and continue sewing the binding to the quilt top [Photo L].

**11.** Repeat Steps 8-10 to complete the quilt.

**12.** When you reach the start of the binding, don't forget to backstitch to strengthen your binding. Trim any loose threads and enjoy! [Photo M]

# How to Prepare a Quilted Wall Hanging

Quilts are not solely made to be displayed on a bed, couch, or chairs. They are works of art and also deserve to be displayed on the wall. Although many of the projects in *The Quilted Home Handbook* have specific purposes and functionalities, in just a few quick steps you can alter a project's purpose and turn it into a wall hanging instead. The following steps can be applied to quilts of all sizes. Turning bed quilts larger than twin size into wall hangings is not recommended, due to the size and weight of the quilts. However, making wall hangings out of projects beyond that size is possible. The following patterns can be transformed into wall hangings:

+ Positive Start Bed Quilt (*page 107*)
+ Positive Start Sham Cases (*page 113*)
+ Lasting Warmth Bed Quilt (*page 135*)
+ Lasting Warmth Sham Cases (*page 151*)
+ Day In, Day Out Lumbar Cushion (*page 171*)
+ Within the Walls Throw Cushion (*page 179*)
+ Soundbars Throw Cushion (*page 193*)
+ Brick-by-Brick Floor Cushion (*page 205*)
+ Never Far Apart Matching Throw Quilts (*page 215*)
+ Game Night Table Runner (*page 231*)

# TOOLS & MATERIALS

Preparing a quilt as a wall hanging starts with a squared-up quilt sandwich *without the binding attached.* For this particular example, the Within the Walls Throw Cushion (see *page 179* for full pattern) is converted into a wall hanging. When squared up, this project measures 22" square. A few additional materials and tools are required:

+ Backing fabric or fabric coordinating with the quilt back and/or quilt binding for dowel casing on the back of the project. A fat eighth or scraps would be sufficient to cover this fabric requirement.

+ Quilt label (optional).

+ Prepared quilt binding. (See *Preparing Binding Tape Strips* on *page 84* for how to do this.)

+ Wooden dowel—the thinner the diameter of the dowel, the more flush it will be with the wall. You may need a thicker dowel or multiple dowels for larger projects to support the length and weight of the quilts. Wooden dowels can be found at your big box or local hardware store, as well as arts and crafts stores. For this particular example, a ¼" diameter dowel was used.

+ Sharp scissors (not for fabric) or handheld saw.

+ Adhesive hook or nail and hammer to hang the wall hanging. More than one hook or nail may be required to withhold the weight and size of the wall hanging.

# PREPARING THE WALL HANGING

**01.** Cut two 5" squares from backing or coordinating fabric. With the wrong sides of the fabric facing each other, fold each square diagonally in half [Photo A] and press with an iron. Set aside **FOLDED SQUARES** for Step 3 [Photo B].

**TIP:** The larger the squares, the more reinforcement there is. The smaller the squares, the less reinforcement there is. The size of these squares is also dependent on the size of the quilt (i.e., larger squares are required to support the weight of a larger quilt).

**02.** For the **DOWEL CASING**, cut one 2½" x 7" rectangle.

With the wrong side facing up, fold the raw edges on each short end of the rectangle toward the center of the rectangle twice and press [Photo C]. Edgestitch to secure the fold [Photo D]. This will create a hem to prevent the raw edges from fraying when adding and removing the dowel. Next, fold the rectangle in half lengthwise, wrong sides together, and press to complete dowel casing rectangle [Photo E].

For larger quilts, repeat this step to create more dowel casings for additional reinforcement.

**03.** As shown in the photo, pin each diagonally folded square (from Step 1) and dowel casing(s) rectangle (from the previous step) to the back of the quilt sandwich, and sew ¼" away from the raw edge to secure these pieces [Photos F and G].

*Optional:* Attach a quilt label on top of one of the diagonally folded squares or in your preferred location.

**04.** Attach binding to the quilt using your preferred method (see *page 84* for instructions on how to bind a quilt) and trim loose threads [Photo H].

**05.** With a pair of sharp scissors or a saw, trim the wooden dowel to the width of the quilt. Slide the dowel through the dowel casing and folded corner squares [Photo I].

Hang and enjoy!

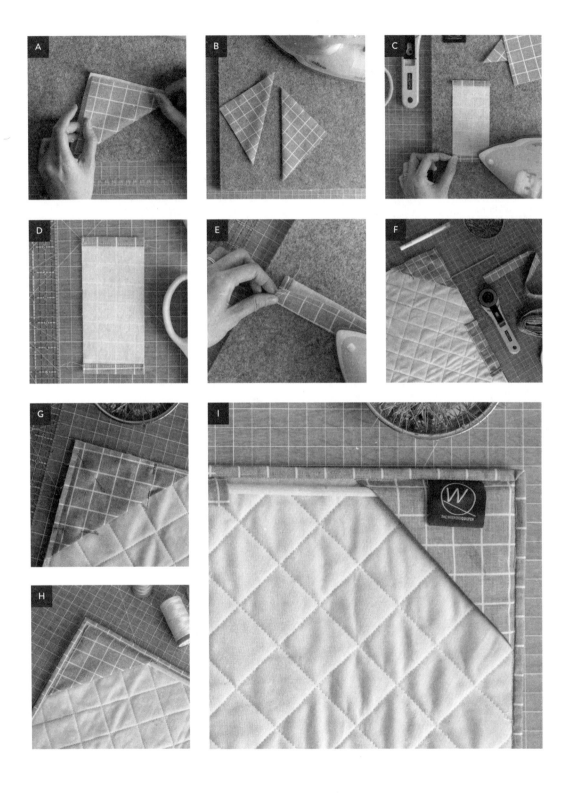

# Quilting Finishes with a Domestic Sewing Machine

You can create several looks and finishes on a domestic sewing machine in the quilting stage of the quiltmaking process. Deciding and marking out the quilting guidelines can seem overwhelming because the options are endless.

Here's a great place to start if you're uncertain—stand back and look at the overall quilt design. Scan the different shapes in the quilt top and follow these outlines to determine where your quilting guidelines will go. For example, in this Soundbars Throw Cushion project (see *page 193* for full pattern), the quilting lines start from the center rectangle and work out to create a repeating U-shape.

For more inspiration, this section of the book covers ten simple and effective straight-line quilting finishes that can be achieved with a domestic sewing machine. These designs can be easily adapted and changed as you feel more confident and acquainted with quilting on a domestic machine.

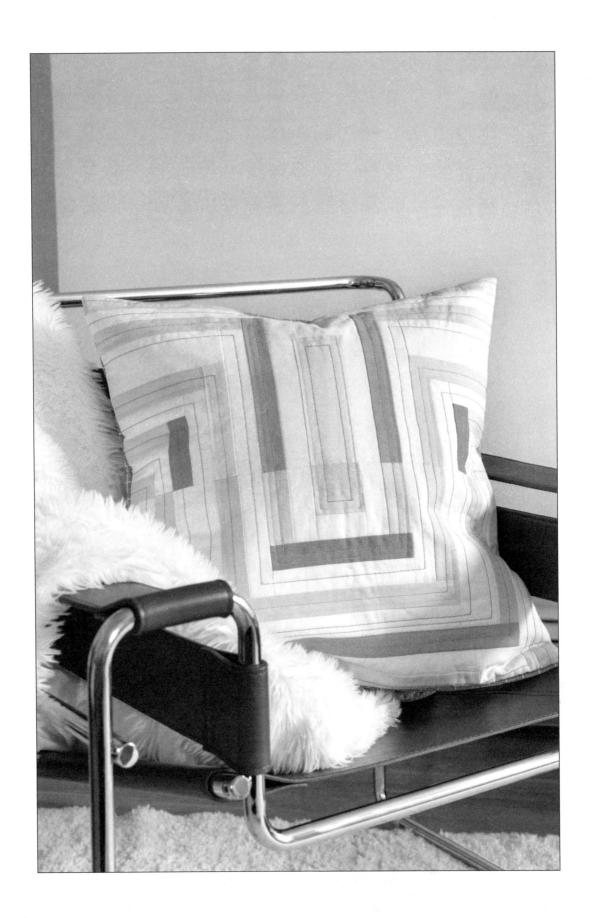

# TIPS & TRICKS: MARKING & SEWING GUIDELINES

Before we dive into different quilting motifs and finishes, let's cover some points to keep in mind as you mark and sew quilting guidelines.

## PROJECT SIZE: THROAT SPACE, SKILL LEVEL, AND QUILTING MOTIF

Throat space (also known as the harp space) refers to the distance between the sewing machine needle and the main part of the machine where the motor is housed (also called the neck). The larger the space between the needle and the neck of the machine, the more flexibility there is to move the project around. This means less folding and rolling of the quilt sandwich is required while quilting the project. It also makes quilting easier for larger projects like throw- and queen-sized projects or those with thicker batting, such as wool.

Throat space varies between different machines. Thereby, that variable plays into determining the size of the project the machine can hold, as well as your skill level and experience with quilting on a domestic sewing machine.

As you are about to start quilting your first few projects on your domestic sewing machine, or are exploring a new motif with more intricate designs, experiment on a scrap quilt sandwich or smaller project (e.g., a cushion or a baby-sized quilt). It's easiest to move smaller projects through a sewing machine, especially if you don't have much throat space to work with.

## SMALL ADDITIONAL INVESTMENTS

To make quilting on a domestic sewing machine more enjoyable, invest in quilting gloves.

Quilting gloves give you better control of the quilt by providing additional firm grip to prevent the quilt from slipping, ensuring greater precision when guiding the quilt sandwich through the sewing machine. There are many variations of quilting gloves, and they generally have rubberized grips at the fingertips. Some quilting gloves are fingerless, with grips on the palms.

An alternative to quilting gloves is gardening or utility gloves with grips. These are cheaper and have rubberized grips on both the palms and fingertips, which means more control, less fatigue, and longer quilting sessions. In the long-term, using gloves is ergonomically better for the hands, wrist, shoulders, and neck because it requires less use of these body parts to guide and move the quilt sandwich through the sewing machine.

Quilting gloves are not a one-time purchase, especially if you do a lot of domestic quilting. They need to be replaced when the grips begin to wear out. Just like car tires need to be replaced as they lose traction, putting the driver at risk, quilting gloves need to be replaced as the grip wears. Otherwise your body will likely compensate to support the quilt, and this could lead to body aches and pains.

Another small investment that sounds ridiculous (but you're going to thank me for it later) is knee pads. These are going to be your savior, especially when you're down on all fours on hardwood floors, concrete, or tile, carefully marking your quilting guidelines for a long period of time. While not essential, knee pads are worth looking into for the long-term health and condition of your knees. They also come in handy when basting your projects on the floor.

If knee pads are on your shopping list, purchase the kind that strap around your knees and legs, not simply a piece of foam placed in front of you on a hard surface. You'll want plenty of room to work when marking your quilting guidelines on the floor, and you won't want to worry about moving a piece of foam every time you reposition.

## PREPARE THE WORKSPACE

Before starting any real work behind the sewing machine, make sure there is enough space beside, in front of, and behind the machine to support the project's weight and length. Without adequate support the project's weight can lead to inaccurate quilting, and the body is more likely to compensate to keep the project stabilized. Consequently, this could lead to poor sitting posture and fatigue.

If there isn't enough space for larger projects, don't be afraid to move your furniture around. Alternatively, set up another desk, a chair, or an ironing board beside and/ or in front of the sewing machine. Ensure this additional support is approximately the same height as the piece with the sewing machine. In terms of space behind the sewing machine, try to place the quilt sandwich on your chest instead of your lap. These little adjustments can make a huge difference to your quilting experience and create more support and control, preventing the quilt from catching on the workspace.

## IDENTIFY THE QUILT CENTER

Whenever you start marking any quilting project, use a hera marker or dull kitchen knife to mark the vertical and horizontal center of the quilt top. These guidelines will be the starting point for marking guidelines and will ensure the planned quilting motif is centered from all sides of the project.

## MARK AND SEW ON QUILTING GUIDELINES AS YOU GO

Once you have a general quilting motif in mind, first mark all the guidelines going in one direction. For example, mark all the vertical guidelines in the quilting motif first.

Sew on the marked guidelines on the quilt sandwich. This first round of sewing prevents the layers from shifting as more guidelines are marked and sewn. This is also an opportunity to identify and correct any folds, lumps, or bumps on the quilt back or top. These initial sewn lines also help determine where the next set of marked guidelines go. Using existing sewn lines as a guide to marking more guidelines ensures more accurate quilting, because the next set of guidelines are determined by permanent guidelines. Alternate between marking and sewing until the final quilting motif is achieved.

Exploring intricate and more difficult motifs might be in the cards as you feel more confident and accustomed to quilting on a domestic sewing machine. Marking and sewing as you go is more important with such motifs, as it reduces confusion and mistakes that require a seam ripper to correct.

## DON'T BE A LOSER IN THE THREAD-AND-BOBBIN CHICKEN GAME

Nobody likes to be a loser. (Well, at least I know I don't.) The goal of the thread-and-bobbin chicken game is to see if you have enough thread to finish your project when you are running low on the top of the sewing machine and/or in the bobbin. Here are a couple of pointers on how to be a winner:

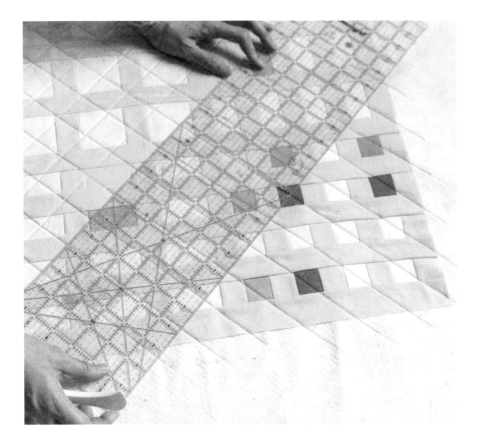

+ Before any sewing commences, ensure there is enough thread to cover the entire front and back of the project, and don't forget to frequently check if there's enough thread in the bobbin. It's easy to get into the quilting zone and then realize there's no thread in the bobbin.

+ It's inconvenient when you run out of thread; the needle has likely stopped in the middle of the quilt and you either have to bury the loose ends of thread within the quilt sandwich or use a seam ripper to remove the row of seams just sewn on (and start that row again once the bobbin has been filled).

+ Alternatively, pick up where the thread ran out by putting the needle down a few stitches before the thread ended, backstitch to secure the threads and continue sewing. The down side in this method is the backstitch will be visible on both sides of the quilt. These steps are necessary to prevent quilting stitches from unravelling while using or washing the quilt.

+ Wind up at least two bobbins (depending on the project size and intricacy, and details of the quilting motif) and have them ready for when the bobbin in the sewing machine is running low or out of thread. This makes the quilting process more efficient because you can simply switch out the bobbin and sew away without pausing to wind a new bobbin.

## SEW FROM THE CENTER

Depending on the quilting motif and how large the project is, you may want to start from the center of the quilt and work your way from left to right or from right to left as you sew quilting lines onto the project. This is more efficient and provides the opportunity to push out any air bubbles or lumps before more quilting lines are added. This is particularly important when sewing the first set of quilting lines as that sets the foundation of the quilting on the project.

## EDGE-TO-EDGE QUILTING

All the suggested straight-line quilting motifs in this book are edge-to-edge quilting. Edge-to-edge quilting is a continuous line that starts at one edge of the quilt top and ends at the other.

When starting a new line of quilting, begin sewing approximately 1" to 1½" before the edge of the quilt top and end approximately 1" to 1½" beyond the opposite edge. This prevents a thread nest (bunched-up thread) from forming on the quilt back, and the quilting stitches will be secured when the quilt sandwich is squared up and bound.

## BE BOLD

One of the joys of quilting with a domestic sewing machine is the opportunity to pick out different thread colors. Don't be afraid to use varied thread weights or colors—including winding up the bobbin with a different color of thread than one used on top of the quilt.

## IT'S OKAY TO MAKE MISTAKES OR CHANGES ALONG THE WAY

It happens to all of us. Sometimes we get lost in the moment of quilting zen, with the humming noise of our sewing machine running. While deep in our own wandering thoughts, a captivating podcast, music, show, or movie playing in the background, our hands can have a mind of their own. It's totally fine if you need to make a sewing stop to remove sewn quilting lines and redraw quilting guidelines. You might find yourself adding new quilting guidelines as you go to cover up an error or because another cool motif appears as you're quilting—no one will notice unless you point it out.

A final piece of advice for quilting on a domestic machine: take your time and enjoy the process. No matter the size of the project, quilting on a domestic machine is possible, and the results are rewarding. It might not look perfect the first time, but there are plenty of fun-filled projects in this book to hone your skills.

## THE SIMPLE GRID AND VARIATIONS

The Simple Grid motif is the easiest of all the motif designs in this book. It's also one of the most versatile designs. Once all the grid guidelines are marked and sewn, the look and feel can be completely altered by adding additional lines on top. But let's not get ahead of ourselves . . . let's start with the basics of the Simple Grid motif.

### THE SIMPLE GRID MOTIF AND RECTANGLE GRID MOTIF

**01.** Start by finding the center point of the quilt vertically and horizontally, and mark two intersecting lines as shown (Fig. 1).

**02.** Mark equally spaced, parallel lines either vertically (Fig. 2) or horizontally (Fig. 3); either way is fine as long as they all go one direction. Sew on the marked guidelines.

**03.** Mark equally spaced, parallel lines in the opposite direction (Fig. 4) to form a Simple Grid motif. Sew on the guidelines to complete the look.

**04.** The quilting guidelines marked in this step are not limited to the same distance between each line, as per Step 2. The spacing between each horizontal or vertical line can be increased to create a Rectangle Grid motif. See examples shown (Fig. 5 and Fig. 6).

### THE SIMPLE GRID MOTIF, VARIATION 1: GOING DIAGONAL

With the Simple Grid motif laid out, using each square grid as a guide, mark a diagonal guideline from one corner to the other within each grid. Repeat to cover the entire quilt top with parallel diagonal guidelines. Sew on the guidelines to complete the Going Diagonal motif.

The diagonal quilting lines could go either way (Fig. 7 and Fig. 8), depending on the quilt top design and personal preference.

The Going Diagonal motif also works with Rectangle Grid motifs (Fig. 9 and Fig. 10).

### THE SIMPLE GRID MOTIF, VARIATION 2: CROSSWAYS

Add another layer of diagonal guidelines to create excitement in the Going Diagonal look. As in the previous look, mark diagonal guidelines going the opposite direction to create a cross within each grid (Fig. 11: square grid and Fig. 12: rectangle grid).

**TOP▲**  FIGURE 1

VERTICAL → CENTER GUIDELINE

↑ HORIZONTAL CENTER GUIDELINE

**TOP▲**  FIGURE 2

**TOP▲**  FIGURE 3

**TOP▲**  FIGURE 4

**TOP▲**  FIGURE 5

**TOP▲**  FIGURE 6

**TOP▲**  FIGURE 7

**TOP▲**  FIGURE 8

**TOP▲**  FIGURE 9

**TOP▲**  FIGURE 10

**TOP▲**  FIGURE 11

**TOP▲**  FIGURE 12

## THE SIMPLE 45-DEGREE GRID AND VARIATIONS

For the Simple 45-Degree Grid, simply adapt the Simple Grid look, turning it onto a 45-degree angle. Achieving this and its variations is easy.

### THE SIMPLE 45-DEGREE GRID MOTIF

**01.** Instead of finding the quilt's center point by identifying the vertical and horizontal centers, the center point is determined by the four corners of the quilt top.

Mark two diagonal guidelines from one corner of the quilt top to the opposite corner, essentially creating a giant letter "x" in the middle of the project (Fig. 13).

*If the project is a rectangle*, this same technique can be applied and is just as effective. However, the angle of the diagonal guidelines won't be 45 degrees (Fig. 14). To apply the Simple 45-Degree Grid on a rectangular project, see *The Simple 45-Degree Grid Motif on a Rectangle Project* on the next page.

**02.** Mark equally spaced, diagonal parallel lines. It doesn't matter which way, as long as they go the same direction. Sew on the guidelines (Fig. 15).

**03.** Using the second diagonal guideline marked in Step 1 and the sewn diagonal lines in Step 2, mark the second set of diagonal guidelines going the other direction (Fig. 16) and sew on the lines to form the *Simple 45-Degree Grid motif*.

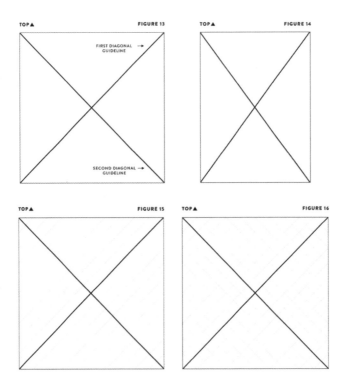

## THE SIMPLE 45-DEGREE GRID MOTIF ON
## A RECTANGULAR PROJECT

**01.** To achieve a 45-degree-angled grid on a rectangular-shaped project, first identify and mark the center of the quilt horizontally and vertically. Use these two lines only as a guide and do not sew on them (Fig. 17).

**02.** Using a quilting ruler, line up the 45-degree-angle mark against the vertical center guideline and mark 45-degree diagonal guidelines (Fig.18).

**03.** Using the marked 45-degree lines in the previous step, mark parallel guidelines until the top is covered (Fig. 19). Sew on the diagonal guidelines.

**04.** Repeat the previous step going in the opposite direction diagonally to complete the Simple 45-Degree Grid motif on a rectangular project (Fig. 20).

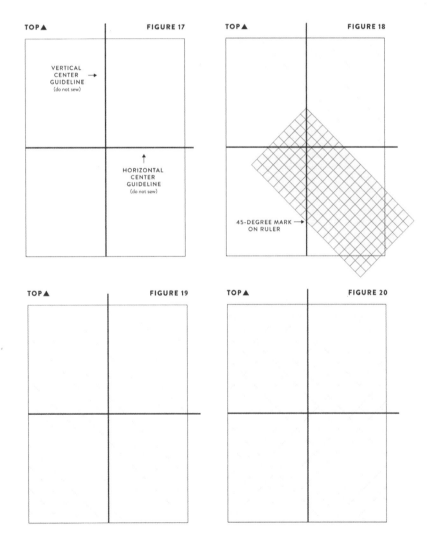

## THE SIMPLE 45-DEGREE GRID MOTIF,
## VARIATION 1: DOUBLE GRID

An alternative variation of the Simple 45-Degree Grid is to add another parallel line to the left or right of the original 45-degree grid to create the Double Grid motif (Fig. 21).

When adding the additional parallel line to the original grid, keep two things in mind: (1) Stay consistent and only add additional lines to the right or left of the original grid. This ensures the spacing between the original and new grid looks consistent all around. (2) Make sure the distance between the lines of the original grid and the new grid is smaller compared with the spacing between the original grid lines. Otherwise, it will look like a denser Simple 45-Degree Grid motif.

CLOSE UP OF DOUBLE
GRID MOTIF

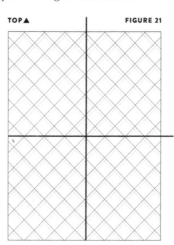

TOP▲                    FIGURE 21

## THE SIMPLE 45-DEGREE GRID MOTIF, VARIATION 2: TRIPLE GRID

For more complexity, add a second parallel line running outside of the Simple 45-Degree Grid motif, Steps 1-3 (*page 79*), to create the Triple Grid motif (Fig. 22).

CLOSE UP OF DOUBLE
GRID MOTIF

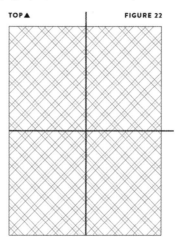

TOP▲                    FIGURE 22

## THE SIMPLE 60-DEGREE GRID MOTIF

For the Simple 60-Degree Grid motif, all the steps in the Simple 45-Degree Grid motif on a rectangular project (page 79) apply. However, instead of using the 45-degree-angle mark on the quilting ruler as a guide, use the 60-degree-angle mark (Fig. 23 to Fig. 25). This method can be applied on all shapes and sizes of projects.

The Double Grid and Triple Grid motifs can both be applied to the Simple Grid motif (page 76) and the Simple 60-Degree Grid motif.

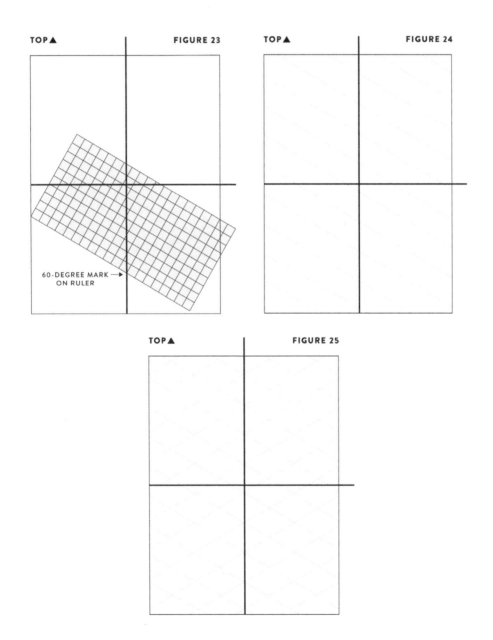

## THE SIX-POINTED STAR

Now let's put all these quilting skills to the test. Of all the motifs presented, the Six-Pointed Star motif is the most difficult. There is a lot of marking and sewing involved, and the various intersecting lines can get confusing. Refer to the diagram (Fig. 26), which illustrates how each grid square should appear when all the quilting is completed.

**01.** Mark and sew a square grid, as per the Simple Grid motif, Steps 1–3 on *page 78* (Fig. 27).

**02.** Using the square grid as a guide, mark 45-degree diagonal guidelines from one corner to another corner to create an "x" in each square, as per the Simple Grid Motif, Variation 2: Crossways, Step 1 on *page 76* (Fig. 28). Sew on the marked guidelines.

**03.** Starting at the top of the quilt, use two squares from Step 1 as a guide (imagine a rectangle), and mark an "x" in the rectangle, from one corner to the other (Fig. 29). Adding these additional lines creates an equilateral triangle within each square grid. Sew on the marked guidelines.

**04.** Starting from the top of the quilt again, begin from the second row of the square grid outlined in Step 1 and combine two squares, as in the previous step, as a guide. Mark an "x" within the imaginary rectangle by marking a diagonal guideline from one corner to the other. These additional lines create a second equilateral triangle within each square grid (Fig. 30). Sew on the marked guidelines to complete the Six-Pointed Star motif.

The Six-Pointed Star motif can also be applied to a rectangular-shaped project, and you can play around with the scale of each grid to manipulate the motif and create a completely different look.

**TOP▲**                                        **FIGURE 26**

TOP▲       FIGURE 27

TOP▲       FIGURE 28

TOP▲

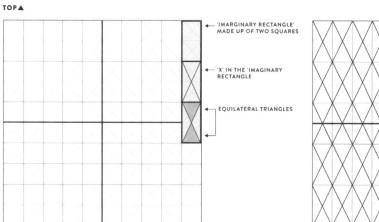

'IMARGINARY RECTANGLE' MADE UP OF TWO SQUARES

'X' IN THE 'IMAGINARY RECTANGLE

EQUILATERAL TRIANGLES

FIGURE 29

TOP▲       FIGURE 30

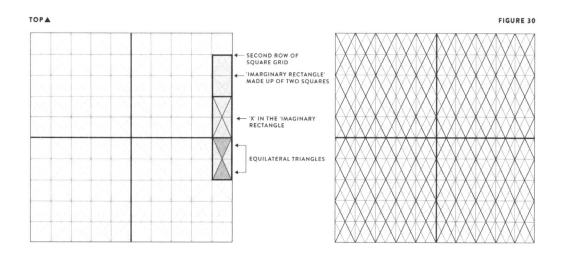

SECOND ROW OF SQUARE GRID

'IMARGINARY RECTANGLE' MADE UP OF TWO SQUARES

'X' IN THE 'IMAGINARY RECTANGLE

EQUILATERAL TRIANGLES

# Bias Binding Tape: What and How

Occasionally bias binding tape makes a guest appearance in quilt projects, and when it does it shows off its flexible, stretchy moves and pliable nature. These key characteristics make it easier to attach bindings to projects with curved finishes and rounded edges. It also helps the final project to lie nice and flat.

Shown in the photo on the right are two rounded finishes: (1) straight grain binding (what we're used to seeing and using in quilt projects), and (2) bias binding tape. Notice the raised and puckered corner on the upper-right corner? That is because straight grain binding was used. The bottom-left corner sits nice and flat because of the bias binding tape finish.

Using bias binding tape is more important on smaller projects, such as sleeping eye masks. This is because the rounded corners are smaller and require that additional stretch that bias binding tape offers. Bias binding tape has many other uses, including drawstrings, button loops, embellishments on sewing projects, applique on stained glass quilts, and more. However, in this book it is only used to finish projects with curved and rounded edges. This section covers what bias binding tape is, some of its benefits, the different types, and how to prepare and attach it.

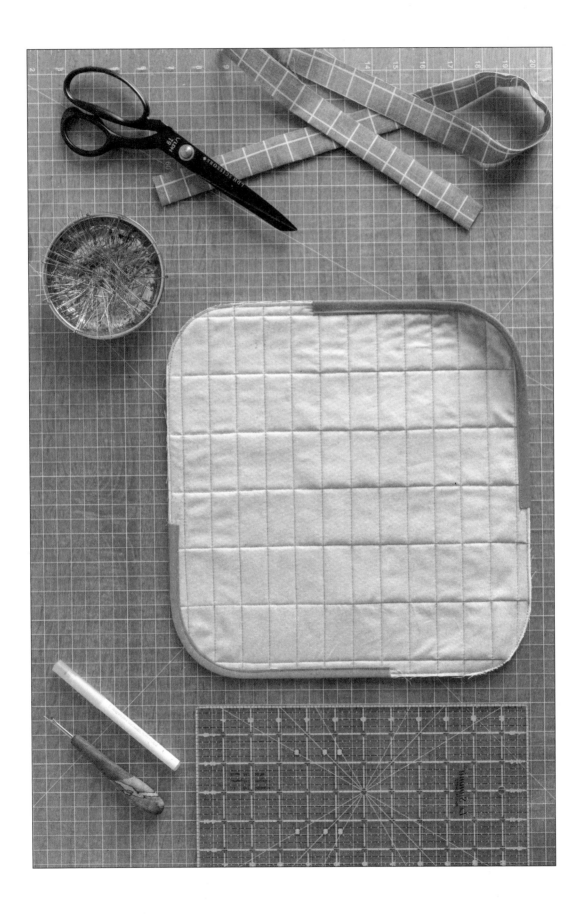

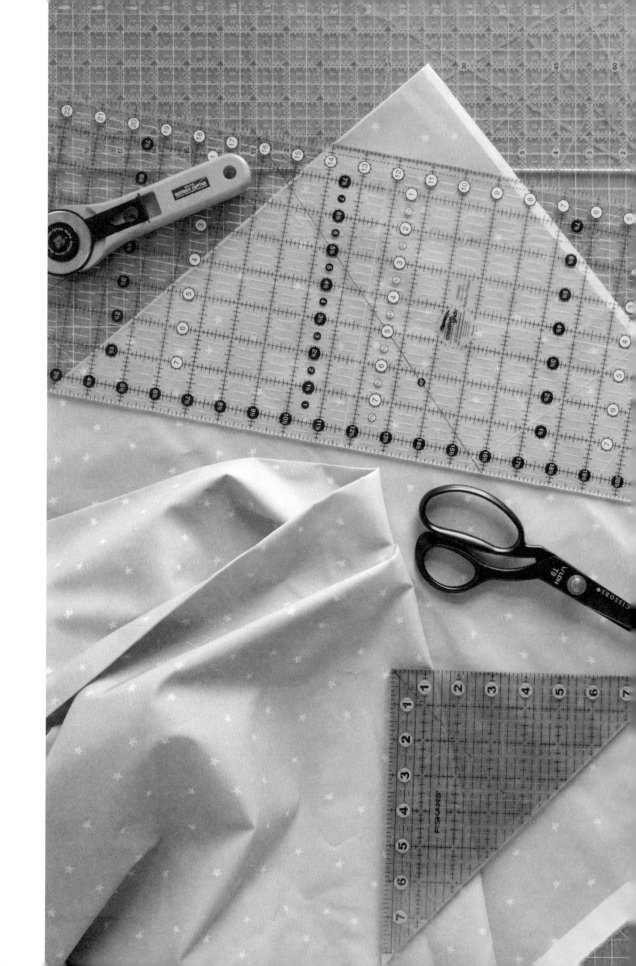

# WHAT IS BIAS BINDING TAPE?

Bias binding tape gets its name from the way the strips of binding are cut: on the fabric's bias. To understand where the bias of the fabric is, we need to take a step back and understand what "fabric grain" is.

Fabric grain describes the threads that are arranged and woven together vertically and horizontally to form a piece of fabric. There are three types of fabric grain:

+ Lengthwise Grain are the fabric threads that run parallel to the selvedge, or lengthwise of the fabric [Photo A].

+ Crosswise Grain are the fabric threads that run perpendicular to the selvedge, or parallel to the raw edge of the fabric as it comes off the bolt [Photo B].

+ Bias Grain is the thread line that is at a 45-degree angle relative to the lengthwise and crosswise grains [Photo C].

Using bias binding tape on quilting projects generally gives a more durable finish. Why? With standard, straight grain binding, the fabric grains run lengthwise and crosswise along the edges of the quilt. Essentially, if a single fabric grain in a straight binding gets compromised, that fabric grain takes the majority of wear and tear. With the lengthwise and crosswise grains running at a 45-degree angle in bias binding tape, the wear and tear is distributed across multiple grains, thereby making it a stronger binding. With this in mind, you may consider switching to bias binding tape when it comes to binding bed quilts, quilts that will get a lot of use, or quilted garments that may rub against your body or other surfaces during wear.

## TYPES OF BIAS BINDING TAPE

Bias binding tape comes in many widths, lengths, and forms. Single and double folded are the two most common ready-made bias tapes found in stores:

+ **SINGLE FOLDED:** The longer edges of the bias binding tape strip are folded toward the center of the tape, and the raw edges meet together in the middle. (Gray binding shown in the photo on the right.)

+ **DOUBLE FOLDED:** The single folded bias binding tape strip is folded in half. (Orange binding shown in the photo on the right.)

It's easiest to purchase pre-packaged bias binding tape from local and online retailers. If you do, carefully read the description on the package—remember, it comes in various widths, lengths, and forms. While creating your own bias binding tape requires more time and effort compared to straight grain binding (as shown in Preparing Binding Strips on *page 84*), having some knowledge or experience in doing so can be helpful at times. For example, when a specific color of bias binding tape is not available to purchase, you want to replicate bias binding tape in a specific print that cannot be sourced, or you simply can't buy it in time to complete your project.

Let's go over how to prepare your own bias binding tape and how to attach pre-packaged double folded bias binding tape.

## CREATING YOUR OWN BIAS BINDING TAPE

Just like making eggs, there are different ways to prepare bias binding tape. There's continuous bias binding tape, which is a little more challenging. This technique requires more precision but less sewing. It is created by sewing a fabric tube, then cutting a spiral to make one long continuous strip of bias binding tape. The method I'll be showing you involves a little more preparation, but it is easier to accomplish and similar to putting together straight grain binding. However, don't feel limited to the one method just because it is demonstrated here. I encourage you to try all methods and find the one you're most comfortable with.

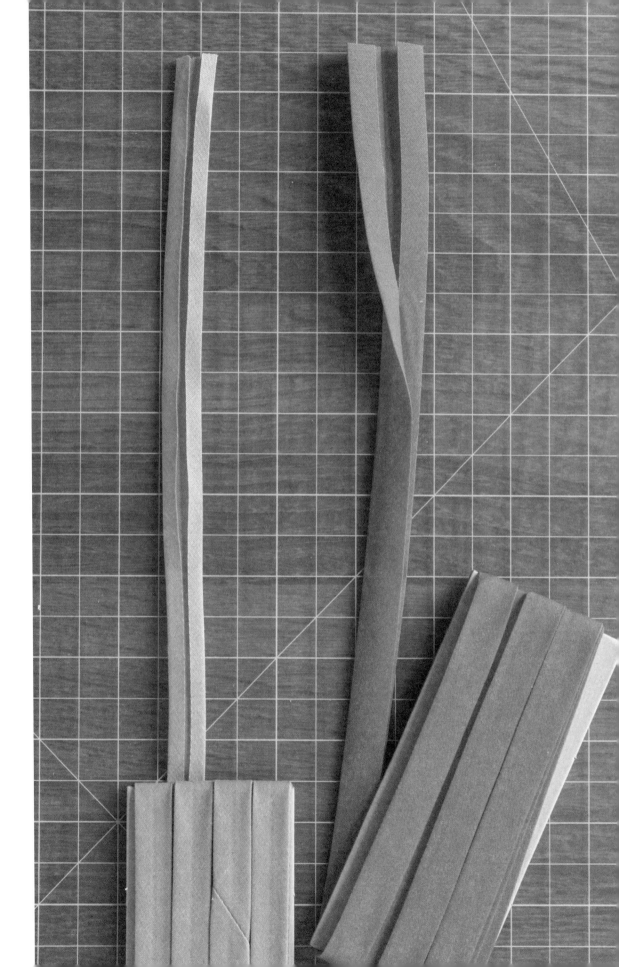

## TOOLS AND MATERIALS

Without further ado, let's get down to bias binding tape business! You'll need the usual cutting tools (cutting mat, rotary cutter), as well as a few other special items:

+ Bias binding tape fabric of choice (of course!).

+ A long quilting ruler with 45-degree-angle guideline (e.g., 6" x 24").

+ A secondary quilting ruler—this is optional and is used to provide additional length for longer cuts. Can be any size, but preferably 6" x 12" or larger.

+ A triangle ruler—this is also optional. If you don't have one, you can still make it work. Just make sure there's a quilting ruler with a 45-degree-angle guideline within reach.

## CALCULATING HOW MUCH BIAS BINDING TAPE IS REQUIRED

Except for the Checked Out Sleeping Eye Mask (*page 125*), the patterns in *The Quilted Home Handbook* call for straight grain binding. If using bias binding tape is your preference, here are a few easy formulas you can follow to calculate how much fabric you'll need.

In quilter's fashion, all the calculations are done in inches. If you are used to using the metric system or buying fabric by metric cuts, complete the calculation in inches and yards first. Then convert the final answer into centimeters or meters. A quick and easy way to convert from imperial to metric is using Google's unit converter. And don't worry—bias binding tape fabric requirements for the Checked Out Sleeping Eye Mask (*page 125*) have already been factored in the pattern.

---

### FORMULA

+ Project perimeter" x width of binding strips" = x"
+ x" ÷ 42" (or the width of fabric, from selvedge to selvedge in inches) = y"
+ y" + 20" to 30" of fabric to factor in errors, slight variances in the fabric width, and the project's corners = z"
+ z" ÷ 36" = bias binding tape fabric requirement in yards

---

## FORMULA NOTES

+ Calculate the project's perimeter: (width" x 2) + (length" x 2). Project dimensions can be found at the start of each pattern.

+ All the patterns in the book call for 2½"-wide binding strips. Feel free to experiment with different widths. However, going smaller than 2" is not recommended. Anything skinnier than 2" does not leave much room to wrap the binding around the three layers of the quilt and makes attaching the binding harder and more finicky.

+ Why 42"? Quilting fabrics usually come in 42"-wide format. If the fabric width is greater or less than 42", update this measurement to match the distance between the fabric's two selvedges.

+ With the additional 20" to 30" of fabric, you may find there is more than enough bias binding tape for the project. It's better to have too much binding rather than too little, which can stop a project in its tracks.

+ Why 36"? There are 36" in one yard.

+ Below is a table converting final fabric requirements for bias binding tape in decimals, fractions, inches, and centimeters. Round up the final answer to the nearest yard to determine how much fabric to make up bias binding tape for project:

| YARDAGE IN DECIMALS | YARDAGE IN FRACTIONS | YARDAGE IN INCHES | YARDAGE IN CENTIMETERS |
|---|---|---|---|
| 0.125 yd. | ⅛ yd. | 4½" | 12cm |
| 0.250 yd. | ¼ yd. | 9" | 23cm |
| 0.375 yd. | ⅜ yd. | 13½" | 35cm |
| 0.500 yd. | ½ yd. | 18" | 46cm |
| 0.625 yd. | ⅝ yd. | 22½" | 58cm |
| 0.750 yd. | ¾ yd. | 27" | 69cm |
| 0.875 yd. | ⅞ yd. | 31½" | 80cm |
| 1.000 yd. | 1 yd. | 36" | 92cm |

## PREPARING BIAS BINDING TAPE STRIPS

**01.** Use a long quilting ruler and rotary cutter to trim jagged or uneven edges of the bias binding tape fabric. To do this, use the folded edge of the fabric as a guide to ensure it is straight and right-angled against the width of the fabric [Photo A].

**02.** Line the long edge of the quilt ruler perpendicular to the trimmed edge and remove selvedges from the bias binding tape fabric [Photo B].

**03.** *With Triangle Ruler:* Place the triangle ruler on the bottom-left corner of the fabric (line up the right-angled edges on the ruler with the left and bottom edge of the fabric, with the 45-degree edge of the ruler away from the corner). This is the fabric's bias grain. Remove the corner to create a 45-degree edge [Photo C].

*Without Triangle Ruler:* Identify the 45-degree-angle guideline on quilting ruler. Line up the guideline against the left or bottom edge of the fabric. Remove the corner to create a 45-degree edge [Photo D].

**04.** Follow the 45-degree edge with longest quilt ruler available. Measure 2½" (or whatever the width of the bias binding tape is) from the 45-degree edge and cut. Make sure the ruler is always lined up against the 45-degree edge and all the cut strips are the same width. Essentially, all the cuts should run parallel and be evenly spaced. Repeat until there is no more fabric to cut [Photo E].

TIP: Place the secondary ruler beside the long quilting ruler to provide additional length for longer cuts. Before cutting, make sure the secondary ruler is also 2½" (or whatever the width of the bias binding tape is) from the 45-degree edge of the fabric [Photo F]. Alternatively, skip the secondary ruler, and move the long quilting ruler as you cut, along the 45-degree edge, maintaining its distance from the edge of the fabric.

**05.** Next, with right sides together, join the strips. It's tempting, but do not flush the diagonal edges of the two strips and sew. The strips won't line up when opened.

The correct way to join these strips is to line up the diagonal edges of the two strips. Position the top strip so the top diagonal edge extends ¼" past the top of the bottom strip, and vice versa. Pin to secure the strips [Photos G and H].

**06.** Sew ¼" away from the diagonal edge [Photo H]. Press the seams open [Photo I]. Do not press the seams to the dark side. Pressing the seams open will reduce seam bulk and create an even surface around the quilt [Photo J].

**07.** With a pair of fabric scissors or a rotary cutter and ruler, carefully remove the dog ears from each joint [Photo J].

**08.** Repeat Steps 5-7 until all strips are combined and pressed.

**09.** Fold the binding in half lengthwise, with wrong sides of the fabric facing each other, and press. The width of the folded binding strip should measure half of what it started as [Photo K]. For example, a 2½"-wide strip folded in half would measure 1¼" wide.

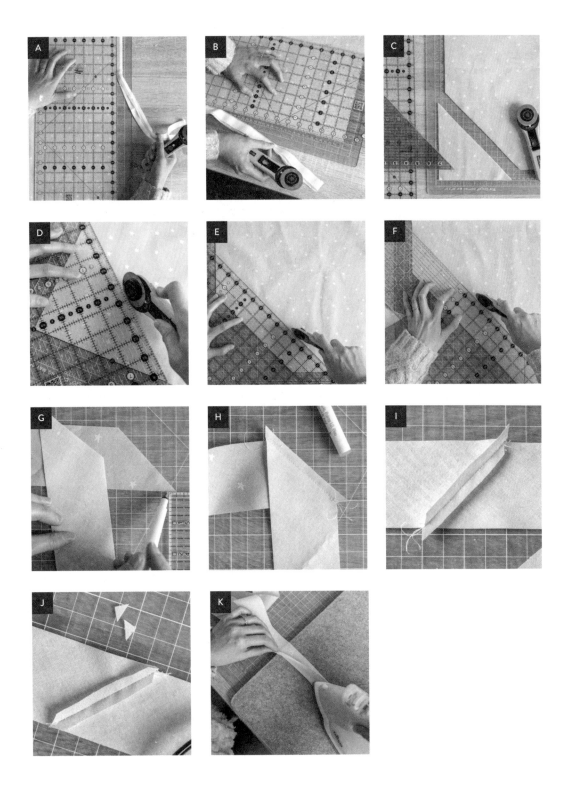

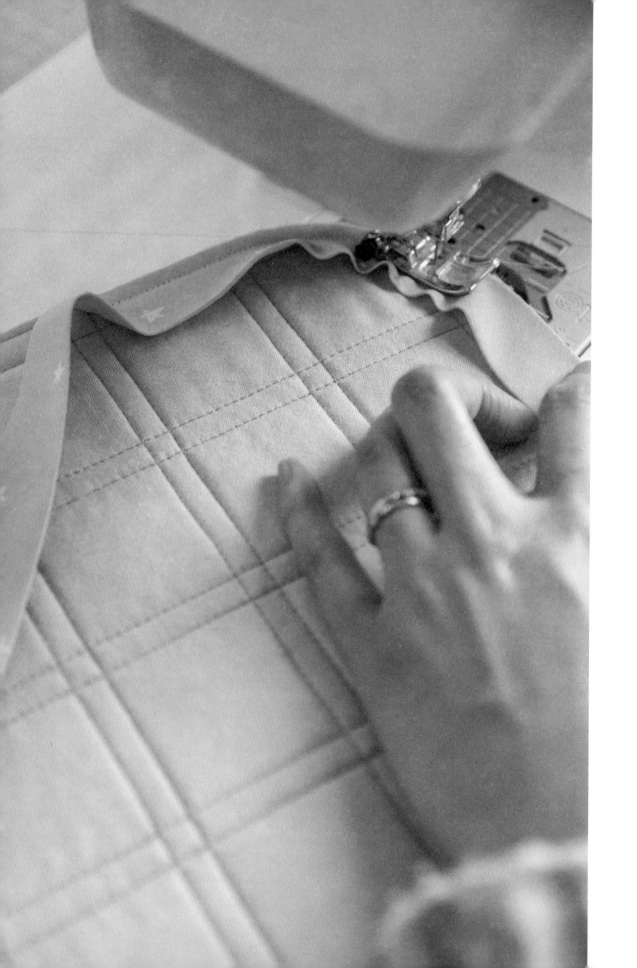

## ATTACHING BIAS BINDING TAPE

See? DIYing bias binding tape is not so bad. Sewing bias binding tape onto a quilt is not so different from straight grain binding. There are only a couple of differences, which are explained here. If needed, flip back to *page 90* for a refresher on how to attach straight grain binding. Knowing how will make it easier to understand how to attach bias binding tape. As previously mentioned, there are various ways to attach binding to a quilt. These instructions reference machine binding to the front and back of the quilt.

## BIAS BINDING TAPE VS. STRAIGHT GRAIN BINDING: WHAT ARE THE DIFFERENCES?

+ *Give it extra slack:* When attaching straight grain binding, it is recommended to start sewing at about 4" from the top of the binding and ¼" away from the raw edges. With bias binding tape, start approximately 10" to 12" from the top of the binding and ¼" away from the raw edges for extra slack when joining the ends of the binding together, if possible. This slight adjustment makes that part of binding process easier. Understandably, this is trickier to achieve or might not even be possible with smaller projects with no room to accommodate this. In this case, allow at least a 3" to 4" tail at the top of the binding.

+ *Do not stretch and pull:* Do not stretch and pull the bias tape while sewing. This is going to be particularly tempting as you get to the rounded and curved edges. Stretching and pulling runs the risk of the project not sitting flat. Allow it to naturally sit and follow the edges. For rounded-edged projects, lift and adjust the presser foot on the machine every few stitches, with the sewing machine needle down, to shift the project to maintain its ¼" allowance from the raw edge.

+ *Join ends diagonally, not straight:* Another major difference between attaching straight grain binding and bias tape binding is that the binding ends need to be cut and joined diagonally from the back of the quilt. This is why having as much slack as possible on each end of bias binding tape strip makes this part of the binding process easier.

To join the two ends of the bias binding tape together:

**01.** Stop sewing the bias binding strip to the quilt about 10" to 12" from the start of the binding. On a smaller project, allow at least 3" to 4" of binding unsewn. Remove the quilt from the sewing machine.

**02.** Lay the quilt flat with the quilt back and the two ends of the binding strip facing up. Place the end of the binding on top of the start of the binding. Use a quilt ruler to mark 2½" (or the width of the bias binding tape), so the two ends overlap each other [Photo A]. Carefully cut on the marked guideline to remove excess binding.

**03.** Similar to joining straight grain binding strips, lay the binding strip horizontally, wrong side up, on the start of the binding strip, and mark a small dot or draw a short line 2½" (or the width of the bias binding tape) from the left edge. Then draw a 45-degree diagonal guideline from the bottom left corner to the mark [Photo B].

**04.** Pin the start and end of the binding strip together at a 90-degree angle, with right sides together and the diagonal marked guideline facing up [Photo C]. Sew on the guideline.

**05.** Trim a ¼" seam allowance to the outside of the sewn line [Photo D]. Press the seams open at the joints. Do not press the seams to the dark side.

**06.** Attach the rest of the binding to the back of the quilt. Remove the quilt from the sewing machine.

Attaching the remainder of the binding onto the front of the quilt is the same as attaching straight grain binding (see Attach Binding to Quilt, Step 8, *page 59*).

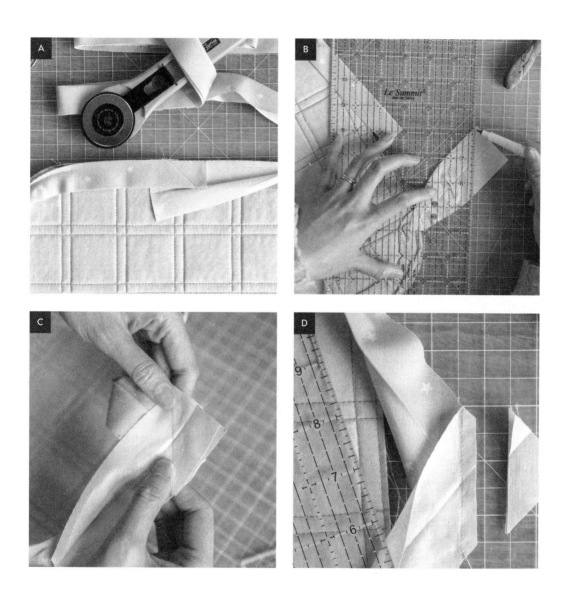

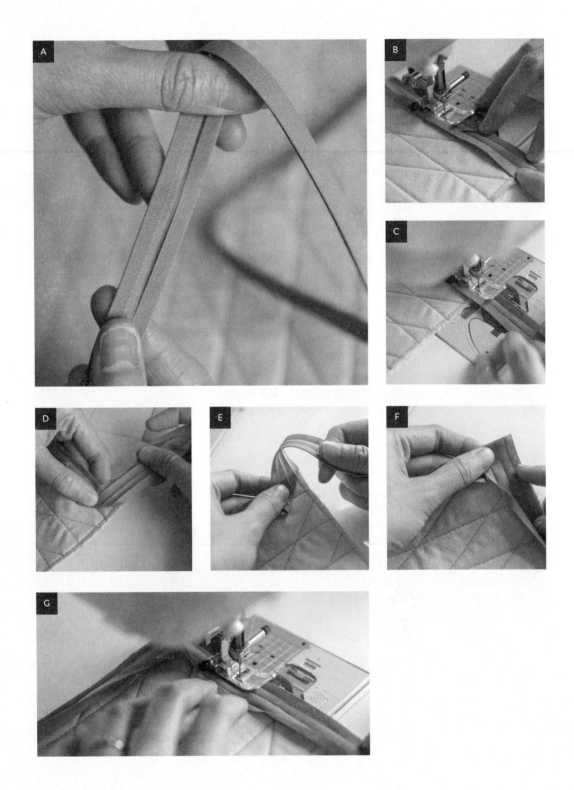

# ATTACHING PRE-PACKAGED DOUBLE FOLDED BIAS BINDING TAPE

Pre-packaged bias binding tape offers the fastest way to get binding onto a project because the manufacturer has done all the hard work in creating it. Yay! Working with double folded bias tape is slightly different from DIYed double folded bias tape and straight grain binding. Use ⅜" to ½"-wide pre-packaged double folded bias binding tape. (This would fold out to be approx. 2"-wide.) Again, these instructions reference machine binding to the front and back of the quilt.

**01.** Note that pre-packaged bias binding tape is not exactly folded in half. Identify the narrower half and unfold the binding [Photo A]. With the quilt back facing up, line up the raw edge of the quilt back and the narrower half of the binding edge. Place one layer of the bias binding tape on top of the quilt back.

**02.** Start sewing approximately 10" to 12" from the top of the binding, if possible. If the project is smaller and it isn't possible, allow at least a 3" to 4" tail at the top of the binding. Instead of sewing ¼" away from the raw edge like you would with DIY bias binding tape and straight grain binding, line up the sewing machine needle on the inside of the first crease line of the bias binding tape [Photo B].

**03.** *Project with rounded edges:*

    **a.** If necessary, as you stitch rounded edges lift and adjust the presser foot on the machine every few stitches, with the sewing machine needle down, to shift the project to continue sewing on, or slightly inside of, the first crease line of the bias binding tape.

*Project with mitered corners:*

    **b.** Keep sewing until your needle hits ¼" from the corner. Stop here and back-stitch. Then remove the quilt from the sewing machine [Photo C].

    **c.** Turn the quilt 90 degrees, with the raw edge of the quilt sandwich on the right. Fold the binding at a 45-degree angle [Photos D and E] and then fold the binding strip back down so the raw edge is aligned with the raw edge of the quilt sandwich [Photo F].

    **d.** Position the sewing machine needle directly on or slightly inside of the first crease of the bias binding tape. Continue to attach the binding as in Steps 2, 3a, and 3b [Photo G].

Stop about 10" to 12" from the start of the binding. For a smaller project, leave at least 3" to 4" of binding unsewn. Remove the quilt from the sewing machine.

**04.** Lay the quilt flat with the quilt back and the two ends of the binding strip facing up [Photo H]. Place the end of the binding on top of the start of the binding. Use a quilt ruler to mark 2" (or the width of the bias binding tape), so the two ends overlap each other. Carefully cut on the marked guideline to remove excess binding.

**05.** Similar to joining straight grain binding strips together, lay the binding strip flat and horizontally at the start of the binding strip, wrong side facing up. Mark a small dot or draw a short line 2" (or the width of the bias binding tape) from the left edge. Then draw a 45-degree-diagonal guideline from the bottom left corner to the mark [Photo I].

TIP: Double folded bias binding tape comes pre-folded and pressed. You may find keeping the tape completely open and flat is difficult. Use an iron on low heat and, about 2½" from each end of the binding strips, press the bias binding tape flat while keeping the double folded creases visible.

**06.** Pin the start and end of the binding strip together at a 90-degree angle, with right sides together and the diagonal marked guideline facing up. Sew on the guideline.

**07.** Trim a ¼" seam allowance to the outside of the sewn line [Photo J]. Press the seams open at the joints with an iron on low heat to ensure the double folded creases are still visible. Do not press seams to the dark side.

TIP: Concerned about double folded creases disappearing after using an iron to press the seams open? Finger press the joint instead.

**08.** Attach the rest of the binding to the back of the quilt. Remove the quilt from the sewing machine [Photo K].

**09.** We're almost there! Looking at the double folded bias tape all opened up, with the raw edges of the quilt away from the body, you'll notice there are three folds in the double folded bias binding tape [Photo K]:

+ The **FIRST FOLD** is where the bias binding tape was attached to the quilt.

+ The **SECOND FOLD** is what will go around the raw edge of the quilt.

+ The **THIRD FOLD** is kept folded to enclose the raw edge of the double folded bias binding tape.

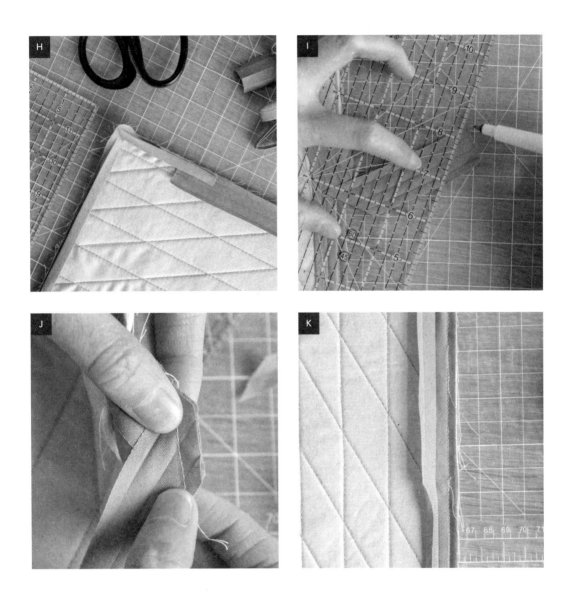

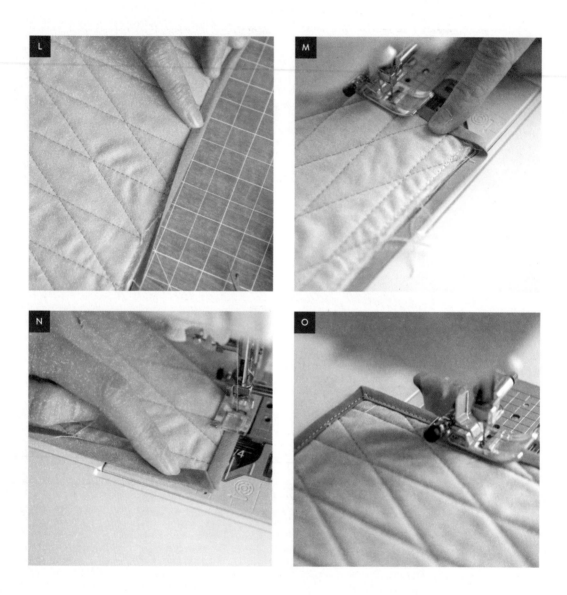

Allow the bias tape to refold along the creases already present then push the thicker half of the double folded bias binding tape over to the quilt top and sew to secure it [Photo L].

**10.** *Project with rounded edges:*

a. If necessary, lift and adjust the presser foot on the machine every few stitches, with the sewing machine needle down, to shift the project to continue sewing bias binding tape onto the quilt.

*Project with mitered corners:*

a. Stop approximately 2" from the corner of the quilt, and leave the needle and presser foot down [Photos M].

b. Gently fold and hold down the finished edge of the binding on the quilt top so there is a 45-degree-angle overhang of the binding at the corner of the quilt. Fold the binding perpendicular to the edge you just attached, toward the center of the quilt, to form the corner. You can secure the corner with your hands, pins, or a clip [Photo N].

c. Continue sewing, and when you get to the tip of the corner fold, leave the needle in. Carefully lift the presser foot to pivot the quilt 90 degrees counterclockwise, and continue sewing the binding to the quilt top [Photo O].

d. Repeat Steps 10a-10c to complete the quilt.

**11.** When you reach the start of the binding, don't forget to backstitch to strengthen the binding.

**12.** Trim any loose threads and enjoy!

# General Instructions

Now that you're ready to start your project, here are a few quick reminders and tips before you get going:

+ Similar to a cooking recipe, read through all the instructions in the quilt pattern before you start. This will help you both identify the supplies you need and understand what to expect throughout the project. Supplies outside of the usual quilting realm will be highlighted in the "Other Materials" section of each project.

+ Remember: all fabric requirements are based on 42" WOF (width of fabric).

+ Remember: cutting dimensions include ¼" seam allowances.

+ Share *Quilted Home Handbook* moments on social media by using the project's unique hashtag, highlighted at the end of each pattern. And don't forget to tag @the.weekendquilter and use the #theweekendquilter and #quiltedhomehandbook hashtags as well so I can see your project. It's always exciting seeing your progress shots and final projects in use!

FOLLOW @THE.WEEKENDQUILTER ON INSTAGRAM AND PINTEREST FOR MORE QUILTED HOME HANDBOOK IDEAS AND INSPIRATION.

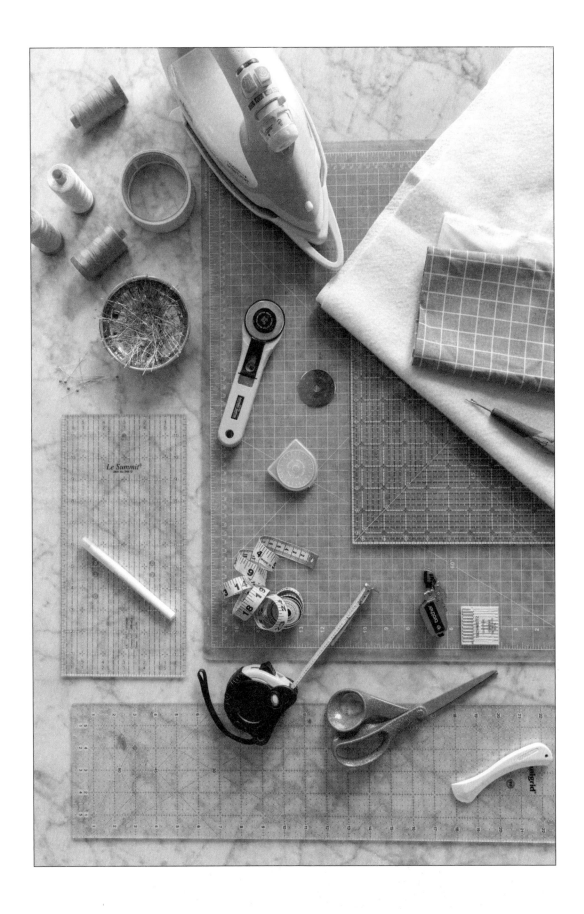

# POSITIVE START BED QUILT

In this day and age, when we spend so much time on our devices, it's not uncommon to wake up and go to bed with our phones next to us. Being able to switch off is hard. And that is something I really struggle with. It's the worst when I toss and turn a lot, and wake up at least twice during my sleep. This leads to my bad habits of checking my phone, overthinking, and stressing about what I need to tackle the following day. Sometimes I lose hours of sleep because of this.

I am continuously learning the importance of restoration and what a good night's rest can do. The lack of it can impact your mood, focus, and productivity throughout the day, as well as your mental and physical health.

So, let's kick off the day with a positive start.

---

**PROJECT SIZES**
+ **BABY:** 45" x 45" (115 cm x 115 cm)
+ **TWIN:** 63" x 90" (160 cm x 229 cm)
+ **QUEEN:** 81" x 99" (206 cm x 252 cm)
+ **KING:** 99" x 108" (252 cm x 275 cm)

---

**PIECING METHODS AND TECHNIQUES**
Strip piecing

---

**OTHER MATERIALS**
Batting

---

**TRANSFORMING THE QUILT INTO A WALL HANGING:** This project can also be a wall hanging. Simply stop right before adding the binding on the quilt, and follow the instructions on how to make a quilt into a wall hanging (*page 60*). I do not recommend turning bed quilts larger than twin size into wall hangings, due to their size and weight. However, with that said, it is possible.

**SHARE YOUR WORK ON SOCIAL MEDIA:** #postivestartquilt #theweekendquilter #quiltedhomehandbook

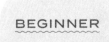
BEGINNER

## FABRIC REQUIREMENTS

|  | BABY | TWIN | QUEEN | KING |
|---|---|---|---|---|
| **QUILT TOP** | | | | |
| ▤ FABRIC A | 2 yards (183 cm) | 4⅝ yards (423 cm) | 6½ yards (595 cm) | 8½ yards (778 cm) |
| ▦ FABRIC B | ½ yard (46 cm) | 1 yard (92 cm) | 1½ yards (138 cm) | 1¾ yards (160 cm) |
| ☐ FABRIC C | ⅜ yard (35 cm) | ¾ yard (69 cm) | 1 yard (92 cm) | 1¼ yards (115 cm) |
| **QUILT BACK** | | | | |
| ▤ FABRIC D | 3 yards (275 cm) | 5½ yards (506 cm) | 7½ yards (686 cm) | 9 yards (823 cm) |
| **QUILT BINDING** | | | | |
| ▤ FABRIC E | ⅜ yard (35 cm) | ⅝ yard (58 cm) | ¾ yard (69 cm) | ⅞ yard (80 cm) |

## CUTTING DIRECTIONS

|  | BABY | TWIN | QUEEN | KING |
|---|---|---|---|---|
| **QUILT TOP** | | | | |
| ▤ FABRIC A | 8 strips, 4" x WOF (FOR STRIP PIECING) | 18 strips, 4" x WOF (FOR STRIP PIECING) | 26 strips, 4" x WOF (FOR STRIP PIECING) | 34 strips, 4" x WOF (FOR STRIP PIECING) |
|  | 4 strips, 2" x WOF (FOR STRIP PIECING) | 10 strips, 2" x WOF (FOR STRIP PIECING) | 14 strips, 2" x WOF (FOR STRIP PIECING) | 18 strips, 2" x WOF (FOR STRIP PIECING) |
|  | 13 strips, 2" x WOF, sub-cut: · 50 rectangle, 2" x 9½" | 35 strips, 2" x WOF, sub-cut: · 140 rectangle, 2" x 9½" | 50 strips, 2" x WOF, sub-cut: · 198 rectangle, 2" x 9½" | 66 strips, 2" x WOF, sub-cut: · 264 rectangle, 2" x 9½" |
| ▦ FABRIC B | 2 strips, 6½" x WOF (FOR STRIP PIECING) | 5 strips, 6½" x WOF (FOR STRIP PIECING) | 7 strips, 6½" x WOF (FOR STRIP PIECING) | 9 strips, 6½" x WOF (FOR STRIP PIECING) |
| ☐ FABRIC C | 4 strips, 2½" x WOF (FOR STRIP PIECING) | 9 strips, 2½" x WOF (FOR STRIP PIECING) | 13 strips, 2½" x WOF (FOR STRIP PIECING) | 17 strips, 2½" x WOF (FOR STRIP PIECING) |
| **QUILT BINDING** | | | | |
| ▤ FABRIC E | 5 strips, 2½" x WOF | 8 strips, 2½" x WOF | 10 strips, 2½" x WOF | 11 strips, 2½" x WOF |

For sections *Strip Piecing Units* and *Block Assembly (page 110),* sew pieces right side together with **SCANT ¼" SEAM ALLOWANCES,** unless specified otherwise.

## STRIP PIECING UNITS

**STEP 1:** Lay 2 Fabric A 2" x WOF strips and 1 Fabric B 6½" x WOF strip in sewing order, as shown. With the right sides together, pin 2 strips together lengthwise and sew. Press the seams open and repeat with the third strip to make **1 STRIP SET A1** unit.

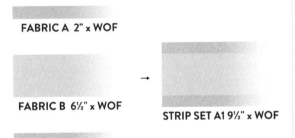

**FABRIC A 2" x WOF**

**FABRIC B 6½" x WOF**

**STRIP SET A1 9½" x WOF**

**FABRIC A 2" x WOF**

**REPEAT TO CREATE A TOTAL OF:**
Baby: 2 Strip Set A1 units
Twin: 5 Strip Set A1 units
Queen: 7 Strip Set A1 units
King: 9 Strip Set A1 units

Set aside for *Strip Piecing Units, Step 3.*

**STEP 2:** As shown, lay 2 Fabric A 4" x WOF strips and 1 Fabric C 2½" x WOF strip in sewing order. With the right sides together, pin 2 strips together lengthwise and sew. Press the seams open and repeat with the third strip to make **1 STRIP SET B1** unit.

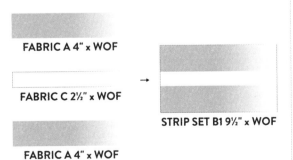

**FABRIC A 4" x WOF**

**FABRIC C 2½" x WOF**

**STRIP SET B1 9½" x WOF**

**FABRIC A 4" x WOF**

**REPEAT TO CREATE A TOTAL OF:**
Baby: 4 Strip Set B1 units
Twin: 9 Strip Set B1 units
Queen: 13 Strip Set B1 units
King: 17 Strip Set B1 units

**STEP 3:** Trim the right-hand edge of all Strip Set units to ensure they are straight and perpendicular against the length of the strip set. If you are left-handed, trim the left-hand edge of all Strip Set units. *Strip Set A1 unit used in this example:*

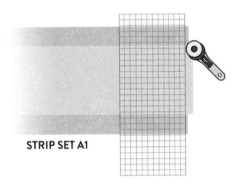

**STRIP SET A1**

TIP: When trimming, use the top and bottom edges of the Strip Set units and the horizontal lines and marks on the ruler to align the strips for more accurate cutting and piecing.

**STEP 4:** Rotate the Strip Set units 180 degrees. Using the straight edge of the left-hand side (right-hand side if you are left-handed) as a guide, cut a total of:

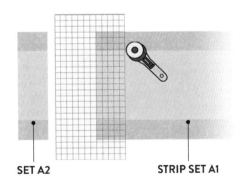

**SET A2**     **STRIP SET A1**

(*Step 4 continued on next page*)

*(Continued from step 4)*

| | BABY | TWIN | QUEEN | KING |
|---|---|---|---|---|
| Set A2 2½" x 9½" Rectangles (from Strip Set A1) | | | | |
| | 25 | 70 | 99 | 132 |
| Set B2 2½" x 9½" Rectangles (from Strip Set B1) | | | | |
| | 50 | 140 | 198 | 264 |

## REPEAT TO CREATE A TOTAL OF:

Baby: 25 Block A1 units
Twin: 70 Block A1 units
Queen: 99 Block A1 units
King: 132 Block A1 units

## QUILT ASSEMBLY

Take extra care when arranging and sewing the Block A1 units together. The rotation and placement of the blocks alternate—imagine a checkerboard.

**TIP:** Use Fabric B in Block A1 as a guide in determining the rotation and placement. If it helps, divide the blocks into two piles based on the rotation of the block, and take from the piles as required.

**STEP 1:** (Shown in the diagram to the right) To construct the **QUILT TOP**, refer to the assembly diagram shown and combine:

Baby: 5 rows of 5 Block A1 units
Twin: 7 rows of 10 Block A1 units
Queen: 9 rows of 11 Block A1 units
King: 11 rows of 12 Block A1 units

Press the seams open as you go.

**STEP 2:** Press the quilt top and backing fabric. Layer the backing, batting, and quilt top. Baste, quilt, and bind, as desired.

**FOR A WALL HANGING:** Stop right before the binding on the quilt is added, and follow the instructions on how to put a quilt into a wall hanging on *page 60.*

## BLOCK ASSEMBLY

**STEP 1:** Following the diagram, sew together 2 Fabric A 2" x 9½" rectangles, 1 Set A2 2½" x 9½" rectangle, and 2 Set B2 2½" x 9½" rectangles to create **1 BLOCK A1** unit. Press the seams open.

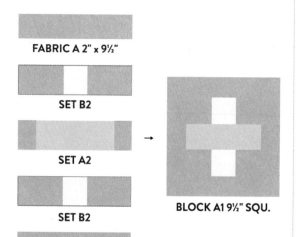

FABRIC A 2" x 9½"

SET B2

SET A2 → BLOCK A1 9½" SQU.

SET B2

FABRIC A 2" x 9½"

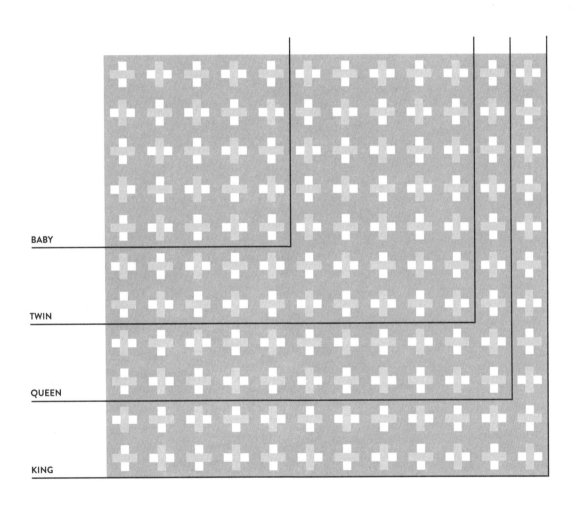

**BABY**

**TWIN**

**QUEEN**

**KING**

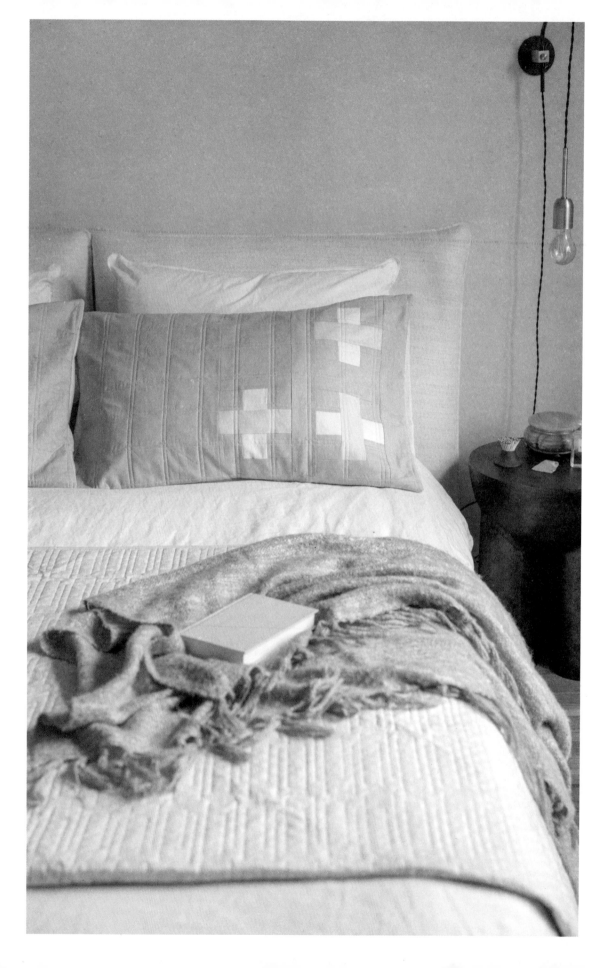

# POSITIVE START SHAM CASES

One of the most basic quilt blocks, the Nine-Patch block is made up of nine identical squares that create a larger square. The Nine-Patch blocks in the Positive Start quilt and shams project are slightly different. Instead of three identical squares in the center row, one long rectangle makes up three squares.

There are a couple of ways to construct a Nine-Patch block. We explored the strip piecing method in the Positive Start bed quilt project. It's the quickest method when constructing Nine-Patch blocks and is perfect for constructing multiple identical blocks. An alternative method is the traditional method, which entails cutting and piecing together nine identically sized squares. This method is best when the colors within the block, or across multiple Nine-Patch blocks in the project, vary, or when you need to put together a small number of Nine-Patches. For this final reason, this project incorporates the traditionally pieced method.

There are two sham sizes in this pattern: (1) standard size for twin- and queen-size beds and (2) king size for king-size beds. The following pattern refers to twin, queen, and king sizes. Twin size makes one standard sham, queen size makes two standard shams, and king size makes two king shams.

---

| | |
|---|---|
| **PROJECT SIZES** | **+ STANDARD:** 20" x 31" (51 cm x 79 cm) |
| | **+ KING:** 20" x 41" (51 cm x 105 cm) |

---

| | |
|---|---|
| **PIECING METHODS AND TECHNIQUES** | Nine-Patch blocks |

---

| | |
|---|---|
| **OTHER MATERIALS** | Batting; |
| | **TWIN-SIZE BED:** One standard-size pillow insert; |
| | **QUEEN-SIZE BED:** Two standard-size pillow inserts; |
| | **KING-SIZE BED:** Two king-size pillow inserts; |
| | Point turner (optional) |

---

**DON'T WANT TO CREATE SHAM CASES?** This project can also be a wall hanging. Simply stop after *Basting and Quilting, Step 2* and follow the instructions on how to turn a quilt into a wall hanging on *page 60*.

**SHARE YOUR WORK ON SOCIAL MEDIA:** #positivestartshams #theweekendquilter #quiltedhomehandbook

BEGINNER

## FABRIC REQUIREMENTS

| | TWIN<br>(One standard-size sham) | QUEEN<br>(Two standard-size shams) | KING<br>(Two king-size shams) |
|---|---|---|---|
| **SHAM FRONT** | | | |
| ▧ FABRIC A | ¾ yard (69 cm) | 1¼ yards (115 cm) | 1½ yards (138 cm) |
| ▧ FABRIC B* | ⅛ yard (12 cm) or<br>1 Fat Eighth (FE) | ⅛ yard (12 cm) or<br>1 Fat Eighth (FE) | ⅛ yard (12 cm) or<br>1 Fat Eighth (FE) |
| ☐ FABRIC C* | ⅛ yard (12 cm) or 1 FE | ⅛ yard (12 cm) or 1 FE | ⅛ yard (12 cm) or 1 FE |
| **SHAM BACK** | | | |
| ▧ FABRIC D | ¾ yard (69 cm) | 1¼ yards (115 cm) | 1¾ yards (161 cm) |
| **TRIM** | | | |
| ▧ FABRIC E | ¼ yard (23 cm) or<br>1 Fat Quarter (FQ) | ¼ yard (23 cm) or<br>1 Fat Quarter (FQ) | ¼ yard (23 cm) or<br>1 Fat Quarter (FQ) |
| **LINING (FOR SHAMS) / BACK (FOR WALL HANGINGS), FABRIC F** | | | |
| ☐ SHAM(S) | 2½ yards (229 cm) | 4⅛ yards (383 cm) | 5¾ yards (526 cm) |
| ▧ WALL HANGING(S) | ¾ yard (69 cm) | 1½ yards (138 cm) | 1½ yards (161 cm) |
| **BINDING (FOR WALL HANGING(S) ONLY)** | | | |
| ▧ FABRIC G | ¼ yard (23 cm) | ½ yard (46 cm) | ⅔ yard (66 cm) |

*Have extra Fabrics B and C laying around from your Positive Start quilt project (*page 107*)? Use those leftovers to supplement Fabrics B and C for the shams.

**FOR A WALL HANGING**: Omit Fabrics D (sham back) and E (trim), and adjust the fabric requirement for Fabric F (lining) to become the fabric for the back of the wall quilt, tabs, and dowel casing to hang.

# CUTTING DIRECTIONS

| | TWIN<br>(One standard-size sham) | QUEEN<br>(Two standard-size shams) | KING<br>(Two king-size shams) |
|---|---|---|---|
| **SHAM FRONT** | | | |
| ■ FABRIC A | 1 strip, 15" x WOF, sub-cut:<br>• 1 rectangle, 15" x 21"<br>• 1 rectangle, 6½" x 12¼"<br>• 1 rectangle, 3½" x 6½"<br>• 3 rectangles, 3¼" x 6½"<br>• 12 squares, 2½"<br><br>1 strip 3½" x WOF, sub-cut:<br>• 1 rectangle, 3½" x 21"<br>• 1 rectangle, 2½" x 21" | 1 strip, 15" x WOF, sub-cut:<br>• 1 rectangle, 15" x 21"<br>• 1 rectangle, 6½" x 12¼"<br>• 2 rectangles, 3½" x 6½"<br>• 6 rectangles, 3¼" x 6½"<br><br>1 strip, 15" x WOF, sub-cut:<br>• 1 rectangle, 15" x 21"<br>• 1 rectangle, 6½" x 12¼"<br>• 24 squares, 2½"<br><br>1 strip, 3½" x WOF, sub-cut:<br>• 2 rectangles, 3½" x 21"<br><br>1 strip, 2½" x WOF, sub-cut:<br>• 2 rectangles, 2½" x 21" | 1 strip, 21" x WOF, sub-cut:<br>1 rectangle, 21" x 25"<br>• 1 rectangle, 6½" x 12¼"<br>• 2 rectangles, 3½" x 6½"<br>• 6 rectangles, 3¼" x 6½"<br><br>1 strip, 21" x WOF, sub-cut:<br>• 1 rectangle, 21" x 25"<br>• 1 rectangle, 6½" x 12¼"<br>• 24 squares, 2½"<br><br>1 strip, 3½" x WOF, sub-cut:<br>• 2 rectangles, 3½" x 21"<br><br>1 strip, 2½" x WOF, sub-cut:<br>• 2 rectangles, 2½" x 21" |
| ■ FABRIC B | 1 strip, 2½" x WOF, sub-cut:<br>• 3 rectangles, 2½" x 6½" | 1 strip, 2½" x WOF, sub-cut:<br>• 6 rectangles, 2½" x 6½" | 1 strip, 2½" x WOF, sub-cut:<br>• 6 rectangles, 2½" x 6½" |
| ☐ FABRIC C | 1 strip, 2½" x WOF, sub-cut:<br>• 6 squares, 2½" | 1 strip, 2½" x WOF, sub-cut:<br>•12 squares, 2½" | 1 strip, 2½" x WOF, sub-cut:<br>• 12 squares, 2½" |
| **SHAM BACK** | | | |
| ■ FABRIC D | 1 strip, 21" x WOF, sub-cut:<br>• 1 rectangle, 21" x 16"<br>• 1 square, 21" | 2 strips, 21" x WOF, sub-cut:<br>• 2 rectangles, 21" x 16"<br>• 2 squares, 21" | 2 strips, 21" x WOF, sub-cut:<br>• 2 rectangles, 21" x 42"<br><br>1 strip, 11" x WOF, sub-cut:<br>• 2 rectangles, 11" x 21"<br><br>Sew 1 Fabric D 11" x 21" rectangle to 1 Fabric D 21" x 42" rectangle widthwise, with a ½" seam allowance* to create 1 Fabric D 21" x 52" rectangle. Press the seams open.<br><br>Repeat to create a total of 2 Fabric D 21" x 52" rectangles |

*Increase seam allowance from ¼" to ½" and press the seams open when piecing Fabric F rectangles together for the Queen and King shams. Incorporating these two steps in preparing your sham lining will reduce seam bulk, strengthen the sham long-term, and reduce air bubbles in your sham sandwich.

CONTINUED ON NEXT PAGE

## CUTTING DIRECTIONS, CONT.

| | TWIN (One standard-size sham) | QUEEN (Two standard-size shams) | KING (Two king-size shams) |
|---|---|---|---|
| **TRIM** | | | |
| ▦ FABRIC E | **FOR ¼ YARD (23 CM):** 2 strips, 2" x WOF, sub-cut: • 2 rectangles, 2" x 23"  **FOR FAT QUARTER (FQ):** Cut and sew together 3 rectangles, 2" x 21", short ends together. Then sub-cut: • 2 rectangles, 2" x 23" | **FOR ¼ YARD (23 CM):** Cut and sew together 3 strips, 2" x WOF, short ends together. Then sub-cut: • 4 rectangles, 2" x 23"  **FOR FAT QUARTER (FQ):** Cut and sew together 5 rectangles, 2" x 21", short ends together. Then sub-cut: • 4 rectangles, 2" x 23" | **FOR ¼ YARD (23 CM):** Cut and sew together 3 strips, 2" x WOF, short ends together. Then sub-cut: • 4 rectangles, 2" x 23"  **FOR FAT QUARTER (FQ):** Cut and sew together 5 rectangles, 2" x 21", short ends together. Then sub-cut: • 4 rectangles, 2" x 23" |
| **LINING (FOR SHAMS) / BACK (FOR WALL HANGINGS), FABRIC F** | | | |
| ☐ SHAM(S) | 3 strips, 29" x WOF, sub-cut: • 1 rectangle, 29" x 40" • 1 square, 29" • 1 rectangle, 29" x 24" | 4 strips, 29" x WOF, sub-cut: • 2 rectangles, 29" x 40" • 2 squares, 29" • 2 rectangles, 29" x 12½"*  1 strip 29" x WOF, sub-cut: • 1 rectangle, 29" x 24"  Sew 2 Fabric F 29" x 12½" rectangles widthwise, with ½" seam allowance* to create 1 Fabric F 29" x 24" rectangle. Press the seams open. | 7 strips, 29" x WOF, sub-cut: • 2 rectangles, 29" x 40" • 2 rectangles, 29" x 34" • 2 squares, 29" • 2 rectangles, 29" x 11"  Sew 1 Fabric F 29" x 40" rectangle and 1 Fabric F 29" x 11" rectangle widthwise with a ½" seam allowance* to create 1 Fabric F 29" x 50" rectangle. Press the seams open.  Repeat this to create a total of 2 Fabric F 29" x 50" rectangles. |
| ▦ WALL HANGING(S) | 1 strip 25" x WOF, sub-cut: • 1 rectangle, 25" x 36" | 2 strips 25" x WOF, sub-cut: • 2 rectangles, 25" x 36" | 2 strips, 25" x WOF |
| **BINDING (FOR WALL HANGING(S) ONLY)** | | | |
| ▦ FABRIC G | 3 strips, 2½" x WOF | 6 strips, 2½" x WOF | 8 strips, 2½" x WOF |

*Increase seam allowance from ¼" to ½" and press the seams open when piecing Fabric F rectangles together for the Queen and King shams. Incorporating these two steps in preparing your sham lining will reduce seam bulk, strengthen the sham long-term, and reduce air bubbles in your sham sandwich.

## BLOCK ASSEMBLY

For this section, sew pieces right-side together with **SCANT ¼" SEAM ALLOWANCES**, unless specified otherwise.

**STEP 1:** Following the diagram, sew together 2 Fabric A 2½" squares and 1 Fabric C 2½" square to create **1 STRIP SET A** unit. Press the seams open.

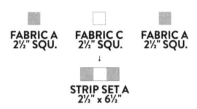

REPEAT TO CREATE A TOTAL OF:
Twin: 6 Strip Set A units
Queen: 12 Strip Set A units
King: 12 Strip Set A units

**STEP 2:** Combine 2 Strip Set A units and 1 Fabric B 2½" x 6½" rectangle to create **1 BLOCK A1** unit. Press the seams open.

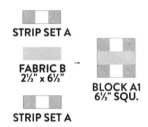

REPEAT TO CREATE A TOTAL OF:
Twin: 3 Block A1 units
Queen: 6 Block A1 units
King: 6 Block A1 units

## SHAM TOP

Take extra care when arranging and sewing the Block A1 units together at *Sham Top, Steps 1 and 2.* Some of the blocks are rotated.

TIP: Use Fabric B in Block A1 unit as a guide in determining the rotation. Alternatively, place Block A1 units into two piles based on the rotation of the block, and take out the piles as required.

**STEP 1:** Referring to the diagram, form **1 COLUMN A** unit by sewing together 2 Fabric A 3¼" x 6½" rectangles, 1 Fabric A 3½" x 6½" rectangle, and 2 Block A1 units with **A SCANT ¼" SEAM ALLOWANCE**. Press the seams open.

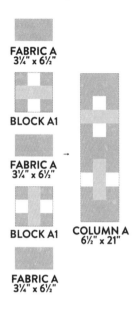

REPEAT TO CREATE A TOTAL OF:
Twin: n/a
Queen: 2 Column A units
King: 2 Column A units

**STEP 2:** Create **1 COLUMN B** unit by combining 1 Fabric A 3¼" x 6½" rectangle, 1 Fabric A 6½" x 12¼" rectangle, and 1 Block A1 unit with a **SCANT ¼" SEAM ALLOWANCE**. Press the seams open.

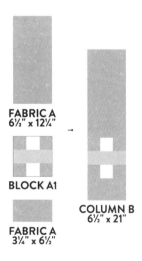

*(Step 2 continued on next page)*

*(Continued from step 2)*

**REPEAT TO CREATE A TOTAL OF:**

Twin: n/a

Queen: 2 Column B units

King: 2 Column B units

**STEP 3:** To create a STANDARD-SIZE SHAM TOP FOR TWIN- AND QUEEN-SIZE BEDS, line up and sew together 1 Fabric A 15" x 21" rectangle, 1 Fabric A 2½" x 21" rectangle, 1 Fabric A 3½" x 21" rectangle, 1 Column A unit, and 1 Column B unit. Press the seams open.

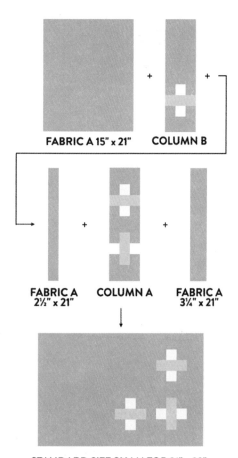

**STANDARD SIZE SHAM TOP 21" x 32"**

**REPEAT TO CREATE A TOTAL OF:**

Twin: n/a

Queen: 2 Standard-Size Sham Top units

To create a **KING-SIZE SHAM TOP FOR KING-SIZE BEDS,** line up and sew together 1 Fabric A 25" x 21" rectangle, 1 Fabric A

2½" x 21" rectangle, 1 Fabric A 3½" x 21" rectangle, 1 Column A unit, and 1 Column B unit. Press the seams open.

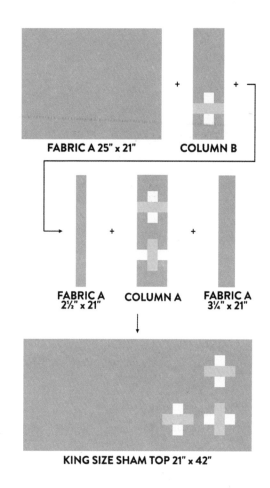

**KING SIZE SHAM TOP 21" x 42"**

Repeat to create a total of **2 KING-SIZE SHAM TOP** units.

## BASTING AND QUILTING

**STEP 1:** For this project you need to create three different sizes of sham sandwich for each sham: **1 SHAM TOP SANDWICH** and **2 SHAM BACK SANDWICHES.**

**FOR WALL HANGING:** Create **SHAM TOP SANDWICH(ES).**

Each sham sandwich is comprised of the following layers:

## SHAM TOP SANDWICH

| TWIN / QUEEN: |
| --- |
| Standard-Size Sham Top, Batting, 1 Fabric F 29" x 40" rectangle |
| KING: |
| King-Size Sham Top, Batting, 1 Fabric F 29" x 50" rectangle |

**REPEAT TO CREATE A TOTAL OF:**
Twin: n/a
Queen: 2 Standard Sham Top Sandwiches
King: 2 King-Sham Top Sandwiches

*Standard Size Sham Top Sandwich:*

*King Size Sham Top Sandwich:*

## SHAM BACK SANDWICH A

| TWIN / QUEEN: |
| --- |
| 1 Fabric D 16" x 21" rectangle, Batting, 1 Fabric F 24" x 29" rectangle |
| KING: |
| 1 Fabric D 21" square, Batting, 1 Fabric F 29" square |

**REPEAT TO CREATE A TOTAL OF:**
Twin: n/a
Queen: 2 Standard Sham Back Sandwiches A
King: 2 King Sham Back Sandwiches A

*Standard Size Sham Back Sandwich A:*

*King Size Sham Back Sandwich A:*

*(Step 1 continued on next page)*

*(Continued from Step 1)*

## SHAM BACK SANDWICH B

| TWIN / QUEEN: |
| --- |
| 1 Fabric D 21" square, Batting, 1 Fabric F 29" square |
| **KING:** |
| 1 Fabric D 21" x 26" rectangle, Batting, 1 Fabric F 29" x 34" rectangle |

### REPEAT TO CREATE A TOTAL OF:

Twin: n/a
Queen: 2 Standard Sham Back Sandwiches B
King: 2 King Sham Back Sandwiches B

*Standard Size Sham Back Sandwich B:*

**FABRIC D 21" SQU.**
**BATTING**
**FABRIC F 29" SQU.**

*King Size Sham Back Sandwich B:*

**FABRIC D 21" x 26"**
**BATTING**
**FABRIC F 29" x 34"**

Baste and quilt using your preferred method.

**STEP 2:** Trim excess batting and lining fabrics, and square up all sham sandwiches. Take extra care when squaring up. Each sham sandwich must measure:

### TWIN / QUEEN

+ Standard Sham Top Sandwich: 21" x 32" rectangle
+ Standard Sham Back Sandwich A: 16" x 21" rectangle
+ Standard Sham Back Sandwich B: 21" square

### KING

+ King Sham Top Sandwich: 21" x 42" rectangle
+ King Sham Back Sandwich A: 21" square
+ King Sham Back Sandwich B: 21" x 26" rectangle

**WALL HANGING:** Follow Sham Top Sandwich dimensions and see *How to Prepare a Quilted Wall Hanging* on *page 60* to complete the project.

**TIP:** Before removing excess batting and lining fabric, use a fabric marker or pen and ruler to mark out the measurements listed in Step 2. This additional step ensures all edges of the sham sandwiches are straight, each corner is right-angled, and the sham top design is not cut off while trimming.

## SHAM TRIM

Attaching sham trims is similar to attaching binding to a regular quilt project.

**STEP 1:** Start with 1 Fabric E 2" x 23" rectangle. Fold the Fabric E rectangle in half lengthwise and press to create **1 TRIM** unit.

### REPEAT TO CREATE A TOTAL OF:

Twin: 2 Trim units
Queen: 4 Trim units
King: 4 Trim units

**STEP 2:** With the wrong side of 1 Standard Sham Back Sandwich A for **TWIN-** and **QUEEN-SIZE BEDS** or 1 King Sham Back Sandwich A for a **KING-SIZE BED** facing up, align the raw edge of 1 Trim unit

with the shorter raw edge of the quilt sandwich. Sew ¼" away from the raw edge. Remember to backstitch the start and the end of the seam.

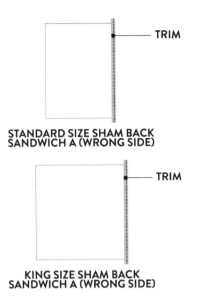

**STANDARD SIZE SHAM BACK SANDWICH A (WRONG SIDE)**

— TRIM

**KING SIZE SHAM BACK SANDWICH A (WRONG SIDE)**

— TRIM

**STEP 3:** Fold the finished edge of the trim over to Fabric D Sham Back, use a coordinating thread, and sew to secure the trim. Backstitch the start and end of the seam. *Standard Size Sham Back Sandwich A used in this example:*

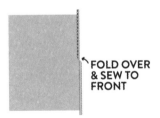

**FOLD OVER & SEW TO FRONT**

**STEP 4:** Use a ruler and rotary cutter to remove excess trim. *Standard Size Sham Back Sandwich A used in this example:*

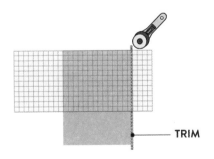

— TRIM

**STEP 5:** Repeat Steps 1–4 with Standard Sham Back Sandwich B for **TWIN-** and **QUEEN-SIZE BEDS** or King Sham Back Sandwich B for a **KING-SIZE BED.**

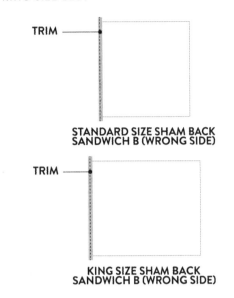

TRIM —

**STANDARD SIZE SHAM BACK SANDWICH B (WRONG SIDE)**

TRIM —

**KING SIZE SHAM BACK SANDWICH B (WRONG SIDE)**

## SHAM ASSEMBLY

**STEP 1:** For **TWIN-** and **QUEEN-SIZE BEDS,** lay 1 Standard Sham Back Sandwich B on top of the Standard Sham Top Sandwich, right sides together. Then, with right sides together, lay 1 Standard Sham Back Sandwich A, and pin as shown. Ensure the trim of the Standard Sham Back Sandwiches A and B are positioned away from the outer edges of the sham. *Standard Size Sham Top used in this example.* For **QUEEN-SIZE BED** only, repeat this step with the second sham.

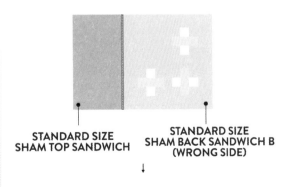

**STANDARD SIZE SHAM TOP SANDWICH**

**STANDARD SIZE SHAM BACK SANDWICH B (WRONG SIDE)**

↓

*(Step 1 continued on next page)*

*(Continued from Step 1)*

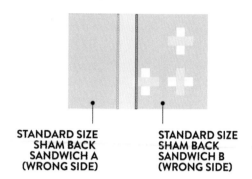

**STANDARD SIZE SHAM BACK SANDWICH A (WRONG SIDE)**

**STANDARD SIZE SHAM BACK SANDWICH B (WRONG SIDE)**

For **KING-SIZE BEDS**, lay 1 King Sham Back Sandwich B on top of the King Sham Top Sandwich, right sides together. Then, with right sides together, lay 1 King Sham Back Sandwich A, and pin as shown in the *Standard Size Sham Top* example on the current and previous pages. Ensure the trim of the King Sham Back Sandwiches A and B are positioned away from the outer edges of the sham.

For **KING-SIZE BED** only, repeat this step with the second sham.

The 2 Sham Back Sandwiches for both sham sizes should lay partially on top of each other—this is intentional.

It's also okay for Sham Back Sandwich B to go on the right or the left of the Sham Top Sandwich, as long as it goes on before Sham Back Sandwich A and the trim sides are positioned away from the outer edges.

**STEP 2:** Sew all the way around the outer edge with a ½" seam allowance. Backstitch at the beginning and end.

For **QUEEN**- and **KING-SIZE BEDS** only, repeat this step with the second sham. *Standard Size Sham used in this example:*

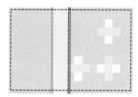

**STEP 3:** Use a serger, or zigzag stitch to cover the raw edges to prevent them from fraying.

For **QUEEN**- and **KING-SIZE BEDS** only, repeat this step with the second sham. *Standard Size Sham used in this example:*

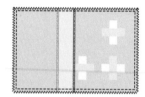

**STEP 4:** Carefully clip the corners without cutting into the seam for each sham. Turn the sham right side out, poking out the corners with a point turner or a pen with a cap on to create a crisp and flat finish. Trim loose threads and insert a pillow in each sham to complete the project. *Standard Size Sham used in this example:*

*Standard Size Sham:*

*King Size Sham:*

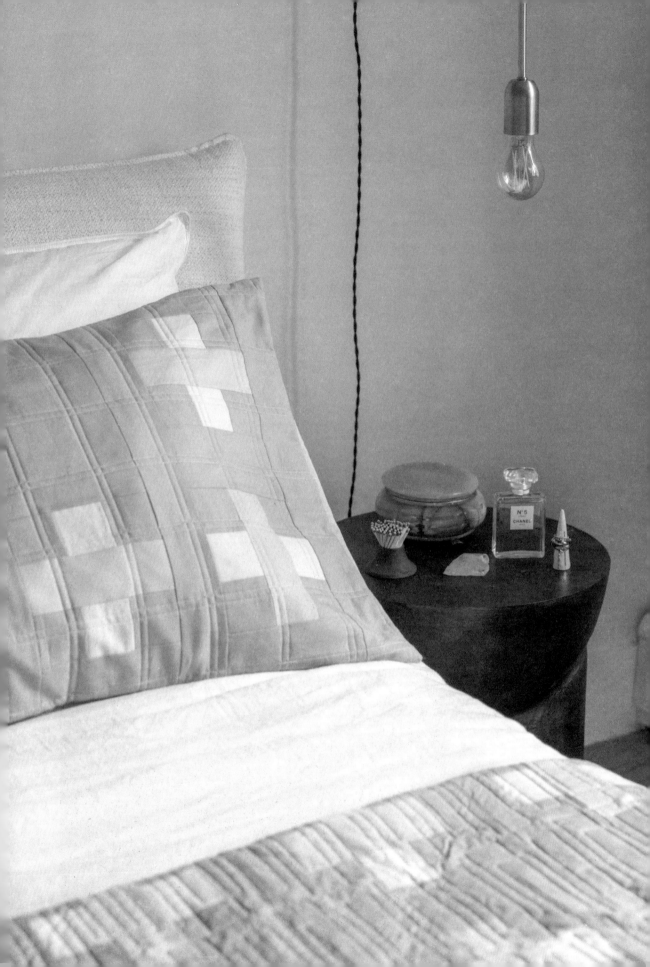

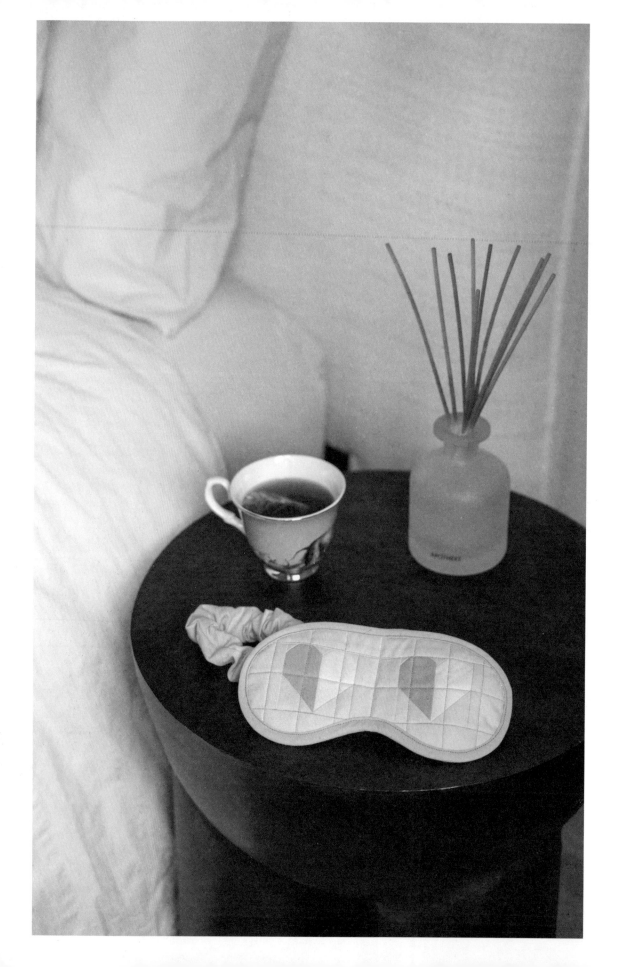

# CHECKED OUT SLEEPING EYE MASK

Have you recently stopped to make time for yourself? Switching off can be tricky at times, especially when it is often viewed as selfish or unproductive. So many things are happening simultaneously in our lives . . . working or studying, looking after other household members, completing chores, managing household bills and life admin, attending social gatherings, and the list just goes on. Yet, self-care is crucial for the health of our physical, emotional, and mental well-being. The Checked Out Sleeping Eye Mask offers the wearer a perfect excuse for that extra time in bed or afternoon nap to recharge. With the sleeping eye mask on, you can block all artificial and natural light for uninterrupted rest.

The Checked Out Sleeping Eye Mask project is scrap friendly. Dig through your scrap bin, stash, or use scrap fabrics from other projects in *The Quilted Home Handbook* to make coordinating sleeping eye masks.

---

| | |
|---|---|
| **PROJECT SIZE** | 3¾" x 8" (10 cm x 21 cm) |

---

| | |
|---|---|
| **PIECING METHODS AND TECHNIQUES** | Snowball units, bias binding tape, machine quilting on a domestic machine |

---

| | |
|---|---|
| **OTHER MATERIALS** | Photocopy of the sleeping eye mask template on *page 258;* At least 32" of double folded, ¼"- to ⅞"-wide pre-packaged bias binding tape (optional, if not making your own bias binding tape); Tailor measuring tape; ⅜"-wide knit elastic to go around the back of the head, temple to temple. (The amount of elastic required will vary from person to person. To determine how much elastic is required, use a tailor measuring tape to measure the back half of the head—go around the back of the head, temple to temple); Two safety pins; Batting: This project requires two layers of batting to block as much light as possible. |

---

**SHARE YOUR WORK ON SOCIAL MEDIA:** #checkedoutsleepingeyemask  #theweekendquilter #quiltedhomehandbook

ADVANCED
BEGINNER

## FABRIC REQUIREMENTS

### SLEEPING EYE MASK FRONT

| | |
|---|---|
| ▨ FABRIC A | ⅛ yard (12 cm) or 1 Fat Eighth (FE) |
| ▧ FABRIC B | ⅛ yard (12 cm) or 1 FE |
| ☐ FABRIC C | ⅛ yard (12 cm) or 1 FE |

### SLEEPING EYE MASK BACK

| | |
|---|---|
| ▨ FABRIC D | ⅛ yard (12 cm) or 1 FE |

Since the backing fabric (Fabric D) will be against the eyes while the sleeping eye mask is worn, try to use a softer fabric, such as double gauze, silk, or flannel.

### ELASTIC CASING

| | |
|---|---|
| ▨ FABRIC E | ⅛ yard (12 cm) or 1 FE |

### BIAS BINDING TAPE

| | |
|---|---|
| ▨ FABRIC F | **FOR DIY BIAS BINDING TAPE:** |

11" square. See *page 84* for how to make and attach bias binding tape.

**FOR PRE-PACKAGED BIAS BINDING TAPE:**

At least 32" of double folded, ¼" to ⅞"-wide* pre-packaged bias binding tape.

Note: Bias binding tape measures 2" to 2½" wide unfolded.

## CUTTING DIRECTIONS

### SLEEPING EYE MASK FRONT

| | |
|---|---|
| ▨ FABRIC A | 2 squares, 2½" |
| | 1 rectangle, 2½" x 1¾" |
| | 2 rectangles, 2" x 9¾" |
| | 4 squares, 1½" |
| | 8 squares, ¾" |
| ▧ FABRIC B | 2 rectangles, 1½" x 2½" |
| ☐ FABRIC C | 2 rectangles, 1½" x 2½" |

### SLEEPING EYE MASK BACK

| | |
|---|---|
| ▨ FABRIC D | 1 rectangle, 7½" x 11½" |

### ELASTIC CASING

| | |
|---|---|
| ▨ FABRIC E | 1 rectangle, 3" x 28" |

## PREPARE THE TEMPLATE

**STEP 1:** Scan the QR code and print or photocopy the template *(page 258)* at 100% scale. Be sure the 1" test square measures 1" when the template is copied. Cut on the bold black line to create the sleeping eye mask template.

## SLEEPING EYE MASK TOP ASSEMBLY

**STEP 1:** On the wrong side of all Fabric A ¾" squares and Fabric A 1½" squares, mark a diagonal guideline.

**STEP 2:** Following the diagram, noting the orientation of each marked Fabric A ¾" square, place 2 Fabric A ¾" squares on the top two corners of 1 Fabric B 1½" x 2½" rectangle, and place 2 Fabric A ¾" squares on the top 2 corners of 1 Fabric C 1½" x 2½" rectangle. Sew on the marked guidelines.

| 2 FABRIC A ¾" SQUS. + 1 FABRIC B 1½" x 2½" | 2 FABRIC A ¾" SQUS. + 1 FABRIC C 1½" x 2½" |

**STEP 3:** As shown in the diagram, arrange and place 1 Fabric A 1½" square on top of 1 Fabric B 1½" x 2½" rectangle from the previous step, and place 1 Fabric A 1½" square on top of 1 Fabric C 1½" x 2½" rectangle from the previous step. Sew on the marked guidelines.

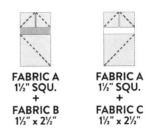

| FABRIC A 1½" SQU. + FABRIC B 1½" x 2½" | FABRIC A 1½" SQU. + FABRIC C 1½" x 2½" |

**STEP 4:** Trim a ¼" seam allowance outside of each sewn line. Press the seams open to create **1 HEART HALF A1** unit and **1 HEART HALF B1** unit.

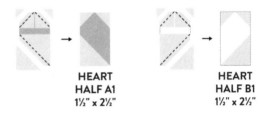

HEART HALF A1 1½" x 2½"    HEART HALF B1 1½" x 2½"

**STEP 5:** Repeat Steps 2–4 to create a total of 2 Heart Half A1 units and 2 Heart Half B1 units.

**STEP 6:** Sew together the following with a **SCANT ¼" SEAM ALLOWANCE** to create **1 EYE MASK TOP A1** unit: 2 Fabric A 2½" squares, 1 Fabric A 1¾" x 2½" rectangle, 2 Heart Half A1 units, and 2 Heart Half B1 units. Press the seams open.

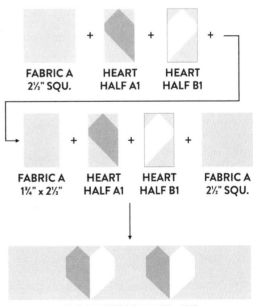

FABRIC A 2½" SQU.  +  HEART HALF A1  +  HEART HALF B1  +

FABRIC A 1¾" x 2½"  +  HEART HALF A1  +  HEART HALF B1  +  FABRIC A 2½" SQU.

**EYE MASK TOP A1 2½" x 9¾"**

**STEP 7**: Combine 2 Fabric A 2" x 9¾" rectangles on the top and bottom of 1 Eye Mask Top A1 unit to create **1 EYE MASK TOP B1**. Press the seams.

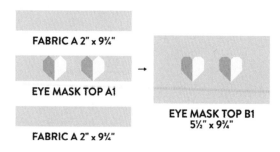

**FABRIC A 2" x 9¾"**

**EYE MASK TOP A1**

**FABRIC A 2" x 9¾"**

→

**EYE MASK TOP B1**
**5½" x 9¾"**

## BASTING AND QUILTING

A quilt sandwich usually consists of three layers: quilt top, batting, and quilt back. For this project, the sandwich is made up of the sleeping eye mask top created in the previous step and two layers of batting to block as much light as possible. To ensure maximum comfort when wearing the sleeping eye mask, the backing fabric is omitted from the sandwich and will be added in a later step.

**STEP 1**: Lay 2 layers of batting followed by 1 Eye Mask Top B1 unit, wrong side touching the batting. Baste the three layers together using your preferred method, and machine quilt on a domestic sewing machine* to secure the three layers to create the **SLEEPING EYE MASK SANDWICH**.

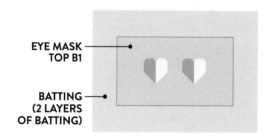

**EYE MASK TOP B1**

**BATTING (2 LAYERS OF BATTING)**

*Note: This project is too small to be quilted by a professional longarm quilter. This is the perfect project to practice or try machine quilting on a domestic machine*

*for the first time. Head to page 66 for all the tips and advice on how to machine quilt on a domestic machine and different quilting motifs to finish the project.*

**STEP 2**: Spray baste or pin Fabric D 7½" x 11½" rectangle to the Sleeping Eye Mask Sandwich with the wrong side of Fabric D touching the batting to temporarily secure the layers.

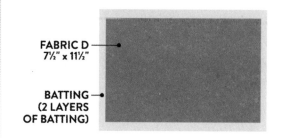

**FABRIC D 7½" x 11½"**

**BATTING (2 LAYERS OF BATTING)**

**STEP 3**: Mark central guidelines on the sleeping eye mask with a hera maker or non-serrated dull knife:

+ **VERTICAL CENTRAL GUIDELINE**: Use a quilting ruler to measure ⅝" from the right edge of the left heart on the Sleeping Eye Mask Sandwich and mark the guideline.

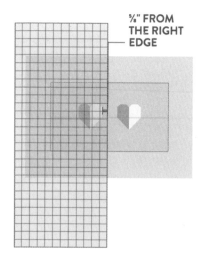

**⅝" FROM THE RIGHT EDGE**

+ **HORIZONTAL CENTRAL GUIDELINE**: Use a quilting ruler to measure 1" from the top edge of both hearts on the Sleeping Eye Mask Sandwich and mark the guideline.

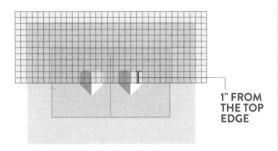

1" FROM THE TOP EDGE

**TIP**: Do not use a fabric pen or pencil to mark these guidelines, as they are directly on the front of the sleeping eye mask.

**STEP 4**: Using the grey dotted lines on the paper template and the marked central guidelines from the previous step, lay the paper template on top of the Sleeping Eye Mask Sandwich. Secure the template and use a fabric pen or pencil to trace the sleeping eye mask outline onto the Sleeping Eye Mask Sandwich.

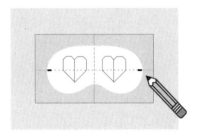

**TIP**: Place pattern weights, large washers, or something with a bit of weight (e.g., a rotary cutter) on top of the template to prevent it from shifting. Ensure the weights or heavy item(s) do not obstruct the outline of the template.

Alternatively, you may pin the template onto the project. However, this is not recommended, as the pins can distort the template and make it trickier to cut the quilt sandwich.

**STEP 5**: Sew approximately ⅛" to the inside of the drawn guideline. The sewn line is **INSIDE**, and not outside of the marked guideline, so when it comes to cutting on the guideline, the seams keep all the layers intact.

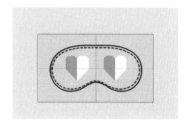

**STEP 6**: Use a pair of fabric scissors to carefully cut on the drawn line to complete the Sleeping Eye Mask Sandwich. Set aside for *Sleeping Eye Mask Casing, Step 8*.

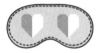

## ELASTIC CASING

**STEP 1**: Fold 1 Fabric E 3" x 28" rectangle in half lengthwise, with right sides of the fabric facing each other and press flat. Sew ¼" away from the raw edge to secure the fold and create **1 ELASTIC CASING**.

**TIP**: Do not forget to backstitch at the start and end of the seam. This will provide additional reinforcement when turning the Elastic Casing right side out.

**STEP 2**: Turn the Elastic Casing right side out by attaching a safety pin to one end of the casing. Pierce the safety pin through one layer of fabric, centrally and approximately ½" from the edge of the casing.

**STEP 3:** Turn the pin around so the head is inside the tube. Push the safety pin through the tube until it comes out of the other end. It's normal for the Elastic Casing fabric to gather and bunch up.

**STEP 4:** Continue to carefully pull the safety pin through until the right side of the fabric is exposed. Remove the safety pin and press the Elastic Casing flat. Set aside for *Elastic Casing, Step 6*.

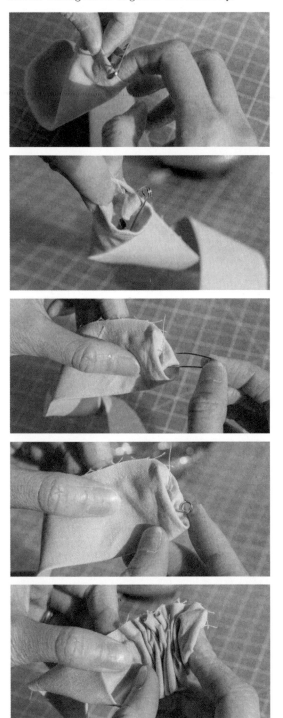

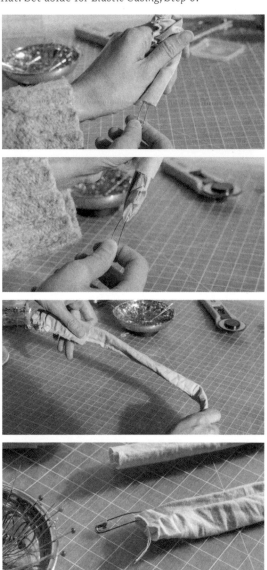

**TIP:** Take your time and use extra care when threading the safety pin through the tube and pulling it out. Don't tug too hard, as the force can tear the pin out of the fabric or burst the side seams.

**STEP 5:** Pierce a safety pin on each end of the elastic. These safety pins act as anchors and prevent the elastic from getting stuck halfway in the tube.

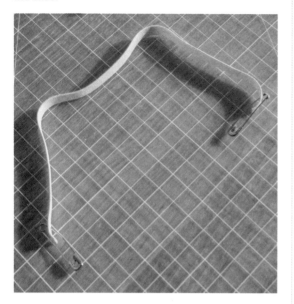

**STEP 6:** Slide one safety pin and elastic through the Elastic Casing. Carefully remove the safety pin. Align the elastic with the raw edge of the Elastic Casing and use a safety pin to secure the layers.

Repeat with the other end of the Elastic Casing.

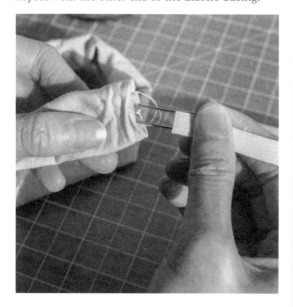

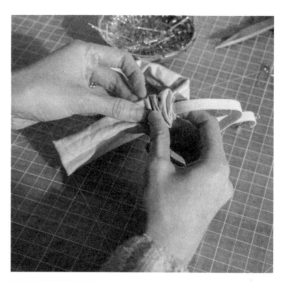

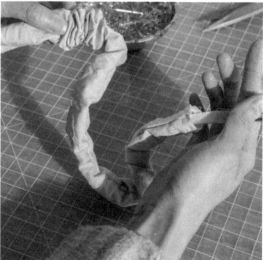

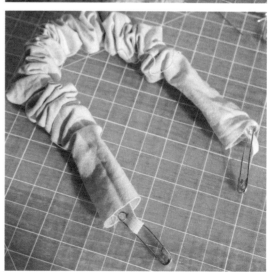

**STEP 7:** Take the Sleeping Eye Mask Sandwich (from *Basting and Quilting, Step 6*), wrong side facing up. Carefully remove one of the safety pins from the Elastic Casing. Ensure the elastic does not lose its place in the tube. Use the horizontal guideline from the front of the Sleeping Eye Mask Sandwich as a guide, and use a sewing pin to pin the Elastic Casing on to the back of the Sleeping Eye Mask Sandwich.

Repeat with the other end of the Elastic Casing.

**TIP:** Before pinning the second end of the Elastic Casing to the back of the Eye Mask Sandwich, make sure the elastic in the tube is not twisted.

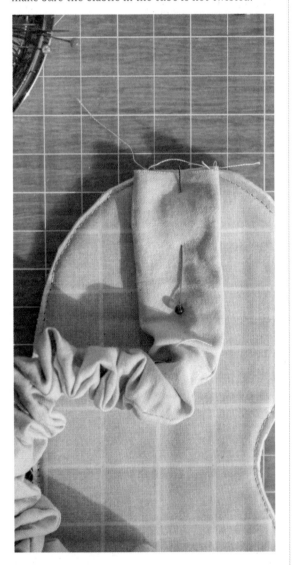

**STEP 8:** Secure each end of the Elastic Casing onto the back of the Sleeping Eye Mask Sandwich by sewing ⅛" away from the raw edge. These seams must go through the elastic casing.

Don't forget to backstitch at the start and end of each seam to provide additional reinforcement.

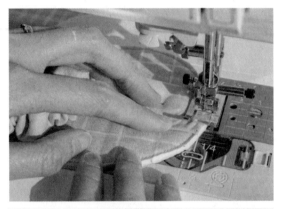

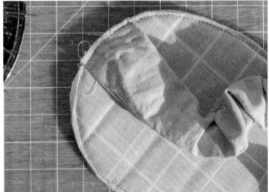

## BINDING AND FINISHING

**STEP 1:** Attach bias binding tape using your preferred method to finish the project. Refer to *page 92* on how to attach DIY bias binding tape and *page 99* for instructions on how to attach pre-packaged double folded bias binding tape.

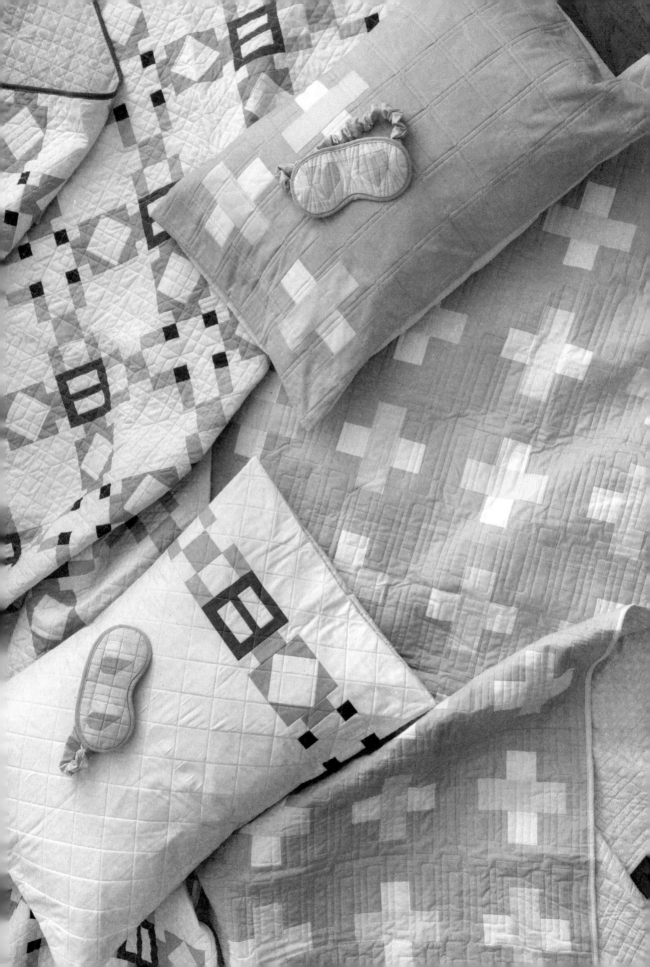

# LASTING WARMTH BED QUILT

Quilts play a greater role than just filling our practical needs for warmth and protection. They also adorn the spaces we use every day and preserve our stories and the art of quiltmaking. They are a reflection of us. They commemorate significant life events, such as the union of two families, moving into a new home, welcoming a new member to the family, graduations, retirements, or the passing of a loved one. As these quilts and the craft are passed down to future generations, so are the stories behind them.

The Lasting Warmth Bed Quilt is a nod to the traditional Nine-Patch quilt block. It is one of the most basic quilt blocks and dates back as far as the beginning of the nineteenth century as a utilitarian article, and continues to be incorporated into modern quilts. Traditionally, the quilt block is made up of nine identical squares in a larger square. The Lasting Warmth Bed Quilt takes that traditional block and distorts some of the squares and adds new elements into the mix. The grid-like layout of this design is a symbol of relationships, stories, and memories intertwined—a bond so strong, it cannot be broken or forgotten.

---

| | |
|---|---|
| **PROJECT SIZES** | ✛ **BABY**: 46" x 46" (117 cm x 117 cm) |
| | ✛ **TWIN**: 66" x 86" (168 cm x 219 cm) |
| | ✛ **QUEEN**: 86" x 106" (219 cm x 270 cm) |
| | ✛ **KING**: 96" x 116" (244 cm x 295 cm) |

---

| | |
|---|---|
| **PIECING METHODS AND TECHNIQUES** | Square-in-a-square units, Nine-Patch units, strip piecing |

---

| | |
|---|---|
| **OTHER MATERIALS** | Batting |

---

**TRANSFORMING THE QUILT INTO A WALL HANGING**: This project can also be made into a wall hanging. Simply stop right before adding binding on the quilt, and follow the instructions on how to turn a quilt into a wall hanging (*page 60*). I do not recommend turning bed quilts larger than twin size into wall hangings, due to their size and weight. However, with that said, it is possible.

**SHARE YOUR WORK ON SOCIAL MEDIA**: #lastingwarmthquilt #theweekendquilter #quiltedhomehandbook

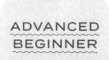

ADVANCED
BEGINNER

## FABRIC REQUIREMENTS

| | BABY | TWIN | QUEEN | KING |
|---|---|---|---|---|
| **QUILT TOP** | | | | |
| ☐ FABRIC A | 2 yards (184 cm) | 4⅛ yards (378 cm) | 6½ yards (595 cm) | 7¾ yards (709 cm) |
| ■ FABRIC B | ⅝ yard (58 cm) | 1¼ yards (115 cm) | 2 yards (183 cm) | 2½ yards (229 cm) |
| ■ FABRIC C | ½ yard (46 cm) | 1 yard (92 cm) | 1½ yards (138 cm) | 1¾ yards (103 cm) |
| ■ FABRIC D | ¼ yard (23 cm) | ⅝ yard (58 cm) | ¾ yard (69 cm) | 1 yard (92 cm) |
| ■ FABRIC E | ¼ yard (23 cm) | ¼ yard (23 cm) | ⅜ yard (35 cm) | ½ yard (46 cm) |
| **QUILT BACK** | | | | |
| ■ FABRIC F | 3 yards (275 cm) | 5¼ yards (481 cm) | 8 yards (732 cm) | 8¾ yards (800 cm) |
| **BINDING** | | | | |
| ■ FABRIC G | ½ yard (46 cm) | ¾ yard (69 cm) | ⅞ yard (80 cm) | 1 yard (92 cm) |

## CUTTING DIRECTIONS

| | BABY | TWIN | QUEEN | KING |
|---|---|---|---|---|
| **QUILT TOP** | | | | |
| ☐ FABRIC A | 5 strips, 6½" x WOF, sub-cut:<br>• 25 squares, 6½"<br>• 8 rectangles, 2½" x 4½" | 11 strips, 6½" x WOF, sub-cut:<br>• 63 squares, 6½"<br>• 19 rectangles, 2½" x 4½" | 17 strips, 6½" x WOF, sub-cut:<br>• 99 squares, 6½"<br>• 25 rectangles, 2½" x 4½" | 20 strips, 6½" x WOF, sub-cut:<br>• 120 squares, 6½"<br>• 20 rectangles, 2½" x 4½" |
| | 2 strips, 3⅜" x WOF, sub-cut:<br>• 20 squares, 3⅜" | 5 strips, 3⅜" x WOF, sub-cut:<br>• 55 squares, 3⅜" | 8 strips, 3⅜" x WOF, sub-cut:<br>• 89 squares, 3⅜" | 10 strips, 3⅜" x WOF, sub-cut:<br>• 109 squares, 3⅜" |
| | 1 strip, 3" x WOF<br>(FOR STRIP PIECING) | 2 strips, 3" x WOF<br>(FOR STRIP PIECING) | 3 strips, 3" x WOF<br>(FOR STRIP PIECING) | 4 strips, 3" x WOF<br>(FOR STRIP PIECING) |
| | 4 strips, 2½" x WOF<br>(FOR STRIP PIECING) | 1 strip, 2½" x WOF, sub-cut:<br>• 5 rectangles, 2½" x 4½" | 2 strips, 2½" x WOF, sub-cut:<br>• 15 rectangles, 2½" x 4½" | 4 strips, 2½" x WOF, sub-cut:<br>• 29 rectangles, 2½" x 4½" |
| | 8 strips, 1½" x WOF<br>(FOR STRIP PIECING) | 9 strips, 2½" x WOF<br>(FOR STRIP PIECING) | 15 strips, 2½" x WOF<br>(FOR STRIP PIECING) | 18 strips, 2½" x WOF<br>(FOR STRIP PIECING) |
| | | 16 strips, 1½" x WOF<br>(FOR STRIP PIECING) | 26 strips, 1½" x WOF<br>(FOR STRIP PIECING) | 30 strips, 1½" x WOF<br>(FOR STRIP PIECING) |
| ■ FABRIC B | 4 strips, 3¼" x WOF, sub-cut:<br>• 40 squares, 3¼" | 10 strips, 3¼" x WOF, sub-cut:<br>• 110 squares, 3¼" | 15 strips, 3¼" x WOF, sub-cut:<br>• 178 squares, 3¼" | 19 strips, 3¼" x WOF, sub-cut:<br>• 218 squares, 3¼" |
| | 2 strips, 2½" x WOF<br>(FOR STRIP PIECING) | 4 strips, 2½" x WOF<br>(FOR STRIP PIECING) | 7 strips, 2½" x WOF<br>(FOR STRIP PIECING) | 8 strips, 2½" x WOF<br>(FOR STRIP PIECING) |

| | BABY | TWIN | QUEEN | KING |
|---|---|---|---|---|
| ▨ FABRIC C | 2 strips, 2½" x WOF<br>(FOR STRIP PIECING) | 4 strips, 2½" x WOF<br>(FOR STRIP PIECING) | 6 strips, 2½" x WOF<br>(FOR STRIP PIECING) | 7 strips, 2½" x WOF<br>(FOR STRIP PIECING) |
| | 6 strips, 1½" x WOF<br>(FOR STRIP PIECING) | 14 strips, 1½" x WOF<br>(FOR STRIP PIECING) | 24 strips, 1½" x WOF<br>(FOR STRIP PIECING) | 28 strips, 1½" x WOF<br>(FOR STRIP PIECING) |
| ■ FABRIC D | 1 strip, 4½" x WOF,<br>sub-cut:<br>• 16 rectangles,<br>1¼" x 4½"<br>• 8 rectangles,<br>1" x 4½" | 3 strips, 4½" x WOF,<br>sub-cut:<br>• 48 rectangles,<br>1¼" x 4½"<br>• 24 rectangles,<br>1" x 4½" | 4 strips, 4½" x WOF,<br>sub-cut:<br>• 80 rectangles,<br>1¼" x 4½"<br>• 40 rectangles,<br>1" x 4½" | 5 strips, 4½" x WOF,<br>sub-cut:<br>• 100 rectangles,<br>1¼" x 4½"<br>• 50 rectangles,<br>1" x 4½" |
| | 2 strips, 1¼" x WOF<br>(FOR STRIP PIECING) | 4 strips, 1¼" x WOF<br>(FOR STRIP PIECING) | 6 strips, 1¼" x WOF<br>(FOR STRIP PIECING) | 8 strips, 1¼" x WOF<br>(FOR STRIP PIECING) |
| ■ FABRIC E | 2 strips, 1½" x WOF<br>(FOR STRIP PIECING) | 4 strips, 1½" x WOF<br>(FOR STRIP PIECING) | 6 strips, 1½" x WOF<br>(FOR STRIP PIECING) | 8 strips, 1½" x WOF<br>(FOR STRIP PIECING) |
| **BINDING** | | | | |
| ■ FABRIC G | 5 strips, 2½" x WOF | 8 strips, 2½" x WOF | 10 strips, 2½" x WOF | 11 strips, 2½" x WOF |

## STRIP PIECING UNITS

In this section, sew all the strip set units right-side together with **SCANT ¼" SEAM ALLOWANCES.**

**STEP 1:** Lay 2 Fabric A 1½" x WOF strips and 1 Fabric B 2½" x WOF strip in sewing order, as shown. With the right sides together, pin two strips together lengthwise and sew. Press the seams open and repeat with the third strip to make **1 STRIP SET B1** unit.

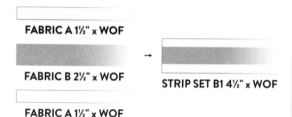

**FABRIC A 1½" x WOF**

**FABRIC B 2½" x WOF**

**FABRIC A 1½" x WOF**

**STRIP SET B1 4½" x WOF**

**REPEAT TO CREATE A TOTAL OF:**
Baby: 2 Strip Set B1 units
Twin: 4 Strip Set B1 units
Queen: 7 Strip Set B1 units
King: 8 Strip Set B1 units

Set aside for *Strip Piecing Units, Step 6.*

**STEP 2:** As shown, lay 1 Fabric A 2½" x WOF strip and 2 Fabric C 1½" x WOF strips in sewing order. With the right sides together, pin two strips together lengthwise and sew. Press the seams open and repeat with the third strip to make **1 STRIP SET C1** unit.

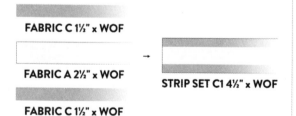

**FABRIC C 1½" x WOF**

**FABRIC A 2½" x WOF**

**FABRIC C 1½" x WOF**

**STRIP SET C1 4½" x WOF**

**REPEAT TO CREATE A TOTAL OF:**
Baby: 3 Strip Set C1 units
Twin: 7 Strip Set C1 units
Queen: 12 Strip Set C1 units
King: 14 Strip Set C1 units

Set aside for *Strip Piecing Units, Step 6.*

**STEP 3:** Sew together 2 Fabric A 1½" x WOF strips and 1 Fabric C 2½" x WOF strip in sewing order, as shown. Press the seams open and repeat to create **1 STRIP SET C2** unit.

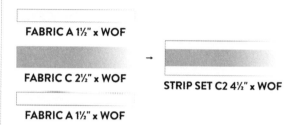

**FABRIC A 1½" x WOF**

**FABRIC C 2½" x WOF**

**FABRIC A 1½" x WOF**

**STRIP SET C2 4½" x WOF**

**REPEAT TO CREATE A TOTAL OF:**
Baby: 2 Strip Set C2 units
Twin: 4 Strip Set C2 units
Queen: 6 Strip Set C2 units
King: 7 Strip Set C2 units

Set aside for *Strip Piecing Units, Step 6.*

**STEP 4:** As per the diagram, with the right sides together, pin and sew 1 Fabric A 3" x WOF strip and 2 Fabric D 1¼" x WOF strips together to create **1 STRIP SET D1** unit.

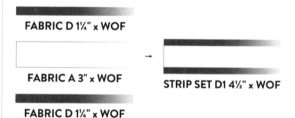

**FABRIC D 1¼" x WOF**

**FABRIC A 3" x WOF**

**FABRIC D 1¼" x WOF**

**STRIP SET D1 4½" x WOF**

**REPEAT TO CREATE A TOTAL OF:**
Baby: 1 Strip Set D1 unit
Twin: 2 Strip Set D1 units
Queen: 3 Strip Set D1 units
King: 4 Strip Set D1 units

Set aside for *Strip Piecing Units, Step 6.*

**STEP 5:** Lay 1 Fabric A 2½" x WOF strip between 2 Fabric E 1½" x WOF strips. With right sides together, pin and sew strips in order to create **1 STRIP SET E1** unit.

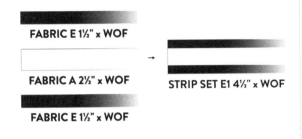

**FABRIC E 1½" x WOF**

**FABRIC A 2½" x WOF** → **STRIP SET E1 4½" x WOF**

**FABRIC E 1½" x WOF**

**REPEAT TO CREATE A TOTAL OF:**

Baby: 1 Strip Set E1 unit

Twin: 2 Strip Set E1 units

Queen: 3 Strip Set E1 units

King: 4 Strip Set E1 units

**STEP 6:** Trim the right-hand edge of all Strip Set units to ensure they are straight and perpendicular against the length of the strip set. If you are left-handed, trim the left-hand edge of all Strip Set units. *Strip Set B1 Unit used in this example:*

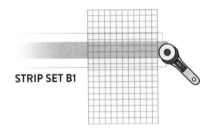

**STRIP SET B1**

**TIP:** When trimming, use the top and bottom edges, and/or the seams of the Strip Set units, and the horizontal lines and marks on the ruler to align the strips for more accurate cutting and piecing.

**STEP 7:** Rotate the Strip Set units 180 degrees. Using the straight edge of the left-hand side (right-hand side if you are left-handed) as a guide, cut a total of:

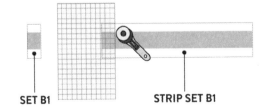

**SET B1**        **STRIP SET B1**

*Strip Set B1 Unit used in this example.*

| | BABY | TWIN | QUEEN | KING |
|---|---|---|---|---|
| **Set B1 1½" x 4½" Rectangles** (from Strip Set B1) | 40 | 110 | 178 | 218 |
| **Set C1 2½" x 4½" Rectangles** (from Strip Set C1) | 40 | 110 | 178 | 218 |
| **Set C2 2½" x 4½" rectangles** (from Strip Set C2) | 20 | 55 | 89 | 109 |
| **Set D1 1½" x 4½" Rectangles** (from Strip Set D1) | 16 | 48 | 80 | 100 |
| **Set E1 1½" x 4½" Rectangles** (from Strip Set E1) | 16 | 48 | 80 | 98 |

Set aside for *Block Assembly Steps 1-4.*

## SQUARE-IN-A-SQUARE UNITS

**STEP 1:** For **ALL QUILT SIZES**, draw a diagonal guideline on the wrong side of all Fabric B 3¼" squares and cut on it to make a total of:

*(Step 1 continued on next page)*

(*Continued from step 1*)

Baby: 80 Fabric B Triangle units
Twin: 220 Fabric B Triangle units
Queen: 356 Fabric B Triangle units
King: 436 Fabric B Triangle units

If you're feeling confident, skip drawing the diagonal guidelines and jump straight to cutting all Fabric B 3¼" squares in half diagonally.

Set aside for *Square-in-a-Square Units, Step 3*.

**STEP 2**: For **ALL QUILT SIZES**, fold and finger press each Fabric A 3⅜" square in half (a) vertically and (b) horizontally, creating guidelines as shown in the diagram.

**STEP 3**: Place 1 Fabric B Triangle unit on 1 Fabric A 3⅜" square with right sides together, so the long side of the triangle is lined up on the one edge of the square, and the tip of the triangle is on the creased center line.

Sew a ¼" seam allowance on the long side of the triangle, as shown in the diagram. Press the seams open.

**STEP 4**: Attach 1 Fabric B Triangle unit to the opposite Fabric A 3⅜" square edge and press the seams open, as per Step 3. Trim excess from both sides of Fabric B Triangle units, as shown in the diagram.

**STEP 5**: Sew 1 Fabric B Triangle unit to each of the remaining two sides of the Fabric A 3⅜" square, as shown in the diagram, to create **1 SQUARE-IN-A-SQUARE (SS)** unit.

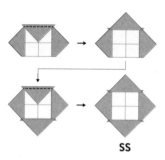

SS

**STEP 6**: Repeat Steps 3-5 to create a total of:
Baby: 20 SS units
Twin: 55 SS units
Queen: 89 SS units
King: 109 SS units

**STEP 7**: Square up all SS units to 4½" square. Squaring up is broken down into two steps. Each step involves removing the right and top sides of the SS unit.

Before removing the right and top sides of the SS unit:

a. Using a ruler, line up the horizontal ¼" line with the top corner of the Fabric A center square and the vertical ¼" line alongside the right corner of the Fabric A center square.

b. Slide the ruler to match the top and right corner of the center square with the 2¼" marks on the top and the right of the ruler.

Trim the top and right edges of the blocks.

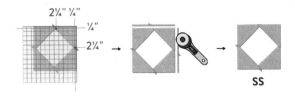

**STEP 8:** Turn the SS unit 180 degrees and repeat Step 7 with the remaining two sides.

Repeat this process for all SS units and set aside for *Block Assembly, Step 1.*

## BLOCK ASSEMBLY

In this section, sew all the pieces right-sides together with **SCANT ¼" SEAM ALLOWANCES.**

**STEP 1:** Sew together 2 Set B1 units and 1 SS unit to create **1 BLOCK B** unit. Press the seams open.

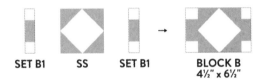

REPEAT TO CREATE A TOTAL OF:
Baby: 20 Block B units
Twin: 55 Block B units
Queen: 89 Block B units
King: 109 Block B units

Set aside for *Quilt Assembly, Steps 1 and 2.*

**STEP 2:** Combine 2 Set C1 units and 1 Set C2 unit to create **1 BLOCK C** unit. Press the seams open.

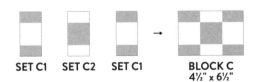

REPEAT TO CREATE A TOTAL OF:
Baby: 20 Block C units
Twin: 55 Block C units
Queen: 89 Block C units
King: 109 Block C units

Set aside for *Quilt Assembly, Steps 1 and 2.*

**STEP 3:** Create **1 BLOCK D** unit by sewing together 2 Fabric D 1¼" x 4½" rectangles, 1 Fabric D 1" x 4½" rectangle, and 2 Set D1 units. Press the seams open.

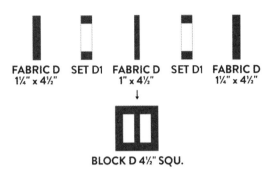

REPEAT TO CREATE A TOTAL OF:
Baby: 8 Block D units
Twin: 24 Block D units
Queen: 40 Block D units
King: 50 Block D units

Set aside for *Quilt Assembly, Step 3.*

**STEP 4:** Referring to the diagram, sew together 1 Fabric A 2½" x 4½" rectangle and 2 Set E1 units to create **1 BLOCK E** unit. Press the seams open.

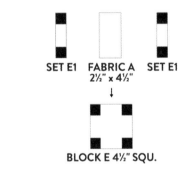

REPEAT TO CREATE A TOTAL OF:
Baby: 8 Block E units
Twin: 24 Block E units
Queen: 40 Block E units
King: 49 Block E units

Set aside for *Quilt Assembly, Step 3.*

## QUILT ASSEMBLY

**STEP 1:** As shown in the diagram, create **1 ROW A** unit by arranging and sewing together:

Baby: 5 Fabric A 6½" squares, 2 Block B units, and 2 Block C units
Twin: 7 Fabric A 6½" squares, 3 Block B units, and 3 Block C units
Queen: 11 Fabric A 6½" squares, 5 Block B units, and 5 Block C units
King: 12 Fabric A 6½" squares, 5 Block B units, and 6 Block C units

Press the seams open.

**REPEAT TO CREATE A TOTAL OF:**
Baby: 5 Row A units
Twin: 9 Row A units
Queen: 9 Row A units
King: 5 Row A units

**LEGEND:**
FA: Fabric A 6½" squ.
BB: Block B
BC: Block C

Set aside for *Quilt Assembly, Step 5.*

---

*For Baby Size Quilt:*

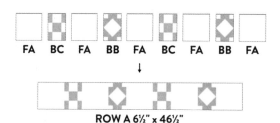

ROW A 6½" x 46½"

---

*For Twin Size Quilt:*

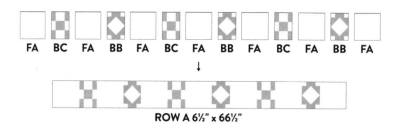

ROW A 6½" x 66½"

---

*For Queen Size Quilt:*

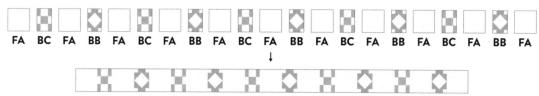

ROW A 6½" x 106½"

*For King Size Quilt:*

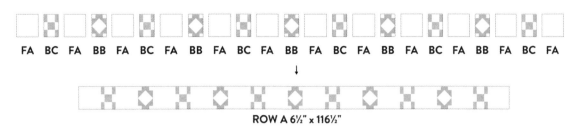

FA BC FA BB FA BC FA BB FA BC FA BB FA BC FA BB FA BC FA BB FA BC FA

↓

**ROW A 6½" x 116½"**

**STEP 2:** Following the diagram, sew together the following units to create **1 ROW B** unit:

Baby: n/a
Twin: n/a
Queen: n/a
King: 12 Fabric A 6½" squares, 6 Block B units, and 5 Block C units

Press the seams open.

**REPEAT TO CREATE A TOTAL OF:**
Baby: n/a
Twin: n/a
Queen: n/a
King: 5 Row B units

**LEGEND:**
FA: Fabric A 6½" squ.
BB: Block B
BC: Block C

Set aside for *Quilt Assembly, Step 5.*

*For King Size Quilt:*

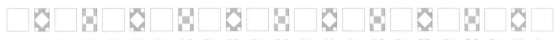

FA BB FA BC FA BB FA BC FA BB FA BC FA BB FA BC FA BB FA BC FA BB FA

↓

**ROW B 6½" x 116½"**

**STEP 3:** Referring to the diagrams below, sew together the following units to create **1 ROW C** unit:

Baby: 2 Block B units, 3 Block C units, 2 Block D units, and 2 Block E units

Twin: 3 Block B units, 4 Block C units, 3 Block D units, and 3 Block E units

Queen: 5 Block B units, 6 Block C units, 5 Block D units, and 5 Block E units

King: 6 Block B units, 6 Block C units, 6 Block D units, and 5 Block E units

Press the seams open.

**REPEAT TO CREATE A TOTAL OF:**

Baby: 2 Row C units

Twin: 4 Row C units

Queen: 4 Row C units

King: 5 Row C units

**LEGEND:**

BB: Block B

BC: Block C

BD: Block D

BE: Block E

Set aside for *Quilt Assembly, Step 6.*

---

*For Baby Size Quilt:*

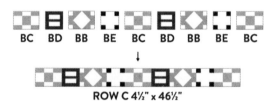

ROW C 4½" x 46½"

---

*For Twin Size Quilt:*

ROW C 4½" x 66½"

---

*For Queen Size Quilt:*

ROW C 4½" x 106½"

---

*For King Size Quilt:*

ROW C 4½" x 116½"

**STEP 4:** Combine the following units to create **1 ROW D** unit:

Baby: 3 Block B units, 2 Block C units, 2 Block D units, and 2 Block E units
Twin: 4 Block B units, 3 Block C units, 3 Block D units, and 3 Block E units
Queen: 6 Block B units, 5 Block C units, 5 Block D units, and 5 Block E units
King: 6 Block B units, 6 Block C units, 5 Block D units, and 6 Block E units

Press the seams open.

**REPEAT TO CREATE A TOTAL OF:**          **LEGEND:**
Baby: 2 Row D units                      BB: Block B
Twin: 4 Row D units                      BC: Block C
Queen: 4 Row D units                     BD: Block D
King: 4 Row D units                      BE: Block E

---

*For Baby Size Quilt:*

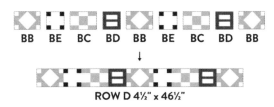

ROW D 4½" x 46½"

---

*For Twin Size Quilt:*

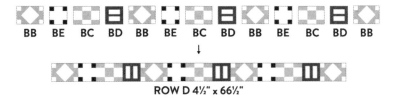

ROW D 4½" x 66½"

---

*For Queen Size Quilt:*

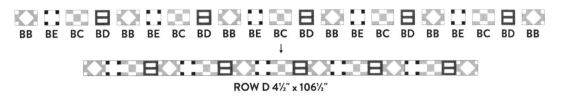

ROW D 4½" x 106½"

---

*For King Size Quilt:*

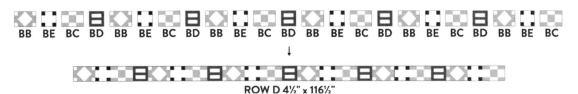

ROW D 4½" x 116½"

**STEP 5:** To create a **BABY-SIZE QUILT TOP**, line up and sew together 5 Row A units*, 2 Row C units, and 2 Row D units. Press the seams open.

*For Baby Size Quilt:*

*Note: Turn the second and fourth Row A units 180 degrees before sewing together.*

To create a **TWIN-SIZE QUILT TOP**, arrange and sew together 9 Row A units*, 4 Row C units, and 4 Row D units. Press the seams open.

*For Twin Size Quilt:*

*Note: Turn the second, fourth, sixth, and eighth Row A units 180 degrees before sewing together.*

(Step 5 continued on next page)

*(Continued from step 5)*

For a **QUEEN-SIZE QUILT TOP**, arrange and sew together 9 Row A units*, 4 Row C units, and 4 Row D units. Press the seams open.

*For Queen Size Quilt:*

*Note: Turn the second, fourth, sixth, and eighth Row A units 180 degrees before sewing together.*

For a **KING-SIZE QUILT TOP**, arrange and sew together 5 Row A units, 5 Row B units, 5 Row C units and 4 Row D units. Press the seams open.

*For King Size Quilt:*

**STEP 6:** Press the quilt top and backing fabric. Layer the backing, batting, and quilt top. Baste, quilt, and bind, as desired.

**FOR A WALL HANGING:** Stop right before the binding on the quilt is added, and follow the instructions on how to turn a quilt into a wall hanging on *page 60*.

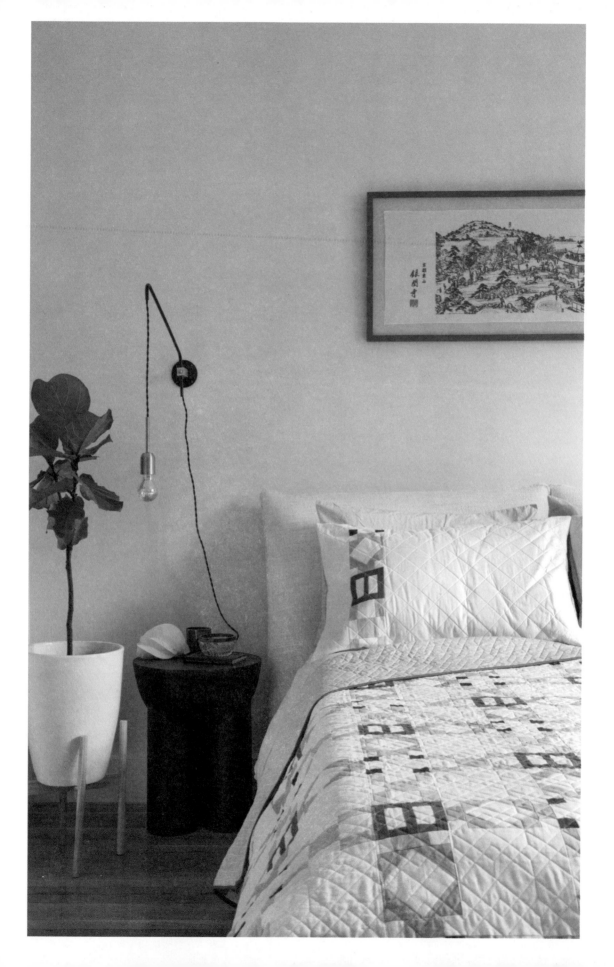

# LASTING WARMTH SHAM CASES

There are two sham sizes in this pattern: (1) standard size for twin- and queen-size beds and (2) king size for king-size beds. The following pattern refers to twin, queen, and king sizes. Twin size makes one standard sham, queen size makes two standard shams, and king size makes two king shams.

A great thing about the Lasting Warmth Sham Cases project is the option to use leftover Strip Set units from the Lasting Warmth quilt project (*page 135*). Using leftover Strip Set units from the quilt project will speed up the block and sham top assembly. This project is also an opportunity to incorporate scraps from another project, and the Strip Set Units replace fabric requirements for Fabrics B, C, D, and E.

To accommodate the option to use leftover Strip Set units, the *Fabric Requirements* and *Cutting Directions* will vary slightly. As a result, there are two options in each of these sections: **OPTION 1** assumes leftover Strip Set units *will not* be incorporated, and **OPTION 2** assumes leftover Strip Set units *will* be incorporated.

---

| | |
|---|---|
| **PROJECT SIZES** | **+ STANDARD**: 20" x 31" (51 cm x 79 cm) |
| | **+ KING**: 20" x 41" (51 cm x 105 cm) |

---

| | |
|---|---|
| **PIECING METHODS AND TECHNIQUES** | Nine-Patch block, square-in-a-square unit |

---

| | |
|---|---|
| **OTHER MATERIALS** | Batting; |
| | **TWIN-SIZE BED**: One standard-size pillow insert; |
| | **QUEEN-SIZE BED**: Two standard-size pillows inserts; |
| | **KING-SIZE BED**: Two king-size pillows inserts; |
| | Point turner (optional) |

---

**DON'T WANT TO CREATE SHAM CASES?** This project can also be a wall hanging. Simply stop after *Basting and Quilting, Step 2* and follow the instructions on how on to turn a quilt into a wall hanging on *page 60*.

**SHARE YOUR WORK ON SOCIAL MEDIA:** #lastingwarmthshams #theweekendquilter #quiltedhomehandbook

**BEGINNER**

## FABRIC REQUIREMENTS
### OPTION 1: EXCLUDING STRIP SET UNITS

| | TWIN<br>(One standard-size sham) | QUEEN<br>(Two standard-size shams) | KING<br>(Two king-size shams) |
|---|---|---|---|
| **SHAM FRONT** | | | |
| □ FABRIC A | ⅝ yard (58 cm) | 1¼ yards (115 cm) | 1⅜ yards (126 cm) |
| ▨ FABRIC B | ⅛ yard (12 cm) or<br>1 Fat Eighth (FE) | ⅛ yard (12 cm) or<br>1 Fat Eighth (FE) | ⅛ yard (12 cm) or<br>1 Fat Eighth (FE) |
| ▨ FABRIC C | ⅛ yard (12 cm) or 1 FE | ⅛ yard (12 cm) or 1 FE | ⅛ yard (12 cm) or 1 FE |
| ■ FABRIC D | ⅛ yard (12 cm) or 1 FE | ⅛ yard (12 cm) or 1 FE | ⅛ yard (12 cm) or 1 FE |
| ■ FABRIC E | ⅛ yard (12 cm) or 1 FE | ⅛ yard (12 cm) or 1 FE | ⅛ yard (12 cm) or 1 FE |
| **SHAM BACK** | | | |
| ▨ FABRIC F | ⅝ yard (58 cm) | 1¼ yards (115 cm) | 1⅞ yards (172 cm) |
| **TRIM** | | | |
| ▨ FABRIC G | ¼ yard (23 cm) or<br>1 Fat Quarter (FQ) | ¼ yard (23 cm) or<br>1 Fat Quarter (FQ) | ¼ yard (23 cm) or<br>1 Fat Quarter (FQ) |
| **LINING (FOR SHAMS) / BACK (FOR WALL HANGINGS), FABRIC H** | | | |
| □ SHAM(S) | 2½ yards (229 cm) | 4⅛ yards (383 cm) | 5 yards (458 cm) |
| ▨ WALL HANGING(S) | ¾ yard (69 cm) | 1½ yards (138 cm) | 1½ yards (138 cm) |
| **BINDING (FOR WALL HANGING(S) ONLY)** | | | |
| ■ FABRIC I | ¼ yard (23 cm) | ½ yard (46 cm) | ⅝ yard (58 cm) |

**FOR A WALL HANGING:** Omit Fabrics F (sham back) and G (trim), and adjust fabric requirement for Fabric H (lining), treating this as the fabric for the back of the wall quilt, tabs, and dowel casing to hang.

## FABRIC REQUIREMENTS
### OPTION 2: INCLUDING STRIP SET UNITS

| | TWIN (One standard-size sham) | QUEEN (Two standard-size shams) | KING (Two king-size shams) |
|---|---|---|---|
| **SHAM FRONT** | | | |
| □ FABRIC A | ¾ yard (69 cm) | 1¼ yards (115 cm) | 1¼ yards (115 cm) |
| ▣ FABRIC B | ⅛ yard (12 cm) or 1 Fat Eighth (FE) | ⅛ yard (12 cm) or 1 Fat Eighth (FE) | ⅛ yard (12 cm) or 1 Fat Eighth (FE) |
| ■ FABRIC D | ⅛ yard (12 cm) or 1 FE | ⅛ yard (12 cm) or 1 FE | ⅛ yard (12 cm) or 1 FE |

The following outlines the minimum length for each Strip Set unit from the Lasting Warmth quilt project (*page 135*) required by project/bed size. Refer to *Strip Piecing Units, Steps 1–6* to reference how the Strip Set B1, Strip Set C1, Strip Set C2, Strip Set D1, and Strip Set E1 units look.

| | TWIN | QUEEN | KING |
|---|---|---|---|
| **STRIP SET B1 UNIT** | At least 5" long | At least 8" long | At least 8" long |
| **STRIP SET C1 UNIT** | At least 7¼" long | At least 12½" long | At least 12½" long |
| **STRIP SET C2 UNIT** | At least 4½" long | At least 7" long | At least 7" long |
| **STRIP SET D1 UNIT** | At least 5" long | At least 8" long | At least 8" long |
| **STRIP SET E1 UNIT** | At least 5¼" long | At least 8½" long | At least 8½" long |
| **SHAM BACK** | | | |
| ▣ FABRIC F | ⅝ yard (58 cm) | 1¼ yards (115 cm) | 1⅞ yards (172 cm) |
| **TRIM** | | | |
| ▣ FABRIC G | ¼ yard (23 cm) or 1 Fat Quarter (FQ) | ¼ yard (23 cm) or 1 Fat Quarter (FQ) | ¼ yard (23 cm) or 1 Fat Quarter (FQ) |
| **LINING (FOR SHAMS) / BACK (FOR WALL HANGINGS), FABRIC H** | | | |
| □ SHAM(S) | 2½ yards (229 cm) | 4⅛ yards (383 cm) | 5¾ yards (526 cm) |
| ▣ WALL HANGING(S) | ¾ yard (69 cm) | 1½ yards (138 cm) | 1⅝ yards (149 cm) |
| **BINDING (FOR WALL HANGING(S) ONLY)** | | | |
| ■ FABRIC I | ¼ yard (23 cm) | ½ yard (46 cm) | ⅔ yard (61 cm) |

**FOR A WALL HANGING:** Omit Fabrics F (sham back) and G (trim), and adjust fabric requirement for Fabric H (lining), treating this as the fabric for the back of the wall quilt, tabs, and dowel casing to hang.

## CUTTING DIRECTIONS
### OPTION 1: EXCLUDING STRIP SET UNITS

| | TWIN<br>(One standard-size sham) | QUEEN<br>(Two standard-size shams) | KING<br>(Two king-size shams) |
|---|---|---|---|
| **SHAM FRONT** | | | |
| ☐ FABRIC A | 1 strip, 21" x WOF, sub-cut:<br>• 1 rectangle, 21" x 23½"<br>• 1 rectangle, 21" x 5"<br>• 1 square, 3⅜"<br>• 2 rectangles, 3" x 1½"<br>• 1 rectangle, 2¾" x 2½"<br>• 1 rectangle, 2½" x 4½"<br>• 1 square, 2½"<br>• 1 rectangle, 2½" x 1¾"<br>• 2 rectangles, 2½" x 1½"<br>• 4 squares, 1½" | 1 strip, 21" x WOF, sub-cut:<br>• 1 rectangle, 21" x 23½"<br>• 1 rectangle, 21" x 5"<br>• 2 squares, 3⅜"<br>• 4 rectangles, 3" x 1½"<br>• 2 rectangles, 2¾" x 2½"<br>• 2 rectangles, 2¾" x 1½"<br>• 2 rectangles, 2½" x 4½"<br>• 2 squares, 2½"<br>• 2 rectangles, 2½" x 1¾"<br>• 4 rectangles, 2½" x 1½"<br>• 8 squares, 1½"<br><br>1 strip, 21" x WOF, sub-cut:<br>• 1 rectangle, 21" x 23½"<br>• 1 rectangle, 21" x 5" | 1 strip, 21" x WOF, sub-cut:<br>• 1 rectangle, 21" x 33½"<br>• 1 rectangle, 21" x 5"<br>• 2 squares, 3⅜"<br>• 4 rectangles, 3" x 1½"<br>• 2 rectangles, 2¾" x 2½"<br><br>1 strip, 21" x WOF, sub-cut:<br>• 1 rectangle, 21" x 33½"<br>• 1 rectangle, 21" x 5"<br><br>1 strip, 2½" x WOF, sub-cut:<br>• 2 rectangles, 2¾" x 1½"<br>• 2 rectangles, 2½" x 4½"<br>• 2 squares, 2½"<br>• 2 rectangles, 2½" x 1¾"<br>• 4 rectangles, 2½" x 1½"<br>• 8 squares, 1½" |
| ▦ FABRIC B | **FOR ⅛ YARD (12 CM):**<br>1 strip, 3¼" x WOF, sub-cut:<br>• 2 squares, 3¼"<br>• 2 rectangles, 1½" x 2½"<br><br>**FOR FAT EIGHTH (FE):**<br>• 2 squares, 3¼"<br>• 2 rectangles, 1½" x 2½" | **FOR ⅛ YARD (12 CM):**<br>1 strip, 3¼" x WOF, sub-cut:<br>• 4 squares, 3¼"<br>• 4 rectangles, 1½" x 2½"<br><br>**FOR FAT EIGHTH (FE):**<br>• 4 squares, 3¼"<br>• 4 rectangles, 1½" x 2½" | **FOR ⅛ YARD (12 CM):**<br>1 strip, 3¼" x WOF, sub-cut:<br>• 4 squares, 3¼"<br>• 4 rectangles, 1½" x 2½"<br><br>**FOR FAT EIGHTH (FE):**<br>• 4 squares, 3¼"<br>• 4 rectangles, 1½" x 2½" |
| ▦ FABRIC C | **FOR ⅛ YARD (12 CM):**<br>1 strip, 2¾" x WOF, sub-cut:<br>• 2 rectangles, 2¾" x 1½"<br>• 1 square, 2½"<br>• 2 rectangles, 2½" x 1½"<br><br>**FOR FE:**<br>• 2 rectangles, 2¾" x 1½"<br>• 1 square, 2½"<br>• 2 rectangles, 2½" x 1½" | **FOR ⅛ YARD (12 CM):**<br>1 strip, 2¾" x WOF, sub-cut:<br>• 4 rectangles, 2¾" x 1½"<br>• 2 squares, 2½"<br>• 4 rectangles, 2½" x 1½"<br><br>**FOR FE:**<br>• 4 rectangles, 2¾" x 1½"<br>• 2 squares, 2½"<br>• 4 rectangles, 2½" x 1½" | **FOR ⅛ YARD (12 CM):**<br>1 strip, 2¾" x WOF, sub-cut:<br>• 4 rectangles, 2¾" x 1½"<br>• 2 squares, 2½"<br>• 2 rectangles, 2½" x 1½"<br><br>**FOR FE:**<br>• 4 rectangles, 2¾" x 1½"<br>• 2 squares, 2½"<br>• 4 rectangles, 2½" x 1½" |

| | TWIN<br>(One standard-size sham) | QUEEN<br>(Two standard-size shams) | KING<br>(Two king-size shams) |
|---|---|---|---|
| ■ FABRIC D | **FOR ⅛ YARD (12 CM):**<br>1 strip, 4½" x WOF, sub-cut:<br>• 2 rectangles, 4½" x 1¼"<br>• 1 rectangle, 4½" x 1"<br>• 4 rectangles, 1½" x 1¼"<br><br>**FOR FE:**<br>• 2 rectangles, 4½" x 1¼"<br>• 1 rectangle, 4½" x 1"<br>• 4 rectangles, 1½" x 1¼" | **FOR ⅛ YARD (12 CM):**<br>1 strip, 4½" x WOF, sub-cut:<br>• 4 rectangles, 4½" x 1¼"<br>• 2 rectangles, 4½" x 1"<br>• 8 rectangles, 1½" x 1¼"<br><br>**FOR FE:**<br>• 4 rectangles, 4½" x 1¼"<br>• 2 rectangles, 4½" x 1"<br>• 8 rectangles, 1½" x 1¼" | **FOR ⅛ YARD (12 CM):**<br>1 strip, 4½" x WOF, sub-cut:<br>• 4 rectangles, 4½" x 1¼"<br>• 2 rectangles, 4½" x 1"<br>• 8 rectangles, 1½" x 1¼"<br><br>**FOR FE:**<br>• 4 rectangles, 4½" x 1¼"<br>• 2 rectangles, 4½" x 1"<br>• 8 rectangles, 1½" x 1¼" |
| ■ FABRIC E | **FOR ⅛ YARD (12 CM):**<br>1 strip, 1¾" x WOF, sub-cut:<br>• 2 rectangles, 1¾" x 1½"<br>• 2 squares, 1½"<br><br>**FOR FE:**<br>• 2 rectangles, 1¾" x 1½"<br>• 2 squares, 1½" | **FOR ⅛ YARD (12 CM):**<br>1 strip, 1¾" x WOF, sub-cut:<br>• 4 rectangles, 1¾" x 1½"<br>• 4 squares, 1½"<br><br>**FOR FE:**<br>• 4 rectangles, 1¾" x 1½"<br>• 4 squares, 1½" | **FOR ⅛ YARD (12 CM):**<br>1 strip, 1¾" x WOF, sub-cut:<br>• 4 rectangles, 1¾" x 1½"<br>• 4 squares, 1½"<br><br>**FOR FE:**<br>• 4 rectangles, 1¾" x 1½"<br>• 4 squares, 1½" |
| **SHAM BACK** | | | |
| ▨ FABRIC F | 1 strip, 21" x WOF, sub-cut:<br>• 1 rectangle, 21" x 16"<br>• 1 square, 21" | 2 strips, 21" x WOF, sub-cut:<br>• 2 rectangles, 21" x 16"<br>• 2 squares, 21" | 1 strip, 21" x WOF, sub-cut:<br>• 2 squares, 21"<br><br>2 strips, 21" x WOF, sub-cut:<br>• 2 rectangles, 21" x 26" |
| **TRIM** | | | |
| ▨ FABRIC G | **FOR ¼ YARD (23 CM):**<br>2 strips, 2" x WOF, sub-cut:<br>• 2 rectangles, 2" x 23"<br><br>**FOR FAT QUARTER (FQ):**<br>Cut and sew together 3<br>rectangles, 2" x 21" widthwise.<br>Then sub-cut:<br>• 2 rectangles, 2" x 23" | **FOR ¼ YARD (23 CM):**<br>Cut and sew together 3 strips,<br>2" x WOF widthwise.<br>Then sub-cut:<br>• 4 rectangles, 2" x 23"<br><br>**FOR FAT QUARTER (FQ):**<br>Cut and sew together 5<br>rectangles, 2" x 21" widthwise.<br>Then sub-cut:<br>• 4 rectangles, 2" x 23" | **FOR ¼ YARD (23 CM):**<br>Cut and sew together 3 strips,<br>2" x WOF widthwise.<br>Then sub-cut:<br>• 4 rectangles, 2" x 23"<br><br>**FOR FAT QUARTER (FQ):**<br>Cut and sew together 5<br>rectangles, 2" x 21" widthwise.<br>Then sub-cut:<br>• 4 rectangles, 2" x 23" |

CONTINUED ON NEXT PAGE

## CUTTING DIRECTIONS, OPTION 1, CONT.

| | TWIN<br>(One standard-size sham) | QUEEN<br>(Two standard-size shams) | KING<br>(Two king-size shams) |
|---|---|---|---|
| **LINING (FOR SHAMS) / BACK (FOR WALL HANGINGS), FABRIC H** | | | |
| ☐ SHAM(S) | 3 strips, 29" x WOF, sub-cut:<br>• 1 rectangle, 29" x 40"<br>• 1 square, 29"<br>• 1 rectangle, 29" x 24" | 4 strips, 29" x WOF, sub-cut:<br>• 2 rectangles, 29" x 40"<br>• 2 squares, 29"<br>• 2 rectangles, 29" x 12½"*<br><br>1 strip, 29" x WOF, sub-cut:<br>• 1 rectangle, 29" x 24"<br><br>Sew 2 Fabric H 29" x 12½" rectangles widthwise, a ½" seam allowance* to create 1 Fabric H 29" x 24" rectangle. Press the seams open. | 6 strips, 29" x WOF, sub-cut:<br>• 2 rectangles, 29" x 40"<br>• 2 rectangles, 29" x 34"<br>• 2 squares, 29"<br>• 2 rectangles, 29" x 11"<br><br>Sew 1 Fabric H 29" x 40" rectangle and 1 Fabric H 29" x 11" rectangle widthwise, a ½" seam allowance* to create 1 Fabric H 29" x 50" rectangle. Press the seams open.<br><br>Repeat to create a total of 2 Fabric H 29" x 50" rectangles. |
| ▨ WALL HANGING(S) | 1 strip 25" x WOF, sub-cut:<br>• 1 rectangle, 25" x 36" | 2 strips 25" x WOF, sub-cut:<br>• 2 rectangles, 25" x 36" | 2 strips, 25" x WOF |
| **BINDING (FOR WALL HANGING(S) ONLY)** | | | |
| ■ FABRIC I | 3 strips, 2½" x WOF | 6 strips, 2½" x WOF | 8 strips, 2½" x WOF |

*For **QUEEN-** and **KING-SIZE BEDS** only: Increase seam allowance from ¼" to ½" and press the seams open when piecing 2 Fabric H 29" x 13" rectangles. Incorporating these two steps in preparing your sham back reduces seam bulk, strengthens the sham long-term, and reduces air bubbles in your sham sandwich.

# CUTTING DIRECTIONS
## OPTION 2: INCLUDING STRIP SET UNITS

| | TWIN<br>(One standard-size sham) | QUEEN<br>(Two standard-size shams) | KING<br>(Two king-size shams) |
|---|---|---|---|
| **SHAM FRONT** | | | |
| ☐ FABRIC A | 1 strip, 21" x WOF, sub-cut:<br>• 1 rectangle, 21" x 23"<br>• 1 rectangle, 21" x 5"<br>• 1 square, 3⅜"<br>• 1 rectangle, 2¾" x 1½"<br>• 1 rectangle, 2½" x 4½" | 1 strip, 21" x WOF, sub-cut:<br>• 1 rectangle, 21" x 23"<br>• 1 rectangle, 21" x 5"<br>• 2 squares, 3⅜"<br>• 2 rectangles, 2¾" x 1½"<br>• 2 rectangles, 2½" x 4½"<br><br>1 strip, 21" x WOF, sub-cut:<br>• 1 rectangle, 21" x 23½"<br>• 1 rectangle, 21" x 5" | 1 strip, 21" x WOF, sub-cut:<br>• 1 rectangle, 21" x 33"<br>• 1 rectangle, 21" x 5"<br>• 2 squares, 3⅜"<br>• 2 rectangles, 2½" x 4½"<br><br>1 strip, 21" x WOF, sub-cut:<br>• 1 rectangle, 21" x 33½"<br>• 1 rectangle, 21" x 5" |
| ■ FABRIC B | **FOR ⅛ YARD (12 CM):**<br>1 strip, 3¼" x WOF, sub-cut:<br>• 2 squares, 3¼"<br><br>**FOR FAT EIGHTH (FE):**<br>• 2 squares, 3¼" | **FOR ⅛ YARD (12 CM):**<br>1 strip, 3¼" x WOF, sub-cut:<br>• 4 squares, 3¼"<br><br>**FOR FAT EIGHTH (FE):**<br>• 4 squares, 3¼" | **FOR ⅛ YARD (12 CM):**<br>1 strip, 3¼" x WOF, sub-cut:<br>• 4 squares, 3¼"<br><br>**FOR FAT EIGHTH (FE):**<br>• 4 squares, 3¼" |
| ■ FABRIC D | **FOR ⅛ YARD (12 CM):**<br>1 strip, 4½" x WOF, sub-cut:<br>• 2 rectangles, 4½" x 1¼"<br>• 1 rectangle, 4½" x 1"<br><br>**FOR FE:**<br>• 2 rectangles, 4½" x 1¼"<br>• 1 rectangle, 4½" x 1" | **FOR ⅛ YARD (12 CM):**<br>1 strip, 4½" x WOF, sub-cut:<br>• 4 rectangles, 4½" x 1¼"<br>• 2 rectangles, 4½" x 1"<br><br>**FOR FE:**<br>• 4 rectangles, 4½" x 1¼"<br>• 2 rectangles, 4½" x 1" | **FOR ⅛ YARD (12 CM):**<br>1 strip, 4½" x WOF, sub-cut:<br>• 4 rectangles, 4½" x 1¼"<br>• 2 rectangles, 4½" x 1"<br><br>**FOR FE:**<br>• 4 rectangles, 4½" x 1¼"<br>• 2 rectangles, 4½" x 1" |
| **STRIP SET UNITS** | | | |
| | *Follow Strip Piecing Units, Steps 6 and 7 from the Lasting Warmth quilt pattern (page 135) on how to sub-cut the following Strip Set units.* | | |
| STRIP SET B1 UNIT | Strip Set B1 unit, sub-cut:<br>• 2 rectangles,<br>Set B1 1½" x 4½" | Strip Set B1 unit, sub-cut:<br>• 4 rectangles,<br>Set B1 1½" x 4½" | Strip Set B1 unit, sub-cut:<br>• 4 rectangles,<br>Set B1 1½" x 4½" |
| STRIP SET C1 UNIT | Strip Set C1 unit, sub-cut:<br>• 1 rectangle,<br>Set C1A 2½" x 4½"<br>• 1 rectangle,<br>Set C1B 2¾" x 4½" | Strip Set C1 unit, sub-cut:<br>• 2 rectangles,<br>Set C1A 2½" x 4½"<br>• 2 rectangles,<br>Set C1B 2¾" x 4½" | Strip Set C1 unit, sub-cut:<br>• 2 rectangles,<br>Set C1A 2½" x 4½"<br>• 2 rectangles,<br>Set C1B 2¾" x 4½" |

CONTINUED ON NEXT PAGE

## CUTTING DIRECTIONS, OPTION 2, CONT.

| | TWIN (One standard-size sham) | QUEEN (Two standard-size shams) | KING (Two king-size shams) |
|---|---|---|---|
| **STRIP SET C2 UNIT** | Strip Set C2 unit, sub-cut:<br>• 1 rectangle,<br>Set C2 2½" x 4½" | Strip Set C2 unit, sub-cut:<br>• 2 rectangles,<br>Set C2 2½" x 4½" | Strip Set C2 unit, sub-cut:<br>• 2 rectangles,<br>Set C2 2½" x 4½" |
| **STRIP SET D1 UNIT** | Strip Set D1 unit, sub-cut:<br>• 2 rectangles,<br>Set D1 1½" x 4½" | Strip Set D1 unit, sub-cut:<br>• 4 rectangles,<br>Set D1 1½" x 4½" | Strip Set D1 unit, sub-cut:<br>• 4 rectangles,<br>Set D1 1½" x 4½" |
| **STRIP SET E1 UNIT** | Strip Set E1 unit, sub-cut:<br>• 1 rectangle,<br>Set E1 1½" x 4½"<br><br>• 1 rectangle,<br>Set E2 1¾" x 4½" | Strip Set E1 unit, sub-cut:<br>• 2 rectangles,<br>Set E1 1½" x 4½"<br><br>• 2 rectangles,<br>Set E2 1¾" x 4½" | Strip Set E1 unit, sub-cut:<br>• 2 rectangles,<br>Set E1 1½" x 4½"<br><br>• 2 rectangles,<br>Set E2 1¾" x 4½" |
| **SHAM BACK** | | | |
| ▦ **FABRIC F** | 1 strip, 21" x WOF, sub-cut:<br>• 1 square, 21"<br><br>• 1 rectangle, 21" x 16" | 2 strips, 21" x WOF, sub-cut:<br>• 2 squares, 21"<br><br>• 2 rectangles, 21" x 16" | 3 strips, 21" x WOF, sub-cut:<br>• 2 rectangles, 21" x 26"<br><br>• 2 squares, 21" |
| **TRIM** | | | |
| ▦ **FABRIC G** | **FOR ¼ YARD (23 CM):**<br>2 strips, 2" x WOF, sub-cut:<br>• 2 rectangles, 2" x 23"<br><br>**FOR FAT QUARTER (FQ):**<br>Cut and sew together 3 rectangles, 2" x 21" widthwise.<br>Then sub-cut:<br>• 2 rectangles, 2" x 23" | **FOR ¼ YARD (23 CM):**<br>Cut and sew together 3 strips, 2" x WOF widthwise.<br>Then sub-cut:<br>• 4 rectangles, 2" x 23"<br><br>**FOR FAT QUARTER (FQ):**<br>Cut and sew together 5 rectangles, 2" x 21" widthwise.<br>Then sub-cut:<br>• 4 rectangles, 2" x 23" | **FOR ¼ YARD (23 CM):**<br>Cut and sew together 3 strips, 2" x WOF widthwise.<br>Then sub-cut:<br>• 4 rectangles, 2" x 23"<br><br>**FOR FAT QUARTER (FQ):**<br>Cut and sew together 5 rectangles, 2" x 21" widthwise.<br>Then sub-cut:<br>• 4 rectangles, 2" x 23" |

| | TWIN (One standard-size sham) | QUEEN (Two standard-size shams) | KING (Two king-size shams) |
|---|---|---|---|
| **LINING (FOR SHAMS) / BACK (FOR WALL HANGINGS), FABRIC H** | | | |
| ☐ SHAM(S) | 3 strips, 29" x WOF, sub-cut:<br>• 1 rectangle, 29" x 40"<br>• 1 square, 29"<br>• 1 rectangle, 29" x 24" | 4 strips, 29" x WOF, sub-cut:<br>• 2 rectangles, 29" x 40"<br>• 2 squares, 29"<br>• 2 rectangles, 29" x 12½"*<br><br>1 strip, 29" x WOF, sub-cut:<br>• 1 rectangle, 29" x 40"<br><br>Sew 2 Fabric H 29" x 12½" rectangles width wise, a ½" seam allowance* to create 1 Fabric 29" x 24" rectangle. Press the seams open. | 6 strips, 29" x WOF, sub-cut:<br>• 2 rectangles, 29" x 40"<br>• 2 rectangles, 29" x 34"<br>• 2 squares, 29"<br>• 2 rectangles, 29" x 11"<br><br>Sew 1 Fabric H 29" x 40" rectangle and 1 Fabric H 29" x 11" rectangle width wise, a ½" seam allowance* to create 1 Fabric 29" x 50" rectangle. Press the seams open.<br><br>Repeat to create a total of 2 Fabric H 29" x 50" rectangles. |
| ▨ WALL HANGING(S) | 1 strip 25" x WOF, sub-cut:<br>• 1 rectangle, 25" x 36" | 2 strips 25" x WOF, sub-cut:<br>• 2 rectangles, 25" x 36" | 2 strips, 25" x WOF |
| **BINDING (FOR WALL HANGING(S) ONLY)** | | | |
| ■ FABRIC I | 3 strips, 2½" x WOF | 6 strips, 2½" x WOF | 8 strips, 2½" x WOF |

*For **QUEEN-** and **KING-SIZE SIZE BED** only: Increase seam allowance from ¼" to ½" and press the seams open when piecing 2 Fabric H 29" x 13" rectangles. Incorporating these two steps in preparing your sham back reduces seam bulk, strengthens the sham long-term, and reduces air bubbles in your sham sandwich.

## BLOCK B UNITS ASSEMBLY

**STEP 1:** For **ALL SHAM SIZES**, draw a diagonal guideline on the wrong side of all Fabric B 3¼" squares, and cut on it to make a total of:

Twin: 4 Fabric B Half-Triangle units
Queen: 8 Fabric B Half-Triangle units
King: 8 Fabric B Half-Triangle units

If you're feeling confident, skip drawing the diagonal guidelines and jump straight to cutting all Fabric B 3¼" squares in half diagonally.

Set aside for *Block B Units Assembly, Step 3.*

**STEP 2:** Fold and finger press each Fabric A 3⅜" square in half (a) vertically and (b) horizontally, creating guidelines as shown in the diagram. Repeat with all Fabric A 3⅜" squares for all sham sizes.

**STEP 3:** Place 1 Fabric B Half-Triangle unit on 1 Fabric A 3⅜" square with right sides together, so the long end of the triangle is lined up on the one side of the square, and the tip of the triangle is on the creased center line.

Sew a ¼" seam allowance on the long side of the triangle, as shown in the diagram. Press the seams open.

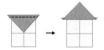

**STEP 4:** Attach 1 Fabric B Half-Triangle unit to the opposite Fabric A 3⅜" square edge and press the seams open, as per Step 3. Remove the excess Fabric B Half-Triangle units on each side, as shown in the diagram.

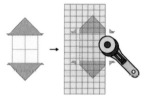

**STEP 5:** Sew 1 Fabric B Half-Triangle unit to each of the two remaining sides of the Fabric A 3⅜" square, as shown in the diagram, to create **1 SQUARE-IN-A-SQUARE (SS)** unit. Press the seams open as you go.

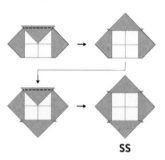

SS

**STEP 6:** Repeat Steps 3–5 to create a total of:

Twin: n/a
Queen: 2 SS units
King: 2 SS units

**STEP 7:** Square up all SS units to 4½" square. Squaring up is broken down into two steps. Each part involves removing the right and top sides of the SS unit.

Before removing the right and top sides of the SS unit:

**A.** Using a ruler, line up the horizontal ¼" line with the top corner of the Fabric A center square and the vertical ¼" line alongside the right corner of the Fabric A center square.

**B.** Slide the ruler to match the top and right corner of the center square with the 2¼" marks on the top and the right of the ruler.

Trim the top and right edges of the blocks.

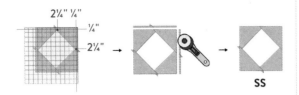

SS

**STEP 8:** Turn the SS unit 180 degrees and repeat Step 7 with the remaining two sides. Repeat this process for all SS units.

Set SS units aside for *Block B Units Assembly, Step 10.*

**STEP 9:** If using leftover Strip Set B1 units from the Lasting Warmth quilt project to create Set B1 units, skip this step and proceed to *Block B Units Assembly, Step 10.*

Sew together 2 Fabric A 1½" squares and 1 Fabric B 1½" x 2½" rectangle with a **SCANT ¼" SEAM ALLOWANCE** to create **1 SET B1** unit. Press the seams open.

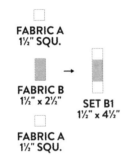

**FABRIC A**
1½" SQU.

**FABRIC B**
1½" x 2½"

**SET B1**
1½" x 4½"

**FABRIC A**
1½" SQU.

**REPEAT TO CREATE A TOTAL OF:**
Twin: 2 Set B1 units
Queen: 4 Set B1 units
King: 4 Set B1 units

**STEP 10:** Sew together 2 Set B1 units and 1 SS unit with a **SCANT ¼" SEAM ALLOWANCE** to create **1 BLOCK B** unit. Press the seams open.

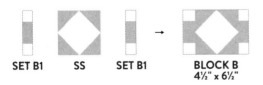

**SET B1**      **SS**      **SET B1**      **BLOCK B**
4½" x 6½"

**REPEAT TO CREATE A TOTAL OF:**
Twin: 1 Block B units
Queen: 2 Block B units
King: 2 Block B units

Set Block B units aside for *Sham Top Assembly, Step 1.*

## BLOCK C UNITS ASSEMBLY

If using leftover Strip Set C1 and Strip Set C2 units from the Lasting Warmth quilt project to create Set C1A, Set C1B, and Set C2 units, skip *Block C Assembly, Steps 1-3* and proceed to *Step 4.*

**STEP 1:** Create **1 SET C1A** unit by sewing together 1 Fabric A 2½" square and 2 Fabric C 1½" x 2½" rectangles with a **SCANT ¼" SEAM ALLOWANCE.** Press the seams open.

**FABRIC C**
1½" x 2½"

**FABRIC A**
2½" SQU.

**SET C1A**
2½" x 4½"

**FABRIC C**
1½" x 2½"

**REPEAT TO CREATE A TOTAL OF:**
Twin: n/a
Queen: 2 Set C1A units
King: 2 Set C1A units

Set C1A units aside for Block C Unit Assembly, Step 4.

**STEP 2:** Create **1 SET C1B** unit by sewing together 1 Fabric A 2½" x 2¾" rectangle and 2 Fabric C 1½" x 2¾" rectangles with a **SCANT ¼" SEAM ALLOWANCE.** Press the seams open.

*(Step 2 continued on next page)*

*(Continued from step 2)*

**FABRIC C**
1½" x 2¾"

**FABRIC A**
2½" x 2¾"

**SET C1B**
2¾" x 4½"

**FABRIC C**
1½" x 2¾"

**REPEAT TO CREATE A TOTAL OF:**

Twin: n/a

Queen: 2 Set C1B units

King: 2 Set C1B units

Set C1B units aside for *Block C Units Assembly, Step 4.*

**STEP 3:** Create **1 SET C2** unit by sewing 2 Fabric A 1½" x 2½" rectangles and 1 Fabric C 2½" square together with a **SCANT ¼" SEAM ALLOWANCE.** Press the seams open.

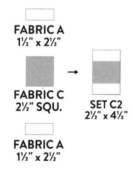

**FABRIC A**
1½" x 2½"

**FABRIC C**
2½" SQU.

**SET C2**
2½" x 4½"

**FABRIC A**
1½" x 2½"

**REPEAT TO CREATE A TOTAL OF:**

Twin: n/a

Queen: 2 Set C2 units

King: 2 Set C2 units

**STEP 4:** Create **1 BLOCK C** unit by sewing together 1 Set C1A unit, 1 Set C1B unit, and 1 Set C2 unit with a **SCANT ¼" SEAM ALLOWANCE.** Press the seams open.

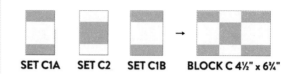

**SET C1A**   **SET C2**   **SET C1B**   **BLOCK C 4½" x 6¾"**

**REPEAT TO CREATE A TOTAL OF:**

Twin: n/a

Queen: 2 Block C units

King: 2 Block C units

Set Block C units aside for *Sham Top Assembly, Step 1.*

## BLOCK D UNITS ASSEMBLY

**STEP 1:** If using leftover Strip Set D1 units from the Lasting Warmth quilt project to create Set D1 units, skip this step and proceed to *Block D Units Assembly, Step 2.*

Create **1 SET D1** unit by sewing together 1 Fabric A 1½" x 3" rectangle and 2 Fabric D 1¼" x 1½" rectangles with a **SCANT ¼" SEAM ALLOWANCE.** Press the seams open.

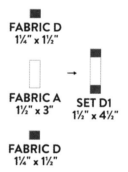

**FABRIC D**
1¼" x 1½"

**FABRIC A**
1½" x 3"

**SET D1**
1½" x 4½"

**FABRIC D**
1¼" x 1½"

**REPEAT TO CREATE A TOTAL OF:**

Twin: 2 Set D1 units

Queen: 4 Set D1 units

King: 4 Set D1 units

**STEP 2:** Form **1 BLOCK D** unit by sewing together 2 Fabric D 1¼" x 4½" rectangles, 1 Fabric D 1" x 4½", rectangle and 2 Set D1 units with a **SCANT ¼" SEAM ALLOWANCE.** Press the seams open.

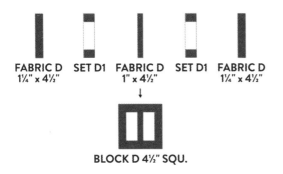

FABRIC D
1¼" x 4½"    SET D1    FABRIC D
1" x 4½"    SET D1    FABRIC D
1¼" x 4½"

↓

BLOCK D 4½" SQU.

**REPEAT TO CREATE A TOTAL OF:**

Twin: n/a

Queen: 2 Block D units

King: 2 Block D units

Set Block D units aside for *Sham Top Assembly, Step 1.*

## BLOCK E UNITS ASSEMBLY

If using leftover Strip Set E1 units from the Lasting Warmth quilt project to create Set E1 and Set E2 units, skip *Block E Units Assembly, Steps 1* and *2* and proceed to *Step 3.*

**STEP 1:** Create **1 SET E1** unit by sewing together 1 Fabric A 1½" x 2½" rectangle and 2 Fabric E 1½" squares with a **SCANT ¼" SEAM ALLOWANCE.** Press the seams open.

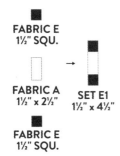

FABRIC E
1½" SQU.

FABRIC A
1½" x 2½"    →    SET E1
1½" x 4½"

FABRIC E
1½" SQU.

**REPEAT TO CREATE A TOTAL OF:**

Twin: n/a

Queen: 2 Set E1 units

King: 2 Set E1 units

Set E1 units aside for *Block E Units Assembly, Step 3.*

**STEP 2:** Create **1 SET E2** unit by sewing together 1 Fabric A 1¾" x 2½" rectangle and 2 Fabric E 1½" x 1¾" rectangles with a **SCANT ¼" SEAM ALLOWANCE.** Press the seams open.

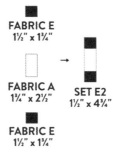

FABRIC E
1½" x 1¾"

FABRIC A
1¾" x 2½"    →    SET E2
1½" x 4¼"

FABRIC E
1½" x 1¾"

**REPEAT TO CREATE A TOTAL OF:**

Twin: n/a

Queen: 2 Set E2 units

King: 2 Set E2 units

**STEP 3:** Referring to the diagram, sew together 1 Fabric A 2½ x 4½" rectangle and 1 Set E1 unit and 1 Set E2 unit with a **SCANT ¼" SEAM ALLOWANCE** to create **1 BLOCK E** unit. Press the seams open.

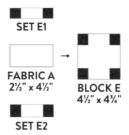

SET E1

FABRIC A
2½" x 4½"    →    BLOCK E
4½" x 4¾"

SET E2

**REPEAT TO CREATE A TOTAL OF:**

Twin: n/a

Queen: 2 Block E units

King: 2 Block E units

## SHAM TOP ASSEMBLY

**STEP 1:** For **ALL SHAM SIZES,** following the diagram, sew together 1 Block B unit*, 1 Block C unit, 1 Block D unit, and 1 Block E* unit, with a **SCANT ¼" SEAM ALLOWANCE,** to create **1 COLUMN A** unit. Press the seams open.

*(Step 1 continued on next page)*

(Continued from step 1)

*Note: Take extra care when arranging the Block B and Block E units. Ensure the Set C1B unit of Block C and Set E2 unit are placed on the outer edges of the Column A unit. Arranging these blocks this way accounts for the fabric loss from the ½" seam allowance when the sham top and sham back sandwiches are sewn together in a later step.

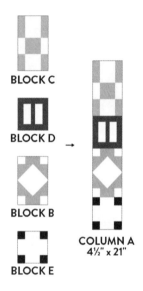

BLOCK C

BLOCK D →

BLOCK B

BLOCK E

COLUMN A
4½" x 21"

**REPEAT TO CREATE A TOTAL OF:**
Twin: n/a
Queen: 2 Column A units
King: 2 Column A units

**STEP 2:** Each sham size has two different layouts. You have the option to follow both or either of the layouts shown. For **QUEEN-** and **KING-SIZE BEDS** (refer to the diagrams on the right) it is recommended to create one of each layout to create a balanced look when the shams are placed on the bed.

For a standard-size sham for **TWIN-** and **QUEEN-SIZE BEDS, LAYOUT 1** and **LAYOUT 2**, sew together 1 Fabric A 21" x 23½" rectangle, 1 Fabric A 5¼" x 21¼" rectangle, and 1 Column A unit to create **1 STANDARD-SIZE SHAM TOP.** Press the seams open.

*Standard Size Sham Top, Layout 1:*

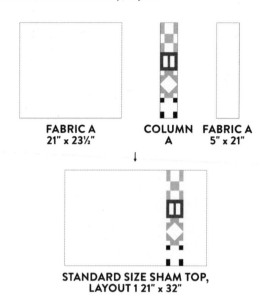

FABRIC A
21" x 23½"

COLUMN
A

FABRIC A
5" x 21"

↓

STANDARD SIZE SHAM TOP,
LAYOUT 1 21" x 32"

*Standard Size Sham Top, Layout 2:*

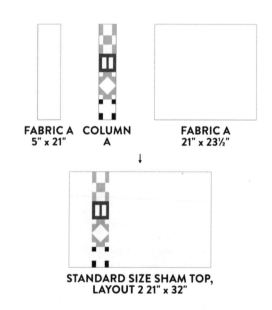

FABRIC A
5" x 21"

COLUMN
A

FABRIC A
21" x 23½"

↓

STANDARD SIZE SHAM TOP,
LAYOUT 2 21" x 32"

For a king-size sham for a **KING-SIZE BED, LAYOUT 1** and **LAYOUT 2**, sew together 1 Fabric A 21" x 33½" rectangle, 1 Fabric A 5" x 21" rectangle, and 1 Column A unit to create **1 KING-SIZE SHAM TOP.** Press the seams open.

*King Size Sham Top, Layout 1:*

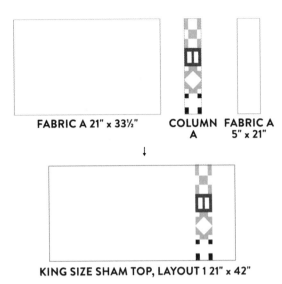

FABRIC A 21" x 33½"    COLUMN A    FABRIC A 5" x 21"

↓

KING SIZE SHAM TOP, LAYOUT 1 21" x 42"

*King Size Sham Top, Layout 2:*

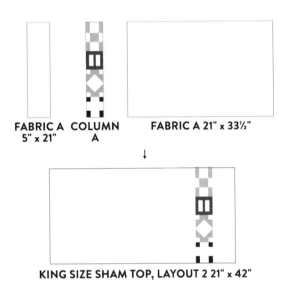

FABRIC A 5" x 21"    COLUMN A    FABRIC A 21" x 33½"

↓

KING SIZE SHAM TOP, LAYOUT 2 21" x 42"

For **QUEEN**- and **KING-SIZE** beds, repeat this step to create a total of two sham tops.

## BASTING AND QUILTING

**STEP 1:** For this project you need to create three different-sized sham sandwiches for each sham: 1 SHAM TOP SANDWICH and 2 SHAM BACK SANDWICHES.

**FOR A WALL HANGING:** create **SHAM TOP SANDWICH(ES)**.

Each sham sandwich is comprised of the following layers. *Standard and King Size Sham Tops, Layout 1 used in this example.*

### SHAM TOP SANDWICH

| TWIN / QUEEN: |
|---|
| Standard-Size Sham Top, Batting, 1 Fabric H 29" x 40" rectangle |
| **KING:** |
| King-Size Sham Top, Batting, 1 Fabric H 29" x 50" rectangle |

**REPEAT TO CREATE A TOTAL OF:**
Twin: n/a
Queen: 2 Standard Sham Top Sandwiches
King: 2 King Sham Top Sandwiches

*Standard Size Sham Top Sandwich:*

STANDARD SIZE SHAM TOP
BATTING
FABRIC H 29"x 40"

*King Size Sham Top Sandwich:*

KING SIZE SHAM TOP
BATTING
FABRIC H 29"x 50"

## SHAM BACK SANDWICH A

| TWIN / QUEEN: |
| --- |
| 1 Fabric F 16" x 21" rectangle, Batting, 1 Fabric H 24" x 29" rectangle |

| KING: |
| --- |
| 1 Fabric F 21" square, Batting, 1 Fabric H 29" square |

**REPEAT TO CREATE A TOTAL OF:**

Twin: n/a

Queen: 2 Standard Sham Back Sandwiches A

King: 2 King Sham Back Sandwiches A

*Standard Size Sham Back Sandwich A:*

*King Size Sham Back Sandwich A:*

## SHAM BACK SANDWICH B

| TWIN / QUEEN: |
| --- |
| 1 Fabric F 21" square, Batting, 1 Fabric H 29" square |

| KING: |
| --- |
| 1 Fabric F 21" x 26" rectangle, Batting, 1 Fabric H 29" x 34" rectangle |

**REPEAT TO CREATE A TOTAL OF:**

Twin: n/a

Queen: 2 Standard Sham Back Sandwiches B

King: 2 King Sham Back Sandwiches B

*Standard Size Sham Back Sandwich B:*

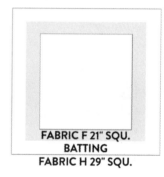

*King Size Sham Back Sandwich B:*

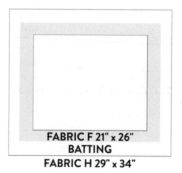

Baste and quilt using your preferred method.

**STEP 2:** Trim excess batting and lining fabrics, and square up all sham sandwiches. Take extra care when squaring up. Each sham sandwich must measure:

TWIN / QUEEN

+ Standard Sham Top Sandwich: 21" x 32" rectangle
+ Standard Sham Back Sandwich A: 16" x 21" rectangle
+ Standard Sham Back Sandwich B: 21" square

KING

+ King Sham Top Sandwich: 21" x 42" rectangle
+ King Sham Back Sandwich A: 21" square
+ King Sham Back Sandwich B: 21" x 26" rectangle

**FOR A WALL HANGING:** Follow Sham Top Sandwiches dimensions and go *to How to Prepare a Quilted Wall Hanging* on *page 60* to complete the project.

**TIP:** Before removing excess batting and lining fabric, use a fabric marker or pen and ruler to mark out the measurements. This additional step ensures all edges of the sham sandwiches are straight, each corner is right-angled, and the sham top design is not cut off while trimming.

## SHAM TRIM

Attaching sham trims is similar to attaching binding to a regular quilt project.

**STEP 1:** Start with 1 Fabric G 2" x 23" rectangle. Fold the Fabric G rectangle in half lengthwise and press to create **1 TRIM** unit.

REPEAT TO CREATE A TOTAL OF:
Twin: 2 Trim units
Queen: 4 Trim units
King: 4 Trim units

**STEP 2:** With the wrong side of 1 Standard Sham Back Sandwich A for **TWIN-** and **QUEEN-SIZE BEDS** or 1 King Sham Back Sandwich A for a **KING-SIZE BED** facing up, align the raw edge of 1 Trim unit

with the 21" raw edge of the quilt sandwich. Sew ¼" away from the raw edge. Remember to backstitch the start and the end of the seam.

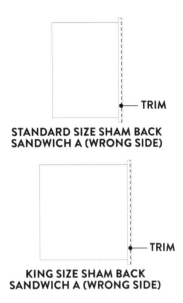

**STANDARD SIZE SHAM BACK SANDWICH A (WRONG SIDE)**

**KING SIZE SHAM BACK SANDWICH A (WRONG SIDE)**

**STEP 3:** Fold the finished edge of the trim over to Fabric F Sham Back, use a coordinating thread, and sew to secure the trim. Backstitch the start and end of the seam.

*Standard Size Sham Back Sandwich A used in this example:*

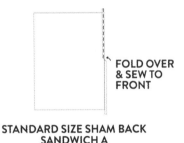

**FOLD OVER & SEW TO FRONT**

**STANDARD SIZE SHAM BACK SANDWICH A**

**STEP 4:** Use a ruler and rotary cutter to remove excess trim. *Standard Size Sham Back Sandwich A used in this example.*

*(Step 4 continued on next page)*

*(Continued from step 4)*

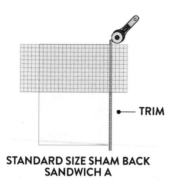

**STANDARD SIZE SHAM BACK
SANDWICH A**

**STEP 5:** Repeat Steps 1-4 with Standard Sham Back Sandwich B for **TWIN-** and **QUEEN-SIZE BEDS** or King Sham Back Sandwich B for a **KING-SIZE BED.**

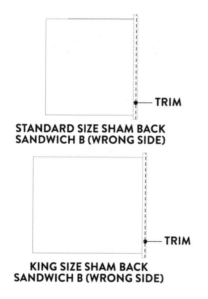

**STANDARD SIZE SHAM BACK
SANDWICH B (WRONG SIDE)**

**KING SIZE SHAM BACK
SANDWICH B (WRONG SIDE)**

## SHAM ASSEMBLY

**STEP 1:** For **TWIN-** and **QUEEN-SIZE BEDS,** with right sides together, lay 1 Standard Sham Back Sandwich B on top of the Standard Sham Top Sandwich. Then, with right sides together, lay 1 Standard Sham Back Sandwich A and pin as shown. Ensure the trim of the Standard Sham Back Sandwiches A and B are positioned away from the outer edges of the sham.

For a **QUEEN-SIZE BED ONLY,** repeat this step with the second sham.

*Standard Size, Layout 1 Sham used in this example.*

**STANDARD SIZE
SHAM TOP
SANDWICH**

**STANDARD SIZE
SHAM BACK
SANDWICH B
(WRONG SIZE)**

**STANDARD SIZE
SHAM BACK
SANDWICH A
(WRONG SIZE)**

**STANDARD SIZE
SHAM BACK
SANDWICH B
(WRONG SIZE)**

For **KING-SIZE BED,** with right sides together, lay 1 King Sham Back Sandwich B on top of the King Sham Top Sandwich. Then, with right sides together, lay 1 King Sham Back Sandwich A and pin as shown. Ensure the trim of the King Sham Back Sandwiches A and B are positioned away from the outer edges of the sham. Repeat with the second sham. See Standard Size diagram for example.

It's fine that the 2 Sham Back Sandwiches for both sham sizes should lay partially on top of each other—this is intentional.

And it's okay if Sham Back Sandwich B goes on the right or the left of the Sham Top Sandwich, as long as it goes on before and on the opposite side from Sham Back Sandwich A and the trim sides are positioned away from the outer edges.

**STEP 2:** Sew all the way around the outer edge with a ½" seam allowance, backstitching at the beginning and end.

For **QUEEN-** and **KING-SIZE BEDS ONLY,** repeat this step with the second sham.

*Standard Size, Layout 1 Sham used in this example.*

**STEP 3:** Use a serger or zigzag stitch to cover the raw edges to prevent them from fraying.

For **QUEEN-** and **KING-SIZE BEDS ONLY,** repeat this step with the second sham. *Standard Size, Layout 1 Sham used in this example.*

**STEP 4:** Carefully clip the corners without cutting into the seam for each sham. Turn the sham right side out, poking out the corners with a point turner to create a crisp and flat finish. Trim loose threads and insert a pillow in each sham to complete the project. *Standard Size, Layout 1 Sham used in this example.*

*Front of Standard Size Sham, Layout 1*

*Front of Standard Size Sham, Layout 2*

*Back of Standard Size Sham, Layout 1 and Layout 2*

*Front of King Size Sham, Layout 1 and 2*

*Back of King Size Sham, Layout 1 and 2*

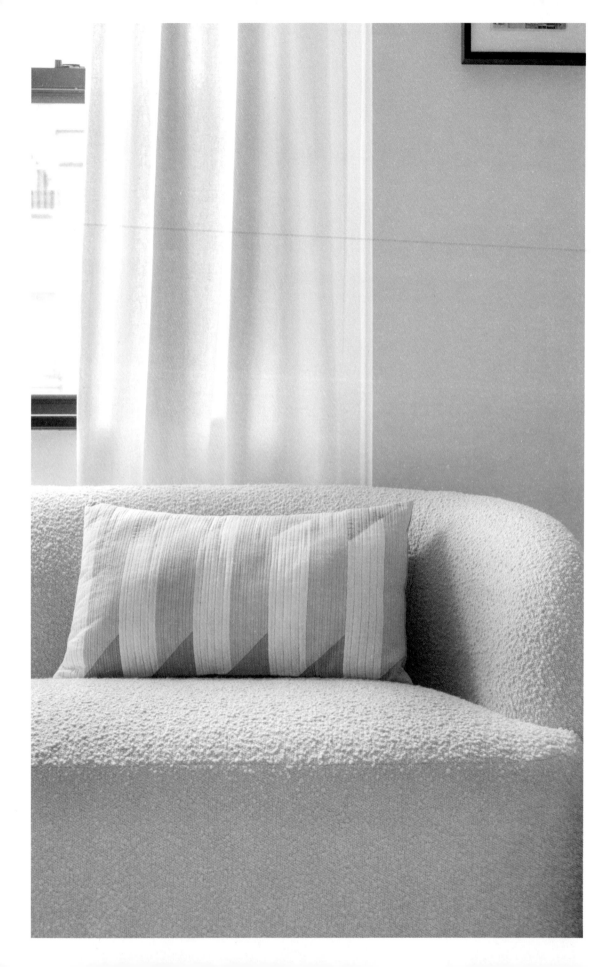

# DAY IN, DAY OUT LUMBAR CUSHION AND COASTERS

The decorative Day In, Day Out Lumbar Cushion is a reflection of the hard shadow lines cast into our apartment as the sun slowly comes up each day. It is also a reminder of another day to seize the moment and create more memories at home.

    **BONUS**: With the scraps from this project, you can create a set of five 4½"-square coasters. See *For Scrappy Coaster (page 174)* for all the details.

| | |
|---|---|
| **PROJECT SIZE** | 14" x 23½" (36 cm x 60 cm) |
| **PIECING METHODS AND TECHNIQUES** | Quick-corner units |
| **OTHER MATERIALS** | Batting; **FOR THE CUSHION**: Cushion insert, approximately 14" x 23½" (36 cm x 60 cm); Point turner (optional). **FOR SCRAPPY COASTERS**: Fusible heavyweight permanent stabilizer or interfacing (optional): This additional layer in the coaster sandwich provides more structure. Similar to batting and quilt back (in this instance, coaster back), the stabilizer needs to cover the entire area of the quilt top (coaster top), with some overhang. |

**DON'T WANT TO CREATE A CUSHION?** This project can also be made into wall hanging. Simply stop after *Basting and Quilting, Step 2*. Baste and quilt as desired, and follow the instructions on how to turn a quilt into a wall hanging on *page 60*.

**SHARE YOUR WORK ON SOCIAL MEDIA:** #dayindayoutcushion #theweekendquilter #quiltedhomehandbook

BEGINNER

## FABRIC REQUIREMENTS

| | |
|---|---|
| **CUSHION TOP** | |
| ■ FABRIC A | ⅜ yard (35 cm) |
| ▨ FABRIC B | ⅜ yard (35 cm) |
| ■ FABRIC C | ⅜ yard (35 cm) or 1 Fat Quarter (FQ) |
| **CUSHION BACK** | |
| ■ FABRIC D (CUSHION BACK) | ½ yard (46 cm) |
| **CUSHION TRIM** | |
| ■ FABRIC E | ⅛ yard (12 cm) or 1 Fat Eighth (FE) |
| **LINING (FOR CUSHION) OR BACKING (FOR WALL HANGING AND SCRAPPY COASTERS), FABRIC F** | |
| ☐ CUSHION | 2⅛ yards (195 cm) |
| ■ WALL HANGING | ¾ yard (69 cm) |
| ▨ ▨ ■ SCRAPPY COASTERS | ⅜ yard (35 cm) |
| **BINDING, FABRIC G (FOR WALL HANGING AND SCRAPPY COASTERS ONLY) …** | |
| ■ WALL HANGING | ¼ yard (23 cm) |
| ▨ ▨ ■ SCRAPPY COASTERS | ⅜ yard (35 cm) |

**FOR A WALL HANGING AND/OR SCRAPPY COASTERS:** Omit Fabrics D (cushion back) and E (trim), and adjust fabric requirement for Fabric F (lining), treating this as the fabric for the back of the wall quilt, tabs, and dowel casing to hang, and/or back of the coasters.

# CUTTING DIRECTIONS

## CUSHION FRONT

| | |
|---|---|
| ■■ FABRICS A & B | **EACH FABRIC, A & B, CUT:** |
| | 3 strips, 3" x WOF, sub-cut: |
| | • 5 rectangles, 3" x 15½" |
| ■ FABRIC C | **FOR ⅜ YARD (35 CM), CUT:** |
| | 1 strip, 5½" x WOF, sub-cut: |
| | • 5 squares, 5½" |
| | • 3 squares, 4" |
| | 1 strip, 4" x WOF, sub-cut: |
| | • 2 squares, 4" |
| | **FOR FAT QUARTER (FQ), CUT:** |
| | • 5 squares, 5½" |
| | • 5 squares, 4" |

## CUSHION BACK

| | |
|---|---|
| ■ FABRIC D | 1 strip, 15½" x WOF, sub-cut: |
| | • 2 rectangles, 15½" x 17½" |

## TRIM

| | |
|---|---|
| ■ FABRIC E | **FOR ⅛ YARD (12 CM), CUT:** |
| | 1 strip, 2" x WOF, sub-cut: |
| | • 2 rectangles, 2" x 17½" |
| | **FOR FAT EIGHTH (FE), CUT:** |
| | • 2 rectangles, 2" x 17½" |

## LINING (FOR CUSHION) OR BACKING (FOR WALL HANGING AND SCRAPPY COASTERS), FABRIC F

| | |
|---|---|
| ☐ CUSHION | 2 strips, 25" x WOF, sub-cut: |
| | • 2 rectangles, 25" x 23" |
| | 1 strip, 22" x WOF, sub-cut: |
| | • 1 rectangle, 22" x 33" |
| ■ WALL HANGING | 1 strip, 22" x WOF, sub-cut: |
| | • 1 rectangle, 22" x 33" |
| ■ SCRAPPY COASTERS | 1 strip, 10" x WOF |

## BINDING, FABRIC G (FOR WALL HANGING AND SCRAPPY COASTERS ONLY)

| | |
|---|---|
| ■ WALL HANGING | 3 strips, 2½" x WOF |
| ■ ■ ■ SCRAPPY COASTERS | 4 strips, 2½" x WOF |
| | Sew together all 4 Fabric G 2½" x WOF rectangles, as shown on *page 56, Preparing Binding Strips*. Cut sewn strip into approx. 5 Fabric G 2½" x 28" rectangles. |

## CUSHION TOP ASSEMBLY

**STEP 1:** As shown in the diagram, sew 1 Fabric A 3" x 15½" rectangle and 1 Fabric B 3" x 15½" rectangle together to create **1 STRIP A1** unit. Press the seams open.

**FABRIC B**
**3" x 15½"**

**FABRIC A**
**3" x 15½"**

**STRIP A1**
**5½" x 15½"**

Repeat to create a total of **5 STRIP A1** units. Set aside for *Cushion Top Assembly, Step 3.*

**STEP 2:** On the wrong side of all Fabric C 4" and 5½" squares, mark a diagonal guideline.

**FABRIC C**
**5½" SQU.**

**FABRIC C**
**4" SQU.**

**STEP 3:** Note the orientation of 1 Strip A1 unit and 1 Fabric C 4" square; with right sides together, place marked square on bottom right corner of 1 Strip A1 unit. Sew on the marked guideline to create **1 STRIP A2** unit.

**STRIP A2**
**5½" x 15½"**

Repeat to create a total of **5 STRIP A2** units.

**STEP 4:** Similar to the previous step, noting the direction of the marked guideline on Fabric C 5½" square, with right sides together, place the marked square on the top half of 1 Strip A2 unit, as shown. Sew on the marked guideline to create **1 STRIP A3** unit.

**STRIP A3**
**5½" x 15½"**

Repeat to create a total of **5 STRIP A3** units.

### FOR SCRAPPY COASTERS

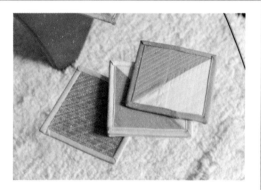

Before trimming a ¼" seam allowance in Step 5, sew a second seam ½" away from the first diagonal seam. Cut between the two seams. Now you have a half-square triangle (HST) instead of two scrappy triangle bits in your scrap stash.

With the larger HSTs, you can create a set of five 4½"-square coasters with batting and fabric scraps. Like you would a regular quilt, baste, quilt, and trim each quilt sandwich to 4½" square and bind as desired. For additional stability and structure, add a layer of iron-on fabric stabilizer between the coaster back and batting while basting the project.

Turn to *In Position Coasters, Basting, Quilting, and Binding, Step 1 (page 254)* to see how to maximize yardage when creating a coaster sandwich and speed up the quilting process.

Quilt and bind each coaster as desired.

**STEP 5:** Trim a ¼" seam allowance to the outside of the sewn guidelines on all Fabric C 4" and 5½" squares. Press the seams open to create a total of **5 STRIP A4** units.

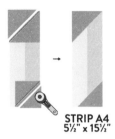

STRIP A4
5½" x 15½"

**STEP 6:** Following the diagram, sew together all 5 Strip A4 units to create **1 CUSHION TOP** unit. Press the seams open.

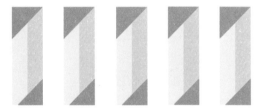

STRIP A4   STRIP A4   STRIP A4   STRIP A4   STRIP A4

↓

CUSHION TOP 15½ x 25½

## BASTING AND QUILTING

**STEP 1:** For this project you need to create a total of three cushion sandwiches: **1 CUSHION TOP SANDWICH** and **2 CUSHION BACK SANDWICHES**.

**WALL HANGING:** Create **1 CUSHION TOP SANDWICH**.

Each cushion sandwich consists of the following layers.

**CUSHION TOP SANDWICH**
+ Cushion Top unit (from the previous step)
+ Batting
+ 1 Fabric F 22" x 33" rectangle

*Cushion Top Sandwich:*

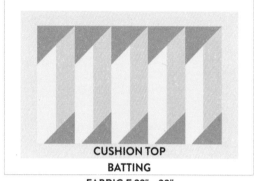

CUSHION TOP
BATTING
FABRIC F 22" x 33"

**CUSHION BACK SANDWICH**
+ 1 Fabric D 15½" x 17½" rectangle
+ Batting
+ 1 Fabric F 23" x 25" rectangle

*Cushion Back Sandwich:*

FABRIC D 15½" x 17½"
BATTING
FABRIC F 23" x 25"

Baste and quilt using your preferred method.

**STEP 2:** Trim excess batting and lining fabrics, and square up all cushion sandwiches. Take extra care when squaring up. Each cushion sandwich must measure:

+ Cushion Top Sandwich: 15½" x 25" rectangle
+ Cushion Back Sandwich: 15½" x 17½" rectangle

**FOR A WALL HANGING:** Follow Cushion Top Sandwich dimensions and see *How to Prepare a Quilted Wall Hanging* on *page 60* to complete the project.

**TIP:** Before removing excess batting and lining fabric, use a fabric marker or pen and ruler to mark out the measurements. This additional step ensures all edges of the cushion sandwich are straight, each corner is right-angled, and the cushion top design is not cut off while trimming.

## CUSHION TRIM

Attaching cushion trims is similar to attaching binding to a regular quilt project.

**STEP 1:** Start with 2 Fabric E 2" x 17½" rectangles. Fold each Fabric E rectangle in half lengthwise and press to create **2 TRIM** units.

**STEP 2:** With the wrong side of 1 Cushion Back Sandwich facing up, align the raw edge of 1 Trim unit with the shorter raw edge of the quilt sandwich. Sew ¼" away from the raw edge. Remember to backstitch the start and end of the seam.

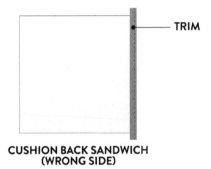

CUSHION BACK SANDWICH
(WRONG SIDE)

**STEP 3:** Fold the finished edge of the trim over to Fabric D Cushion Back. Use a coordinating thread and sew to secure the trim. Backstitch the start and end of the seam.

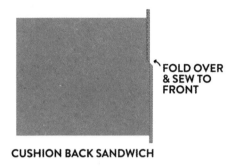

CUSHION BACK SANDWICH

**STEP 4:** Use a ruler and rotary cutter to remove excess trim.

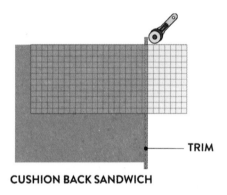

CUSHION BACK SANDWICH

**STEP 5:** Repeat Steps 1-4 with the second Cushion Back Sandwich.

## CUSHION ASSEMBLY

**STEP 1:** With right sides together, lay 1 Cushion Back Sandwich on top of Cushion Top Sandwich. Then, with the right sides together, lay the second Cushion Back Sandwich on top of the Cushion Top Sandwich and pin, as shown. Ensure the trims on the Cushion Back Sandwiches are positioned away from the outer edges of the cushion.

The 2 Cushion Back Sandwiches should lay partially on top of each other—this is intentional.

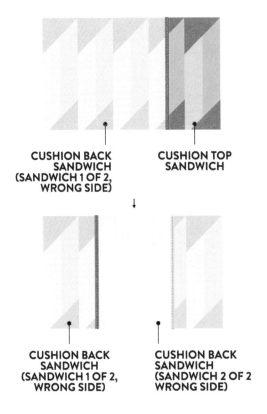

**CUSHION BACK SANDWICH (SANDWICH 1 OF 2, WRONG SIDE)**

**CUSHION TOP SANDWICH**

**CUSHION BACK SANDWICH (SANDWICH 1 OF 2, WRONG SIDE)**

**CUSHION BACK SANDWICH (SANDWICH 2 OF 2 WRONG SIDE)**

**STEP 2:** Sew all the way around the outer edge with a ½" seam allowance, backstitching at the beginning and end.

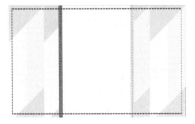

**STEP 3:** Use a serger or zigzag stitch to cover the raw edges to prevent them from fraying.

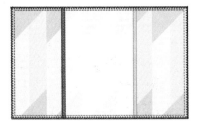

**STEP 4:** Carefully clip the corners without cutting into the seam. Turn the cushion right side out, poking out the corners to create a crisp and flat finish. Trim loose threads and insert a cushion to complete the project.

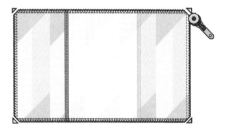

*Front of Cushion:*

*Back of Cushion:*

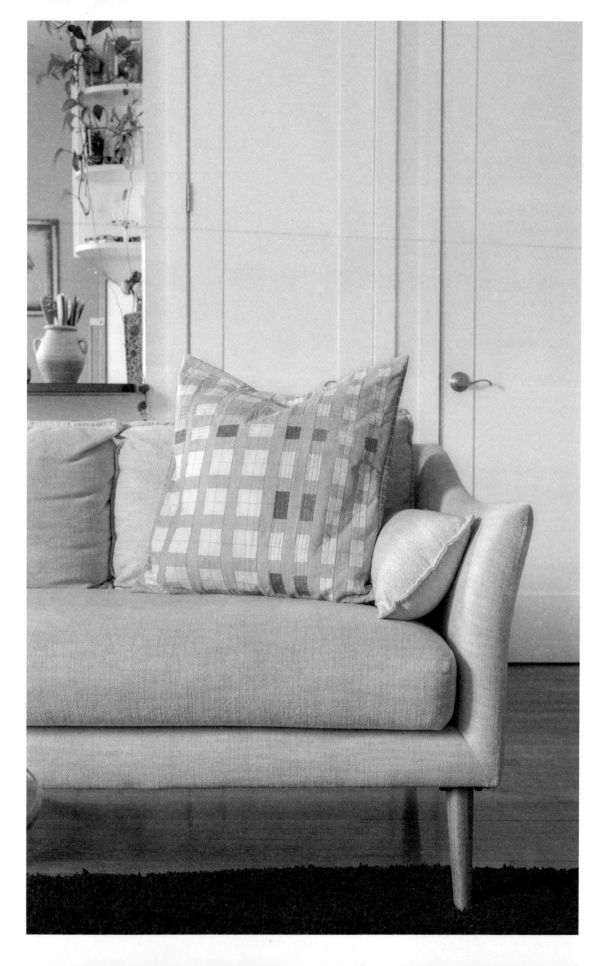

# WITHIN THE WALLS THROW CUSHION

A home is more than a physical structure. It is also a blank canvas where lasting and meaningful memories with loved ones can be created and embedded into the walls. Whether it's the significant milestones and repeating household traditions, or simple daily rituals like sitting on the windowsill with a cup of coffee in the morning, each home tells a different story—and each place you call home holds different memories in your heart.

The grid-like design on the Within the Walls Cushion is a bird's-eye view into the various rooms in a home. It can also be interpreted as a side view of a wall when it is taken apart, exposing the structural beams.

| | |
|---|---|
| **PROJECT SIZE** | 21" x 21" (54 cm x 54 cm) |
| **PIECING METHODS AND TECHNIQUES** | Strip piecing |
| **OTHER MATERIALS** | Batting; Cushion insert, approximately 21" x 21" (54 cm x 54 cm); Point turner (optional) |

**DON'T WANT TO CREATE A CUSHION?** This project can also be made into a wall hanging. Simply stop after *Basting and Quilting, Step 2* and follow the instructions on how to turn a quilt into a wall hanging on *page 60*.

**SHARE YOUR WORK ON SOCIAL MEDIA:** #withinthewallscushion #theweekendquilter #quiltedhomehandbook

BEGINNER

| FABRIC REQUIREMENTS | |
|---|---|
| **CUSHION TOP** | |
| ■ FABRIC A | ½ yard (46 cm) |
| ▢ FABRIC B | ¼ yard (23 cm) or 1 Fat Quarter (FQ) |
| ■ FABRIC C | ⅛ yard (12 cm) or 1 Fat Eighth (FE) |
| ■ FABRIC D | ⅛ yard (12 cm) or 1 FE |
| ■ FABRIC E | ⅛ yard (12 cm) or 1 FE |
| ▨ FABRIC F | ⅛ yard (12 cm) or 1 FE |
| **CUSHION BACK** | |
| ▨ FABRIC G | ¾ yard (69 cm) |
| **TRIM** | |
| ▨ FABRIC H | ¼ yard (23 cm) |
| **LINING (FOR CUSHION) OR BACKING (FOR WALL HANGING), FABRIC I** | |
| ▢ CUSHION | 2⅛ yards (195 cm) |
| ▨ WALL HANGING | 1 yard (92 cm) |
| **BINDING (FOR WALLING HANGING ONLY)** | |
| ▨ FABRIC J | ¼ yard (23 cm) |

Note: Fabrics C through F are scrap friendly. See *Cutting Directions* on *page 181-183* to determine how much scrap fabric is required to meet the project requirements.

**FOR A WALL HANGING:** Omit Fabrics G (cushion back) and H (trim), and adjust fabric requirement for Fabric I (lining), treating this as the fabric for the back of the wall quilt, tabs, and dowel casing to hang.

## CUTTING DIRECTIONS

**CUSHION FRONT**

■ FABRIC A

1 strip, 2" x WOF, sub-cut:
- 1 rectangle, 2" x 22½"
- 1 rectangle, 2" x 14½"
- 3 rectangles, 2" x 1½"

1 strip, 2" x WOF, sub-cut:
- 1 rectangle, 2" x 22½"
- 1 rectangle, 2" x 14½"
- 2 rectangles, 2" x 1½"

1 strip, 2" x WOF, sub-cut:
- 1 rectangle, 2" x 8"
- 1 rectangle, 2" x 6½"
- 1 rectangle, 1½" x 22½"

4 strips, 1½" x WOF, sub-cut:
- 4 rectangles, 1½" x 22½"
- 4 rectangles, 1½" x 14½"

1 strip, 1½" x WOF, sub-cut:
- 1 rectangle, 1½" x 22½"
- 2 rectangles, 1½" x 8"

1 strip, 1½" x WOF, sub-cut:
- 1 rectangle, 1½" x 22½"
- 1 rectangle, 1½" x 8"
- 1 rectangle, 1½" x 6½"
- 3 squares, 1½"

1 strip, 1½" x WOF, sub-cut:
- 2 rectangles, 1½" x 6½"
- 14 squares, 1½"

CONTINUED ON NEXT PAGE

## CUTTING DIRECTIONS, CONT.

| | |
|---|---|
| ▪ **FABRIC B** | **FOR ¼ YARD (23 CM):** |
| | 1 strip, 2½" x WOF, sub-cut: |
| | • 2 rectangles, 2½" x 14½" |
| | • 4 rectangles, 2½" x 1½" |
| | |
| | 1 strip, 2½" x WOF, sub-cut: |
| | • 2 rectangles, 2½" x 14½" |
| | • 2 rectangles, 1½" x 6½" |
| | |
| | 1 strip, 1½" x WOF, |
| | • 4 rectangles, 1½" x 8" |
| | • 4 squares, 1½" |
| | |
| | **FOR FAT QUARTER (FQ), CUT:** |
| | • 4 rectangles, 2½" x 14½" |
| | • 4 rectangles, 1½" x 8" |
| | • 2 rectangles, 1½" x 6½" |
| | • 4 rectangles, 1½" x 2½" |
| | • 4 squares, 1½" |
| ▪ **FABRIC C** | **FOR ⅛ YARD (12 CM), CUT:** |
| | 1 strip, 1½" x WOF, sub-cut: |
| | • 1 rectangle, 1½" x 6½" |
| | • 2 rectangles, 1½" x 2½" |
| | • 1 square, 1½" |
| | |
| | **FOR FAT EIGHTH (FE) OR SCRAPS, CUT:** |
| | • 1 rectangle, 1½" x 6½" |
| | • 2 rectangles, 1½" x 2½" |
| | • 1 square, 1½" |
| ▪ **FABRIC D** | **FOR ⅛ YARD (12 CM), CUT:** |
| | 1 strip, 1½" x WOF, sub-cut: |
| | • 1 rectangle, 1½" x 6½" |
| | • 2 squares, 1½" |
| | |
| | **FOR FE OR SCRAPS, CUT:** |
| | • 1 rectangle, 1½" x 6½" |
| | • 2 squares, 1½" |
| ▪ **FABRIC E** | **FOR ⅛ YARD (12 CM), CUT:** |
| | 1 strip, 1½" x WOF, sub-cut: |
| | • 2 rectangles, 1½" x 2½" |
| | • 2 squares, 1½" |
| | |
| | **FOR FE OR SCRAPS, CUT:** |
| | • 2 rectangles, 1½" x 2½" |
| | • 2 squares, 1½" |

| ▨ FABRIC F | **FOR ⅛ YARD (12 CM), CUT:** |
|---|---|
| | 1 strip, 1½" x WOF, sub-cut: |
| | 3 squares, 1½" |
| | **FOR FE OR SCRAPS, CUT:** |
| | • 3 squares, 1½" |

### CUSHION BACK

| ▨ FABRIC G | 1 strip, 22" x WOF, sub-cut: |
|---|---|
| | • 2 rectangles, 22" x 14½" |

### TRIM

| ▨ FABRIC H | 2 strips, 2" x WOF, sub-cut: |
|---|---|
| | • 2 rectangles, 2" x 24" |

### LINING (FOR CUSHION) OR BACKING (FOR WALL HANGING), FABRIC I

| □ CUSHION | 1 strip, 30" x WOF, sub-cut: |
|---|---|
| | • 1 square, 30" |
| | 2 strips, 22½" x WOF, sub-cut: |
| | • 2 rectangles, 22½" x 30" |
| ▨ WALL HANGING | 1 strip, 30" x WOF, sub-cut: |
| | • 1 square, 30" |

### BINDING (FOR WALL HANGING ONLY)

| ▨ FABRIC J | 3 strips, 2½" x WOF |
|---|---|

From sections *Strip Piecing Units* to *Cushion Top Assembly*, sew pieces right sides together **WITH SCANT ¼" SEAM ALLOWANCES**, unless specified otherwise.

## STRIP PIECING UNITS

**STEP 1**: Lay 1 Fabric A 2" x 14½" rectangle, 4 Fabric A 1½" x 14½" rectangles, and 4 Fabric B 2½" x 14½" rectangles in sewing order, as shown. Sew the strips lengthwise and press the seams open to create **1 STRIP SET A1** unit.

Set aside for *Strip Piecing Units, Step 4*.

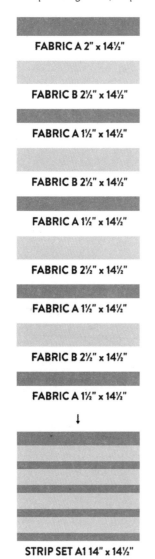

FABRIC A 2" x 14½"

FABRIC B 2½" x 14½"

FABRIC A 1½" x 14½"

FABRIC B 2½" x 14½"

FABRIC A 1½" x 14½"

FABRIC B 2½" x 14½"

FABRIC A 1½" x 14½"

FABRIC B 2½" x 14½"

FABRIC A 1½" x 14½"

↓

**STRIP SET A1 14" x 14½"**

**STEP 2**: Lay 1 Fabric A 2" x 8" rectangle, 3 Fabric A 1½" x 8" rectangles, and 4 Fabric B 1½" x 8" rectangles in sewing order, as shown. Sew the strips lengthwise and press the seams open to create **1 STRIP SET B1** unit.

Set aside for *Strip Piecing Units, Step 4*.

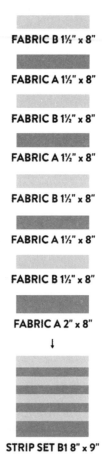

FABRIC B 1½" x 8"

FABRIC A 1½" x 8"

FABRIC B 1½" x 8"

FABRIC A 1½" x 8"

FABRIC B 1½" x 8"

FABRIC A 1½" x 8"

FABRIC B 1½" x 8"

FABRIC A 2" x 8"

↓

**STRIP SET B1 8" x 9"**

**STEP 3:** As shown in the diagram, sew together 1 Fabric A 2" x 6½" rectangle, 3 Fabric A 1½" x 6½" rectangles, 2 Fabric B 1½" x 6½" rectangles, 1 Fabric C 1½" x 6½" rectangle, and 1 Fabric D 1½" x 6½" rectangle to create **1 STRIP SET C1** unit.

Set aside for *Strip Piecing Units, Step 4.*

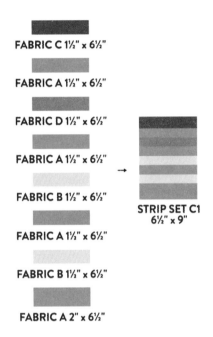

FABRIC C 1½" x 6½"

FABRIC A 1½" x 6½"

FABRIC D 1½" x 6½"

FABRIC A 1½" x 6½"

FABRIC B 1½" x 6½"

FABRIC A 1½" x 6½"

FABRIC B 1½" x 6½"

FABRIC A 2" x 6½"

**STRIP SET C1**
6½" x 9"

**STEP 4:** Trim the right-hand edge of all Strip Set units to ensure they are straight and perpendicular against the length of the strip set. If you are left-handed, trim the left-hand edge of all Strip Set units. *Strip Set A1 used in this example:*

**STRIP SET A1**

**TIP:** When trimming, use the top and bottom edges, and/or the seams of the Strip Set units, and the horizontal lines and marks on the ruler to align the strips for more accurate cutting and piecing.

**STEP 5:** Rotate the Strip Set units 180 degrees. Using the straight edge of the left-hand side (right-hand side if you are left-handed) as a guide, cut a total of:

| STRIP PIECING UNITS | NUMBER OF UNITS TO CUT |
|---|---|
| Set A2 2½" x 14" rectangles (from Strip Set A1 unit) | 4 units |
| Set A3 1½" x 14" rectangles (from Strip Set A1 unit) | 2 units |
| Set B2 2½" x 9" rectangles (from Strip Set B1 unit) | 2 units |
| Set B3 1½" x 9" rectangle (from Strip Set B1 unit) | 1 unit |
| Set C2 2½" x 9" rectangles (from Strip Set C2 unit) | 2 units |

*Strip Set A1 used in this example.*

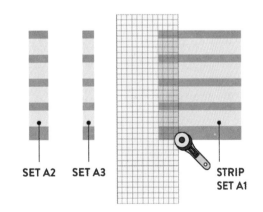

**SET A2**   **SET A3**   **STRIP SET A1**

## CUSHION TOP ASSEMBLY

**STEP 1:** Following the diagram, sew together
1 Set A3 rectangle, 1 Fabric A 2" x 1½" rectangle,
3 Fabric A 1½" squares, 2 Fabric B 1½" squares,
1 Fabric E 1½" square, and 1 Fabric F 1½" square
to create **1 ROW A1** unit. Press the seams open.

Set aside for *Cushion Top Assembly, Step 7.*

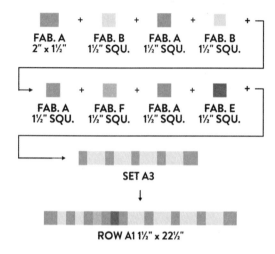

**STEP 2:** Combine 1 Set A3 unit and
1 Set B3 unit to create **1 ROW A2** unit.
Press the seams open.

Set aside for *Cushion Top Assembly, Step 7.*

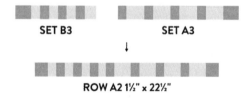

**STEP 3:** Sew together 2 Fabric A 2" x 1½" rect-
angles, 7 Fabric A 1½" squares, 1 Fabric B 1½"
square, 2 Fabric B 1½" x 2½" rectangles, 2 Fabric E
1½" x 2½" rectangles, 1 Fabric E 1½" square, and
2 Fabric F 1½" squares to create **1 ROW A3** unit.
Press the seams open.

Set aside for *Cushion Top Assembly, Step 7.*

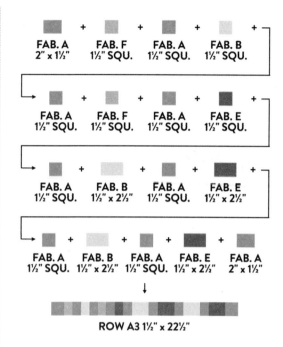

**STEP 4:** As shown in the diagram, sew together
2 Fabric A 2" x 1½" rectangles, 7 Fabric A 1½"
squares, 1 Fabric B 1½" square, 2 Fabric B 1½" x
2½" rectangles, 2 Fabric C 1½" x 2½" rectangles,
1 Fabric C 1½" square, and 2 Fabric D 1½" squares
to create **1 ROW A4** unit.

Set aside for *Cushion Top Assembly, Step 7.*

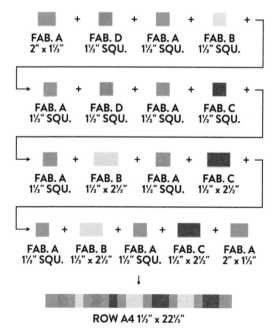

**STEP 5:** Combine 1 Set A2 unit and 1 Set B2 unit to form **1 ROW B1** unit. Press the seams open.

SET B2    SET A2

↓

ROW B1 2½" x 22½"

Repeat to create a total of **2 ROW B1** units. Set aside for *Cushion Top Assembly, Step 7.*

**STEP 6:** Sew together 1 Set A2 unit and 1 Set C2 unit to form **1 ROW B2** unit. Press the seams open.

SET C2    SET A2

↓

ROW B2 2½" x 22½"

Repeat to create a total of **2 ROW B2** units.

**STEP 7:** Following the diagram to the right, sew together the following to create **1 CUSHION TOP:** 2 Fabric A 2" x 22½" rectangles, 7 Fabric A 1½" x 22½" rectangles, 1 Row A1 unit, 1 Row A2 unit, 1 Row A3 unit, 1 Row A4 unit, 2 Row B1 units, and 2 Row B2 units. Press the seams open.

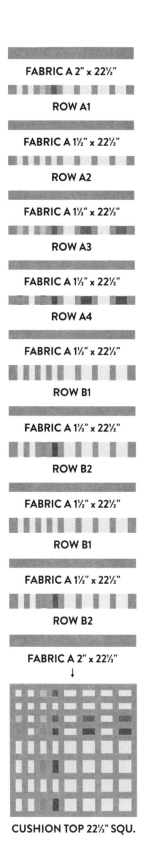

FABRIC A 2" x 22½"

ROW A1

FABRIC A 1½" x 22½"

ROW A2

FABRIC A 1½" x 22½"

ROW A3

FABRIC A 1½" x 22½"

ROW A4

FABRIC A 1½" x 22½"

ROW B1

FABRIC A 1½" x 22½"

ROW B2

FABRIC A 1½" x 22½"

ROW B1

FABRIC A 1½" x 22½"

ROW B2

FABRIC A 2" x 22½"

↓

CUSHION TOP 22½" SQU.

## BASTING AND QUILTING

**STEP 1:** For this project you need to create a total of three cushion sandwiches: **1 CUSHION TOP SANDWICH** and **2 CUSHION BACK SANDWICHES.**

**FOR A WALL HANGING:** Create **1 CUSHION TOP SANDWICH.**

Each cushion sandwich consists of the following layers.

### CUSHION TOP SANDWICH
+ Cushion Top unit (from previous step)
+ Batting
+ 1 Fabric I 30" square

### CUSHION BACK SANDWICH
+ 1 Fabric G 14½" x 22" rectangle
+ Batting
+ 1 Fabric I 22½" x 30" rectangle

Baste and quilt using your preferred method.

*Cushion Top Sandwich:*

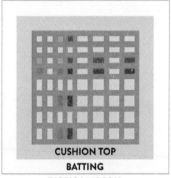

CUSHION TOP
BATTING
FABRIC I 30" SQU.

*Cushion Back Sandwich:*

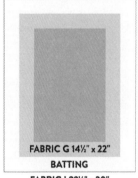

FABRIC G 14½" x 22"
BATTING
FABRIC I 22½" x 30"

**STEP 2:** Trim excess batting and lining fabrics, and square up all cushion sandwiches. Take extra care when squaring up. Each cushion sandwich must measure:

+ Cushion Top Sandwich: 22" square
+ Cushion Back Sandwich: 14½" x 22" rectangle

**FOR A WALL HANGING:** Follow Cushion Top Sandwich dimensions and see *How to Prepare a Quilted Wall Hanging* on *page 60* to complete the project.

**TIP:** Before removing excess batting and lining fabric, use a fabric marker or pen and ruler to mark out the measurements. This additional step ensures all edges of the cushion sandwich are straight, each corner is right-angled, and the cushion top design is not cut off while trimming.

## CUSHION TRIM

Attaching cushion trims is similar to attaching binding to a regular quilt project.

**STEP 1:** Start with 2 Fabric H 2" x 24" rectangles. Fold each Fabric H rectangle in half lengthwise and press to create **2 TRIM** units.

**STEP 2:** With the wrong side of 1 Cushion Back Sandwich facing up, align the raw edge of 1 Trim unit with the shorter raw edge of the quilt sandwich. Sew ¼" away from the raw edge. Remember to backstitch the start and end of the seam.

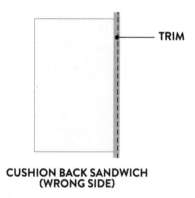

TRIM

CUSHION BACK SANDWICH
(WRONG SIDE)

**STEP 3:** Fold the finished edge of the trim over to Fabric G Cushion Back. Use a coordinating thread and sew to secure the trim. Backstitch the start and end of the seam.

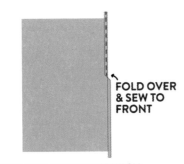

**CUSHION BACK SANDWICH**

**STEP 4:** Use a ruler and rotary cutter to remove excess trim.

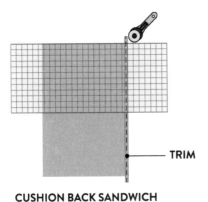

**CUSHION BACK SANDWICH**

**STEP 5:** Repeat Steps 1-4 with the second Cushion Back Sandwich.

## CUSHION ASSEMBLY

**STEP 1:** With right sides together, lay 1 Cushion Back Sandwich on top of Cushion Top Sandwich. Then, with right sides together, lay the second Cushion Back Sandwich on top of the Cushion Top Sandwich and pin, as shown. Ensure the trims on the Cushion Back Sandwiches are positioned away from the outer edges of the cushion.

The 2 Cushion Back Sandwiches should lay partially on top of each other—this is intentional.

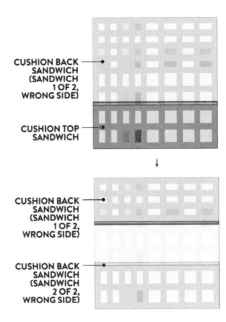

**STEP 2:** Sew all the way around the outer edge with a ½" seam allowance, backstitching at the beginning and end.

**STEP 3:** Use a serger or zigzag stitch to cover the raw edges to prevent them from fraying.

**STEP 4:** Carefully clip the corners without cutting into the seam. Turn the cushion right side out, poking out the corners with a point turner to create a crisp and flat finish. Trim loose threads and insert a cushion to complete the project.

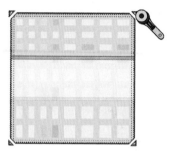

*Front of Cushion:*

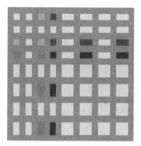

*Back of Cushion:*

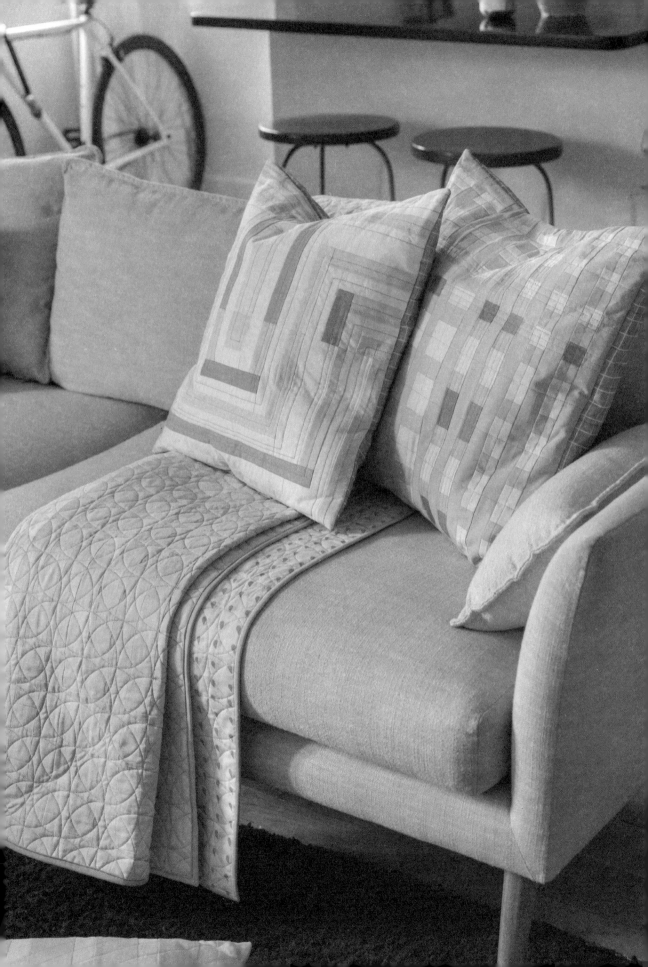

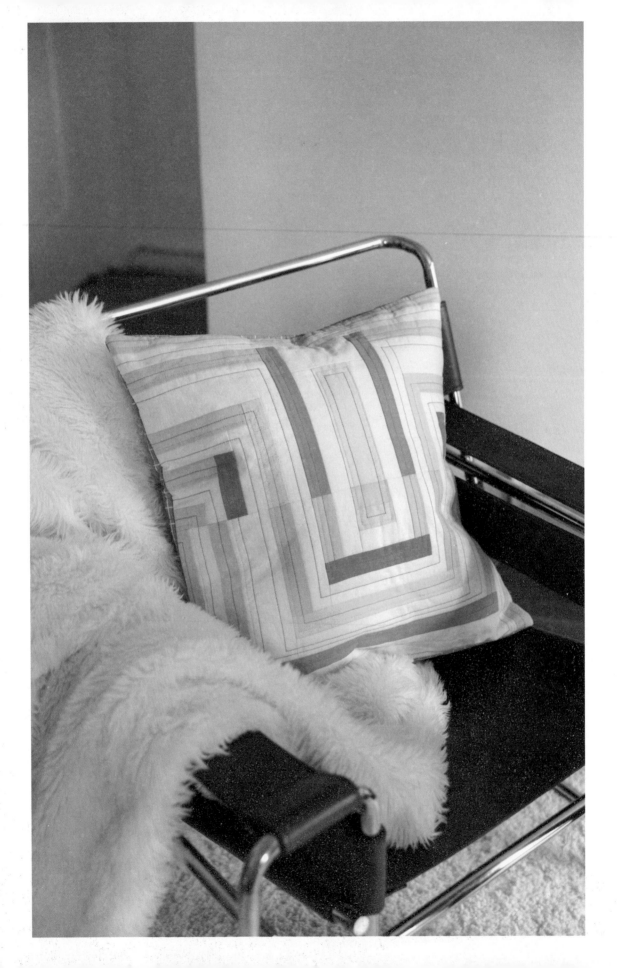

# SOUNDBARS THROW CUSHION

Aside from afternoon power naps, whenever we're in the living area, we have something on—music, a show, a movie, or a podcast. This decorative Soundbars Throw Cushion captures the energy and noise that fills the room. The design adds movement and a pop of color to any room in your home.

The design adopts techniques from traditional Log Cabin and Courthouse Steps quilt blocks. Both quilt blocks start with one square or rectangle in the middle, with strips added around the shape, circling around until desired block shape and size is reached.

| | |
|---|---|
| **PROJECT SIZE** | 20" x 20" (51 cm x 51 cm) |
| **PIECING METHODS AND TECHNIQUES** | Log Cabin, Courthouse Step blocks |
| **OTHER MATERIALS** | Batting; Cushion insert, approximately 20" x 20" (51 cm x 51 cm); Point turner (optional) |

**DON'T WANT TO CREATE A CUSHION?** This project can also be made into a wall hanging. Simply stop after *Basting and Quilting, Step 2* and follow the instructions on how to turn a quilt into a wall hanging on *page 60*.

**SHARE YOUR WORK ON SOCIAL MEDIA**: #soundbarscushion #theweekendquilter #quiltedhomehandbook

BEGINNER

## FABRIC REQUIREMENTS

### CUSHION TOP

| | |
|---|---|
| ☐ FABRIC A | ⅜ yard (35 cm) |
| ▨ FABRIC B | ¼ yard (23 cm) |
| ▨ FABRIC C | ⅛ yard (12 cm) or 1 Fat Eighth (FE) |
| ▨ FABRIC D | ⅛ yard (12 cm) or 1 FE |
| ▨ FABRIC E | ⅛ yard (12 cm) or 1 FE |
| ▨ FABRIC F | ⅛ yard (12 cm) or 1 FE |
| ▨ FABRIC G | ⅛ yard (12 cm) or 1 FE |

### CUSHION BACK

| | |
|---|---|
| ▨ FABRIC H | ½ yard (46 cm) |

### TRIM

| | |
|---|---|
| ▨ FABRIC I | ⅛ yard (12 cm) |

### LINING (FOR CUSHION) OR BACKING (FOR WALL HANGING), FABRIC J

| | |
|---|---|
| ☐ CUSHION | 1½ yards (138 cm) |
| ▨ WALL HANGING | ⅞ yard (80 cm) |

### BINDING (FOR WALL HANGING ONLY)

| | |
|---|---|
| ▨ FABRIC K | ¼ yard (23 cm) |

Fabrics C through G are scrap friendly. See *Cutting Directions* on *page 195-197* to determine how much scrap fabric is necessary to meet the project requirements.

**FOR A WALL HANGING:** Omit Fabrics H (cushion back) and I (trim), and adjust fabric requirement for Fabric J (lining), treating this as the fabric for the back of the wall quilt, tabs, and dowel casing to hang.

## CUTTING DIRECTIONS

### CUSHION FRONT

☐ FABRIC A

1 strip, 2½" x WOF, sub-cut:
- 2 rectangles, 2½" x 7½"
- 2 rectangles, 2½" x 6¾"
- 1 rectangle, 2½" x 4½"
- 2 rectangles, 2¾" x 3½"

1 strip, 1½" x WOF, sub-cut:
- 1 rectangle, 1½" x 21"
- 1 rectangle, 1½" x 10½"
- 2 rectangles, 1½" x 3½"

1 strip, 1½" x WOF, sub-cut:
- 2 rectangles, 1½" x 8½"
- 2 rectangles, 1½" x 6½"
- 1 rectangle, 1½" x 5½"

1 strip, 1½" x WOF, sub-cut:
- 1 rectangle, 1½" x 12½"
- 1 rectangle, 1½" x 7½"
- 1 rectangle, 1½" x 6½"
- 1 rectangle, 1½" x 5½"
- 2 rectangles, 1½" x 4¾"
- 2 rectangles, 1½" x 4½"

1 strip, 1½" x WOF, sub-cut:
- 1 rectangle, 1½" x 7½"
- 2 rectangles, 1½" x 2¾"
- 3 rectangles, 1½" x 2½"

FABRIC B

1 strip, 1¾" x WOF, sub-cut:
- 1 rectangle, 1¾" x 21"
- 2 rectangles, 1½" x 5¾"
- 1 rectangle, 1½" x 5½"
- 1 rectangle, 1½" x 2½"

1 strip, 1¾" x WOF, sub-cut:
- 2 rectangles, 1¾" x 10¾"
- 2 rectangles, 1¾" x 1½"
- 2 rectangles, 1½" x 7½"

1 strip, 1½" x WOF, sub-cut:
- 2 rectangles, 1½" x 7¾"
- 1 rectangle, 1½" x 5½"
- 2 rectangles, 1½" x 3¾"
- 2 rectangles, 1½" x 3½"

CONTINUED ON NEXT PAGE

## CUTTING DIRECTIONS, CONT.

| ▦ FABRIC C | **FOR ⅛ YARD (12 CM), CUT:** |
|---|---|
| | 1 strip, 2½" x WOF, sub-cut: |
| | • 1 rectangle, 2½" x 6½" |
| | • 1 rectangle, 1¾" x 12½" |
| | |
| | **FOR FE OR SCRAPS, CUT:** |
| | • 1 rectangle, 2½" x 6½" |
| | • 1 rectangle, 1¾" x 12½" |
| ▦ FABRIC D | **FOR ⅛ YARD (12 CM), CUT:** |
| | 1 strip, 1½" x WOF, sub-cut: |
| | • 1 rectangle, 1½" x 16½" |
| | • 2 rectangles, 1½" x 8½" |
| | |
| | **FOR FE OR SCRAPS, CUT:** |
| | • 1 rectangle, 1½" x 16½" |
| | • 2 rectangles, 1½" x 8½" |
| ▦ FABRIC E | **FOR ⅛ YARD (12 CM), CUT:** |
| | 1 strip, 1½" x WOF, sub-cut: |
| | • 1 rectangle, 1½" x 10½" |
| | • 2 rectangles, 1½" x 5½" |
| | |
| | **FOR FE OR SCRAPS, CUT:** |
| | • 1 rectangle, 1½" x 10½" |
| | • 2 rectangles, 1½" x 5½" |
| ▦ FABRIC F | **FOR ⅛ YARD (12 CM), CUT:** |
| | 1 strip, 1½" x WOF, sub-cut: |
| | • 1 rectangle, 1½" x 6½" |
| | • 2 rectangles, 1½" x 3½" |
| | |
| | **FOR FE OR SCRAPS, CUT:** |
| | • 1 rectangle, 1½" x 6½" |
| | • 2 rectangles, 1½" x 3½" |
| ▦ FABRIC G | **FOR ⅛ YARD (12 CM), CUT:** |
| | 1 strip, 1½" x WOF, sub-cut: |
| | • 1 rectangle, 1½" x 2½" |
| | • 2 squares, 1½" |
| | |
| | **FOR FE OR SCRAPS, CUT:** |
| | • 1 rectangle, 1½" x 2½" |
| | • 2 squares, 1½" |
| **CUSHION BACK** | |
| ▦ FABRIC H | 1 strip, 14½" x WOF, sub-cut: |
| | • 2 rectangles, 14½" x 21" |

| TRIM | |
|---|---|
| ▣ FABRIC I | 2 strips, 2" x WOF, sub-cut:<br>• 2 rectangles, 2" x 24" |
| **LINING (FOR CUSHION) OR BACKING (FOR WALL HANGING), FABRIC J** | |
| ☐ CUSHION | 1 strip, 26" x WOF, sub-cut:<br>• 2 rectangles, 26" x 21"<br><br>1 strip, 26" x WOF, sub-cut:<br>• 1 rectangle, 26" square |
| ▣ WALL HANGING | 1 strip, 26" x WOF, sub-cut:<br>• 1 rectangle, 26" square |
| **BINDING (FOR WALL HANGING ONLY)** | |
| ▣ FABRIC K | 3 strips, 2½" x WOF |

The Cushion Top is divided into two main sections: **CUSHION TOP A** and **CUSHION TOP B**. Sew all Cushion Top pieces right sides together with a **SCANT ¼" SEAM ALLOWANCES**, unless specified otherwise.

## CUSHION TOP A BLOCK

**STEP 1:** Assemble 1 **CUSHION TOP A1** unit in the order shown in the diagram. Press the seams open as you go to ensure accurate piecing.

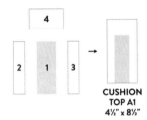

**CUSHION TOP A1**
4½" x 8½"

**ORDER:**

1. 1 Fabric C 2½" x 6½" rectangle
2. 1 Fabric A 1½" x 6½" rectangle
3. 1 Fabric A 1½" x 6½" rectangle
4. 1 Fabric A 2½" x 4½" rectangle

Set aside for *Cushion Top A Unit, Step 5.*

**STEP 2:** Create 1 **CUSHION TOP A2** unit in the order shown in the diagram. Press the seams open as you go.

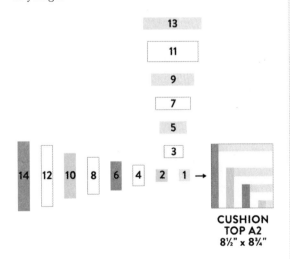

**CUSHION TOP A2**
8½" x 8¾"

**ORDER:**

1. 1 Fabric B 1½" x 1¾" rectangle
2. 1 Fabric G 1½" square
3. 1 Fabric A 1½" x 2¾" rectangle
4. 1 Fabric A 1½" x 2½" rectangle
5. 1 Fabric B 1½" x 3¾" rectangle
6. 1 Fabric F 1½" x 3½" rectangle
7. 1 Fabric A 1½" x 4¾" rectangle
8. 1 Fabric A 1½" x 4½" rectangle
9. 1 Fabric B 1½" x 5¾" rectangle
10. 1 Fabric E 1½" x 5½" rectangle
11. 1 Fabric A 2½" x 6¾" rectangle
12. 1 Fabric A 1½" x 7½" rectangle
13. 1 Fabric B 1½" x 7¾" rectangle
14. 1 Fabric D 1½" x 8½" rectangle

Set aside for *Cushion Top A Unit*, Step 5.

**STEP 3:** Create 1 **CUSHION TOP A3** unit in order shown in the diagram. Press the seams open as you go.

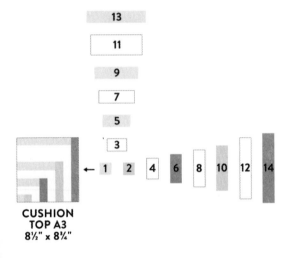

**CUSHION TOP A3**
8½" x 8¾"

**TIP:** The placement of squares and rectangles for a Cushion Top A3 unit mirrors the Cushion Top A2 unit.

**ORDER**

1. 1 Fabric B 1½" x 1¾" rectangle
2. 1 Fabric G 1½" square
3. 1 Fabric A 1½" x 2¾" rectangle
4. 1 Fabric A 1½" x 2½" rectangle

5. 1 Fabric B 1½" x 3¾" rectangle
6. 1 Fabric F 1½" x 3½" rectangle
7. 1 Fabric A 1½" x 4¾" rectangle
8. 1 Fabric A 1½" x 4½" rectangle
9. 1 Fabric B 1½" x 5¾" rectangle
10. 1 Fabric E 1½" x 5½" rectangle
11. 1 Fabric A 2½" x 6¾" rectangle
12. 1 Fabric A 1½" x 7½" rectangle
13. 1 Fabric B 1½" x 7¾" rectangle
14. 1 Fabric D 1½" x 8½" rectangle

Set aside for *Cushion Top A Unit, Step 5.*

**STEP 4**: Sew together 1 Fabric A 1½" x 21" rectangle and 1 Fabric B 1¾" x 21" rectangle to create **1 CUSHION TOP A4** unit. Press the seams open.

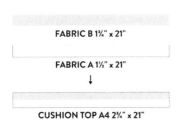

FABRIC B 1¼" x 21"

FABRIC A 1½" x 21"

↓

CUSHION TOP A4 2¾" x 21"

**STEP 5**: Following the diagram, combine 1 Cushion Top A1 unit, 1 Cushion Top A2 unit, 1 Cushion Top A3 unit, and 1 Cushion Top A4 unit to create **1 CUSHION TOP A BLOCK** unit. Press the seams open as you go.

Set aside for *Cushion Top Assembly, Step 1.*

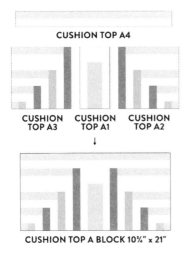

CUSHION TOP A4

CUSHION TOP A3 | CUSHION TOP A1 | CUSHION TOP A2

↓

CUSHION TOP A BLOCK 10¾" x 21"

# CUSHION TOP B BLOCK

**STEP 1**: Lay 1 Fabric B 1½" x 2½" rectangle, 1 Fabric G 1½" x 2½" rectangle, and 1 Fabric A 1½" x 2½" rectangle in sewing order. Combine to create **1 CUSHION TOP B1** unit. Press the seams open.

Set aside for *Cushion Top B Unit, Step 3.*

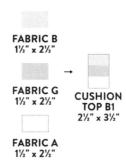

FABRIC B
1½" x 2½"

FABRIC G
1½" x 2½"

→   CUSHION
TOP B1
2½" x 3½"

FABRIC A
1½" x 2½"

**STEP 2**: Assemble **1 CUSHION TOP B2** unit in the order shown in the diagram. Press the seams open as you go.

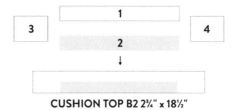

3 | 1 | 4
| 2 |

↓

CUSHION TOP B2 2¾" x 18½"

ORDER

1. 1 Fabric A 1½" x 12½" rectangle
2. 1 Fabric C 1¾" x 12½" rectangle
3. 1 Fabric A 2¾" x 3½" rectangle
4. 1 Fabric A 2¾" x 3½" rectangle

**STEP 3:** Create **1 CUSHION TOP B BLOCK** unit in the order shown in the diagram. Press the seams open as you go.

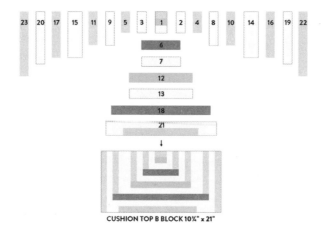

**CUSHION TOP B BLOCK 10¾" x 21"**

ORDER

1. 1 Cushion Top B1 unit
2. 1 Fabric A 1½" x 3½" rectangle
3. 1 Fabric A 1½" x 3½" rectangle
4. 1 Fabric B 1½" x 3½" rectangle
5. 1 Fabric B 1½" x 3½" rectangle
6. 1 Fabric F 1½" x 6½" rectangle
7. 1 Fabric A 1½" x 6½" rectangle
8. 1 Fabric A 1½" x 5½" rectangle
9. 1 Fabric A 1½" x 5½" rectangle
10. 1 Fabric B 1½" x 5½" rectangle
11. 1 Fabric B 1½" x 5½" rectangle
12. 1 Fabric E 1½" x 10½" rectangle
13. 1 Fabric A 1½" x 10½" rectangle
14. 1 Fabric A 2½" x 7½" rectangle
15. 1 Fabric A 2½" x 7½" rectangle
16. 1 Fabric B 1½" x 7½" rectangle
17. 1 Fabric B 1½" x 7½" rectangle
18. 1 Fabric D 1½" x 16½" rectangle
19. 1 Fabric A 1½" x 8½" rectangle
20. 1 Fabric A 1½" x 8½" rectangle
21. 1 Cushion Top B2 unit
22. 1 Fabric B 1¾" x 10¾" rectangle
23. 1 Fabric B 1¾" x 10¾" rectangle

## CUSHION TOP ASSEMBLY

**STEP 1:** Combine **1 CUSHION TOP A BLOCK** unit with **1 CUSHION TOP B BLOCK** unit to create **1 CUSHION TOP**. Press the seams open.

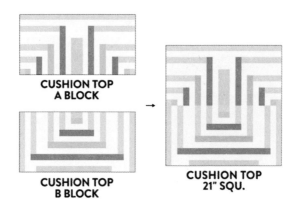

**CUSHION TOP A BLOCK**

**CUSHION TOP B BLOCK**

**CUSHION TOP 21" SQU.**

## BASTING AND QUILTING

**STEP 1:** For this project you need to create a total of three cushion sandwiches: **1 CUSHION TOP SANDWICH** and **2 CUSHION BACK SANDWICHES**.

**WALLING HANGING:** Create **1 CUSHION TOP SANDWICH**.

Each cushion sandwich consists of the following layers.

**CUSHION TOP SANDWICH**

+ Cushion Top unit (from previous step)
+ Batting
+ 1 Fabric J 26" square

**CUSHION BACK SANDWICH**

+ 1 Fabric H 14½" x 21" rectangle
+ Batting
+ 1 Fabric J 21" x 26" rectangle

Baste and quilt using your preferred method.

*Cushion Top Sandwich:*

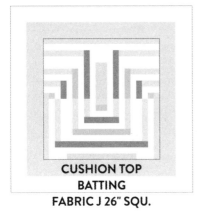

**CUSHION TOP**
**BATTING**
**FABRIC J 26" SQU.**

*Cushion Back Sandwich:*

**FABRIC H 14½" x 21"**
**BATTING**
**FABRIC J 21" x 26"**

**STEP 2:** Trim excess batting and lining fabrics, and square up all cushion sandwiches. Take extra care when squaring up. Each cushion sandwich must measure:

+ Cushion Top Sandwich: 21" square
+ Cushion Back Sandwich: 14½" x 21" rectangle

**FOR A WALL HANGING:** Follow Cushion Top Sandwich dimensions and see *How to Prepare a Quilted Wall Hanging* on *page 60* to complete the project.

**TIP:** Before removing excess batting and lining fabric, use a fabric marker or pen and ruler to mark out the measurements. This additional step ensures all edges of the cushion sandwich are straight, each corner is right-angled, and the cushion top design is not cut off while trimming.

## CUSHION TRIM

Attaching cushion trims is similar to attaching binding to a regular quilt project.

**STEP 1:** Start with 2 Fabric I 2" x 24" rectangles. Fold each Fabric I rectangle in half lengthwise and press to create **2 TRIM** units.

**STEP 2:** With the wrong side of 1 Cushion Back Sandwich facing up, align the raw edge of 1 Trim unit with the shorter raw edge of the quilt sandwich. Sew ¼" away from the raw edge. Remember to backstitch the start and end of the seam.

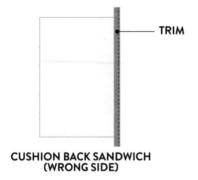

CUSHION BACK SANDWICH
(WRONG SIDE)

**STEP 3:** Fold the finished edge of the trim over to Fabric H Cushion Back. Use a coordinating thread and sew to secure the trim. Backstitch the start and end of the seam.

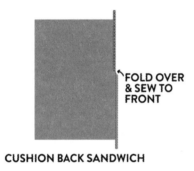

FOLD OVER
& SEW TO
FRONT

CUSHION BACK SANDWICH

**STEP 4:** Use a ruler and rotary cutter to remove excess trim.

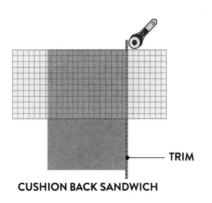

TRIM

CUSHION BACK SANDWICH

**STEP 5:** Repeat Steps 1-4 with the second Cushion Back Sandwich.

## CUSHION ASSEMBLY

**STEP 1:** With right sides together, lay 1 Cushion Back Sandwich on top of the Cushion Top Sandwich. Then, with right sides together, lay the second Cushion Back Sandwich on top of the Cushion Top Sandwich and pin, as shown. Ensure the trims on the Cushion Back Sandwiches are positioned away from the outer edges of the cushion.

The 2 Cushion Back Sandwiches should lay partially on top of each other—this is intentional.

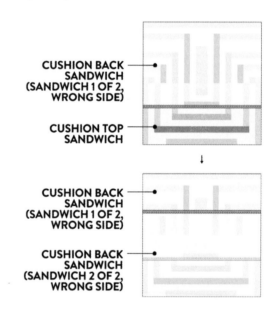

CUSHION BACK
SANDWICH
(SANDWICH 1 OF 2,
WRONG SIDE)

CUSHION TOP
SANDWICH

CUSHION BACK
SANDWICH
(SANDWICH 1 OF 2,
WRONG SIDE)

CUSHION BACK
SANDWICH
(SANDWICH 2 OF 2,
WRONG SIDE)

**STEP 2:** Sew all the way around the outer edge with a ½" seam allowance, backstitching at the beginning and end.

**STEP 3:** Use a serger or zigzag stitch to cover the raw edges to prevent them from fraying.

**STEP 4:** Carefully clip the corners without cutting into the seam. Turn the cushion right side out, poking out the corners with a point turner to create a crisp and flat finish. Trim loose threads and insert a cushion to complete the project.

*Front of Cushion:*

*Back of Cushion:*

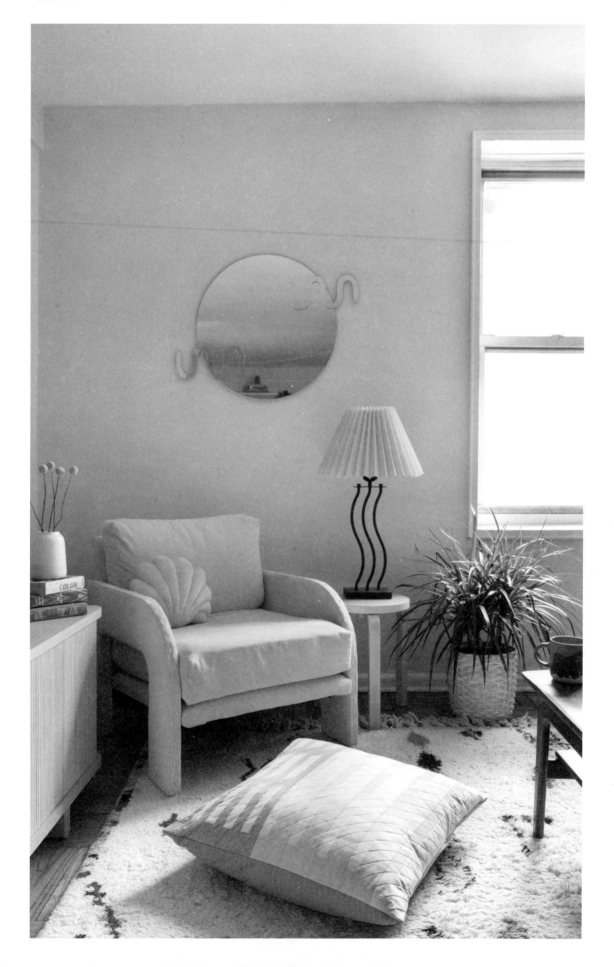

# BRICK-BY-BRICK FLOOR CUSHION

There's no place like home, even if it is temporary or a rental. Home is a place of relaxation after a long day, a place where we entertain and make new memories with friends and family. We should feel the most ease, comfort, and joy when we're at home. That's why creating a space that you and your household love and enjoy is important. However, building a space filled with personal and meaningful touches authentic to your household takes time. The Brick-by-Brick Floor Cushion is a great place to start. The larger cushion size isn't limited to just the floor. It can be used to create height and variation among cushions on the couch or bed. It also makes a great bed for four-legged friends.

| | |
|---|---|
| **PROJECT SIZE** | 25" x 25" (64 cm x 64 cm) |
| **PIECING METHODS AND TECHNIQUES** | Binding strips |
| **OTHER MATERIALS** | Batting; Cushion insert, approximately 25" x 25" (64 cm x 64 cm); Point turner (optional) |

**DON'T WANT TO CREATE A CUSHION?** This project can also be made into a wall hanging. Simply stop after *Basting and Quilting, Step 2* and follow the instructions on how to turn a quilt into a wall hanging on *page 60*.

**SHARE YOUR WORK ON SOCIAL MEDIA**: #brickbybrickcushion #theweekendquilter #quiltedhomehandbook

BEGINNER

## FABRIC REQUIREMENTS

| | |
|---|---|
| **CUSHION TOP** | |
| ■ FABRIC A | ¼ yard (23 cm) |
| ■ FABRIC B | ⅜ yard (35 cm) |
| ■ FABRIC C | ⅜ yard (35 cm) |
| □ FABRIC D | ⅛ yard (12 cm)* |
| **CUSHION BACK** | |
| ■ FABRIC E | ⅞ yard (80 cm) |
| **TRIM** | |
| ■ FABRIC F | ⅛ yard (12 cm)* |
| **LINING, FABRIC G** | |
| □ CUSHION | 2⅜ yards (218 cm) |
| ■ WALL HANGING | 1 yards (92 cm) |
| **BINDING (FOR WALL HANGING ONLY)** | |
| ■ FABRIC H | ¼ yard (23 cm) |

*Note: For Fabrics D and F, do not substitute with a fat eighth. The length of the fabric width is required to make up some of the cuts in the cutting directions.

**FOR A WALL HANGING:** Omit Fabrics E (cushion back) and F (trim), and adjust fabric requirement for Fabric G (lining), treating this as the fabric for the back of the wall quilt, tabs, and dowel casing to hang.

## CUTTING DIRECTIONS

| | |
|---|---|
| **CUSHION FRONT** | |
| ■ FABRIC A | 2 strips, 1½" x WOF, sub-cut:<br>• 9 rectangles, 1½" x 7½"<br><br>3 strips, 1½" x WOF, sub-cut:<br>• 18 rectangles, 1½" x 6½" |
| ■ FABRIC B | 1 strip, 2¾" x WOF, sub-cut:<br>• 1 rectangle, 2¾" x 26"<br>• 8 rectangles, 2¾" x 1½"<br><br>4 strips, 1½" x WOF, sub-cut:<br>• 4 rectangles, 1½" x 26"<br>• 8 rectangles, 1½" x 3½" |

| ■ FABRIC C | 1 strip, 2½" x WOF, sub-cut: |
|---|---|
| | • 1 rectangle, 2½" x 26" |
| | • 5 rectangles, 1½" x 2¾" |
| | |
| | 1 strip, 2½" x WOF, sub-cut: |
| | • 1 rectangle, 2½" x 26" |
| | • 3 rectangles, 1½" x 2¾" |
| | • 2 rectangles, 1½" x 3½" |
| | |
| | 1 strip, 2½" x WOF, sub-cut: |
| | • 1 rectangle, 2½" x 26" |
| | • 4 rectangles, 1½" x 3½" |
| | |
| | 1 strip, 2½" x WOF, sub-cut: |
| | • 1 rectangle, 2½" x 26" |
| | • 2 rectangles, 1½" x 3½" |
| □ FABRIC D | 1 strip, 2¾" x WOF, sub-cut: |
| | • 1 rectangle, 2¾" x 26" |
| | • 2 rectangles, 1½" x 2¾" |
| | • 2 rectangles, 1½" x 3½" |

**CUSHION BACK**

| ■ FABRIC E | 1 strip, 26" x WOF, sub-cut: |
|---|---|
| | 2 rectangles, 26" x 15½" |

**TRIM**

| ■ FABRIC F | 2 strips, 2" x WOF, sub-cut: |
|---|---|
| | 2 rectangles, 2" x 28" |

**LINING (FOR CUSHION) OR BACKING (FOR WALL HANGING), FABRIC G**

| □ CUSHION | 1 strip, 34" x WOF, sub-cut: |
|---|---|
| | • 1 square, 34" |
| | |
| | 2 strips, 23½" x WOF, sub-cut: |
| | • 2 rectangles, 23½" x 34" |
| ■ WALL HANGING | 1 strip, 34" x WOF, sub-cut: |
| | • 1 square, 34" |

**BINDING (FOR WALL HANGING ONLY)**

| ▪ FABRIC H | 3 strips, 2½" x WOF |
|---|---|

## STRIP UNITS

The strip unit construction in this section uses the same method as straight grain binding strips.

**TIP:** Many of the Fabrics A through D rectangles are similar in size. Separate them into piles by fabric color and size to avoid confusion and mistakes while piecing the Strip Units section.

**STEP 1:** On the wrong side of all Fabric A 1½" x 7½" rectangles, 9 Fabric A 1½" x 6½" rectangles, all Fabric B 1½" x 3½" rectangles, all Fabric C 1½" x 3½" rectangles, and all Fabric D 1½" x 3½" rectangles, mark a 45-degree diagonal guideline.

To do this, ensure the wrong side of the fabric is facing up, lay the rectangle horizontally and mark 1½" from the left edge. Use this 1½" guide to draw a 45-degree diagonal guideline from the bottom left corner.

*Fabric A 1½" x 7½" rectangle used in this example.*

**STEP 2:** With right sides together, place 1 marked Fabric B 1½" x 3½" rectangle on top of 1 unmarked Fabric A 1½" x 6½" rectangle, as shown. Sew on the guideline and trim a ¼" seam allowance outside of the sewn line to create **1 STRIP A1** unit. Press the seams open.

Repeat to create a total of **4 STRIP A1** units.

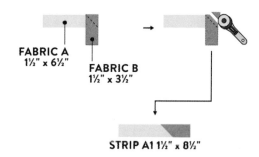

**STEP 3:** With right sides together, place 1 marked Fabric A 1½" x 7½" rectangle on top of 1 Strip A1 unit, as shown. Sew on the guideline and trim a ¼" seam allowance outside of the sewn line to create **1 STRIP A2** unit. Press the seams open.

Repeat to create a total of **4 STRIP A2** units.

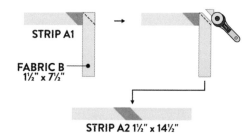

**STEP 4:** With right sides together, place 1 marked Fabric B 1½" x 3½" rectangle on top of 1 Strip A2 unit, as shown. Sew on the guideline and trim a ¼" seam allowance outside of the sewn line to create **1 STRIP A3** unit. Press the seams open.

Repeat to create a total of **4 STRIP A3** units.

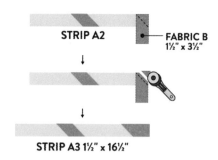

**STEP 5**: With right sides together, place 1 marked Fabric A 1½" x 6½" rectangle on top of 1 Strip A3 unit, as shown. Sew on the guideline and trim a ¼" seam allowance outside of the sewn line to create **1 STRIP A4** unit. Press the seams open.

Repeat to create a total of **4 STRIP A4** units.

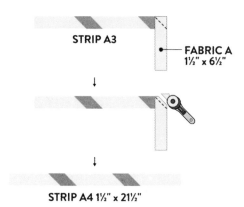

**STEP 6**: Create **1 STRIP A5** unit by sewing 1 Fabric B 1½" x 2¾" rectangle on each end of 1 Strip A4 unit with a **SCANT ¼" SEAM ALLOWANCE**, as shown. Press the seams open.

Repeat steps 2–6 to create a total of **4 STRIP A5** units. Set aside for *Cushion Top Assembly, Step 1.*

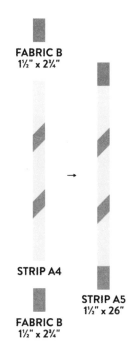

**STEP 7**: To create the strip B5 units, follow steps 2–6, using Fabric C 1½" x 3½" rectangles and Fabric C 1½" x 2¾" rectangles in place of the Fabric B rectangles. Begin with 1 unmarked Fabric A 1½" x 6½" strip. Create a total of **4 STRIP B5** units.

Set aside for *Cushion Top Assembly, Step 1.*

**STEP 8**: As in step 7, create 1 Strip C5 unit, alternating Fabrics A and D. Use Fabric D 1½" x 3½" rectangles and Fabric D 1½" x 2¾" rectangles in place of the Fabric B rectangles. Begin with 1 unmarked Fabric A 1½" x 6½" strip. Create a total of **1 STRIP C5** unit.

## CUSHION TOP ASSEMBLY

**STEP 1:** Following the diagram, sew together the following and press the seams open as you go to create
**1 CUSHION TOP** unit: 1 Fabric B 2¾" x 26" rectangle, 4 Fabric B 1½" x 26" rectangles, 4 Strip A5 units,
4 Fabric C 2½" x 26" rectangles, 4 Strip B5 units, 1 Strip C5 unit, and 1 Fabric D 2¾" x 26" rectangle.

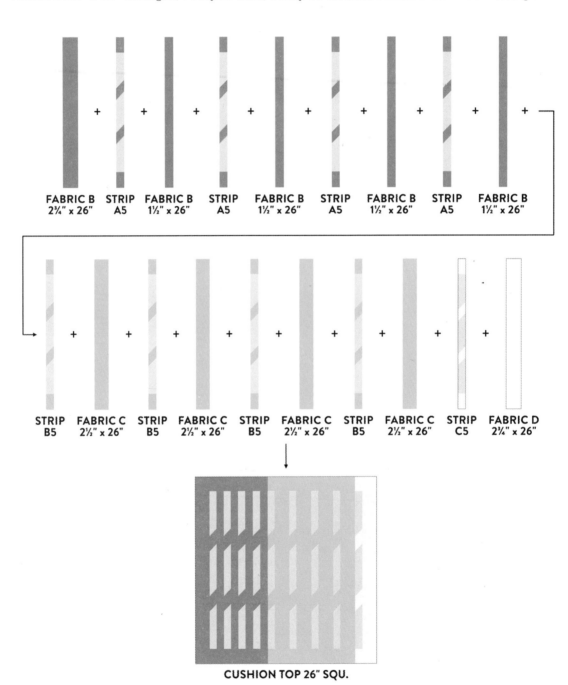

CUSHION TOP 26" SQU.

## BASTING AND QUILTING

**STEP 1:** For this project you need to create a total of three cushion sandwiches: **1 CUSHION TOP SANDWICH** and **2 CUSHION BACK SANDWICHES.**

**FOR A WALL HANGING:** Create *1 Cushion Top Sandwich.*

Each cushion sandwich consists of the following layers.

### CUSHION TOP SANDWICH
+ Cushion Top unit (from previous step)
+ Batting
+ 1 Fabric G 34" square

### CUSHION BACK SANDWICH
+ 1 Fabric E 15½" x 26" rectangle
+ Batting
+ 1 Fabric G 23½" x 34" rectangle

Baste and quilt using your preferred method.

*Cushion Top Sandwich:*

**CUSHION TOP**
**BATTING**
**FABRIC G 34" SQU.**

*Cushion Back Sandwich:*

**FABRIC E 15½" x 26"**
**BATTING**
**FABRIC G 23½" x 34"**

**STEP 2:** Trim excess batting and lining fabrics, and square up all cushion sandwiches. Take extra care when squaring up. Each cushion sandwich must measure:

+ Cushion Top Sandwich: 26" square
+ Cushion Back Sandwich: 15½" x 26" rectangle

**FOR A WALL HANGING:** Follow Cushion Top Sandwich dimensions and see *How to Prepare a Quilted Wall Hanging* on *page 60* to complete the project.

**TIP:** Before removing excess batting and lining fabric, use a fabric marker or pen and ruler to mark out the measurements. This additional step ensures all edges of the cushion sandwich are straight, each corner is right-angled, and the cushion top design is not cut off while trimming.

## CUSHION TRIM

Attaching cushion trims is similar to attaching binding to a regular quilt project.

**STEP 1:** Start with 2 Fabric F 2" x 28" rectangles. Fold each Fabric F rectangle in half lengthwise and press to create **2 TRIM** units.

**STEP 2:** With the wrong side of 1 Cushion Back Sandwich facing up, align the raw edge of 1 Trim unit with the shorter raw edge of the quilt sandwich. Sew ¼" away from the raw edge. Remember to backstitch the start and end of the seam.

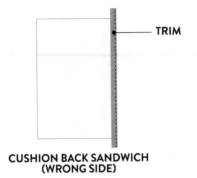

**CUSHION BACK SANDWICH
(WRONG SIDE)**

**STEP 3:** Fold the finished edge of the trim over to Fabric E Cushion Back. Use a coordinating thread and sew to secure the trim. Backstitch the start and end of the seam.

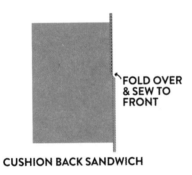

FOLD OVER & SEW TO FRONT

**CUSHION BACK SANDWICH**

**STEP 4:** Use a ruler and rotary cutter to remove excess trim.

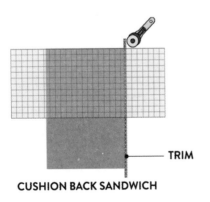

TRIM

**CUSHION BACK SANDWICH**

**STEP 5:** Repeat Steps 1-4 with the second Cushion Back Sandwich.

## CUSHION ASSEMBLY

**STEP 1:** With right sides together, lay 1 Cushion Back Sandwich on top of the Cushion Top Sandwich. Then, with the right sides together, lay the second Cushion Back Sandwich on top of the Cushion Top Sandwich and pin, as shown. Ensure the trims on the Cushion Back Sandwiches are positioned away from the outer edges of the cushion.

The 2 Cushion Back Sandwiches should lay partially on top of each other—this is intentional.

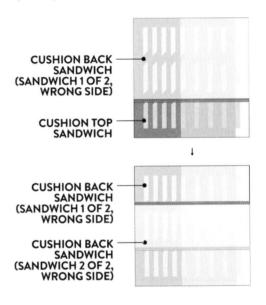

**CUSHION BACK SANDWICH
(SANDWICH 1 OF 2,
WRONG SIDE)**

**CUSHION TOP SANDWICH**

**CUSHION BACK SANDWICH
(SANDWICH 1 OF 2,
WRONG SIDE)**

**CUSHION BACK SANDWICH
(SANDWICH 2 OF 2,
WRONG SIDE)**

**STEP 2:** Sew all the way around the outer edge with a ½" seam allowance, backstitching at the beginning and end.

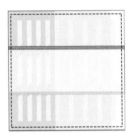

**STEP 3:** Use a serger or zigzag stitch to cover the raw edges to prevent them from fraying.

**STEP 4:** Carefully clip the corners without cutting into the seam. Turn the cushion right side out, poking out the corners with a point turner to create a crisp and flat finish. Trim loose threads and insert a cushion to complete the project.

*Front of Cushion:*

*Back of Cushion:*

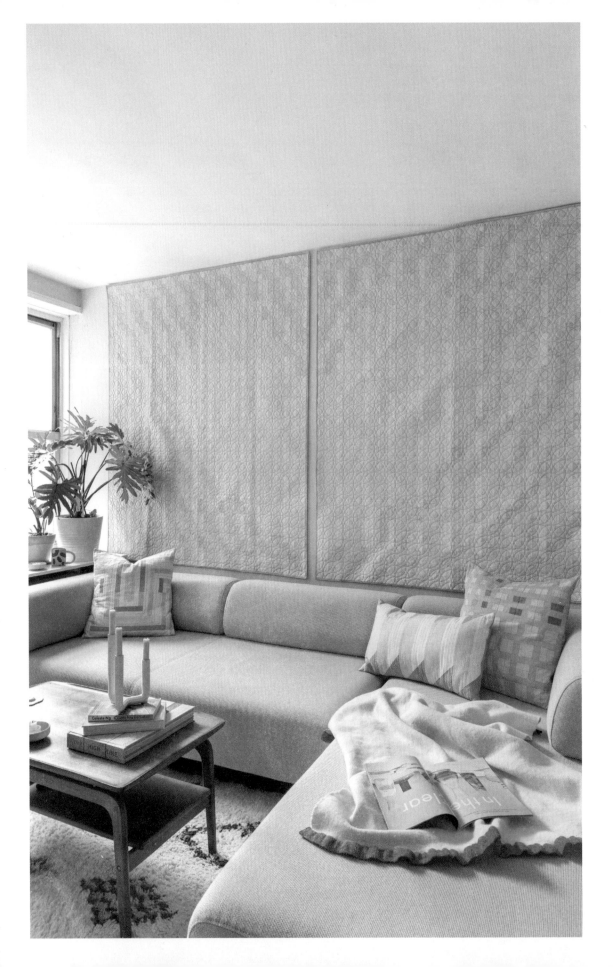

# NEVER FAR APART MATCHING THROW QUILTS

The Never Far Apart Matching Throw Quilts are all about bringing loved ones closer together—whether they are inches away from you on the couch or miles away on the other side of the world. Similar to a heart friendship necklace, these two quilts combined symbolize the special bond with a close friend or family member. It is also a celebration of the love that connects two people.

Want to create each throw size quilt in a different color scheme? That's totally possible—after all, one person might not have the same taste or preference in colors and prints as the other. The fabric requirements and cutting directions take into consideration making the throw quilts in two color schemes: one for each side of the heart (Version 2)—and one color scheme (Version 1).

| | |
|---|---|
| **PROJECT SIZE** | Two throw size quilts, each 60" x 72" |
| **PIECING METHODS AND TECHNIQUES** | Strip piecing |
| **OTHER MATERIALS** | Batting |

**TRANSFORMING THE QUILTS INTO A WALL HANGING**: This project can also be made into a wall hanging. Simply stop right before the binding is added, and follow the instructions on how to turn a quilt into a wall hanging on *page 60*.

Matching quilts would look great hung behind the beds in a shared room, college dorm, or children's room. They also make a great statement piece in the dining room, entryway, or living room.

**SHARE YOUR WORK ON SOCIAL MEDIA**: #neverfarapartquilts #theweekendquilter #quiltedhomehandbook

ADVANCED
BEGINNER

## FABRIC REQUIREMENTS
### VERSION 1: ONE COLOR SCHEME

| QUILT TOPS | |
| --- | --- |
| ▪ FABRIC A | 4½ yards (412 cm) |
| ▪ FABRIC B | 1⅞ yards (172 cm) |
| ▪ FABRIC C | 3½ yards (320 cm) |
| **QUILT BACKS** | |
| ▪ FABRIC D | 4 yards (366 cm) for each throw-size quilt |
| **BINDING** | |
| ▪ FABRIC E | 1 yard (92 cm) for both throw-size quilts |

## FABRIC REQUIREMENTS
### VERSION 2: TWO COLOR SCHEMES

| QUILT TOP | |
| --- | --- |
| ▪ FABRIC A | 2½ yards (229 cm) |
| ▪ FABRIC B | 1⅛ yards (103 cm) |
| ▪ FABRIC C | 2 yards (183 cm) |
| **QUILT BACK** | |
| ▪ FABRIC D | 4 yards (366 cm) |
| **BINDING** | |
| ▪ FABRIC E | ½ yard (46 cm) |

# CUTTING DIRECTIONS
## VERSION 1: ONE COLOR SCHEME

**QUILT TOP**

| FABRIC A | | |
|---|---|---|

**FABRIC A**

5 strips, 5" x WOF
(FOR STRIP PIECING)

6 strips, 2" x WOF
(FOR STRIP PIECING)

7 strips, 5" x WOF, sub-cut:
- 28 rectangles, 5" x 9½"

1 strip, 2" x WOF, sub-cut:
- 4 rectangles, 2" x 8"
- 1 rectangle, 2" x 6½"

1 strip, 5" x WOF, sub-cut:
- 2 rectangles, 5" x 9½"
- 4 rectangles, 2" x 8"

1 strip, 2" x WOF, sub-cut:
- 8 rectangles, 2" x 5"

3 strips, 5" x WOF, sub-cut:
- 12 rectangles, 5" x 9½"
- 6 rectangles, 2" x 3½"

1 strip, 2" x WOF, sub-cut:
- 2 rectangles, 2" x 6½"
- 4 rectangles, 2" x 5"

2 strips, 5" x WOF, sub-cut:
- 8 rectangles, 5" x 9½"
- 8 squares, 2"

1 strip, 2" x WOF, sub-cut:
- 1 rectangle, 2" x 6½"

14 strips, 3½" x WOF
(FOR STRIP PIECING)

**FABRIC B**

9 strips, 5" x WOF
(FOR STRIP PIECING)

9 strips, 2" x WOF
(FOR STRIP PIECING)

**FABRIC C**

11 strips, 5" x WOF
(FOR STRIP PIECING)

11 strips, 3½" x WOF
(FOR STRIP PIECING)

10 strips, 2" x WOF
(FOR STRIP PIECING)

1 strip, 2" x WOF, sub-cut:
- 8 rectangles, 2" x 5"

1 strip, 2" x WOF, sub-cut:
- 6 rectangles, 2" x 3½"
- 10 squares, 2"

1 strip, 2" x WOF, sub-cut:
- 6 squares, 2"

**BINDING**

**FABRIC E**

**FOR EACH QUILT:**

7 strips, 2½" x WOF

## CUTTING DIRECTIONS
### VERSION 2: TWO COLOR SCHEMES

**QUILT TOP**

| FABRIC A | 3 strips, 5" x WOF<br>(FOR STRIP PIECING) | 8 strips, 3½" x WOF<br>(FOR STRIP PIECING) |
|---|---|---|
| | 5 strips, 5" x WOF, sub-cut:<br>• 20 rectangles, 5" x 9½" | 3 strips, 2" x WOF<br>(FOR STRIP PIECING) |
| | 1 strip, 5" x WOF, sub-cut:<br>• 1 rectangle, 5" x 9½"<br>• 4 rectangles, 2" x 8" | 1 strip, 2" x WOF, sub-cut:<br>• 6 rectangles, 2" x 5"<br>• 3 rectangles, 2" x 3½" |
| | 1 strip, 5" x WOF, sub-cut:<br>• 4 rectangles, 5" x 9½"<br>• 4 rectangles, 2" x 3½" | 1 strip, 2" x WOF, sub-cut:<br>• 2 rectangles, 2" x 6½"<br>• 1 square, 2" |
| FABRIC B | 5 strips, 5" x WOF<br>(FOR STRIP PIECING) | |
| | 5 strips, 2" x WOF<br>(FOR STRIP PIECING) | |
| FABRIC C | 6 strips, 5" x WOF<br>(FOR STRIP PIECING) | |
| | 6 strips, 3½" x WOF<br>(FOR STRIP PIECING) | |
| | 6 strips, 2" x WOF<br>(FOR STRIP PIECING) | |
| | 1 strip, 2" x WOF, sub-cut:<br>• 4 rectangles, 2" x 5"<br>• 2 rectangles, 2" x 3½"<br>• 7 squares, 2" | |
| | 1 strip, 2" x WOF, sub-cut:<br>• 1 rectangle, 2" x 3½"<br>• 2 squares, 2" | |

**BINDING**

| FABRIC E | 7 strips, 2½" x WOF | |
|---|---|---|

The following instructions apply to both Version 1 and 2. The diagrams shown throughout the pattern use Version 1 as an example. From sections *Strip Piecing Units* to *Block Assembly*, sew pieces with right sides together, **WITH SCANT ¼" SEAM ALLOWANCES**, unless specified otherwise.

## STRIP PIECING UNITS

**STEP 1:** Create **1 STRIP SET A** unit by sewing together 1 Fabric B 2" x WOF strip, 1 Fabric B 5" x WOF strip, and 1 Fabric C 3½" x WOF strip in sewing order, as shown in the diagram. Press the seams open.

**FABRIC B 2" x WOF**

**FABRIC C 3½" x WOF**

**STRIP SET A 9½" x WOF**

**FABRIC B 5" x WOF**

REPEAT TO CREATE A TOTAL OF:
Version 1: 6 Strip Set A units
Version 2: For each quilt: 3 Strip Set A units

Set aside for *Strip Piecing Units, Step 11.*

**STEP 2:** With right sides together, sew 1 Fabric A 3½" x WOF strip, 1 Fabric B 5" x WOF strip, and 1 Fabric B 2" x WOF strip to create **1 STRIP SET B** unit. Press the seams open.

**FABRIC B 2" x WOF**

**FABRIC A 3½" x WOF**

**STRIP SET B 9½" x WOF**

**FABRIC B 5" x WOF**

REPEAT TO CREATE A TOTAL OF:
Version 1: 3 Strip Set B units
Version 2: For each quilt: 2 Strip Set B units

Set aside for *Strip Piecing Units, Step 11.*

**STEP 3:** Referring to the diagram shown, create **1 STRIP SET C** by combining 1 Fabric A 2" x WOF strip, 1 Fabric A 3½" x WOF strip, and 1 Fabric C 5" x WOF strip. Press the seams open.

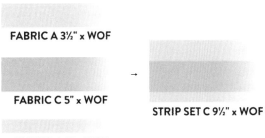

**FABRIC A 3½" x WOF**

**FABRIC C 5" x WOF**

**STRIP SET C 9½" x WOF**

**FABRIC A 2" x WOF**

REPEAT TO CREATE A TOTAL OF:
Version 1: 6 Strip Set C units
Version 2: For each quilt: 3 Strip Set C units

Set aside for *Strip Piecing Units, Step 11.*

**STEP 4:** Create **1 STRIP SET D** unit by sewing together 1 Fabric A 3½" x WOF strip, 1 Fabric C 5" x WOF strip, and 1 Fabric C 2" x WOF strip. Press the seams open.

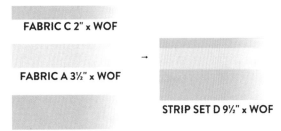

**FABRIC C 2" x WOF**

**FABRIC A 3½" x WOF**

**STRIP SET D 9½" x WOF**

**FABRIC C 5" x WOF**

REPEAT TO CREATE A TOTAL OF:
Version 1: 5 Strip Set D units
Version 2: For each quilt: 3 Strip Set D units

Set aside for *Strip Piecing Units, Step 11.*

**STEP 5:** Lay 1 Fabric A 5" x WOF strip, 1 Fabric C 3½" x WOF strip, and 1 Fabric C 2" x WOF strip in sewing order, as shown in the diagram. Sew together to create **1 STRIP SET E** unit and press the seams open.

*(Step 5 continued on next page)*

*(Continued from step 5)*

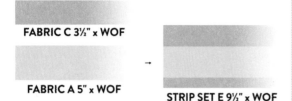

**REPEAT TO CREATE A TOTAL OF:**

Version 1: 5 Strip Set E units

Version 2: For each quilt: 3 Strip Set E units

Set aside for *Strip Piecing Units, Step 11.*

**STEP 6:** Create **1 SET F** unit by combining 1 Fabric A 2" x 3½" rectangle, 1 Fabric A 2" square, 1 Fabric C 2" x 3½" rectangle, and 1 Fabric C 2" square. Press the seams open.

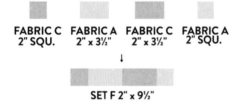

**REPEAT TO CREATE A TOTAL OF:**

Version 1: 2 Set F units

Version 2: For each quilt: 1 Set F unit

Set aside for *Block Assembly, Step 5.*

**STEP 7:** Sew together 1 Fabric A 2" x 5" rectangle and 1 Fabric C 2" x 5" rectangle to create **1 SET G** unit. Press the seams open.

**REPEAT TO CREATE A TOTAL OF:**

Version 1: 8 Set G units

Version 2: For each quilt: 4 Set G units

Set aside for *Block Assembly, Step 3.*

**STEP 8:** Combine 1 Fabric A 2" x 6½" rectangle and 1 Fabric C 2" x 3½" rectangle to create **1 SET H** unit. Press the seams open.

**REPEAT TO CREATE A TOTAL OF:**

Version 1: 4 Set H units

Version 2: For each quilt: 2 Set H units

Set aside for *Block Assembly, Step 5.*

**STEP 9:** Create **1 SET I** unit by sewing together 1 Fabric A 2" x 8" rectangle and 1 Fabric C 2" square. Press the seams open.

**REPEAT TO CREATE A TOTAL OF:**

Version 1: 8 Set I units

Version 2: For each quilt: 4 Set I units

Set aside for *Block Assembly, Step 3.*

**STEP 10:** Create **1 SET J** unit by sewing together 1 Fabric A 2" x 5" rectangle, 1 Fabric A 2" x 3½" rectangle, and 1 Fabric C 2" square. Press the seams open.

**REPEAT TO CREATE A TOTAL OF:**
Version 1: 4 Set J units
Version 2: For each quilt: 2 Set J units

Set aside for *Block Assembly, Step 4.*

**STEP 11:** Trim the right-hand edge of all Strip Set A to E units from *Strip Piecing Units, Steps 1-5* to ensure they are straight and perpendicular against the length of the strip set. If you are left-handed, trim the left-hand edge of all Strip Set units. *Strip Set A used in this example.*

**STRIP SET A**

TIP: When trimming, use the top and bottom edges, and/or the seams of the Strip Set units, and the horizontal lines and marks on the ruler to align the strips for more accurate cutting and piecing.

**STEP 12:** Rotate each of the Strip Set A to E units 180 degrees. Using the straight edge of the left-hand side (right-hand side if you are left-handed) as a guide, cut a total of:

| | VERSION 1 | VERSION 2 |
|---|---|---|
| Set A 2" x 9½" rectangles (from Strip Set A) | 108 units | 54 units |
| Set B 2" x 9½" rectangles (from Strip Set B) | 52 units | 26 units |
| Set C 2" x 9½" rectangles (from Strip Set C) | 106 units | 53 units |
| Set D 2" x 9½" rectangles (from Strip Set D) | 100 units | 50 units |
| Set E 2" x 9½" rectangles (from Strip Set E) | 98 units | 49 units |

Set aside for *Block Assembly, Steps 1-6. Strip Set A used in this example:*

**SET A**          **STRIP SET A**

Sections *Block Assembly* and *Quilt Assembly* apply to both **VERSION 1** (one color scheme) and **VERSION 2** (two color schemes). For the remainder of the pattern, the instructions are broken down into **LEFT HEART** and **RIGHT HEART**. Left Heart is the first throw-size quilt and should be positioned on the left when the two throw quilts are combined. The Right Heart is the second throw-size quilt and should be positioned on the right when the two throw quilts are combined. The placement of the Set units and Block units for each quilt mirrors the other.

## BLOCK ASSEMBLY

**STEP 1:** Combine the following units to create **1 BLOCK A1** unit and **1 BLOCK A2** unit: 1 Set A unit, 1 Set C unit, 1 Set D unit, and 1 Set E unit. Press the seams open.

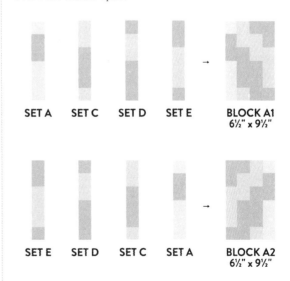

SET A   SET C   SET D   SET E   →   **BLOCK A1**
6½" x 9½"

SET E   SET D   SET C   SET A   →   **BLOCK A2**
6½" x 9½"

*(Step 1 continued on next page)*

*(Continued from step 1)*

**REPEAT TO CREATE A TOTAL OF:**

|  | LEFT HEART | RIGHT HEART |
|---|---|---|
| Block A1 unit | 47 units | n/a |
| Block A2 unit | n/a | 47 units |

Set Block A1 units aside for *Quilt Assembly, Steps 1-8* and Block A2 units for *Quilt Assembly, Steps 10-17.*

**STEP 2:** As shown in the diagram, for each **BLOCK B1** unit and **BLOCK B2** unit, sew together: 1 Set B unit and 1 Fabric A 5" x 9½" unit. Press the seams open.

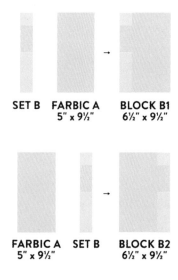

SET B     FARBIC A     BLOCK B1
          5" x 9½"     6½" x 9½"

FARBIC A     SET B     BLOCK B2
5" x 9½"               6½" x 9½"

**REPEAT TO CREATE A TOTAL OF:**

|  | LEFT HEART | RIGHT HEART |
|---|---|---|
| Block B1 unit | 25 units | n/a |
| Block B2 unit | n/a | 25 units |

Set Block B1 units aside for *Quilt Assembly, Steps 2-7* and Block B2 units for *Quilt Assembly, Steps 11-16.*

**STEP 3:** For each **BLOCK C1** unit and **BLOCK C2** unit, combine: 1 Set A unit, 1 Set C unit, 1 Set G unit, and 1 Set I unit. Press the seams open.

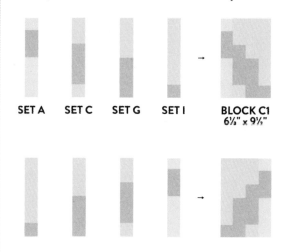

SET A     SET C     SET G     SET I     BLOCK C1
                                        6½" x 9½"

**REPEAT TO CREATE A TOTAL OF:**

|  | LEFT HEART | RIGHT HEART |
|---|---|---|
| Block C1 unit | 4 units | n/a |
| Block C2 unit | n/a | 4 units |

Set Block C1 units aside for *Quilt Assembly, Steps 5-8* and Block C2 units for *Quilt Assembly, Steps 14-17.*

**STEP 4:** Following the diagram, for each **BLOCK D1** unit and **BLOCK D2** unit, sew together: 1 Set A unit, 1 Set D unit, 1 Set E unit, and 1 Set J unit. Press the seams open.

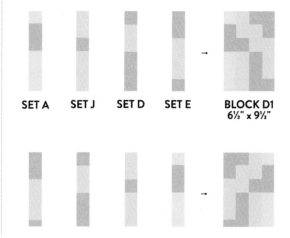

SET A     SET J     SET D     SET E     BLOCK D1
                                        6½" x 9½"

REPEAT TO CREATE A TOTAL OF:

|  | LEFT HEART | RIGHT HEART |
| --- | --- | --- |
| Block D1 unit | 2 units | n/a |
| Block A2 unit | n/a | 2 units |

Set Block D1 units aside for *Quilt Assembly, Steps 2 and 3* and Block D2 units for *Quilt Assembly, Steps 11 and 12.*

**STEP 5:** As shown in the diagram, for each **BLOCK E1** unit and **BLOCK E2** unit, sew together: 1 Set B unit, 1 Set C unit, 1 Set F unit, and 1 Set H unit. Press the seams open. Create a total of **1 BLOCK E1** unit for *Left Heart Quilt only* and **1 BLOCK E2** unit for *Right Heart Quilt only.*

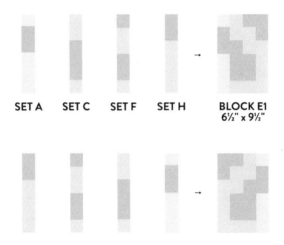

SET A   SET C   SET F   SET H   BLOCK E1
6½" x 9½"

Set Block B1 unit aside for *Quilt Assembly, Step 1* and Block E2 unit for *Quilt Assembly, Step 10.*

**STEP 6:** Following the diagram, for each **BLOCK F1** unit and **BLOCK F2** unit, sew together: 1 Set A unit, 1 Set C unit, 1 Set D unit, and 1 Set H unit. Create a total of **1 BLOCK F1** unit for *the Left Heart only* and **1 BLOCK F2** unit *for Right Heart Quilt only.*

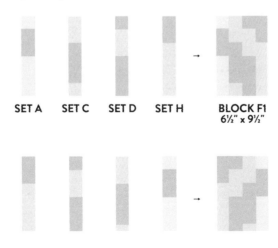

SET A   SET C   SET D   SET H   BLOCK F1
6½" x 9½"

# QUILT ASSEMBLY

*Steps 1-9* in this section apply to *Left Heart Quilt* and *Steps 10-18* apply to *Right Heart Quilt*.

## FOR LEFT HEART QUILT:

**STEP 1:** Combine 9 Block A1 units and 1 Block E1 unit to create **1 ROW A1** unit. Press the seams open.

Set aside for *Quilt Assembly, Step 9.*

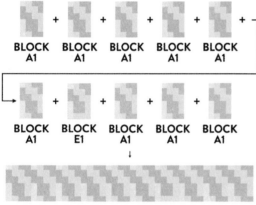

ROW A1 9½" x 60½"

**STEP 2:** Sew together 5 Block A1 units, 3 Block B1 units, 1 Block D1 unit, and 1 Block F1 unit to create **1 ROW B1** unit. Press the seams open.

Set aside for *Quilt Assembly, Step 9.*

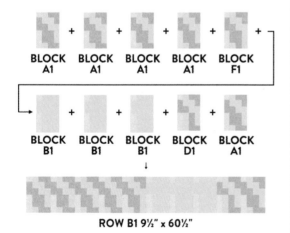

ROW B1 9½" x 60½"

**STEP 3:** Create **1 ROW C1** unit by sewing together 4 Block A1 units, 5 Block B1 units, and 1 Block D1 unit. Press the seams open.

Set aside for *Quilt Assembly, Step 9.*

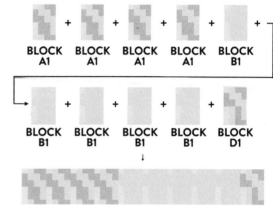

ROW C1 9½" x 60½"

**STEP 4:** Create **1 ROW D1** unit by sewing together 4 Block A1 units and 6 Block B1 units. Press the seams open.

Set aside for *Quilt Assembly, Step 9.*

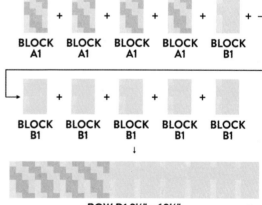

ROW D1 9½" x 60½"

**STEP 5:** Create **1 ROW E1** unit by combining 4 Block A1 units, 5 Block B1, and 1 Block C1 unit. Press the seams open.

Set aside for *Quilt Assembly, Step 9.*

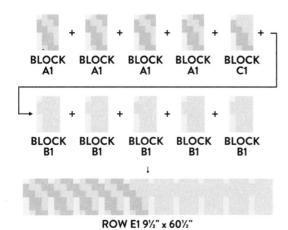

ROW E1 9½" x 60½"

**STEP 6:** Sew together 5 Block A1 units, 4 Block B1 units, and 1 Block C1 unit to create **1 ROW F1** unit. Press the seams open.

Set aside for *Quilt Assembly, Step 9.*

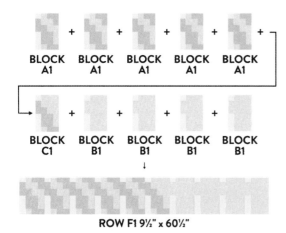

ROW F1 9½" x 60½"

**STEP 7:** Sew together 7 Block A1 units, 2 Block B1 units, and 1 Block C1 unit to create **1 ROW G1** unit. Press the seams open.

Set aside for *Quilt Assembly, Step 9.*

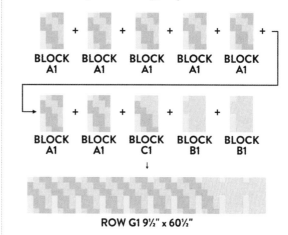

ROW G1 9½" x 60½"

**STEP 8:** Create **1 ROW H1** unit by sewing together 9 Block A1 units and 1 Block C1 unit. Press the seams open.

Set aside for *Quilt Assembly, Step 9.*

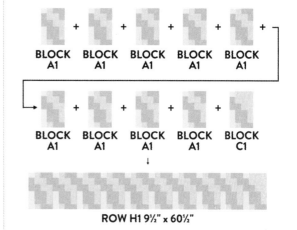

ROW H1 9½" x 60½"

**STEP 9:** Following the diagram, sew together Rows A1–H1 units to create *1 Left Heart Quilt Top.* Press the seams as you go.

Set the Left Heart Quilt Top aside for *Quilt Assembly, Step 19.*

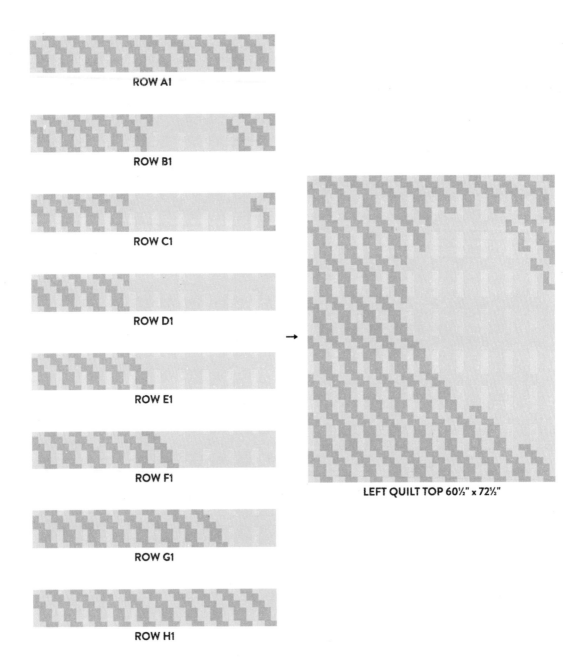

ROW A1

ROW B1

ROW C1

ROW D1

ROW E1

ROW F1

ROW G1

ROW H1

**LEFT QUILT TOP 60½" x 72½"**

## FOR RIGHT HEART QUILT:

**STEP 10:** Sew together 9 Block A2 units and 1 Block E2 unit to create **1 ROW A2** unit. Press the seams open.

Set aside for *Quilt Assembly, Step 18.*

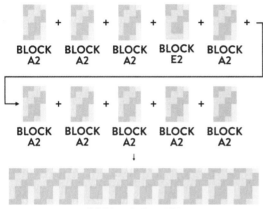

ROW A2 9½" x 60½"

**STEP 11:** Sew together 5 Block A2 units, 3 Block B2 units, 1 Block D2 unit, and 1 Block F2 unit to create **1 ROW B2** unit. Press the seams open.

Set aside for *Quilt Assembly, Step 18.*

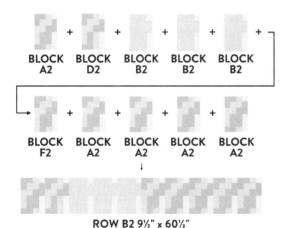

ROW B2 9½" x 60½"

**STEP 12:** Sew together 4 Block A2 units, 5 Block B2 units, and 1 Block D2 unit to create **1 ROW C2** unit. Press the seams open.

Set aside for *Quilt Assembly, Step 18.*

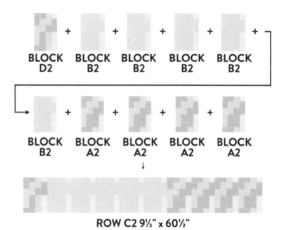

ROW C2 9½" x 60½"

**STEP 13:** Sew together 4 Block A2 units and 6 Block B2 units to create **1 ROW D2** unit. Press the seams open.

Set aside for *Quilt Assembly, Step 18.*

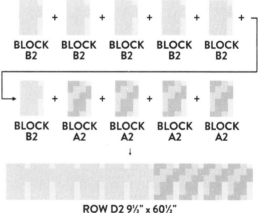

ROW D2 9½" x 60½"

**STEP 14:** Sew together 4 Block A2 units, 5 Block B2 units, and 1 Block C2 unit to create **1 ROW E2** unit. Press the seams open.

Set aside for *Quilt Assembly, Step 18.*

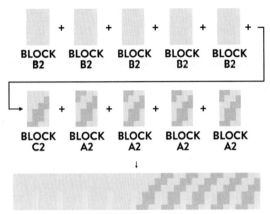

**ROW E2 9½" x 60½"**

**STEP 15:** Sew together 5 Block A2 units, 4 Block B2 units, and 1 Block C2 unit to create **1 ROW F2** unit. Press the seams open.

Set aside for *Quilt Assembly, Step 18.*

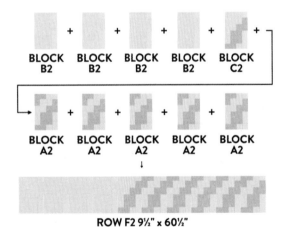

**ROW F2 9½" x 60½"**

**STEP 16:** Sew together 7 Block A2 units, 2 Block B2 units, and 1 Block C2 unit to create **1 ROW G2** unit. Press the seams open.

Set aside for *Quilt Assembly, Step 18.*

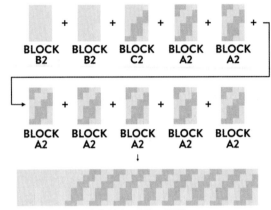

**ROW G2 9½" x 60½"**

**STEP 17:** Sew together 9 Block A2 units and 1 Block C2 unit to create **1 ROW H2** unit. Press the seams open.

Set aside for *Quilt Assembly, Step 18.*

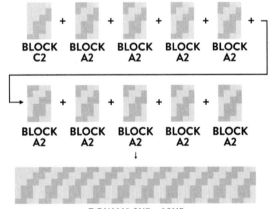

**ROW H2 9½" x 60½"**

**STEP 18:** Following the diagram, sew together Rows A2-H2 units to create *1 Right Heart Quilt Top.* Press the seams as you go.

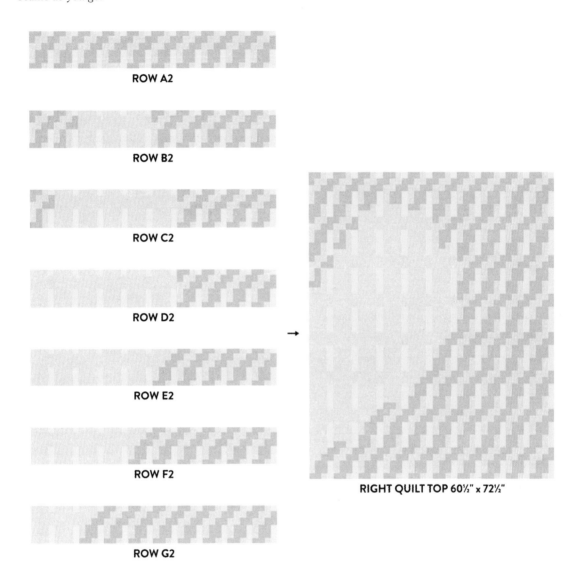

ROW A2

ROW B2

ROW C2

ROW D2

→

ROW E2

ROW F2

RIGHT QUILT TOP 60½" x 72½"

ROW G2

**STEP 19:** Press the quilt tops and backing fabric. For each quilt, layer the backing, batting, and quilt top. Baste, quilt, and bind, as desired, for each quilt.

**FOR WALL HANGINGS:** Stop right before the binding on the quilts is added, and follow the instructions on how to turn a quilt into a wall hanging on *page 60.*

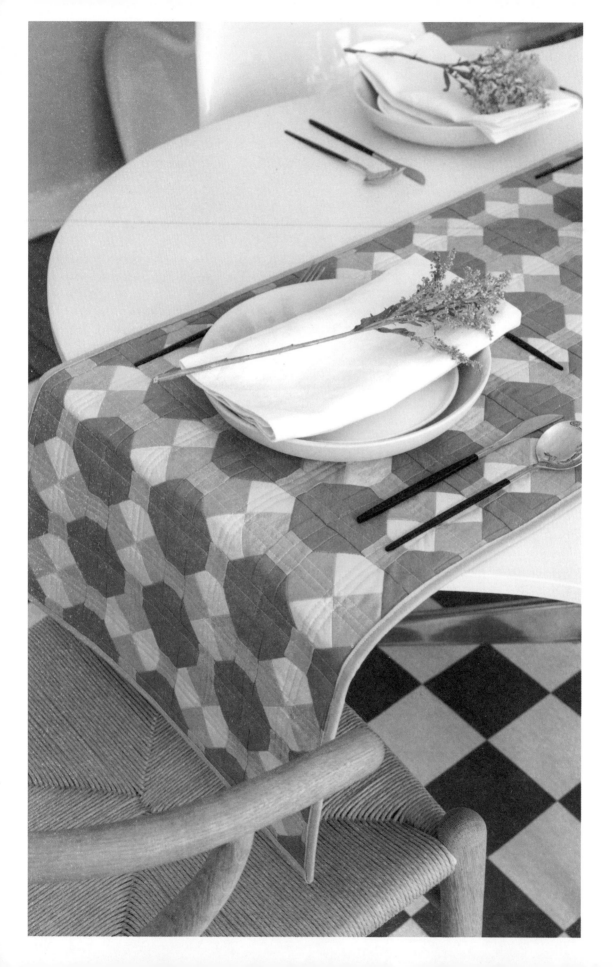

# GAME NIGHT TABLE RUNNER

Some of the best memories in our apartment are from hosting dinner and game nights. The hours of banter, trash talk, and competitiveness never gets old. Since we relocated to a bigger space, we have adulted and upgraded our setup. The addition of our dining set has made these nights a little more enjoyable. We no longer have to squeeze around a small coffee table (which also served as our dining table when we lived in a one-bedroom New York City apartment), sitting on the hardwood floors for the entire evening.

The multicolored octagon shapes in the Game Night Table Runner harks back to the colors of the game pieces and irregular board game shape. The repeating patterns depict the several rounds of game play.

This table runner is a little more challenging to put together than the other projects in the book. But don't let the tiny pieces of squares and rectangles put you off. To speed things up, the strip piecing and snowball units methods are incorporated. The results will get your guests talking. After all, it's not a game night without a little challenge ahead.

| | |
|---|---|
| **PROJECT SIZE** | 16" x 64" (41 cm x 163 cm) |
| **PIECING METHODS AND TECHNIQUES** | Strip piecing, quarter-square triangles, snowball units |
| **OTHER MATERIALS** | Batting |

**DON'T WANT TO CREATE A TABLE RUNNER?** This project can also be made into a wall hanging. Simply stop right before the binding on the quilt is added, and follow the instructions on how to turn a quilt into a wall hanging on *page 60*.

As a wall hanging, this project would look great above a double-sized or larger bed, in the hallway, above the entryway table, or on the dining room wall parallel to a long dining table.

**SHARE YOUR WORK ON SOCIAL MEDIA:** #gamenighttablerunner #theweekendquilter #theurbanquiltedhome

ADVANCED
BEGINNER

## FABRIC REQUIREMENTS

### TABLE RUNNER TOP

| | |
|---|---|
| ■ FABRIC A | 1⅛ yards (103 cm) |
| ■ FABRIC B | ⅜ yard (35 cm) |
| ■ FABRIC C | ⅜ yard (35 cm) |
| ■ FABRIC D | ⅜ yard (35 cm) |
| ■ FABRIC E | ⅜ yard (35 cm) |
| ■ FABRIC F | ⅜ yard (35 cm) |

### TABLE RUNNER BACK

| | |
|---|---|
| ■ FABRIC G | 1¼ yards (138 cm) |

### BINDING

| | |
|---|---|
| ■ FABRIC H | ⅜ yard (35 cm) |

## CUTTING DIRECTIONS

### TABLE RUNNER TOP

| | |
|---|---|
| ■ FABRIC A | 6 strips, 2" x WOF<br>(FOR STRIP PIECING)<br><br>6 strips, 1½" x WOF<br>(FOR STRIP PIECING)<br><br>10 strips, 1½" x WOF, sub-cut:<br>· 256 squares, 1½" |
| ■ FABRIC B | 6 strips, 1½" x WOF<br>(FOR STRIP PIECING) |
| ■ ■ FABRICS C TO F | **FROM EACH OF FABRICS C TO F, CUT:**<br>2 strips, 4¾" x WOF, sub-cut:<br>· 16 squares, 4¾" |

### BINDING

| | |
|---|---|
| ■ FABRIC H | 5 strips, 2½" x WOF |

## STRIP PIECING UNITS

**STEP 1:** Lay 2 Fabric A 2" x WOF strips and 1 Fabric B 1½" x WOF strip in sewing order, as shown. With the right sides together, pin two strips together lengthwise and sew with a **SCANT ¼" SEAM ALLOWANCE**. Press the seams open and repeat with the third strip to make **1 STRIP SET A1** unit.

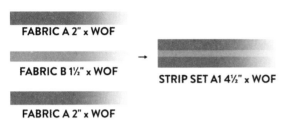

Repeat to create a total of **3 STRIP SET A1** units. Set aside for *Strip Piecing Units, Step 3.*

**STEP 2:** As shown, lay 2 Fabric A 1½" x WOF strips and 1 Fabric B 1½" x WOF strip in sewing order. With right sides together, pin two strips together lengthwise and sew with a **SCANT ¼" SEAM ALLOWANCE**. Press the seams open and repeat with the third strip to make **1 STRIP SET B1** unit.

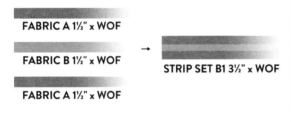

Repeat to create a total of **3 STRIP SET B1** units.

**STEP 3:** Trim the right-hand edge of all Strip Set units to ensure they are straight and perpendicular against the length of the strip set. If you are left-handed, trim the left-hand edge of all Strip Set units. *Strip Set A1 Unit used in this example:*

**TIP:** When trimming, use the top and bottom edges, and/or the seams of the Strip Set units, and the horizontal lines and marks on the ruler to align the strips for more accurate cutting and piecing.

**STEP 4:** Rotate the Strip Set units 180 degrees. Using the straight edge of the left-hand side as a guide, cut a total of:

| | STRIP PIECING UNITS | NUMBER TO CUT |
|---|---|---|
| | Set A2 1½" x 4½" rectangles (from Strip Set A1) | 60 units |
| | Set A3 1" x 4½" rectangles (from Strip Set A1) | 8 units |
| | Set B2 1½" x 3½" rectangles (from Strip Set B1) | 48 units |
| | Set B3 1" x 3½" rectangles (from Strip Set B1) | 32 units |

*Strip Set A1 and Set A2 units used in this example:*

SET A2 — STRIP SET A1

Set aside for *Table Runner Assembly, Steps 1-6.*

## QUARTER-SQUARE TRIANGLE UNITS

**STEP 1:** Draw a diagonal guideline on the wrong side of all Fabric C and D 4¾" squares.

FABRIC C 4¾" SQU.  FABRIC D 4¾" SQU.

**STEP 2:** With right sides together, place 1 marked Fabric C 4¾" square on top of 1 Fabric F 4¾" square to create **1 FABRIC C/F HALF-SQUARE TRIANGLE (HST) PAIR**, and place 1 marked Fabric D 4¾" square on top of 1 Fabric E 4¾" square to create **1 FABRIC D/E HST PAIR**. On each pair, sew ¼" away from both sides of the marked guideline. Pin as needed to keep the pieces secure as you sew.

Repeat to create a total of **16 FABRIC C/F HST PAIRS** and **16 FABRIC D/E HST PAIRS**.

**STEP 3:** Cut on the drawn line on each pair, and press the seams open to create a total of **32 FABRIC C/F HST** units and **32 FABRIC D/E HST** units.

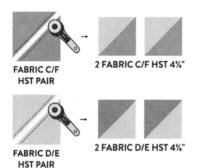

**STEP 4:** Referring to the diagram, draw a diagonal guideline on the wrong side of all Fabric C/F HST units from the previous step.

FABRIC C/F HST

**STEP 5:** With right sides together, place 1 marked Fabric C/F HST unit on top of 1 Fabric D/E HST unit from Step 3. As shown in the diagram, sew ¼" away from both sides of the marked guideline.

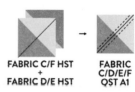

Repeat to create **32 FABRIC C/D/E/F QUARTER-SQUARE TRIANGLE (QST) A1** units.

TIP: To get a perfect intersection in the middle of the QST unit, place 1 marked Fabric C/F HST on top of 1 Fabric D/E HST unit, then pull back one corner of the HST on top to see if the seams line up. If they don't, adjust accordingly, pin, and sew. Press the seams open.

**STEP 6:** Cut on the drawn line on all **FABRIC C/D/E/F QST A1** units
to create to create a total of
**32 FABRIC C/D/E/F QST A2** and
**32 FABRIC C/D/E/F QST A3** units.

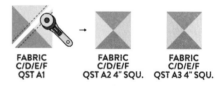

**STEP 7:** Square up all the QST units to 3½" square by matching the intersection of the 1¾" line on the ruler with the center seam of the QST unit *and* the 45-degree mark on the ruler with the diagonal seam line (as shown in blue in the diagram), and trim the top and right edges of the units. *Fabric C/D/E/F QST A2 used in this example:*

**STEP 8:** Rotate the QST unit 180-degrees and repeat **STEP 7** on the remaining two sides on all QST units.

Set **32 FABRIC C/D/E/F QST A2** and **32 FABRIC C/D/E/F QST A3** units aside for *Snowball Units, Step 2*.

FABRIC C/D/E/F
QST A2 3½" SQU.

FABRIC C/D/E/F
QST A3 3½" SQU.

## SNOWBALL UNITS

**STEP 1:** On the wrong side of all Fabric A 1½" squares, mark a diagonal guideline.

**STEP 2:** With right sides together, noting the diagonal guidelines, place 1 Fabric A 1½" square on each corner of 1 Fabric C/D/E/F QST A2 unit and 1 Fabric C/D/E/F QST A3 unit. *Sew slightly to the right* of the diagonal guidelines* to create **1 SNOWBALL A1** unit and **1 SNOWBALL A2** unit.

Repeat to create a total of **32 SNOWBALL A1** and **32 SNOWBALL A2** units.

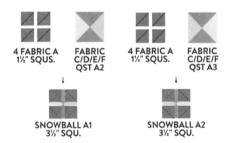

4 FABRIC A
1½" SQUS.

FABRIC
C/D/E/F
QST A2

4 FABRIC A
1½" SQUS.

FABRIC
C/D/E/F
QST A3

SNOWBALL A1
3½" SQU.

SNOWBALL A2
3½" SQU.

*Sewing slightly to the right of the guideline takes into consideration the fabric loss after the seam is pressed open or to the dark side.

**STEP 3:** Trim a ¼" seam allowance outside of the sewn line of all 64 Snowball units. Press the seams open.

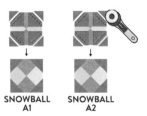

SNOWBALL
A1

SNOWBALL
A2

## TABLE RUNNER ASSEMBLY

In this section, sew pieces right side together with **SCANT ¼" SEAM ALLOWANCES**, unless specified otherwise.

**STEP 1:** Sew together 4 Set A3 units to create **1 COLUMN A1 (CA1)** unit, as shown. Press the seams open.

Repeat to create a total of **2 CA1** units. Set aside for *Table Runner Assembly, Step 7*.

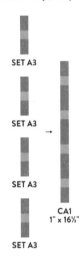

SET A3

SET A3

SET A3

CA1
1" x 16½"

SET A3

**STEP 2:** Combine 4 Set A2 units to create **1 COLUMN A2 (CA2)** unit, as shown. Press the seams open. Repeat to create a total of **15 CA2** units. Set aside for *Table Runner Assembly, Step 5*.

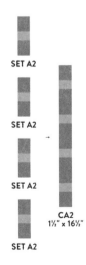

SET A2

SET A2

SET A2

CA2
1½" x 16½"

SET A2

**STEP 3:** Take extra care when arranging and sewing Snowball units together. You will need to rotate the blocks to create the table runner top. Use Fabric C in the Snowball units as a marker to identify the correct orientation of each block. On the left of each Snowball unit in the diagrams for Steps 3-4, there are light grey arrows to assist you with the placement.

Below are the different possible rotations of Snowball A1 and Snowball A2 units relative to the light grey arrows. Refer to this any time while assembling the table runner.

If you're not up for the challenge and don't want to worry about the rotation of the Snowball units, that's totally fine. Go ahead and skip Steps 3 and 4, and sew together 3 Set B2 units, 2 Set B3 units, 2 Snowball A1 units, and 2 Snowball A2 units to create **1 COLUMN C1** unit (CC1). Press the seams as you go. Repeat to create a total of **16 CC1** units and jump to Step 5.

TIP: Lay all blocks for each row on a flat surface in sewing order, and compare the Snowball and Set units with the diagram shown before getting behind the sewing machine.

Following the diagram, sew together 3 Set B2 units, 2 Set B3 units, 2 Snowball A1 units, and 2 Snowball A2 units to create **1 COLUMN B1 (CB1)** unit. Press the seams open.

Repeat to create a total of **8 CB1** units. *Set aside for Table Runner Assembly, Step 5.*

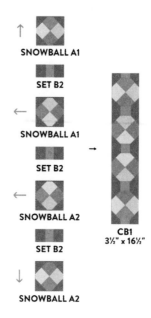

**STEP 4:** As shown, sew together 3 Set B2 units, 2 Set B3 units, 2 Snowball A1 units, and 2 Snowball A2 units to create **1 COLUMN B2 (CB2)** unit. Press the seams open.

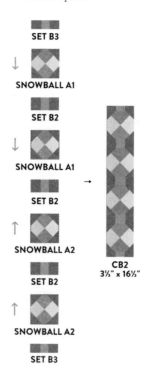

Repeat to create a total of **8 CB2** units.

**STEP 5:** Follow the diagram to assemble all Column units together to complete the **TABLE RUNNER TOP**. Press the seams open.

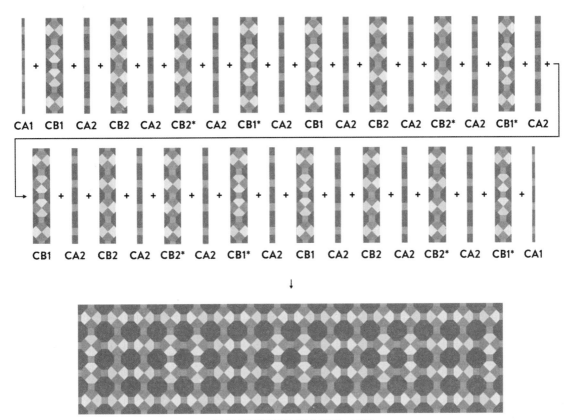

**TABLE RUNNER TOP 16½" x 64½"**

*Note: The CB1 and CB2 units with an asterisk in the diagram need to be turned 180 degrees before sewing together. Take your time here. Lay all the units out on a flat surface. Compare it with the diagram before sewing to avoid seam ripping.*

If you randomized the rotation of the Snowball units and created 16 CC1 units instead, referring to the diagram, replace CB1 units and CB2 units with CC1 units to create **TABLE RUNNER TOP**. Press the seams open as you go.

**STEP 6:** Press the table runner top and backing fabric. Layer the backing, batting, and table runner top. Baste, quilt, and bind, as desired.

**FOR A WALL HANGING:** Stop right before the binding on the quilt is added, and follow the instructions on how to turn a quilt into a wall hanging on *page 60*.

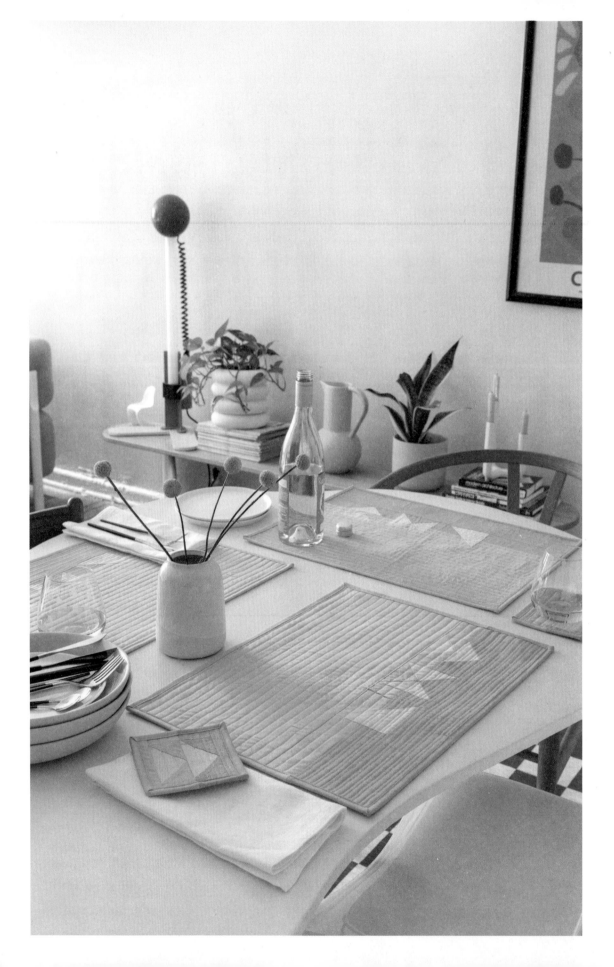

# IN POSITION PLACEMATS

This project is a great place to start if you are new to quilting. It explores various piecing methods, such as strip piecing (my favorite), no-waste flying geese (also an all-time favorite of mine), quarter-square triangles, and snowball units. Each placemat is almost like a tiny quilt, making this a fantastic opportunity to work on your basting, quilting, and binding skills.

And for my seasoned quilters, this is the perfect project to whip out all that scrap batting you've been saving up in your stash.

The In Position Placemats design is an extension of the In Position Coasters (*page 247*) and Game Night Table Runner (*page 231*). Each unique triangle shape in the design represents a different game piece on a board game. Similar to a household or the different rooms in a home—each person has their own roles and responsibilities and each room has a different purpose.

| | |
|---|---|
| **PROJECT SIZE** | 6 placemats, each 14" x 19" (36 cm x 49 cm) |
| **PIECING METHODS AND TECHNIQUES** | Strip piecing, no-waste flying geese, quarter-square triangles, snowball units |
| **OTHER MATERIALS** | Batting; Fusible heavyweight permanent stabilizer or interfacing: This additional layer in the quilt sandwich will provide more structure to the placemats. Similar to batting and quilt back (in this instance, placemat back), the stabilizer needs to cover the entire area of the quilt top (placemat top), with some overhang. |

**IF YOU DO PLAN TO MAKE BOTH** the In Position Placemats and Coasters, make the placemats first. The scraps from the placemats can be used in making the matching coasters.

**SHARE YOUR WORK ON SOCIAL MEDIA**: #inpositionplacemats #theweekendquilter #quiltedhomehandbook

BEGINNER

## FABRIC REQUIREMENTS

| | |
|---|---|
| **PLACEMAT TOP** | |
| ▨ FABRIC A | ¼ yard (23 cm) |
| ▥ FABRIC B | 1⅛ yards (103 cm) |
| ▥ FABRIC C | ⅝ yard (58 cm) |
| **PLACEMAT BACK** | |
| ▨ FABRIC D | 2 yards (183 cm) |
| **BINDING** | |
| ▥ FABRIC E | 1 yard (92 cm) |

## CUTTING DIRECTIONS

| | |
|---|---|
| **PLACEMATS FRONT** | |
| ▨ FABRIC A | 1 strip, 4¾" x WOF, sub-cut:<br>• 4 squares, 4¾"<br>• 4 squares, 4¼"<br><br>1 strip, 3½" x WOF, sub-cut:<br>• 6 squares, 3½" |
| ▥ FABRIC B | 3 strips, 9" x WOF, sub-cut:<br>• 6 rectangles, 9" x 19¼"<br><br>1 strip, 4¾" x WOF, sub-cut:<br>• 2 squares, 4¾"<br>• 8 squares, 2⅜"<br><br>3 strips, 2" x WOF<br>(FOR STRIP PIECING) |
| ▥ FABRIC C | 3 strips, 3" x WOF, sub-cut:<br>• 6 rectangles, 3" x 19¼"<br><br>1 strip, 4¾" x WOF, sub-cut:<br>• 2 squares, 4¾"<br>• 8 squares, 2⅜"<br><br>3 strips, 2" x WOF<br>(FOR STRIP PIECING) |
| **PLACEMATS BACK** | |
| ▨ FABRIC D | 3 strips, 23" x WOF, sub-cut:<br>• 6 rectangles, 23" x 21" |
| **BINDING** | |
| ▥ FABRIC E | 12 strips, 2½" x WOF<br>For each placemat, sew together 2 Fabric E 2½" x WOF rectangles, as shown on *page 56, Preparing Binding Strips*. |

## FLYING GEESE UNITS

**STEP 1:** On the reverse side of all Fabric B and Fabric C 2⅜" squares, draw a diagonal guideline from one corner to the opposite corner.

**STEP 2:** As shown in the diagram, with right sides together and diagonal guidelines lined up, place 2 marked Fabric B 2⅜" squares from the previous step on top of 1 Fabric A 4¼" square to create a **FLYING GEESE SET**. *Fabric A/B Flying Geese Set used in this example:*

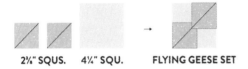

| 2¼" SQUS. | 4¼" SQU. | | FLYING GEESE SET |

Refer to the table below for the required amount of Flying Geese Sets:

| FLYING GEESE SETS | SQUARES IN EACH SET | # OF SETS |
|---|---|---|
| Fabric A/B Flying Geese Set | 2 Fabric B 2⅜" squares, 1 Fabric A 4¼" square | 2 |
| Fabric A/C Flying Geese Set | 2 Fabric C 2⅜" squares, 1 Fabric A 4¼" square | 2 |

**STEP 3:** Sew ¼" on both sides of the drawn line on all Flying Geese Sets. Cut on the drawn guideline to create **2 FLYING GEESE SECTIONS** and press the seams open, as shown in the diagram. *Fabric A/B Flying Geese Sections used in this example:*

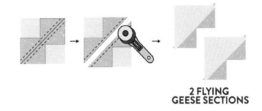

**2 FLYING GEESE SECTIONS**

In total, there should be:

| FLYING GEESE SECTIONS | # OF SECTIONS |
|---|---|
| Fabric A/B Flying Geese Sections | 4 |
| Fabric A/C Flying Geese Sections | 4 |

**STEP 4:** Place 1 marked Fabric B square (from Step 1) on top of 1 Fabric A/B Flying Geese Section, and place 1 marked Fabric C square (from Step 1) on top of 1 Fabric A/C Flying Geese Section, noting the orientation of the marked square shown in the diagram. Sew ¼" on both sides of the drawn line on all Flying Geese Sections. *Fabric A/B Flying Geese Sections used in the example:*

**STEP 5:** Cut on the drawn line on all Flying Geese Sections, and press the seams open to create **FLYING GEESE** units. Trim each Flying Geese unit to a 2" x 3½" rectangle. *Fabric A/B Flying Geese used in this example:*

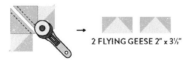

**2 FLYING GEESE 2" x 3½"**

*(Step 5 continued on next page)*

*(Continued from step 5)*

Repeat to create a total of:

| FLYING GEESE UNITS | # OF FLYING GEESE UNITS |
|---|---|
| Fabric A/B Flying Geese units | 8* |
| Fabric A/C Flying Geese units | 8* |

*Note: There will be 2 extra Fabric A/B Flying Geese units and 2 extra Fabric A/C Flying Geese units. Save these for the In Position Coasters project (page 247). These additional units make two coasters.*

**STEP 6:** As shown in the diagram, sew together 1 Fabric A/B Flying Geese unit and 1 Fabric A/C Flying Geese unit to create **1 FLYING GEESE BLOCK** unit. Press the seams open.

Repeat to create a total of **6 FLYING GEESE BLOCK** units. Set aside for *Placemat Top Assembly, Step 1.*

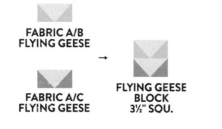

FABRIC A/B
FLYING GEESE

FABRIC A/C
FLYING GEESE

FLYING GEESE
BLOCK
3½" SQU.

## QUARTER-SQUARE TRIANGLE UNITS

**STEP 1:** On the wrong side of all Fabric A 4¾" squares, draw a diagonal guideline.

**STEP 2:** With right sides together, place 1 marked Fabric A 4¾" square from the previous step on top

of one Fabric B 4¾" square to create **1 FABRIC A/B HALF-SQUARE TRIANGLE (HST) PAIR,** and place 1 marked Fabric A 4¾" square on top of one Fabric C 4¾" square to create **1 FABRIC A/C HALF-SQUARE TRIANGLE (HST) PAIR.** On each pair, sew ¼" away from both sides of the marked guideline. Pin as needed to keep the pieces secure as you sew.

Repeat to create a total of **2 FABRIC A/B HST PAIRS** and **2 FABRIC A/C HST PAIRS.**

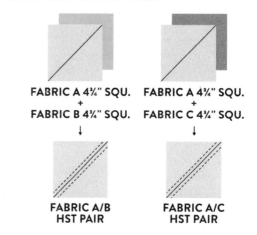

FABRIC A 4¾" SQU.
+
FABRIC B 4¾" SQU.
↓
FABRIC A/B
HST PAIR

FABRIC A 4¾" SQU.
+
FABRIC C 4¾" SQU.
↓
FABRIC A/C
HST PAIR

**STEP 3:** Cut on the drawn line of each pair and press the seams open to create a total of **4 FABRIC A/B HST** units and **4 FABRIC A/C HST** units.

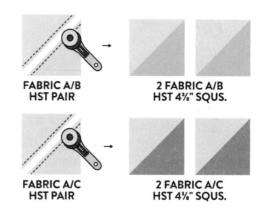

FABRIC A/B
HST PAIR

2 FABRIC A/B
HST 4¾" SQUS.

FABRIC A/C
HST PAIR

2 FABRIC A/C
HST 4¾" SQUS.

*Note: There will be 1 extra Fabric A/B HST unit and 1 extra Fabric A/C HST unit. Save these for the In Position Coasters project (page 247). These additional units make two coasters.*

**STEP 4:** Referring to the diagram, draw a diagonal guideline on the wrong side of all Fabric A/B HST units from the previous step.

**FABRIC A/B
HST 4¾" SQU.**

**STEP 5:** Noting the orientation of each HST unit and with right sides together, place 1 marked Fabric A/B HST unit on top of 1 Fabric A/C HST unit to create **1 QUARTER-SQUARE TRIANGLE (QST) PAIR.** As shown in the diagram, sew ¼" away from both sides of the marked guideline.

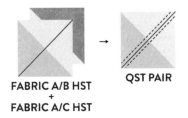

**FABRIC A/B HST
+
FABRIC A/C HST**

**QST PAIR**

Repeat to create a total of **3 QUARTER-SQUARE TRIANGLE (QST) PAIRS.**

**STEP 6:** Cut on the drawn line on all QST Pairs to create a total of **6 QST** units. Press the seams open.

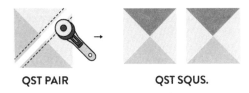

**QST PAIR**  **QST SQUS.**

**STEP 7:** Square up all the QST units to 3½" square by matching the intersection of the 1¾" line on the ruler with the center seam of the QST unit *and* the 45-degree mark on the ruler with the diagonal seam line (as shown in blue in the diagram), and trim the top and right edges of each unit.

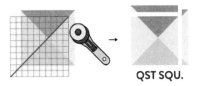

**QST SQU.**

**STEP 8:** Rotate each QST unit 180-degrees and repeat *Step 7* on the remaining two sides on all QST units.

Set **6 QST** units aside for *Placemat Top Assembly, Step 1.*

## STRIP PIECING UNITS

**STEP 1:** With right sides together, sew 1 Fabric B 2" x WOF strip and Fabric C 2" x WOF strip lengthwise to create **1 STRIP SET A1** unit. Press the seams open.

**FABRIC B 2" x WOF** →

**FABRIC C 2" x WOF**

**STRIP SET A1 3½" x WOF**

Repeat to create a total of **3 STRIP SET A1** units.

**STEP 2:** Trim the right-hand edge of all Strip Set A1 units to ensure they are straight and perpendicular against the length of the strip set. If you are left-handed, trim the left-hand edge of all Strip Set units,

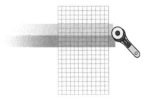

**TIP:** When trimming, use the top and bottom edges, and/or the seams of the Strip Set units, and the horizontal lines and marks on the ruler to align the strips for more accurate cutting and piecing.

**STEP 3:** Rotate the Strip Set A1 units 180 degrees. Using the straight edge of the left-hand side (right-hand side if you are left-handed) as a guide, cut a total of:

SET A1          STRIP SET A1

(Step 3 continued on next page)

(Continued from Step 3)

| STRIP SET | CUT A TOTAL OF |
|---|---|
| Set A1 3½" x 6½" rectangle | 6 |
| Set A2 3½" x 4½" rectangle | 6 |
| Set A3 3½" x 2½" rectangle | 6 |
| Set A4 3½" x 1½" rectangle | 6 |

Set aside the Set A1 rectangles, Set A3 rectangles, and Set A4 rectangles for *Placemat Top Assembly, Step 1* and set aside the Set A2 rectangles for *Snowball Units, Step 2*.

*Note: There will be extra fabric left from Strip Set A1. Save this to create some of the Strip Set units in the In Position coasters project (page 247).*

## SNOWBALL UNITS

**STEP 1:** Draw a diagonal guideline on the reverse side of all Fabric A 3½" squares.

**STEP 2:** As shown in the diagram, carefully note the orientation of the marked diagonal guideline on 1 Fabric A 3½" square and Set A2 unit. Place 1 Fabric A 3½" square on top of 1 Set A2 unit. Sew on the marked guideline to create **1 SNOWBALL** unit.

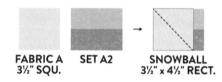

FABRIC A        SET A2          SNOWBALL
3½" SQU.                        3½" x 4½" RECT.

Repeat to create a total of **6 SNOWBALL** units.

**STEP 3:** Complete the Snowball units by trimming a ¼" seam allowance outside of the sewn line on each unit. Press the seams open.

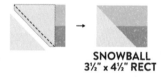

SNOWBALL
3½" x 4½" RECT

## PLACEMAT TOP ASSEMBLY

**STEP 1:** Sew together the following with a **SCANT ¼" SEAM ALLOWANCE** to create **1 ROW A1** unit: 1 Set A1 unit, 1 Snowball unit, 1 QST unit, 1 Set A4 unit, 1 Flying Geese Block unit, and 1 Set A3 unit. Press the seams open as you go.

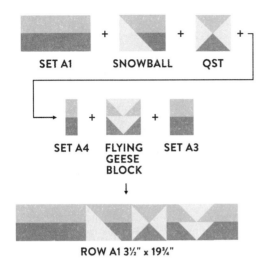

SET A1 + SNOWBALL + QST +

SET A4 + FLYING GEESE BLOCK + SET A3

↓

ROW A1 3½" x 19¾"

Repeat to create a total of **6 ROW A1** units.

**STEP 2:** Following the diagram, combine 1 Fabric B 9" x 19¾" rectangle, 1 Fabric C 3" x 19¾" rectangle, and 1 Row A1 unit to create **1 PLACEMAT TOP**. Press the seams open as you go.

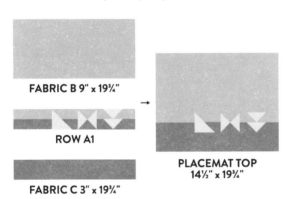

FABRIC B 9" x 19¾"

ROW A1

→

PLACEMAT TOP 14½" x 19¾"

FABRIC C 3" x 19¾"

Repeat to create a total of **6 PLACEMAT TOPS**.

## BASTING, QUILTING, AND BINDING

**STEP 1:** For this project you need to create a total of **6 PLACEMAT SANDWICHES**. Each Placemat Sandwich is the same and is comprised of the following layers:

+ 1 Placemat Top (from the previous step)
+ Batting
+ 1 fusible heavyweight permanent stabilizer, approx. 21" x 23" rectangle (if adding it)*
+ 1 Fabric D 21" x 23" rectangle

Baste and quilt using your preferred method.

*Placemat top sandwich:*

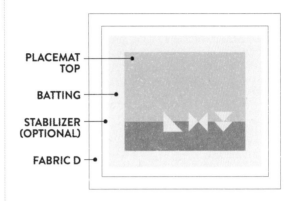

PLACEMAT TOP

BATTING

STABILIZER (OPTIONAL)

FABRIC D

*\*Note: If using fusible heavyweight permanent stabilizer, lay and iron stabilizer onto the wrong side of the backing fabric first, then baste. Hand quilting with the stabilizer is not recommended, it is thick and stiffens the project, making it difficult to pierce the needle through the quilt sandwich layers.*

**STEP 2:** Trim excess batting and backing (and stabilizer), and square up all placemat sandwiches. Take extra care when squaring up. Each placemat sandwich must measure a 14" x 19" rectangle.

**TIP:** Before removing excess batting and backing fabric (and stabilizer), use a fabric marker or pen and ruler to mark out the measurement. This additional step ensures all edges of the placemat sandwiches are straight, each corner is right-angled, and the placemat top design is not cut off while trimming.

**STEP 3:** Bind each placemat using your preferred binding method.

*\*Note: Again, if using stabilizer, hand binding is not recommended, as it may be difficult to pierce the needle through the multiple layers and stabilizer.*

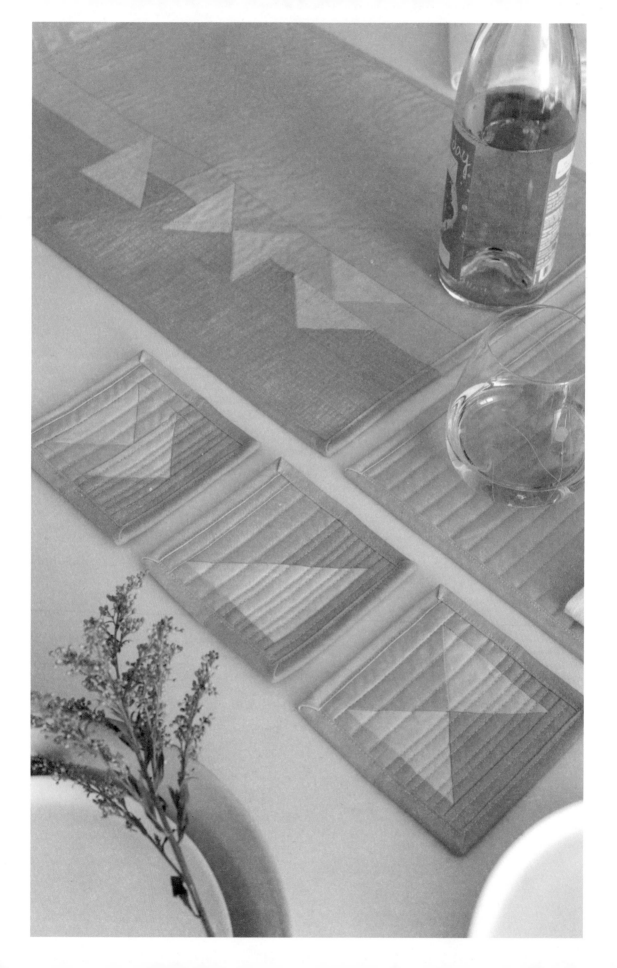

# IN POSITION COASTERS

Already made the In Position Placemats (*page 239*)? Then you're in for a treat, because you can use some of the leftover units and fabrics from that project to supplement some of the fabric requirements. Also, if you use the four extra flying geese units from the placemats project, you've pretty much already made two out of six In Position Coasters!

To accommodate the option to use leftover Flying Geese, Half-Square Triangles, and Strip Set units, the Fabric Requirements and Cutting Directions will vary slightly. As a result, there are two options in each of these sections: **OPTION 1** assumes leftover units *will not* be incorporated, and **OPTION 2** assumes leftover units *will* be incorporated.

---

**PROJECT SIZE**

6 coasters, each 4" x 4" (11 cm x 11 cm)

---

**PIECING METHODS AND TECHNIQUES**

Strip piecing, stitch and flip flying geese, quarter-square triangles, snowball units

---

**OTHER MATERIALS**

Batting; Fusible heavyweight permanent stabilizer or interfacing (optional). This additional layer in the quilt sandwich will provide more structure to the coasters. Similar to batting and quilt back (in this instance, coaster back), the stabilizer needs to cover the entire area of the quilt top (coaster top), with some overhang. If you added this layer to the In Position Placemats project on *page 239*, this is the perfect project to use up any leftover stabilizer or interfacing.

---

BEGINNER

## FABRIC REQUIREMENTS

### OPTION 1: EXCLUDING FLYING GEESE, HALF-SQUARE TRIANGLES, AND STRIP SET UNITS

| COASTERS TOP | |
|---|---|
| ▪ FABRIC A | ¼ yard (23 cm) or 1 Fat Quarter (FQ) |
| ▪ FABRIC B | ¼ yard (23 cm)* |
| ▪ FABRIC C | ¼ yard (23 cm)* |
| **COASTERS BACK** | |
| ▪ FABRIC D | ⅜ yard (35 cm) |
| **BINDING** | |
| ▪ FABRIC E | ⅜ yard (35 cm) |

## FABRIC REQUIREMENTS

### OPTION 2: INCLUDING FLYING GEESE, HALF-SQUARE TRIANGLES, AND STRIP SET UNITS

| COASTERS TOP | |
|---|---|
| ▪ FABRIC A | ⅛ yard (12 cm) or 1 Fat Eighth (FE) |
| ▪ FABRIC B | ⅛ yard (12 cm)* |
| ▪ FABRIC C | ⅛ yard (12 cm)* |
| **COASTERS BACK** | |
| ▪ FABRIC D | ⅜ yard (35 cm) |
| **BINDING** | |
| ▪ FABRIC E | ⅜ yard (35 cm) |

*For Options 1 and 2: Although Fabrics B and C require ¼ yards (option 1) / ⅛ yards (option 2), do not supplement with fat quarters (option 1) / fat eighths (option 2). A length of 42" WOF is required for strip piecing.

# CUTTING DIRECTIONS

## OPTION 1: EXCLUDING FLYING GEESE AND STRIP SET UNITS

### COASTERS FRONT

| FABRIC A | 1 strip, 4¾" x WOF, sub-cut:<br>• 2 squares, 4¾"<br>• 2 squares, 3½"<br>• 4 rectangles, 2" x 3½" |
|---|---|
| FABRIC B | 1 strip, 4¾" x WOF, sub-cut:<br>• 1 square, 4¾"<br>• 6 rectangles, 4½" x 1"<br>• 4 squares, 2"<br><br>1 strip, 2" x WOF<br>(FOR STRIP PIECING) |
| FABRIC C | 1 strip, 4¾" x WOF, sub-cut:<br>• 1 square, 4¾"<br>• 6 rectangles, 4½" x 1"<br>• 4 squares, 2"<br><br>1 strip, 2" x WOF<br>(FOR STRIP PIECING) |

### COASTERS BACK

| FABRIC D | 1 strip, 10" x WOF |
|---|---|

### BINDING

| FABRIC E | 4 strips, 2½" x WOF<br>Sew together all 4 Fabric E 2½" x WOF rectangles, as shown on *page 56*, *Preparing Binding Strips*. Cut into approx. 6 Fabric E 2½" x 28" rectangles. |
|---|---|

## CUTTING DIRECTIONS
### OPTION 2: INCLUDING FLYING GEESE, HALF-SQUARE TRIANGLE, AND STRIP SET UNITS

**COASTERS FRONT**

| | |
|---|---|
| ■ FABRIC A | 1 strip, 3½" x WOF, sub-cut:<br>• 2 squares, 3½" |
| ■ FABRIC B | 1 strip, 1" x WOF, sub-cut:<br>• 6 rectangles, 1" x 4½"<br><br>1 strip, 2" x WOF<br>(FOR STRIP PIECING) |
| ■ FABRIC C | 1 strip, 1" x WOF, sub-cut:<br>• 6 rectangles, 1" x 4½"<br><br>1 strip, 2" x WOF<br>(FOR STRIP PIECING) |

**COASTERS BACK**

| | |
|---|---|
| ■ FABRIC D | 1 strip, 10" x WOF |

**BINDING**

| | |
|---|---|
| ■ FABRIC E | 4 strips, 2½" x WOF<br>Sew together all 4 Fabric E 2½" x WOF rectangles, as shown on *page 56*, *Preparing Binding Strips*. Cut into approx. 6 Fabric E 2½" x 28" rectangles. |

## STRIP PIECING UNITS

**STEP 1:** With right sides together, sew 1 Fabric B 2" x WOF strip and 1 Fabric C 2"x WOF strip lengthwise, with a **SCANT ¼" SEAM ALLOWANCE**, to create **1 STRIP SET A1** unit. Press the seams open.

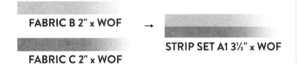

**FABRIC B 2" x WOF** →

**STRIP SET A1 3½" x WOF**

**FABRIC C 2" x WOF**

**STEP 2:** Trim the right-hand edge of all Strip Set A1 units to ensure they are straight and perpendicular against the length of the strip set. If you are left-handed, trim the left-hand edge of all Strip Set units.

TIP: When trimming, use the top and bottom edges of the Strip Set units and the horizontal lines and marks on the ruler to align the strips for more accurate cutting and piecing.

**STEP 3:** Rotate the Strip Set A1 units 180 degrees. Using the straight edge of the left-hand side (right-hand side if you are left-handed) as a guide, cut a total of:

| STRIP SET | CUT A TOTAL OF |
|---|---|
| Set A1 (3½" x 4") | 2 |
| Set A2 (3½" x 1") | 10 |

*Using leftover Strip Set A1 units from the In Position Placemat project?* Use those to supplement some of the Set rectangles listed above.

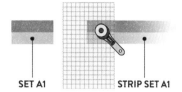

**SET A1**   **STRIP SET A1**

Set aside the Set A1 rectangles aside for *Snowball Units, Step 2* and the Set A2 rectangles for *Flying Geese Units, Step 7; Quarter-Square Triangle Units, Step 9;* and *Snowball Units, Step 4.*

## FLYING GEESE UNITS AND COASTER TOPS

If using Flying Geese units from the In Position Placemats project, skip *Flying Geese Units, Steps 1-5* and go straight to *Step 6.* You've already made those units—winning!

**STEP 1:** On the reverse side of all Fabric B and Fabric C 2" squares, mark a diagonal guideline.

**STEP 2:** Note the orientation of the marked diagonal guideline on a 2" square from the previous step, place it on the left of 1 Fabric A 2" x 3½" rectangle, and sew on the guideline, as shown in the diagram. *Fabric A/B Flying Geese used in this example:*

**FABRIC B**   **FABRIC A**
**2" SQU.**   **2" x 3½"**

Repeat with the following 2" squares and 2" x 3½" rectangles pairs:

| PAIRS | # OF PAIRS |
|---|---|
| 1 Fabric A 2" x 3½" rectangle, 1 Fabric B 2" square | 2 |
| 1 Fabric A 2" x 3½" rectangle, 1 Fabric C 2" square | 2 |

**STEP 3:** Trim a ¼" seam allowance to the outside of all the sewn lines.

**FABRIC A/B
HALF-FLYING
GEESE 2" x 3½"**

Press the seams open or to the dark side to create a total of:

| HALF-FLYING GEESE UNITS | CUT A TOTAL OF |
|---|---|
| Fabric A/B Half-Flying Geese Units | 2 |
| Fabric A/C Half-Flying Geese Units | 2 |

**STEP 4:** Similar to Step 2, note the orientation of the marked diagonal guideline on a 2" square, place it on the right side of 1 coordinating Half-Flying Geese unit, and sew on the guideline.

**FABRIC A/B
HALF-FLYING
GEESE**    **FABRIC B
2" SQU.**

Repeat with the following 2" square and Half-Flying Geese unit pairs:

| PAIRS | # OF PAIRS |
|---|---|
| 1 Fabric A/B Half-Flying Geese unit, 1 Fabric B 2" square | 2 |
| 1 Fabric A/C Half-Flying Geese unit, 1 Fabric C 2" square | 2 |

**STEP 5:** Trim a ¼" seam allowance to the outside of all the sewn lines.

**FABRIC A/B
FLYING GEESE
2" x 3½"**

Press the seams open to create a total of:

+ 2 Fabric A/B Flying Geese units
+ 2 Fabric A/C Flying Geese units

**FABRIC A/B
FLYING GEESE**    **FABRIC A/C
FLYING GEESE**

**STEP 6:** As shown in the diagram, sew together 1 Fabric A/B Flying Geese unit and 1 Fabric A/C Flying Geese unit to create **1 FLYING GEESE BLOCK** unit. Press the seams open.

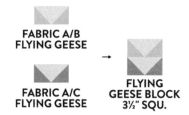

**FABRIC A/B
FLYING GEESE**

**FABRIC A/C
FLYING GEESE**

**FLYING
GEESE BLOCK
3½" SQU.**

**STEP 7:** Create **1 FLYING GEESE COASTER TOP** by sewing together 2 Set A2 units on the left and right of 1 Flying Geese Block, with a **SCANT ¼" SEAM ALLOWANCE**, followed by 1 Fabric B 1" x 4½" rectangle and 1 Fabric C 1" x 4½" rectangle on the top and bottom of the unit.

Press the seams open as you go.

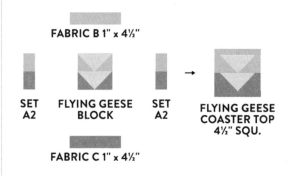

**FABRIC B 1" x 4½"**

**SET
A2**    **FLYING GEESE
BLOCK**    **SET
A2**    **FLYING GEESE
COASTER TOP
4½" SQU.**

**FABRIC C 1" x 4½"**

Repeat to create a total of **2 FLYING GEESE COASTER TOPS**. Set aside for *Basting, Quilting, and Binding, Step 1.*

## QUARTER-SQUARE TRIANGLE UNITS AND COASTER TOPS

Got those Fabric A/B and Fabric A/C Half-Triangle units saved up from the In Position Placemats project *(page 239)*? This is where they are going to come in handy and Steps 1 to 3 in the following section can be skipped.

**STEP 1:** On the wrong side of 2 Fabric A 4¾" squares, draw a diagonal guideline.

**STEP 2:** With right sides together, place 1 marked Fabric A 4¾" square from the previous step on top of one Fabric B 4½" square to create **1 FABRIC A/B HALF-SQUARE TRIANGLE (HST) PAIR**, and place 1 marked Fabric A 4¾" square on top of one Fabric C 4¾" square to create **1 FABRIC A/C HALF-SQUARE TRIANGLE (HST) PAIR**. On each pair, sew on the marked guideline. Pin as needed to keep the pieces secure as you sew.

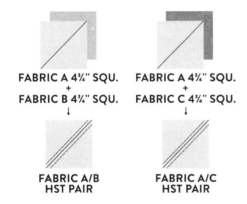

FABRIC A 4¾" SQU.
+
FABRIC B 4¾" SQU.
↓
FABRIC A/B HST PAIR

FABRIC A 4¾" SQU.
+
FABRIC C 4¾" SQU.
↓
FABRIC A/C HST PAIR

**STEP 3:** Trim a ¼" seam allowance outside of the sewn line on each pair. Press the seams open to create **1 FABRIC A/B HST** unit and **1 FABRIC A/C HST** unit.

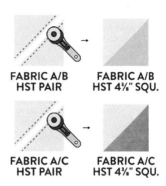

FABRIC A/B HST PAIR → FABRIC A/B HST 4⅜" SQU.

FABRIC A/C HST PAIR → FABRIC A/C HST 4⅜" SQU.

**STEP 4:** Referring to the diagram, draw a diagonal guideline on the reverse side of one Fabric A/B HST unit from the previous step.

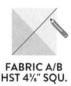

FABRIC A/B HST 4⅜" SQU.

**STEP 5:** Noting the orientation of each HST unit and with right sides together, place 1 marked Fabric A/B HST on top of 1 Fabric A/C HST unit from Step 3. As shown in the diagram, sew on both sides of the drawn lines.

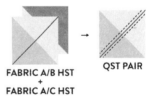

FABRIC A/B HST
+
FABRIC A/C HST → QST PAIR

**STEP 6:** Cut on the drawn the line to create **2 QUARTER-SQUARE TRIANGLE (QST)** units. Press the seams open.

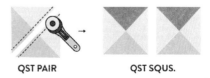

QST PAIR → QST SQUS.

**STEP 7**: Square up all the QST units to 3½" square by matching the intersection of the 1¾" line on the ruler with the center seam of the QST unit **AND** the 45-degree mark on the ruler with the diagonal seam line (as shown in the blue line), and trim the top and right edges of the units.

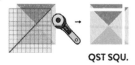

QST SQU.

**STEP 8**: Rotate the QST unit 180-degrees and repeat **STEP 7** on the remaining two sides to complete **1 QST** unit.

Repeat Steps 7 and 8 with the second QST unit.

**STEP 9**: Create **1 QST COASTER TOP** by sewing together 2 Set A2 units on the left and right of 1 QST unit, with a **SCANT ¼" SEAM ALLOWANCE**, followed by 1 Fabric B 1" x 4½" rectangle and 1 Fabric C 1" x 4½" rectangle on the top and bottom of the unit. Press the seams open as you go.

Repeat to create a total of **2 QST COASTER TOPS**. Set aside for *Basting, Quilting, and Binding, Step 1*.

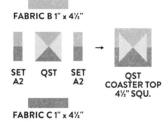

FABRIC B 1" x 4½"

SET A2    QST    SET A2 → QST COASTER TOP 4½" SQU.

FABRIC C 1" x 4½"

## SNOWBALL UNITS AND COASTER TOPS

**STEP 1**: On the reverse side of 2 Fabric A 3½" squares, mark a diagonal guideline.

**STEP 2**: As shown in the diagram, carefully note the orientation of the marked diagonal guideline on

1 Fabric A 3½" square and Set A1 unit. With right sides together, place Fabric A 3½" square on top of 1 Set A1 unit. Sew on the marked guideline to create **1 SNOWBALL** unit.

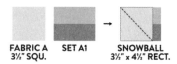

FABRIC A 3½" SQU.    SET A1 → SNOWBALL 3½" x 4½" RECT.

Repeat to create a total of **2 SNOWBALL** units.

**STEP 3**: Complete each Snowball unit by trimming a ¼" seam allowance outside of the sewn line. Press the seams open.

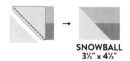

SNOWBALL 3½" x 4½"

**STEP 4**: As shown in the diagram, create **1 SNOWBALL COASTER TOP** by sewing together 1 Set A2 unit on the left of 1 Snowball unit, **WITH A SCANT ¼" SEAM ALLOWANCE**, followed by 1 Fabric B 1" x 4½" rectangle and 1 Fabric C 1" x 4½" rectangle on the top and bottom of the unit. Press the seams open as you go.

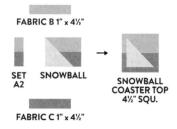

FABRIC B 1" x 4½"

SET A2    SNOWBALL → SNOWBALL COASTER TOP 4½" SQU.

FABRIC C 1" x 4½"

Repeat to create a total of **2 SNOWBALL COASTER TOPS**.

## BASTING, QUILTING, AND BINDING

**STEP 1**: Basting the coasters is slightly different from other projects. The layers and order remain the same—coaster top (usually referred as the quilt

top), batting, and coaster back (usually referred as the quilt back). If using a fusible heavyweight permanent stabilizer, lay and iron stabilizer onto the wrong side of the backing fabric first. Then baste the coaster top, batting, and stabilized coaster back together.

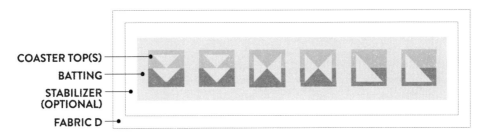

COASTER TOP(S)
BATTING
STABILIZER (OPTIONAL)
FABRIC D

Rather than creating six individual sandwiches for each coaster, create one coaster sandwich for all six coasters to speed things up. Think chain piecing, but with coaster sandwiches. With this method, you can continuously quilt your coasters without cutting the thread between each coaster, if you plan on straight line quilting. Essentially, all your coasters are linked together with continuous lengths of thread and one piece of backing fabric and batting (see the dotted lines in the example below). Not only does this save time in stopping and starting the sewing machine at the end of each coaster, but it also saves thread!

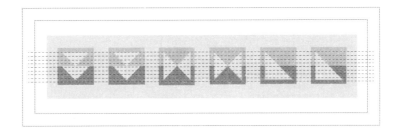

For this to be successful, take extra care when laying each coaster top on the sandwich. Leave approximately 2" to 2½" between each coaster top, and ensure the top and bottom edges of the coaster tops are all lined up and rotated the same way. This groundwork ensures the quilting seams look identical between all the coasters when the excess batting and backing fabric (and stabilizer) are removed and squared up. Baste and quilt using your preferred method.

**STEP 2:** Trim excess batting and backing (and stabilizer), and square up all coaster sandwiches. Take extra care when squaring up. Each coaster sandwich must measure a 4½" square.

**TIP:** When removing excess batting and backing fabric (and stabilizer), take extra care not to accidentally cut on the other coasters. To avoid that, use a pair of fabric scissors and roughly cut in between each coaster to create 6 separate coaster sandwiches. Then use a fabric marker or pen and ruler to mark out the 4½" measurement. This additional step ensures all edges of each coaster sandwich are straight, each corner is right-angled, and the coaster top design is not cut off while trimming.

**STEP 3:** Bind each coaster using your preferred binding method.

*Note: If using stabilizer in the project, hand binding is not recommended, as it may be difficult to pierce the needle through the multiple layers and stabilizer.*

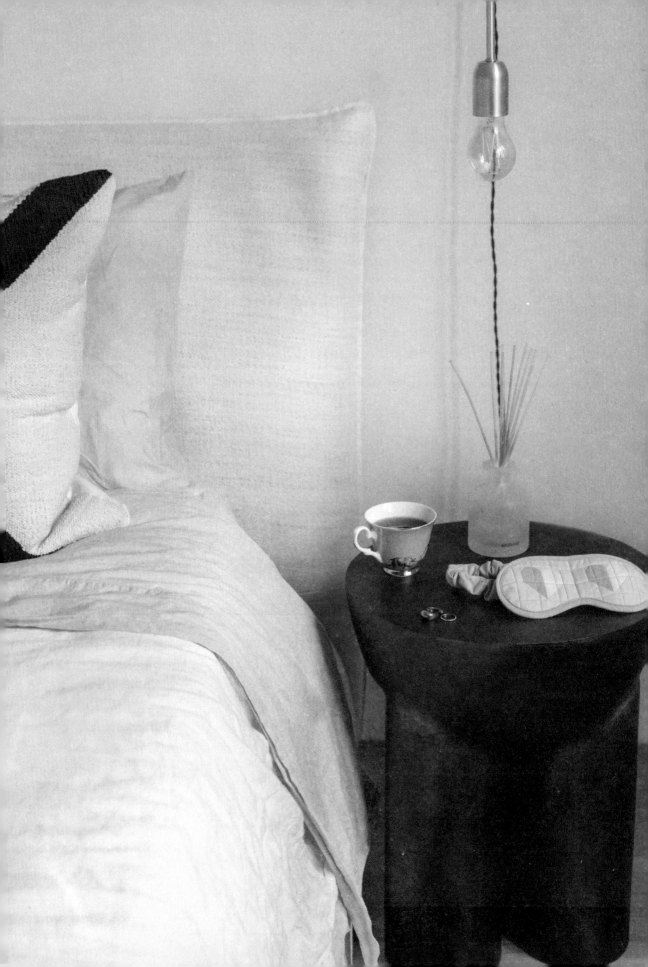

# ACKNOWLEDGMENTS

First and foremost, I want to thank the Blue Star Press family for the opportunity to share my passion and love for quilting with the world, and your continued support and encouragement in turning my dreams into reality: Lindsay Wilkes-Edrington for your guidance, trust, and patience, and for being there every step of the way; Stephanie Carbajal, Lindsay Conner, Elisabeth Myrick, Maya Elson, and Carli Marsico for making sense of the copy and diagrams; Clare Whitehead for the day-to-day logistics and ensuring people have a copy of my book in their hands; Megan Kesting for leading the design and layout of the book, and changing the way in which we look at quilting books and the craft; Sarah Moser getting the word out; Camden Hendricks for working your algorithmic and keyword magic to ensure my books are visible online; Peter and Brenna Licalzi for believing in me and convincing me to write book two.

To my husband, Brian, thank you so much for your never-ending support, words of encouragement, keeping me well caffeinated, and stepping in to keep our home in order when I needed to focus on the book. To Truffle, our little fur baby girl (I know you can't read this . . . but here goes crazy dog mama), although you did put the spanners into the latter half of the book writing process by coming into our lives, you give me the reason to not sit at my desk hours on end and to step outside to go on walks to de-stress, reset and gather inspiration. You bring so much joy into our lives and home. Thank you to all my family and friends who have supported me with all of my creative endeavors and career path.

Photos bring life to what was once an idea and drawing, and this would not have been possible without the help of Rachel Kuzma. Thank you so much, Rachel, for taking on the challenge (again) to photograph my book. I'm so grateful for your willingness, patience and the positive energy that you bring to all our shoots, and eye for detail when it comes to styling.

Unlike the first book, *Urban Quilting*, where almost all the photos were taken out of our bedroom due to New York City's COVID-19 restrictions in 2020, being able to step out was a breath of fresh air (figuratively and literally). Thank you to Frances, Erin, Roberto, and Eva for welcoming Rachel and me into your beautiful homes for photographs, especially during a times of uncertainty and the height of the COVID-19 Omicron variant. A massive thank you to the team of testers that have worked hard to make sense of and create the patterns from the book—Alissa Strouse, Amanda Carye, Amy Robertson, Celena Hsiung, Christina West, Clare Whitehead, Donna McLeod, Genna Calkins-Mushrush, Holly Clarke, Jemima Cosby, Keyana Richardson, Louisa Liang, Lydia Labadie, Maechen Marie, Meaghan O'Malley, Megan Kell, Megan Peebles, Natalia Gilio, Oonagh Griffiths, Raye Hines, Satomi Hoar, and Sewzy Wong. Your feedback on improvements and corrections are so valuable and important in making the book a success. To Laura Money of The Gathering Quilt, Sarah Campbell of Stitch Mode Quilts, and Valerie Springer of Three Birds & Stitches, thank you for your efforts and care you have put into longarming my projects. You have helped to take a lot of pressure off my shoulders and taken my pieced projects to the next level.

And this last shoutout goes to YOU! Thank you for bringing *The Quilted Home Handbook* (and *Urban Quilting*) into your life. It brings me great honor to know that I have somehow been part of your quilting journey. I hope my designs will enhance and bring joy to your space. I also hope your creations become part of you and your loved ones' stories, and that you will be able to connect and share the craft of quilting with others for many years to come.

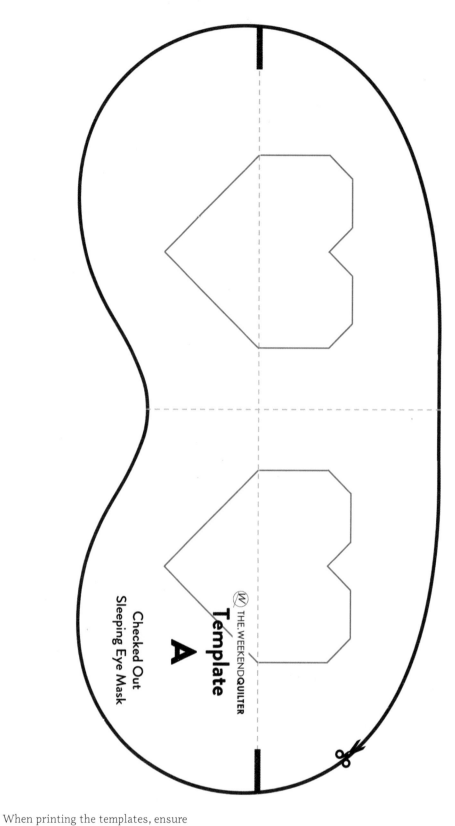

THE WEEKEND QUILTER

Template A

Checked Out
Sleeping Eye Mask

Scan the QR code to
print the template!

TEST
BLOCK
1"

When printing the templates, ensure printer or photocopier settings are set to 100% scale and measure the 1" box below before cutting into the templates and fabrics.

# TERMS AND ABBREVIATIONS

**BATTING:** Batting is the insulating layer of the quilt placed between the quilt top and back. Batting is sold by the yard (or in meters) or is readily available in pre-packaged pieces in various bedding sizes. Batting is usually made of cotton, wool, polyester, or bamboo.

*Note: Some markets outside of the U.S., such as Australia and the U.K., refer to batting as wadding.*

**BASTING:** This step in the quiltmaking process temporarily secures the three layers of the quilt—top, batting, and back—while you incorporate permanent decorative quilting stitches. There are various basting methods, including pinning, spraying, and stitching.

**BIND OR BINDING:** Binding is the long strip of fabric around the edge of the quilt that covers the raw edges of the quilt sandwich. It provides strength and longevity to a project. Attaching the binding to the quilt is usually considered the final step in quiltmaking.

**BIAS:** The bias is the 45-degree-angle thread line relative to the fabric's grain.

**BIAS BINDING TAPE:** This type of binding has been cut on the bias of the fabric. As a result, the binding tape is more stretchy than binding that has been cut along the fabric's grain. This makes the process of attaching binding on curved or rounded edges easier, and the final project will sit nice and flat.

Bias binding tape can easily be made, or ready-made bias binding tape can be purchased. Bias binding tape comes in a variety of widths and forms, including single fold and double folded.

**BLOCK:** Several individual pieces of fabric make up a quilt top. To more easily reference a certain part of a quilt top or how to construct it, a quilt top is divided into different blocks. A quilt block can simply be a square or rectangular piece of fabric cut with a rotary cutter, or it can be several pieces of fabric sewn together to form a larger square or rectangle.

**CHAIN PIECING:** In this piecing technique, pieces of fabric are fed through the sewing machine one after the other, without cutting the thread between each set. A long chain of quilt block units created on one continuous length of thread is referred to as chain pieced.

**DOG EARS:** Dog ears are the excess bits of fabric hanging over the edge of the project or joint after sewing two pieces of fabric together and pressing. Usually triangle-shaped, these little bits should be removed to reduce seam bulk and make a project look and feel tidier. Dog ears in quilting usually appear on half-square triangle units, flying geese units, quarter-square triangle units, and bias binding tape strips.

**EDGESTITCH:** A line of stitches approximately ⅛" from the edge of the fabric (usually a fold) or seam line.

**FABRIC GRAIN:** This refers to the threads that are arranged and woven together vertically and horizontally to form a piece of fabric. There are three types of fabric grain:

+ **LENGTHWISE GRAIN** are the threads of the fabric that run parallel to the selvedge, or lengthwise on the fabric.

- **+ CROSSWISE GRAIN** are the threads of the fabric that run perpendicular to the selvedge, or parallel to the raw edge of the fabric as it comes off the bolt.

- **+ BIAS GRAIN** is the thread line that is at a 45-degree angle relative to the lengthwise and crosswise grains.

**FAT EIGHTH (FE):** A fat eighth is an eighth of a yard of fabric that measures approximately 9" x 22". It is made by cutting a quarter of a yard in half on the fold.

**FAT QUARTER (FQ):** A fat quarter is a quarter of a yard of fabric. It measures approximately 18" x 22" and is made by cutting a yard of fabric in half lengthwise and vertically. These "fatter" cuts of a quarter of a yard accommodate larger and different cuts compared with the standard quarter yard of fabric that measures approximately 9" x 42".

**FINISHED SIZE:** Finished size refers to the size of the completed block or quilt top, excluding the seam allowance.

**HERA MARKER:** A hera marker is a piece of hard plastic with a thin edge and rounded top. It is designed to create creased guidelines without leaving any permanent marks or residue like a marking pen could.

**LOFT:** This term is used to describe the weight and thickness of quilt batting. The higher the loft is, the thicker and puffier the finish will be. The lower the loft, the thinner and flatter the finish will be.

**LONGARM QUILTER OR QUILTING:** Longarm quilting requires a longarm quilting machine. Three layers of the quilt are loaded onto a metal frame, and decorative stitches are sewn on manually or automatically to hold the layers in place permanently. A longarm quilting machine, or sending your project to a longarm quilter, can be very costly. However, it greatly reduces the amount of time and effort in the basting and quilting processes, and there are hundreds of different quilting motifs and designs (also known as pantographs) to select from.

**PIECING:** Piecing is the process of sewing together multiple pieces of cut fabric to form a quilt block or top.

**POINT TURNER:** A point turner is a tool used to gently poke out the corners of pockets, pillows, cushions, or any other tight corner to make a sharp and crisp finish.

**PRESSING:** There's a difference between ironing and pressing. Quilters press their seams and do not iron. Ironing is a back-and-forth motion, and this vigorous repeating movement can stretch and distort the fabric, especially smaller and thinner pieces. To press, use an up-and-down motion with an iron to flatten the seams. Pressing seams is a crucial step and should be done throughout the project to help reduce seam bulk and improve the accuracy of your piecing.

**QUILT BACK OR BACKING:** Backing is the layer or piece of fabric used on the "back" side of a quilt.

**QUILT SANDWICH:** Quilt sandwich refers to the three layers of a quilt combined together: quilt top, batting or wadding, and quilt back.

**QUILT TOP:** The quilt top is where you will put most of your time and effort when making a quilt. It is the top layer of the quilt and features the individually cut pieces of fabric sewn together.

**QUILTING**: Quilting refers to the process of sewing together and securing the three layers of a quilt sandwich with decorative or straight stitches.

**QUILTING MOTIF**: A quilting motif is the decorative design or pattern formed by the stitches that permanently holds the three layers of the quilt sandwich.

**RIGHT AND WRONG SIDES**: The right side of the fabric is the side that is visible when a project is completed. This is usually the side with the printed pattern. The wrong side is the "back" or lighter side of the fabric. With solid fabrics, the front and back are often interchangeable.

**SCANT ¼" SEAM ALLOWANCE**: A scant ¼" seam allowance is ever so slightly narrower than the standard ¼" seam allowance used in quilt projects. Adjusting and scanting your seam allowance takes into consideration fabric loss after the seam is pressed open or to the side.

**SEAM ALLOWANCE**: Seam allowance is the distance between the raw edge of the fabric and the sewn seam. The standard seam allowance on quilting projects is ¼", unless otherwise specified in the instructions. For garment sewing, the standard seam allowance is ⅝".

**SELVEDGE**: Selvedge (or selvage) is the densely woven edge of a fabric that prevents the length of the fabric from unraveling and fraying before it gets into the hands of the consumer. The selvedge usually contains the manufacturer's name, the name of collection, the fabric designer, and the swatch of colors used in that particular fabric. This part of the fabric needs to be removed before starting your new project, as it could be more difficult to sew through and may shrink in the wash.

**SQUARE OR SQUARING UP**: Squaring up, by using a rotary cutter and ruler, ensures all edges of a quilt block or sandwich are straight, and each corner is right-angled. This step helps achieve more accurate piecing and a perfect finish.

**STRIP PIECING**: Strip piecing is a quick and easy piecing method in which multiple strips of fabric are sewn together to create a "strip set." Several vertical cuts are made on the strip set to create multiple segments or units. This replaces the time- and labor-intensive process of cutting and piecing together individual squares and rectangles.

**SUB-CUT**: Sub-cut means to cut smaller squares or rectangles from a larger piece of fabric that is already cut.

**THROAT SPACE**: Throat space (also known as the harp space) refers to the distance between the sewing machine's needle and the main part of the machine where the motor is housed.

**UNITS**: Units refers to the individual pieces or sections that make up a quilt block.

**WIDTH OF FABRIC (WOF)**: This refers to the distance from selvedge to selvedge. When shopping for quilting fabrics, most often you'll find the WOF is 42" to 44" wide. All fabric requirements in this book assume 42" WOF.

**YARDAGE**: In the American market, fabric is sold in yards. Yardage is a term used to refer to fabric requirements or length of a fabric measured in yards for a project.

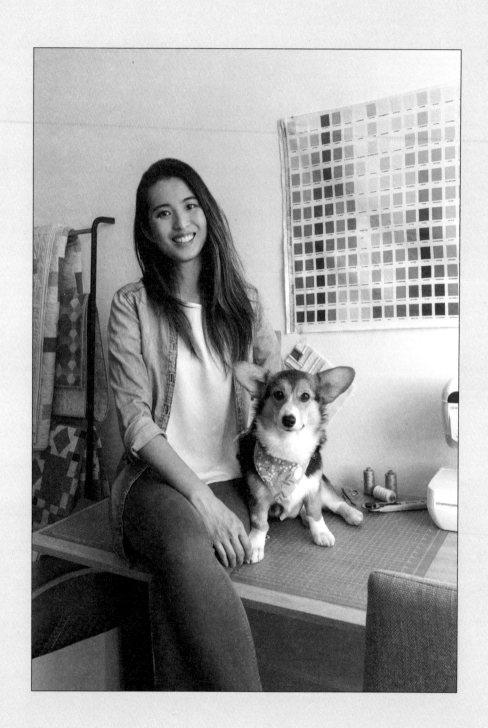

# ABOUT THE AUTHOR

**WENDY CHOW** is an Aussie modern quilter and pattern designer based in New York City. The founder of The Weekend Quilter and author of *Urban Quilting*, she aims to bring a timeless and fresh perspective to one of the oldest forms of needlework with her bold and distinct modern quilt designs.

# Paige Tate & Co.

Copyright © 2022 by Wendy Chow
Published by Paige Tate & Co.
PO Box 8835, Bend, OR 97708
contact@bluestarpress.com | www.bluestarpress.com

Art Direction by Megan Kesting
Production by David VanNess
Photography by Rachel Kuzma

ISBN 978-1950968626

Printed in Colombia

10 9 8 7 6 5 4 3 2 1